The Ceramic Career of M. Louise McLaughlin

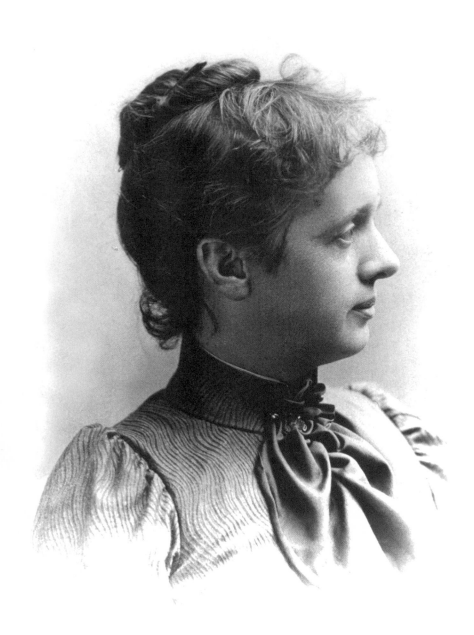

CINCINNATI ART MUSEUM

OHIO UNIVERSITY PRESS

Athens

ANITA J. ELLIS

The Ceramic Career of

M. Louise McLaughlin

The Ceramic Career of M. Louise McLaughlin has been made possible in part by a major grant from the National Endowment for the Humanities, promoting excellence in the humanities. Any views, findings, conclusions, or recommendations expressed in this publication do not necessarily represent those of the National Endowment of the Humanities.

The Ceramic Career of M. Louise McLaughlin has been made possible through the generous support of Mary Lynn and Thomas M. Cooney.

This publication is supported in part by an award from the National Endowment for the Arts.

The Cincinnati Art Museum gratefully acknowledges the generous operating support provided by the Fine Arts Fund, the Ohio Arts Council, the Institute of Museum and Library Services, and the City of Cincinnati.

Ohio University Press, Athens, Ohio 45701

© 2003 by Ohio University Press

Ohio University Press books are printed on acid-free paper ⊚ ™

11 10 09 08 07 06 05 04 03 5 4 3 2 1

Frontispiece. M. Louise McLaughlin. *Courtesy of the Cincinnati Historical Society Library*

Library of Congress Cataloging-in-Publication Data

Ellis, Anita J.
 The ceramic career of M. Louise McLaughlin / Anita J. Ellis.
 p. cm.
 Includes bibliographical references.
 ISBN 0-8214-1504-2 (cl. : alk. paper) — ISBN 0-8214-1505-0 (pbk. : alk. paper)
 1. McLaughlin, M. Louise (Mary Louise), 1847–1939. 2. China painters—Ohio—
Cincinnati—Biography. I. McLaughlin, M. Louise (Mary Louise), 1847–1939.
II. Title.
NK4605.5.U63 M354 2003
738.1'5—dc21
 2002038137

Contents

Appendices

Illustrations

Figures

Preface

The purpose of this book is simply to record the ceramic career of M. Louise McLaughlin. It does not aim to judge her aesthetic or offer a feminist critique of her life. In spite of the enormous influence McLaughlin had on American ceramics, heretofore a serious study of her work has been unavailable. Such early seminal publications as Alice Cooney Frelinghuysen's *American Porcelain, 1770–1920* (1989), Paul Evans's *Art Pottery of the United States* (1987), Garth Clark and Margie Hughto's *A Century of Ceramics in the United States, 1878–1978* (1979), and Paul S. Donhauser's *History of American Ceramics* (1978), all point to McLaughlin's eminence and pave the way for this publication. Certainly it is now time to investigate a figure who was for many years an American leader in china painting, underglaze slip decoration, and porcelain. It is hoped that the ceramics of M. Louise McLaughlin can now be appreciated with renewed understanding, and that feminist scholars and art historians will be able to draw on her career for a better comprehension of American ceramics, the women's movement, and the Arts and Crafts Movement in America.

Anita J. Ellis
Director of Curatorial Affairs &
Curator of Decorative Arts
Cincinnati Art Museum
November 27, 2002

Acknowledgments

Early in the spring of 1990, I requested a one-year sabbatical to research and write a book about the ceramics of M. Louise McLaughlin. To this end, I asked six colleagues, Professor Martin Eidleberg of Rutgers University; Alice Cooney Frelinghuysen, curator, the Department of American Decorative Arts at the Metropolitan Museum of Art, New York; Coille McLaughlin Hooven, porcelain artist and ceramics instructor at Laney College, Oakland, California; Garth Clark of the Garth Clark Gallery; Kenneth R. Trapp, curator-in-charge of the Renwick Gallery of the National Museum of Americans Art; and Gerry Williams, editor of *Studio Potter Magazine,* to write letters of recommendation for the project. All graciously agreed, and because of their involvement, the sabbatical was granted. I cannot thank them enough for their willingness to support my objective.

Special appreciation also goes to The Friends of Women's Studies of the Women's Studies and Resources Institute of the University of Cincinnati, who benevolently awarded me a grant to help cover the cost of research. Once the project began on June 1, 1991, others generously contributed time and expertise to my research and writing. First, I must offer my sincere gratitude to Mary Alice Heekin Burke, a good friend and colleague, who read the manuscript and gave valuable advice based on her extensive knowledge of late-nineteenth-century Cincinnati culture as well as art history. The book is richer because of it. I must also thankfully recognize Mme. Susan Goddard for improving my knowledge of the French language. *Merci beaucoup, Madame.* Wholehearted appreciation is also extended to Karen J. Kriebl for sharing her research and thesis manuscript on McLaughlin, and to Ellen Paul Denker for graciously permitting me to glean from her considerable knowledge of American china painting. I salute the following institutions, without which there would have been virtually no information regarding McLaughlin from which to draw: the

Cincinnati Historical Society Library, the Public Library of Cincinnati & Hamilton County, the Mary R. Schiff Library of the Cincinnati Art Museum, the libraries of the Everson Museum of Art and the Corning Museum of Glass, and the Archives of American Art.

Coille McLaughlin Hooven offered a very special opportunity to me. She not only wrote a letter of recommendation for the project, but also invited me to her studio to work with porcelain. After that learning experience, I had greater respect for Louise McLaughlin, not to mention her great grandniece Coille. I also wish to thank all the collectors who, upon hearing of my project, showed me their pieces by Louise McLaughlin. McLaughlin's work is so scarce at present that every object was helpful to the understanding of her *oeuvre.*

At the Cincinnati Art Museum, I would like to thank Director Emeritus Millard F. Rogers Jr. for allowing me the sabbatical, and former Associate Curator of Decorative Arts Cecie Chewning who so ably manned the fort while I was away. Sincere gratitude is also extended to Photographic Services/Rights and Reproduction Coordinator Scott Hisey for his exquisite handling of the photography needs relating to the Museum's collection, and to photographer Tony Walsh for his fine photography. Finally, I would like to offer special gratitude to Timothy Rub, director of the Cincinnati Art Museum, who has offered his total support toward this publication. His belief in his curators and his encouragement of scholarly publications are the reasons this project has finally come to fruition. Timothy, hats off to you.

A special note of thanks also goes to the staff of Ohio University Press and its director, David Sanders, for believing in this material and extending their talents to copublish this book.

Also extending her considerable talents to make it all happen was Kathryn Russell, managing editor par excellence, who also offered copyediting and picture research services with her usual manner of quiet competence and perfection.

This volume is being published on the occasion of the opening of the Cincinnati Wing at the Cincinnati Art Museum. The book has been made possible through the generous support of Thomas and Mary Lynn Cooney, who understand the value of the written word and scholarly publications. Sincere appreciation and kudos to you both.

The Ceramic Career of M. Louise McLaughlin

chapter 1

BACKGROUND

"I was born into a family of old people. My mother appeared to settle down with a domestic life and as far as contact with the outer world I might have been brought up in a convent," wrote Mary Louise McLaughlin.[1] It is impossible to determine how insulated her childhood was; however, she was indeed the youngest in a family of "old people." At the time of her birth in the early morning (3:00 A.M.) of September 29, 1847, her father William was fifty-five years old, her mother Mary was almost forty-one, and her two brothers George and James were sixteen and twelve years old, respectively.[2] Mary Louise was named after her mother, Mary, and her mother's sister, Louise Robinson. Throughout her life Mary Louise was simply called Louise, giving only a hint of her mother's name by signing all formal letters and documents as M. Louise McLaughlin.

As a young child, Louise displayed an impressive artistic aptitude. "My earliest recollections are of drawing and the desire to cover every available surface with my efforts," she reflected.[3] The source of her artistic talent is somewhat conjectural. There seems to be no trace of such ability on the paternal side of the family. Her father, William McLaughlin, was born in Sewickley, Pennsylvania, near Pittsburgh, on June 4, 1792. In 1818 he left for Cincinnati, where he became a prominent dry goods merchant. At one point he took in a John Shillito as a junior partner in the

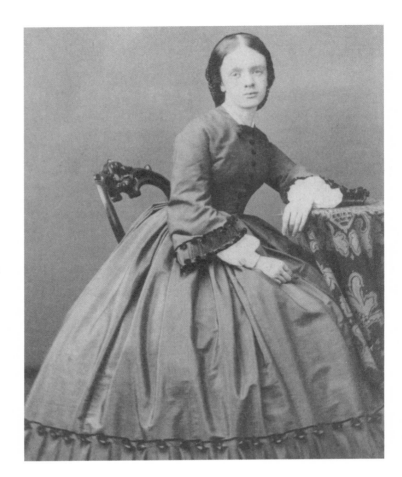

Fig. 1.1. M. Louise McLaughlin as a teenager, early to mid-1860s. *Courtesy of Tom White*

dry goods business.[4] The junior partner eventually became successful with his own department store. Today Shillito's is still a major mercantile establishment in Cincinnati, where its name was changed to Lazarus. Ultimately William McLaughlin gave up the dry goods business and opted for other means of support. In the Cincinnati Directory for 1849–50, he is listed as a clerk in an express office; from 1850 until 1863 he is noted as a bookkeeper with his own office on Pearl Street; and in 1863, at the age of seventy-one, he appears to have retired. Louise was then sixteen. William died eleven years later in 1874, the year his daughter began to work with ceramics. If William McLaughlin had artistic talent, he did not exhibit it in his life as a merchant and bookkeeper.

As for his wife, little is known about Mary McLaughlin. Born Mary Ann Robinson on December 21, 1806, she moved with her family from Baltimore to Cincinnati

in 1814. A young bride of eighteen, she married William on January 4, 1825, in the First Presbyterian Church on Fourth Street in downtown Cincinnati, just a few blocks from their home. Her artistic talent is as moot as her husband's. Nothing survives to suggest that she had the slightest artistic ability. Mary McLaughlin was widowed after a marriage of forty-nine years that produced three offspring. She continued to live with her children until her death seven years later, in 1881, at the age of seventy-four. Louise was thirty-three at the time of her mother's death.

Although there seems to have been no artistic bent on the mother's part, her sister Louise "wrote a very beautiful hand, did wonderful bead work, painted in watercolors etc."[5] Aunt Louise died of pneumonia when Louise was less than a year old, but her art work left an impression on the future artist: "I feel that . . . Aunt Louise must have had artistic talent that in a later day would have blossomed into something worth while [*sic*]. . . . I have always thought that it would probably have made a difference in my life if she had lived." It is impossible to determine what the difference would have been, since the niece could not have been any more devoted to art. Aunt Louise seems to be the only tie that suggests a genetic inclination, however remote, to artistic talent in the McLaughlin family. Nevertheless, the family genes cannot be dismissed since all three children of William and Mary McLaughlin entered art fields.

According to Cincinnati Directories, William brought a son, William Jr., with him from Pennsylvania to Cincinnati. Since William Sr. did not marry Mary Robinson until he had been in Cincinnati for seven years, it is assumed that William Jr. was by a previous marriage. In 1836 William Jr. is recorded as clerking in his father's dry goods store. He continues to be listed in Cincinnati Directories through 1846. After that year, this son is never mentioned again. Moreover, he is not included in any existing family records.

William and Mary McLaughlin's first child was a boy born on April 6, 1831. They named him George. The first we hear of George as an adult (fig. 1.2) is in the Cincinnati Directory for 1853, in which he is listed as residing with his family at 123 West Row Street. In 1855 he is listed as a sculptor; in 1856 he is listed as a student of law; and from 1857 to 1860, he is listed as an attorney. In 1861 he became the treasurer and secretary of the Pendleton and Fifth Street Market Railroad Company and retained that position until 1865, when he became the secretary of the Firemen's Insurance Company. In 1882 he was promoted to the presidency of the Firemen's Insurance Company and he remained in that position until 1893, when he opened

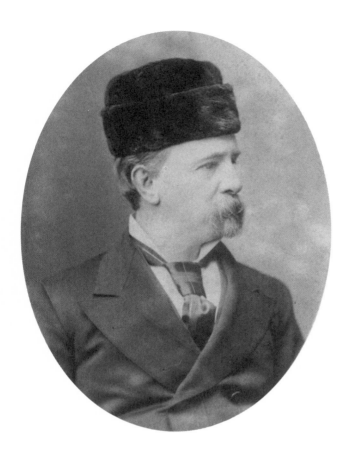

his own accounting firm. In October 1893 he committed suicide. What is impor-
tant to note in all this is that George's first occupation is listed as a sculptor.

How much formal art training he had is impossible to know. Cincinnati had
an active cultural community at the time, and art classes or lessons would have been
available to him. Apparently his career as a sculptor was short-lived; the following
year, 1856, he began to study law. At this time George was twenty-five years old, and
his father was sixty-four. It is conceivable that as the oldest surviving son, his duty
to support the family overruled his desire to be an artist, a profession offering ques-
tionable financial rewards. This scenario is especially plausible because the age of his
father suggested that his mother and sister would soon need a provider. Other than
a need to support the family, it might simply be that George lacked talent as an artist,
or that he found he did not like the profession and so opted out. There are no
known surviving examples of his work to tell of his talent, or lack thereof, but there
are indications that he did indeed enjoy art and regarded himself as a connoisseur

and critic. In the 1870s he is often listed as a contributor of art (not by his hand) to various loan exhibitions.[6] Catalogs for these exhibitions show George to be a collector of drawings and ceramics. Furthermore, during his lifetime he fancied himself an art authority and wrote such publications as a book entitled *Art Work of Cincinnati*, a two-part article for *American Art Review* entitled "Cincinnati Artists of the Munich School," and a series of critical essays for the *Cincinnati Tribune* on the international art collections at the 1893 World's Columbian Exposition.[7] He was knowledgeable about, and felt comfortable analyzing, the art of Cincinnati and the world, which strongly suggests a continued interest in the field. It is wholly conceivable that it was George who introduced his younger siblings to art. George remained single throughout his life, as did his sister Louise, and they lived together until his death in 1893. His influence was probably considerable, since Louise often deferred to George's opinion in artistic matters. Admittedly, the deference could have been because of his seniority or the fact that he was male, or because he was her provider by the time of her career endeavors; but there is every reason to believe that she sought and genuinely respected his advice in aesthetic matters.

James (fig. 1.3), the second son of William and Mary McLaughlin, was, by all contemporary accounts, the star of the family. He was born November 1, 1834, and was educated in the public schools. In 1849, when Louise was a baby of two and George was well on his way to becoming a sculptor, James, at age fifteen, entered the office of the young architect James K. Wilson.[8] Wilson later distinguished himself in Cincinnati as the architect who designed the still extant and still stunning Moorish Revival Plum Street Temple in 1865–66. James studied under Wilson for about five or six years. The Cincinnati Directory first lists James as an architect in 1855. Throughout his lifetime, his professional name was always noted as James W. McLaughlin. Although it is never stated, the "W" perhaps stands for William. James used the middle initial to distinguish himself from other James McLaughlins in Cincinnati. The father's business successes and, by extension, the family's social prominence generated many clients for the young architect. In 1855, the first year of his independent practice, his father's old business partner, John Shillito, commissioned James to design a great dry goods store on West Fourth Street; and the Honorable D. K. Este contracted him to build a house in downtown Cincinnati that was considered the finest in the city. Throughout his career, James never seems to have been at a loss for commissions. With the onset of the Civil War in 1861, he left Cincinnati to become a lieutenant in the Infantry Body Guard of General John C. Fremont. Later

he became a special artist for Frank Leslie's illustrated newspaper in the Army of the Southwest. Louise, fourteen years old at the time the fighting broke out, always had vivid memories of the Civil War, especially her brother's leave-taking.[9] In 1862 James returned from his military duties to continue his practice as an architect and to marry Olive Amelia Barbe on September 27. He and Olive had a lasting marriage of fifty-one years that included nine children. His architectural commissions display an extensive knowledge of design that was eventually broadened even further by studies in Europe. Among the notable examples of his work still standing in Cincinnati are the Cincinnati Art Museum, which has acquired many examples of his sister's art, and the Art Academy of Cincinnati. James was a highly respected member of the American Institute of Architects for more than thirty years, and at one time served as its director. For two years, from 1904 to 1906, he practiced in a partnership with architect James G. Gilmore. James W. McLaughlin is listed in the Cincinnati Directories until 1918, when he retired and moved with his family to New York City. At the time, he was eighty-three years old and had been a successful practicing architect for sixty-three years. He died in New York on March 4, 1923, at age eighty-eight. His body was returned to Cincinnati for burial.

When placed in the context of her family, it is not all that surprising that

Fig. 1.3. James McLaughlin.
Courtesy of Rosemary and Don Burke

Louise McLaughlin had a penchant for art. By the time she was eight years old, one of her brothers was a sculptor and the other an architect, and both of them lived at home with their sister and parents. The parents, if not artistically inclined themselves, obviously tolerated and perhaps even encouraged their children's desires to placate the muse. All things artistic must have been discussed and promoted, and probably were displayed in the McLaughlin household.

Besides Louise's family, one factor that cannot be overlooked as an influence on her artistic career is the city of Cincinnati. Founded in 1788, Cincinnati was a mature and prosperous city by the mid-nineteenth century: Its robust river trade and rich industrial base engendered a cosmopolitan mix and an ever-increasing population. By 1850 the population of Cincinnati was more than 115,000, whereas that of Pittsburgh, the next largest midwestern city, was just short of 68,000.[10] Chicago, not yet twenty years old, could not even be compared at this time. By 1859 Cincinnati was a major American manufacturing center, second only to Philadelphia.[11] After the disruption of the Civil War, Cincinnati's industrial growth continued. Beginning in 1870, the Queen City annually staged the largest industrial expositions held in the United States prior to Philadelphia's 1876 Centennial Exhibition.[12] With the wealth of industry came cultural refinement. Cincinnati seems to have been blessed with wealthy, highly intelligent, creative citizens who patronized and promoted the arts. Before 1860, the Queen City was "the oasis of real intellectual and creative talents west of the Appalachian Mountains."[13] At midcentury, the city encouraged artists through private patronage and a union. The Western Art Union, organized in 1847, was the second in the United States after New York City's Art Union, which had been founded a year earlier. The purpose of a union was to distribute fine art to its members by means of a drawing. Anyone could join the union for $5.00, and hope to have his name chosen as the recipient of a fine painting or piece of sculpture. The union used membership fees to acquire works from artists. By 1849 the Western Art Union had an exhibition hall capable of displaying about three hundred works for all to see. By 1850 its membership numbered 4,724. Local artists enjoyed the prosperity until 1853, when a lottery law put a stop to the union. Nevertheless, interest in art continued as dealers opened art galleries such as William Wiswell's picture gallery, started in 1851. Probably the most significant art organization to begin in the 1850s was the Ladies' Academy of Fine Arts (LAFA), founded by the indomitable Sarah Worthington King Peter.[14] Organized in 1854, its purpose was to build an art collection and to open an art academy. Classes in the proposed School

of Design were to be open to women who could prove that they needed the skills provided by the school to support themselves in the honorable practice of the arts. Initially, the school was prosperous, and Mrs. Peter traveled to Europe, where she bought copies of old master paintings and casts of classical sculpture to start the LAFA art collection. Unfortunately, the school eventually succumbed to the economic and political pressures of the 1860s. However, during the last board meeting in June 1864, the LAFA bequeathed its art collection to Cincinnati's McMicken University. In 1868 this art collection became the core of the newly founded McMicken School of Design (opened in 1869), which in 1871 became the School of Design of the University of Cincinnati (where Louise was educated). Then in 1884, the collection was transferred to the Museum Association's art school that later became known as the Art Academy of Cincinnati in 1887.[15] One month after Mrs. Peter's death in February 1877, the Women's Art Museum Association (WAMA) was organized. Its goals were reached with the founding of the Cincinnati Art Museum in 1881, and the previously mentioned Art Academy of Cincinnati in 1884. Indeed, Cincinnati had an enviable interest in art. Interrupted by the War between the States, the cultural scene fully flowered during the 1870s and 1880s, when Louise McLaughlin was maturing as an artist. An article entitled "Topics of the Time: Cincinnati," from *Scribner's Monthly* in August 1875, gives an interesting national view of this industrial, culturally minded city:

> Cincinnati is a remarkable place. . . . The people drink of the water that flows by them, as yellow as the Tiber. They breathe an atmosphere of lamp-black, and the ladies are accomplished in the delicate art of blowing flocculent carbon from their ears, as it drops from chimneys that vomit blackness. . . . We are told that they make beer there, and sell it. We suppose somebody drinks it, and pays for the privilege of doing so—which is a mystery. They climb their hills in elevators to win the prospect of a city which seems to have been burned down, and to be still smoking in its ruin.
>
> But Cincinnati, with all its drawbacks, is intellectually and artistically alive. More than that, its people . . . are intelligently public-spirited and grandly self-sacrificing. There is not a city in the Union where so much is doing at this time for polite culture, as in Cincinnati. . . . In a hundred years, she will arrive at a higher civilization than the cities of the Old World have attained in a thousand.[16]

It is evident that during the second half of the nineteenth century, Cincinnati was a good place to live if you were inclined to become an artist. It had schools to train

you, wealth to support you, intelligence to promote you, and the sensitivity to accept the artist as an important part of the community. It was not old enough to be encumbered with tradition, and it looked to the present, rather than the past or future, for its glory.

Coupling an understanding of the artistic temperament of Cincinnati in general with that of the McLaughlin family in particular gives an important insight into the psyche of Louise McLaughlin. The family and city that nurtured her had much to offer, and she took full advantage of both.

EDUCATION

"I don't think that I was ever a satisfactory pupil to any of my instructors, having always had a desire to work out things in my own way," confessed Louise McLaughlin.[1] It is unknown whether her primary education was in public or private schools. Whatever the case, she lamented that in those days art was not considered a necessary part of the curriculum. It was not until after her primary education was completed that she sought instruction in drawing at a small private art academy on East Fourth Street. "This school was presided over by a lady of most loveable character whose artistic ideas and methods were, however, decidedly early Victorian," Louise stated, but she failed to give the name of the school or the lady.[2] Continuing, she said, "After some time pleasantly but most unprofitably spent, I went to the Art School." The one institution that fits almost every aspect of her description is Miss Appleton's Private School for Girls. Elizabeth Haven Appleton was forty years old when she began her school for young ladies in downtown Cincinnati in 1855.[3] She promoted the arts and was a staunch supporter of education for women. It is not surprising to find that she was on the Board of Managers of Mrs. Peter's Ladies' Academy of Fine Arts, founded in 1854.[4] Elizabeth Appleton was esteemed by her pupils, who eulogized the Victorian instructor in a flowery prose tribute to her at a meeting held in her

memory on February 19, 1891: "By her instruction in art and literature, she stimulated the imagination and cultivated an artistic appreciation tending towards that harmonious development which makes life so full of interest and beauty."[5] A list of Miss Appleton's students reads like the social register of Cincinnati. All Cincinnati girls with parents of substantial means attended academies like hers where art and literature were considered the twin peaks of refinement. School records show that Louise McLaughlin attended Miss Appleton's during the 1871–72 school year. Louise was twenty-four years old at the time and, of course, had long since completed her basic education. Shortly thereafter, in 1873, the frustrated artist began courses at the School of Design of the University of Cincinnati ("the Art School"), which was later to become the Art Academy of Cincinnati. It is often written that while attending Miss Appleton's, Louise shared classes with Clara Chipman Newton and Maria Longworth, who were to become key individuals in a tightly woven mix of people in Louise's artistic career. This is not true. While they may have met socially, they did not meet at that school for young ladies. Maria Longworth, who later founded The Rookwood Pottery Company, attended Miss Appleton's from 1862 to 1865; Clara Chipman Newton, who later became the secretary to Rookwood Pottery and the Cincinnati Pottery Club, attended from 1863 to 1865. Louise did not grace Miss Appleton's until 1871–72, a full six years after they had left.

Miss Appleton's Private School for Girls seems to fit Louise's description of her first formal art classes—the mistress was indeed loveable and decidedly Victorian, Louise attended as an adult when her practical education was behind her, and the dates of her attendance were shortly before she began courses at the School of Design. The problem with this scenario is that this girls school was on Elm Street, not East Fourth Street as in Louise's description. Until 1867, the school had been on West Fourth, but it was on Elm by Louise's time. Was the address a mistake on the artist's part, or was there yet another school that she attended? Although Mary Spencer taught art on Fourth Street from 1869 until after Louise began courses at the School of Design, Mary Spencer hardly fits the description. She was an artist by profession, not a schoolmistress, and from what is known there is no reason to believe that she was "decidedly early Victorian." Also, her studio was on West Fourth, not East Fourth. For the five-to-ten-year period during which Louise could have attended her first art academy, many schools came and went in downtown Cincinnati. Without a name, it is impossible to determine which one it might have been. Whichever school it was, Louise McLaughlin, whose earliest recollections were of drawing

and the desire to cover every available surface with her efforts, received her first formal drawing lessons as a young adult. That these lessons were unprofitable probably says more about her level of competence and less about her teacher's inability to teach. Growing up at home with her artist brothers and loving to draw, Louise was probably proficient by the time of her first art course, which was most likely taught at a much lower level reflecting the class as a whole. Shortly after this disappointing experience, Louise began her four-year course of study at the School of Design. By the time she graduated in 1877, her career was well on its way.

Before discussing her art career in general and her ceramic career in particular, it is important to understand the training she received at the School of Design.[6] The aim of the School of Design was not only the study of painting and sculpture, but also the improvement of the industrial arts. This latter goal reflected Cincinnati's rich industrial base. The school's curriculum was typical of traditional European academies. The first year was dedicated to training the eye and hand by drawing "from the flat" (i.e., from plates or engraved prints). Beginning with simple forms, such as flowers or plants, the student progressed to those more complex, such as the head or face of the human body, and ended with the entire figure. The ultimate goal was the mastery of perspective and anatomy, all from "the flat." The second year taught drawing and shading from "round and solid models." The models were plaster casts, undoubtedly the same casts that Mrs. Peter had brought from Europe for the Ladies' Academy of Fine Arts, which she ultimately gave to McMicken University, the forerunner of the School of Design. By the third year, students were drawing from nature, especially the human face and form. For the human form, an anatomist would bring in skeletons, engravings of the muscular system, and other visual aids, and would offer detailed lectures. As yet there were no "life classes" where students drew from live, usually nude models. According to Louise, the administration was considering a life class at the time but had yet to institute one. The male students often carried on a night class by themselves. When funds permitted, they hired models; otherwise they posed for each other. Formal life classes began for men not long after Louise graduated; however, because the models were often nude, women were not allowed to attend. Separate life classes for women began in 1885. Also during the third year, composition and design continued with the study of the application of color and any "special studies" provided by the school. "Special studies" could be painting in oil, watercolor, fresco, or distemper; also included were sculpture, wood engraving, lithography, engravings on metals, mechanical drawing, or

the history, principles, and rendering of architecture. Besides all this, pupils could elect to study decorative design, which taught students to create design patterns for furniture, textiles, paper-hangings, etc., or to train for ornamental work in metals and woodcarving. The fourth year continued with composition and design, and any of the special studies.

To be admitted to the School of Design, a student had to be a resident of Cincinnati and at least fourteen years old (Louise McLaughlin was almost twenty-six at entrance); she or he had to be of good moral character and competent in reading, writing, and basic arithmetic; and finally, the prospective student had to have a letter of recommendation from someone who would also agree to pay for any damage inflicted by the student upon school property. Tuition was free to Cincinnati residents.

Thomas S. Noble taught drawing along with his three assistants, William H. Humphries, R. Russell Whittemore, and Mattie Keller. Benn Pitman taught woodcarving, and Louis T. Rebisso taught sculpture. Louise McLaughlin later recalled, "Much as I may have respected the talents and the personal qualities of my teachers [at the School of Design], I do not recall having learned much from them."[7] This is debatable. As will be seen, many of the basic tenets espoused by these teachers, especially Benn Pitman, are reflected in Louise's work. Moreover, "the Art School" was one of only two or three art academies in the United States at the time, and offered one of the best art educations in the nation. What she perhaps meant by this statement is not that she did not learn anything, but that she did not learn anything new. Although well structured, the school was not philosophically progressive. The basics were emphasized over and over again, and Louise probably felt that she was beyond the basics. She wanted to create things in her own way and in her own time without academic restrictions. "This tendency is really one that should be encouraged but Madame Montessori had not then appeared to demonstrate it and, in my time, it was the unpardonable sin."[8]

There were competitions for prizes awarded to art of superior merit in each class. According to Louise, she somehow won one for sculpture in 1876, and another for an original design in an undisclosed year. However, she did not take these competitions too seriously:

> At that time, the medals were competed for the execution of enormous drawings from the antique, heroic size; accomplished entirely by the fine point of a crayon pencil. Necessarily this took a long time and we were accustomed to seeing

the prize medalists, like modern St. Stylites, perched upon their stepladders for months, only not immoveable, as they were patiently engaged in producing the afore-mentioned monstrosities.

I thought then, as I do now, that it was a sinful waste of time and was not tempted, indeed no one ever suggested it to me, to compete for a gold medal.[9]

Although Louise did not think that the School of Design helped her artistic skills in any measurable way, it was at this school that she was introduced to Benn Pitman, who in turn introduced her to china painting. With hindsight, this was probably the most important event of her entire student career. If nothing else, the school started her off in ceramics, albeit indirectly, since Pitman offered his first china painting class outside the auspices of that institution.

Student exhibition catalogs show Louise to have been ahead of her class.[10] In 1873, the first year of her attendance, the catalog for the Fourth Annual Exhibition of the School of Design notes number 20 to be a "Head of Apollo," by M. Louise McLaughlin. "Apollo" was drawn from the "Antique," or plaster cast. In the normal run of things, drawing from casts of antique statuary came during the second year of instruction. Since Louise was already drawing from casts during her first year, she was obviously considered to be beyond the stage of "drawing from the flat." Catalogs dating 1873–74 and 1874 record objects that place the artist in Benn Pitman's wood-carving classes and also have her making original designs for a tabletop and a cabinet, as well as drawing and painting "from life." Students usually took such courses in the third year, but the precocious Louise took them during the first and second. By June 1875, the catalog for the Seventh Annual Exhibition of the School of Design of the University of Cincinnati shows that Louise displayed "Apollo" from the "Antique" (the same one?), a fresco, and her first examples of painted china. In the exhibitions of the following year, Louise again displayed china painting and wood-carving, and added sculpture to her list of credits. In fact, as she later reminisced, in this exhibition she received the "Silver Prize" for an unidentified piece of sculpture, suggesting that she was skilled in three dimensions as well as in two. By June 1877, her final year, she was showing a sketch of beech trees and a portrait etching. She was particularly fond of portraiture, and applied it to virtually every art form that she explored. Curiously, in the Ninth Annual Exhibition of the School of Design in 1877, Louise was the only student cataloged as displaying china painting.

The art school catalogs tell us that Louise McLaughlin had advanced skills by

the time she began the School of Design; that her interests were wide-ranging, and besides drawing, painting, and sculpture, included woodcarving, china painting, etching on copper, and even fresco; and finally, that she had a penchant for china painting. In a catalog of the School of Design for the year 1877–78, one year after Louise had graduated, there is a list of students from 1869 to 1877 who "turned the instruction received there to practical account."[11] "M. Louise McLaughlin" is listed as a "China Painter." Although Louise McLaughlin always saw herself first and foremost as a portrait painter, she was already typecast by graduation, and Benn Pitman's first china painting class is where it all began.

chapter 3

CHINA PAINTING BEGINS,
1873–1875

"As usual I was able to extract but little help from the teacher," mused Louise McLaughlin with regard to her first china painting class.[1] Although she made similar remarks about nearly all her teachers, perhaps this time Louise was correct. To understand the circumstances of that first china painting class and the reason for McLaughlin's remark, it is necessary to understand the history that led to the class's inception. Karl Langenbeck, a neighbor of Maria (pronounced Mar-eye-a) Longworth (fig. 3.1), was a young man interested in art. By the summer of 1873, he had begun experimenting with a set of china paints that he had received from an uncle in Frankfurt, Germany. Maria Longworth, who was by then Mrs. George Ward Nichols, and her friend Mrs. Learner B. (Fanny Goodman) Harrison became fascinated by the art of china painting and worked with Langenbeck until they could import their own colors. Nichols and Harrison are the first females documented as amateur china painters in Cincinnati. Of the two, Maria Longworth Nichols is particularly noteworthy.[2]

Born in 1849 to Cincinnati's wealthiest family, Maria Longworth was raised in an atmosphere of refined culture. The Longworths, noted for their collections and patronage of the arts, encouraged Maria in her marked aptitude for playing the piano,

painting, and sketching. In 1868 she married the dashing Colonel George Ward Nichols, a Civil War veteran knowledgeable in art and music, who had been hired to catalog the Longworth collection of paintings, sculptures, and ceramics. Continuing the Longworth tradition in art patronage, Maria and her husband were instrumental in establishing Cincinnati's biennial (later annual) choral festival, the May Festival, in 1873. (The success of the May Festival is apparent today as it is still a major annual event in Cincinnati.)

Like Louise McLaughlin, Maria Longworth Nichols was particularly interested in ceramics. The two are rightfully viewed as the dominating figures in the Queen City, and ultimately the nation, in the early history of art pottery in America. In 1880 Mrs. Nichols began The Rookwood Pottery Company, which became famous in 1889, when it won a gold medal at the World's Fair in Paris. Rose Angela Boehle, O.S.U., Maria's biographer, records a vivacious lady "with a touch of daring and sometimes even rashness."[3] All accounts agree that Maria had a strong personality, and because of her family's unbounded wealth, wanted for nothing in life. According to McLaughlin, "Mrs. Nichols was a spoiled child of fortune who generally got what she desired as soon as it could be procured for her."[4] Widowed in September 1885, Maria was married again in March 1886 to lawyer/diplomat Bellamy Storer Jr. From then on, her interest in her husband's political career overtook her interest in ceramics. However, between 1874 and 1894, Maria Longworth Nichols found herself or her Rookwood Pottery in constant competition with Louise McLaughlin in Cincinnati's ceramic circles.

In an exhibition at the School of Design in 1874, china-painted examples executed at home by one of the students, possibly Maria Longworth Nichols, were put on display. Seeing these pieces, fellow students told Benn Pitman (fig. 3.2), their woodcarving teacher, of their desire to learn to china paint. One source of this history, a manuscript entitled "Pottery" by an unidentified but knowledgeable author, states that it was actually Benn Pitman's wife who first suggested that he teach china painting. Whether influenced by his wife or his woodcarving students, Benn Pitman embraced the idea with zeal.

An expatriate Englishman, Benn Pitman came to the United States to promote a shorthand system of phonography developed by his brother, Sir Isaac Pitman.[5] By 1853 he had settled in Cincinnati, where he founded the Phonographic Institute to spread his brother's method of shorthand and where he also served as a court recorder. Because of his superior stenographic skills, he was chosen as the court

Fig. 3.1. Maria Longworth Nichols, late 1870s–early 1880s, founder of The Rookwood Pottery Company. *Courtesy of the Cincinnati Historical Society Library*

recorder for the Lincoln assassination trials. According to Louise McLaughlin, Benn Pitman "felt the necessity of having a hobby in his spare hours and for this he practiced woodcarving."[6] Having become highly skilled in this endeavor, he entered the School of Design as an instructor, offering his services gratis during the establishment of a department in woodcarving. Benn Pitman engaged in intellectual and artistic pursuits throughout his lifetime. He was well versed in the decorative arts, and published his views on design reform in many nationally circulated periodicals and privately published booklets. He was greatly influenced—indeed, inspired—by the design reform philosophy of John Ruskin, the social conscience of William Morris, and the back-to-nature philosophy of Ralph Waldo Emerson. One contemporary described him as "a small, nervous, intense man who talks Ruskinese."[7] Pitman's primary message to artists was to create "American" art, not works that mimicked European examples.

Ceramic Career of M. Louise McLaughlin

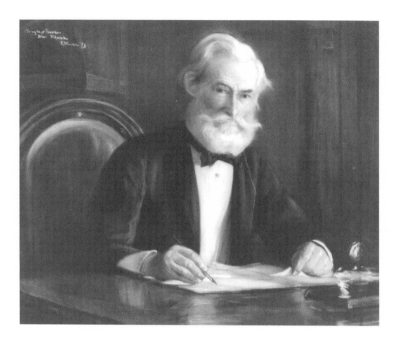

Fig. 3.2. Portrait of Benn Pitman by Cincinnati Pottery Club member Elizabeth Nourse. *Courtesy of the Cincinnati Historical Society Library*

Pitman was a leading exponent of the Aesthetic Movement in the United States. As such, he espoused good taste in the design of industrial arts and sought to provide training in art and design for artists, artisans, and patrons—the makers as well as the buyers of art. Because the production of furniture was a major industry in Cincinnati, the School of Design readily accepted a course in woodcarving. Instruction in woodcarving would enable artists and artisans to acquire jobs in the manufacture of furniture, thereby raising the quality of industrial output by wedding art to industry. Instruction would also enable patrons, or buyers, to choose objects of the best artistic merit, thus making their homes more beautiful and spurring demand for quality products. Perhaps Benn Pitman foresaw the same results in regard to china painting, for Cincinnati was also a major ceramic center. Whatever the case, when his wife and/or woodcarving students (who were mostly women) expressed an interest in china painting, he took them at their word. After the exhibition of those first china-painted examples in the spring of 1874, he took a vacation to New York and returned with very little information and a set of mineral colors. During that summer Pitman invited a number of students from his woodcarving class to experiment in china painting. Lists of students in that first china painting class vary somewhat, but Louise gives names of: Mrs. William Dodd, Mrs. George Dominick, Miss Alice B. Holabird, Mrs. Charles Kebler, Mrs. Harriet Leonard, Mrs. A. B. Merriam, Miss Julia Rice, Miss Clara Chipman Newton, and of course, Louise herself. Additional

names listed in other primary sources include Miss Florence Leonard, Miss Georgie (or Georgia) Wollard, Benn's daughter Agnes Pitman, and the painter Elizabeth Nourse. There were a dozen students at most, and they were probably chosen not only because of their woodcarving skills, but also because of their drawing and/or watercolor painting skills, both seen as fundamental assets in china painting. Many of these women ultimately became members of the Cincinnati Pottery Club.

Besides Louise McLaughlin, the one student who stands out because of her work, and especially because of the records that she left behind, is Miss Clara Chipman Newton (fig. 3.3).[8] Clara Newton came to Cincinnati with her parents in 1852. When her father died in 1871 and her stepmother moved to Denver, she remained in the Queen City with a stepsister. Clara attended Miss Appleton's School for Girls and eventually became a student at the School of Design, where she was a member of Benn Pitman's woodcarving class in 1873–74. Not a woman of independent means, she maintained a studio for many years in downtown Cincinnati, where she exhibited and taught art. Miss Newton always promoted interest in the arts and allied herself with groups experimenting in new media. The ultimate politician, she was everybody's friend. It is impossible to find a negative word written about Clara by her peers. Louise McLaughlin regarded her as a "schoolmate and intimate friend" whose friendship "ended only by her death."[9] Furthermore, it was "a friendship as nearly perfect as anything in this world." Clara had an acute memory, was noted for her distinctly beautiful handwriting and grace of phraseology, and above all was adept in both artistic and business matters. These latter abilities made her the perfect secretary for The Rookwood Pottery Company, the Cincinnati Pottery Club, the Porcelain League, and The Crafters Company. She was instrumental in organizing the display in the Cincinnati Room at the 1893 World's Columbian Exposition in Chicago, and she was a founding member of the Cincinnati Woman's Club, where she served as manager/secretary for many years.

When Benn Pitman returned from New York with "paints, patterns and tiles," he invited his chosen class to meet in his business office at the Phonographic Institute, which was located in the Carlisle Building at the southwest corner of Fourth and Walnut Streets in downtown Cincinnati, diagonally across the street from the School of Design.[10] They met in his business office and not at the School of Design because china painting was not included in the school's curriculum and could therefore not be taught there. Turning to the students, he said, "I know nothing about painting china; I cannot find anybody who does; but there are the materials; now go to work." This is probably why Louise McLaughlin later said that she received little

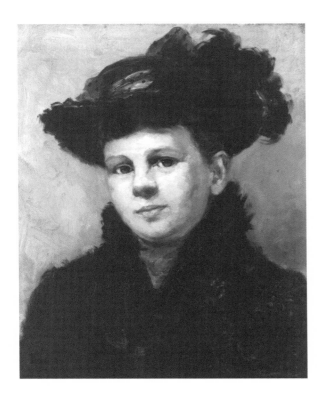

Fig. 3.3. Oil on canvas portrait of Clara Chipman Newton by M. Louise McLaughlin. *Courtesy of the Cincinnati Historical Society Library*

help from the teacher. He admittedly had little to offer. Pitman soon found a Miss Marie Eggers, and at his own expense, paid her to instruct his students. Miss Eggers had recently come from Germany to visit her sister and had limited knowledge of the art of china painting. She came to class a few times and explained the basic methods of the technique. Louise decided to practice her favorite pursuit of painting portraits on the porcelain. Miss Eggers knew nothing of portraiture, so once again Louise was "able to extract but little help from the teacher." At any rate, unfortunately, Miss Eggers soon died, leaving the students to struggle alone. According to Clara Newton, speaking in 1914, they "worked on alone under difficulties that the china decorator of today can hardly realize. The colors were in powders, not even fairly well ground. To get them even moderately free from grit we worked with a vigor that must have been for the development of muscle, a close second to the most strenuous games of tennis and golf, the present day ideals of physical culture."[11] Later, in her manual on china painting, when discussing powdered colors versus colors already prepared in tubes, McLaughlin did not hesitate to advise, "I would most readily declare in favor of the tube colors."[12]

Their knowledge of china painting may have been rudimentary, but their

enthusiasm was unlimited, and the students began to work matters out. Clara's first masterpiece was a tile painted in monochrome with a carefully executed botanical study made from a pressed flower. As a work of art, she found it painstaking and decidedly unsuccessful: "Well, my mother thought it lovely, but then Mothers have a way of seeing differently from the rest of the world."[13]

The summer of 1874 soon found the students off on holidays. For Louise McLaughlin, it had been an eventful spring marked by a death in the family. At 8:30 P.M. on Saturday, May 16, her father, William McLaughlin, passed away at the age of eighty-one, less than two months short of his eighty-second birthday.[14] The following Tuesday at 2:30 P.M., funeral services were held in downtown Cincinnati at the Seventh Presbyterian Church on Broadway. His obituary announcements were brief, and his death did not elicit major notices in the newspapers. Since he had been retired for about ten years, his death probably did not precipitate any family financial upheaval. Louise's brother George was the family provider and continued as such for his sister and their mother after the father's death.

When the students returned to classes in the fall, four of them, including Alice Holabird, Clara Chipman Newton, Clara Fletcher, and Louise McLaughlin, resumed china painting with reawakened zeal. This time, instead of using Benn Pitman's business office, they took unsanctioned possession of a small room in the School of Design. At that time, the school was located in the upper two floors of the old College Building at the northeast corner of Fourth and Walnut Streets in downtown Cincinnati.[15] The little room opened into a larger room, where Benn Pitman taught his woodcarving classes. That they worked diligently throughout the 1874–75 school year was evidenced in 1875 by a "Tea Party" and two exhibitions that not only brought lavish praise for their work, but also demonstrated that the Queen City was a major contender in American porcelain painting and set the stage for Cincinnati's great display at the Centennial Exhibition in Philadelphia. An added consequence of these occasions was that Louise McLaughlin's china painting prowess was brought to public attention.

The first important event was the Martha Washington International Centennial Tea Party, held on February 22, and again from May 20 to 22; the second was the Seventh Annual Exhibition of the School of Design of the University of Cincinnati, held in June; and the third was Cincinnati's Sixth Industrial Exposition, held from September 8 to October 9. The last two exhibitions were the first judged competitions to show painted porcelain by Louise McLaughlin. The Seventh Annual Exhibition of the School of Design displayed three entries by the artist: a plate, a pair

of eggcups, and a fruit plate.[16] Typical of Louise, she decorated each piece with a portrait of a child's head. As stated, McLaughlin had started painting portraits on porcelain while still exploring technique under the tutelage of Miss Eggers. It seems that she mastered the necessary skills in short order. The models for the portraits no doubt were the children of her brother James. He had married in 1862, and by 1875 had six children between the ages of one and eleven years. Louise loved painting their portraits, and her *oeuvre* is replete with their images. Two eggcups (pl. 1) in the collection of the Cincinnati Art Museum are probably the pair from this exhibition. Signed "L. McL.," and dated "1875," they display a mastery of miniature portraiture. One depicts a three-quarter, shoulder-length portrait of a coy adolescent wearing a large black hat. The hat, perhaps a studio prop, can also be seen in her later china paintings. The second eggcup depicts a three-quarter, shoulder-length portrait of a lovely young girl wearing a white lace dress and two strands of pearls. McLaughlin's artistic skills are obvious, as is her mastery of the flesh tones. In china painting, the depiction of flesh tones requires more than just artistic mastery; it also requires knowledge of the paints and their reactions to each other in the heat of the kiln.

The second formal exhibition to display Louise's work was Cincinnati's Sixth Industrial Exposition, held from September 8 to October 9.[17] Cincinnati's Industrial Expositions were major events. More than just regionally important, they could attract up to half a million people. By 1875 Cincinnati itself was a large city with a population of approximately 288,000.[18] In the exposition, Class #71 1/2 for wood-carving, designing, and porcelain painting was "open to lady amateurs only." Louise submitted three entries in the china painting category. The pieces are not described; perhaps they were the same ones displayed in the earlier School of Design exhibition. Whatever the case, she received "Premium No. 1097," a silver medal for the best china painting.

There are few china-painted examples by other Cincinnati artists from this pre-Centennial period. Notably, four eggcups (pl. 2) and a chocolate pot (pl. 3) by Maria Longworth Nichols are in the collection of the Cincinnati Art Museum. They display fanciful, cartoon-like characters of animals personifying human qualities. On the chocolate pot, an owl perched in a tree conducts a chorus of singing birds accompanied by insects playing musical instruments. The eggcups exhibit playful baby chicks running after butterflies, a rooster and hen dressed as Mr. and Mrs. Chicken strolling near their chick, and an owl wearing a red-orange hat and apron, perched on a branch over a nest of hatched eggs. Since the scenes were seemingly taken from nursery tales, it is easy to believe that Nichols, a woman with two children

aged five and three at the time, created them. These eggcups are charming and display pronounced drawing and china painting skills, but the decorations are not as sophisticated as the portraits seen on McLaughlin's eggcups.

With so few known examples of Cincinnati china painting dating before 1876, it is difficult to make comparative studies to determine if there was a "Cincinnati look" to the art. Benn Pitman allowed his students to make their own designs for their china painting and woodcarving; perhaps there was no stylistic "look" to the group's product as a whole. In those days it was fashionable to apply moralizing mottos to the designs. Clara Chipman Newton proudly boasted that the china painters were never guilty of "making mottos," in spite of the fact that "it was good form to hang [such mottos] upon one's walls of one's rooms as sign posts to the roads of righteousness."[19] One contemporary criticism of Pitman's first china painters is found in an 1878 Cincinnati newspaper article by an unidentified correspondent from the *Boston Advertiser*. The article states that "all the china painting done in Ohio [i.e., Cincinnati] was more experimental than in New England."[20] Without question, this is correct. Because the Cincinnati ladies had received very little instruction, they were forced to work out their own techniques, and thus tested many different types of paint applications. However, "more experimental" might have meant that the objects did not look as European as those in New England, where all instruction followed European design. Pitman espoused the creation of "American" art, and his students were quick to follow his directives. Furthermore, there was no imported or long-standing tradition in Cincinnati that predetermined the "look" of their work. Of course, "more experimental" could have been a polite way of saying that the work was inferior, but this inference can be eliminated because the author of the article later states that the work was on par with that of Dresden. Dresden was one of the finest china painting cities in the world at the time, so the comparison was quite a compliment.

That Benn Pitman's classes set history in motion cannot be denied. In 1906, when writing about Cincinnati's contributions to ceramic art for the periodical *Brush and Pencil,* Lawrence Mendenhall said that because of Benn Pitman's china painting classes, "the decorated china fever broke out in this city [i.e., Cincinnati] in almost epidemic form."[21] In 1914 Louise McLaughlin put Pitman's classes in a much broader perspective: "It was the beginning of the Arts and Crafts movement and it was given to Cincinnati to take the first step in its organized development in America."[22]

chapter 4

THE MARTHA WASHINGTON
AND CENTENNIAL
TEA PARTIES, 1875

"During the year 1875 the Centennial Tea-Party swept like an epidemic over the country," explained Clara Chipman Newton as she described the mania for china painting that began in full force with a "Tea-Party."[1] There were a number of tea parties held in the nation that year, and events leading to the momentous occasion in Cincinnati began on October 8, 1874.[2] On February 24, 1873, the American Centennial Board, which had been charged with making preparations for the 1876 Centennial Exhibition to be held in Philadelphia to celebrate the nation's one-hundredth birthday, appointed a committee of thirteen ladies from Philadelphia to arrange for the participation of women in the celebration. The president of the Women's Branch of the Centennial Board was Mrs. E. D. Gillespie, a great-granddaughter of Benjamin Franklin. President Gillespie and her committee were to see that American women would be represented in their "pursuits of art and science, and their skill in any and every department of art manufacture which falls to the lot of an Exposition of this kind."[3] The Women's Branch added one lady from each state and territory as a member of its organization. In turn, each of these additional members was to organize a branch committee in her own state or territory, raise funds, obtain objects of merit

for exhibition, and increase public interest in the Centennial event. Funding was necessary to offset various expenses, such as the transportation of objects and advance payment for the space required in the exhibition building.

On October 8, 1874, Mrs. Gillespie met with the leading ladies of Cincinnati in the Queen City's YMCA building. She presented the goals of her board and described how the women of Philadelphia had raised an impressive sum of money for the cause by the sale of $10.00 shares in the exhibition, the sale of Centennial medals at $1.00, $1.50, and $2.00 each, and by the sponsoring of a "Centennial Tea-Party." Mrs. Gillespie hoped the ladies of Cincinnati would attempt equal success.

Although very impressed, the ladies of Cincinnati were not to be outdone by their counterparts in Philadelphia. After all, Cincinnati had held the largest industrial expositions in the nation at the time. They knew what had to be done. Dauntlessly, they met again on November 23, 1874, in the same Christian Association building. Calling themselves the Women's Centennial Executive Committee of Cincinnati, they chose a president, adopted a constitution, appointed committees, and began specific preparations for the Queen City's contribution to the Centennial. In light of their advanced skills in "carved furniture, painting, etc.," they set a goal to obtain "two ordinary sized rooms in the Exposition building at Philadelphia, and furnish them, one as a bedroom and one as a sitting-room, with handsomely carved furniture, paintings, etc., from the hands of the ladies here, and likewise to contribute other articles in the way of preserved flowers and grasses, antiquated articles of furniture, and all relics of the early days of the Republic." It is interesting to note that china-painted objects were not specifically mentioned for either room. Perhaps the reason was that at the time of the meeting in November 1874, the ladies in Benn Pitman's china painting class, and those few learning the skill outside his class, had yet to prove their worth and were not considered as accomplished as the wood-carvers.

The plan chosen to raise money for the Centennial, as originally suggested by Mrs. Gillespie, was to hold a "Centennial Tea-Party" on February 22, 1875, the anniversary of George Washington's birthday. The tea party was to be a grand affair. Tea would be taken in cups purchased at market with "antiquated patterns resembling those used in early days," and served by young ladies dressed in the style of the Continental Court. Brief patriotic addresses would be given, and a dance hall with exquisite music would be provided. Moreover, the gentlemen tea drinkers would be able to purchase the cups as memorials of the occasion.

At the end of this meeting on November 23, when all the plans had been

determined, a communication was read from a lady in Washington, D.C., inviting the Cincinnati ladies to attend the Washington Committee's tea party in the rotunda of the Capitol on December 16. It is not known if anyone from Cincinnati attended. The Queen City ladies certainly did not feel the need to be taught how to give a tea party. If anything, they would show others.

Virtually every woman of prominence in Cincinnati took up the cause. Involved were such noted personalities as the future founder of The Rookwood Pottery Company, Maria Longworth Nichols; the endearing pedagogue, Elizabeth Appleton; the matriarch of women's art patronage, Sarah Worthington King Peter; and above all, Elizabeth Williams (Mrs. Aaron F.) Perry. From 1874 until her death in 1914, Mrs. Perry was a leader in organizing and promoting women with artistic talent.[4] Although not an artist herself, she was the dominating spokeswoman in almost all the women's art movements in Cincinnati during her time. This included the leadership of the Cincinnati Women's Art Museum Association, which founded the city's Art Museum and Art Academy. Following in the footsteps of Sarah Worthington King Peter, Mrs. Perry realized that the arts, especially the industrial arts, could provide employment and recognition for her fair sex. She was indefatigable in her work towards the gainful application and acknowledgment of women's artistic talents. Later, she and Louise McLaughlin would clash in regard to training for women in ceramics. Elizabeth Perry was the favorite choice for president of the Women's Centennial Executive Committee of Cincinnati, and in this capacity she spearheaded the participation of Cincinnati women in the Centennial Exhibition.

When February 22 arrived, all was ready for what was billed as the Martha Washington Tea Party.[5] Its "fashionable flavor" and "novel nature" made it "one of the most notable social events of the season." It took place at Lookout House in Cincinnati's Mt. Auburn suburb. The large capacity of Lookout House was "over-tested" by the thousands of guests who "went to look and remained to eat, to dance or to be entertained by the hundreds of young and old ladies—all seemed old and young in the 'costumes of our grandmothers.'" The dancing in the upper hall "was not the minuet or the rollicking reel, but the dreamy, delicious waltz and the glad gallop of modern times." All was picturesque, as the walls were covered by flags, evergreens, coats of arms, portraits of George Washington, and the shields of the original thirteen states. Additionally, banners, regimental colors, and festoons, along with a myriad of gas jets, created a patriotic wonderland of "inspiring brilliancy." Tea and coffee flowed like rivers, and the food consisted of a choice of chicken salad

(20¢), oysters (raw and "escalloped," 20¢ per half-dozen), tongue, ham, or turkey, all with bread and butter (10¢ each), baked beans and brown bread (10¢), ice cream (15¢), cakes (10¢), and lemonade (10¢). The pièce de résistance, however, was not the food, or even the tea and coffee, but the china.

On December 7, 1874, Louise M. (Mrs. Alphonso) Taft, the chair of the Committee on China, had reported that her committee had ordered 1,500 cups and saucers with appropriate decorations.[6] Examples (fig. 4.1) currently in the Cincinnati Historical Society collection show by their underglaze printed marks that they were made by the Glasgow Pottery Company of Trenton, New Jersey. These cups and saucers were the main attraction of the bill of fare. They could be purchased filled with tea or coffee and accompanied by a sandwich. Cups decorated with a facsimile autograph of Martha Washington cost 50¢ each, whereas those with her husband's signature commanded 75¢ each. Perhaps the disparity was due to the market. George's signature might have been more desirable, and thus higher priced (after all, it was *his* birthday); or perhaps the higher price was simply sexism. Whenever George or Martha's signature adorned a cup that was buff, pink, or green, however, it sold for $1.00. Ground color seemed to have leveled any sexism or disparity in the market. Whatever the case, no one cared. The finest of the decorated cups sported a flag and Liberty. These gems commanded $1.50. A hit at the event, the decorated china "went off like hot cakes," and the supply was soon exhausted. The next day the *Cincinnati Enquirer* informed readers that those wishing examples could aid the cause by purchasing cups still available at Tice & Huntington, the Cincinnati firm that supplied them for the Centennial Committee. The decorations on the china purchased through Tice & Huntington were printed. It is not known if any of the china sold that night was painted by Cincinnati's fledgling china painters. In Mrs. Taft's report of December 7, she states, "The China Committee have been fortunate in receiving a quantity of French china cups & saucers of beautiful shape, and of the choicest quality, which will be furnished to those willing to engage in decorating them."[7] These examples of "French china" were in addition to the 1,500 printed specimens from Tice & Huntington. It will perhaps never be known if any were painted for the Martha Washington Tea Party. None of the reports to Mrs. Perry or those cited in the newspapers mention examples by the Queen City's china painters. What is known is that the sale of the china made a marked impression on Cincinnati's Centennial Committee.

The Martha Washington Tea Party was such a triumph that it was hailed as "the

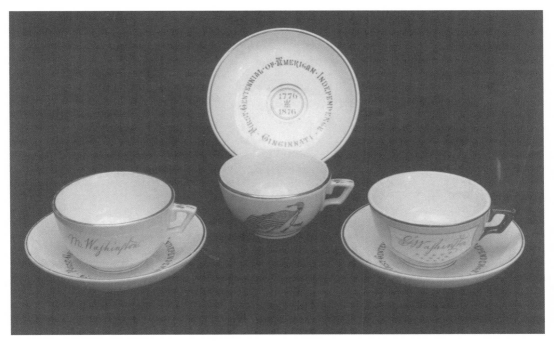

Fig. 4.1. Examples of cups and saucers sold at the Martha Washington Tea Party, February 22, 1875. *Courtesy of the Cincinnati Historical Society Library*

most successful affair of the kind ever undertaken here"; its extraordinary success led to the undertaking of yet another tea party.[8] This time called the Centennial Tea Party, it was to be held in May after the May Festival in Exposition Hall, which offered more space than Lookout Hall. This tea party was to be bigger, better, and even more spectacular than the February 22 affair. Furthermore, given the success of china sales at the first party, this time the fair china painters of Cincinnati would decorate cups and saucers to display and sell at a separate event during the party.

Through Mrs. Perry's leadership, the Centennial Committee provided the china as well as the firing for any china painter who would give her talent in appropriately decorating the cups and saucers to be used for and sold at the May tea party.[9] The aspiring china painters of Cincinnati rose to Mrs. Perry's challenge with zeal. There were between ten and fifteen china painters in all: those few working on their own, and the approximately ten students in Benn Pitman's class. Within his class at this time was the little group of four—Louise McLaughlin, Clara Chipman Newton, Alice Holabird, and Clara Fletcher—that was struggling at china painting in an

unauthorized room at the School of Design. Like all the other china painters, this coterie was thrilled when the Centennial Committee not only invited them to paint teacups, but also supplied the china and the firing.[10]

Soon after they began, they were formally notified by authorities at the School of Design that if they wished to china paint, they would have to vacate the room, indeed the building. Since china painting was not a sanctioned course in the School of Design, holding the class on the premises was an infringement of the rules. This was no less than tragic. "The tea-cups *had* to be painted."[11] Group member Clara Fletcher came to the rescue by offering her house for the work. It was an excellent solution. The house was conveniently located downtown on the southwest corner of Fourth and Pike Streets, and the room in which the foursome worked was flooded with sunlight from a northern exposure.

"Here we toiled, here we failed, and failed, only to rise again," wrote Clara.[12] Since they had no teacher, they learned by trial and error, and the mistakes were many. "The painting in and rubbing out is something fearful to look back upon."[13] Writing of this period in her usual humorous, tongue-in-cheek manner, Clara admitted, "I, with a marvelous patience, rubbed out, painted in and rubbed out again to such an extent that I had two tea-cups to show as the result of the labor of three days each week for a period of three months."[14] Concerned with appropriate decoration, Clara Fletcher painted some cherries on a cup, "and as a touching tribute to that noble tradition of the truthfulness of the Father of Our Country, gracefully entwined a small hatchet some place in the decoration." Not surprisingly, since she thought of herself as a portrait painter, Louise McLaughlin decided to paint portraits on her cups. Since portraiture was considerably more demanding than painting hatchets or cherries, her choice of subject matter alone suggests that her artistic talents were above those of her peers. Portraits would certainly be appropriate, especially when they depicted Martha and George Washington (pl. 4 a–b).

When reminiscing later, McLaughlin recalled the period before the May tea party only in the most general terms: "During the winter of 1874–75, I was one of a party of three or four who met at the home of Miss Fletcher to paint tea cups which were to be sold for the benefit of the cause."[15] While Louise did not offer details of this work, fortunately Clara Chipman Newton did. Clara recalled how each member of the foursome admired the others' work, especially Louise's portraits of Martha and George Washington. While McLaughlin was skilled at painting portraits, she was still learning to resolve the technical problems involved with china

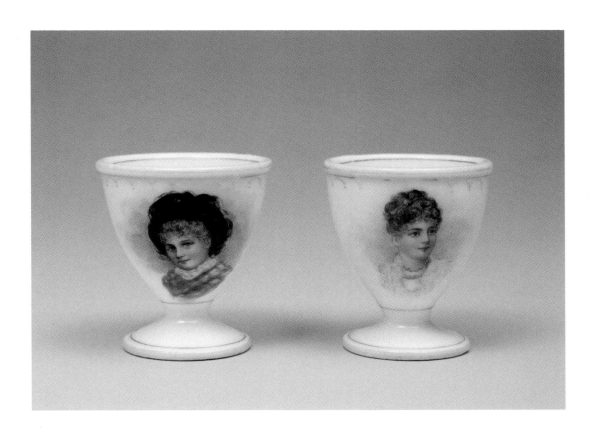

PLATE 1.
Porcelain eggcups, 1875, decorated by M. Louise McLaughlin.
Courtesy of the Cincinnati Art Museum, Gift of Theodore A. Langstroth,
1970.592 (*left*); 1970.593 (*right*)

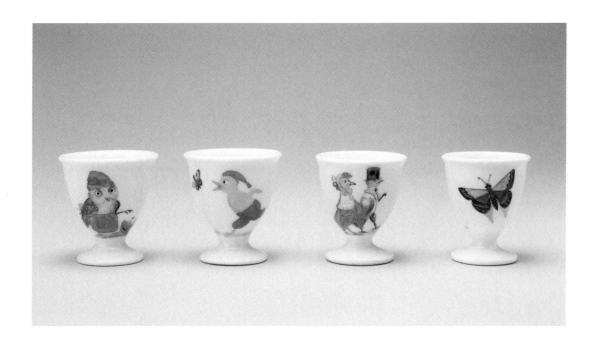

PLATE 2.

Porcelain eggcups, ca. 1875, decorated by Maria Longworth Nichols.

Courtesy of the Cincinnati Art Museum, Gift of W. W. Taylor, 1913.359–362

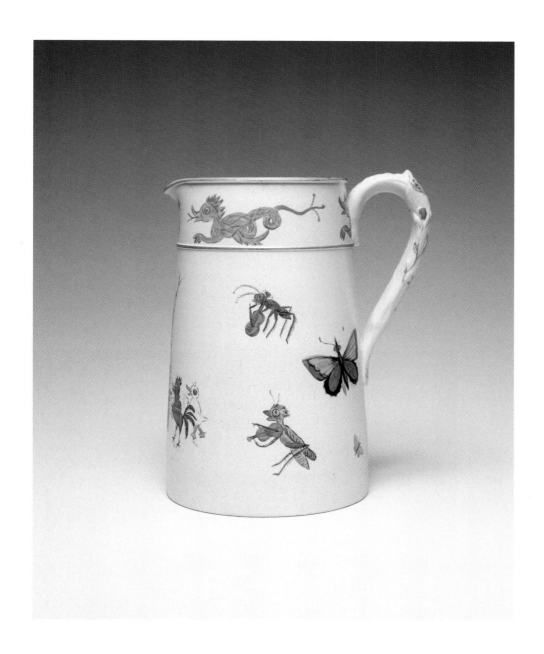

PLATE 3.
Stoneware chocolate pot, 1874–75, decorated by Maria Longworth Nichols.
Courtesy of the Cincinnati Art Museum, Gift of W. W. Taylor, 1913.293

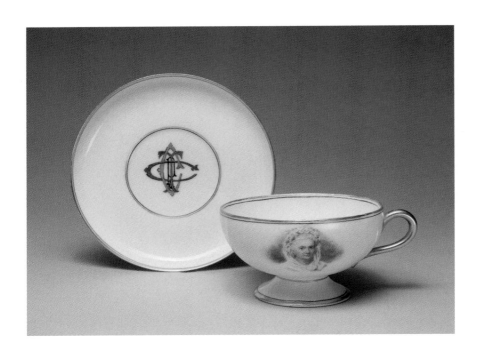

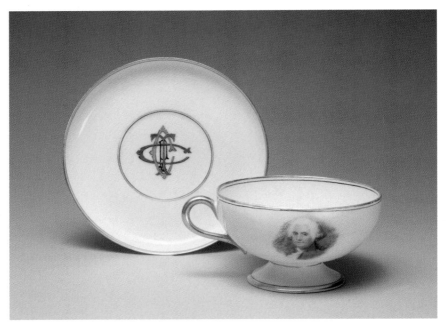

PLATE 4 A–B.

Porcelain saucer and cup *(front)* with Martha Washington, and *(back)* with George Washington, 1875, decorated by M. Louise McLaughlin. This is the cup and saucer that sold for twenty-five dollars at the Centennial Tea Party on May 21, 1875. The entwined "CCTP" painted on the saucer stands for the Cincinnati Centennial Tea Party.

Courtesy of the Cincinnati Art Museum, Gift of Mrs. E. Williams, 1977.126–127

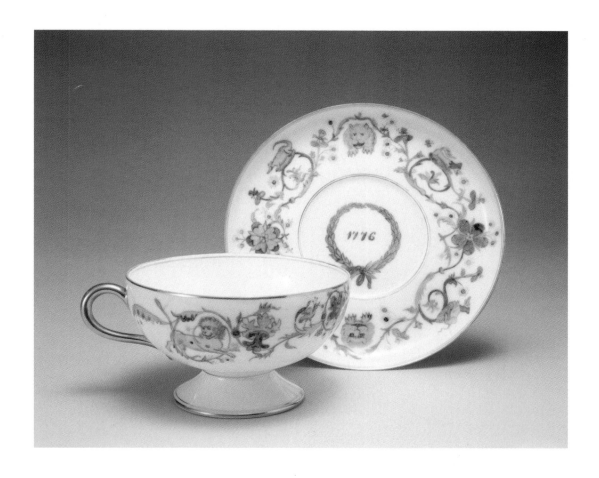

PLATE 5.
Porcelain cup and saucer, 1875, decorated by Maria Longworth
Nichols and sold at the Centennial Tea Party on May 21, 1875.
It is perhaps the one that sold for twenty-five dollars.
Courtesy of the Cincinnati Art Museum, Gift of the Women's Art Museum
Association, 1886.2–3

PLATE 6.
Porcelain plate manufactured in 1858 and decorated 1875–76 by
Clara Chipman Newton.

Courtesy of the Cincinnati Art Museum, Gift of Mrs. Murat Davidson, 1982.5

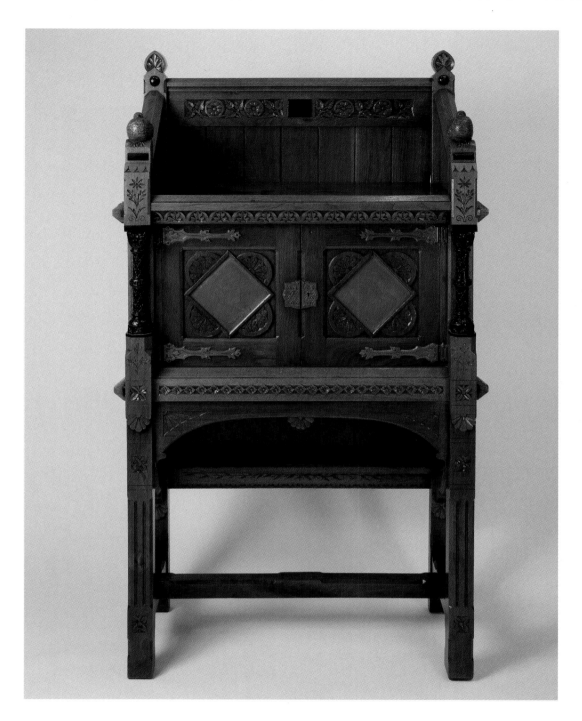

PLATE 7.
Hanging desk (legs added later) by M. Louise McLaughlin, inspired by designs by
B. J. Talbert and exhibited at the 1876 Centennial Exhibition in Philadelphia. During
her 1873–74 year at the School of Design, M. Louise McLaughlin created original
designs for a cabinet. This cabinet is probably the result of those designs.
Courtesy of Rosemary and Don Burke

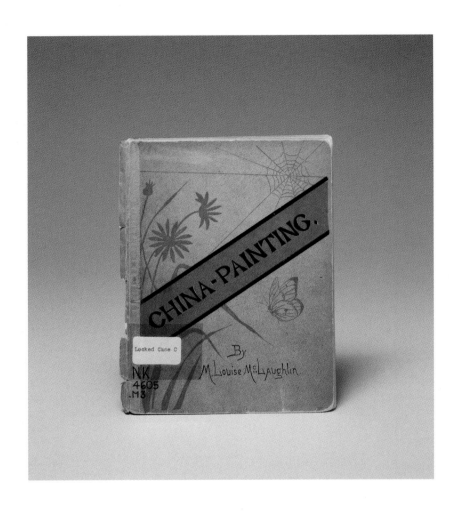

PLATE 8.

Cover of *China Painting: A Practical Manual* by M. Louise McLaughlin.

Courtesy of the Cincinnati Art Museum, Mary R. Schiff Library

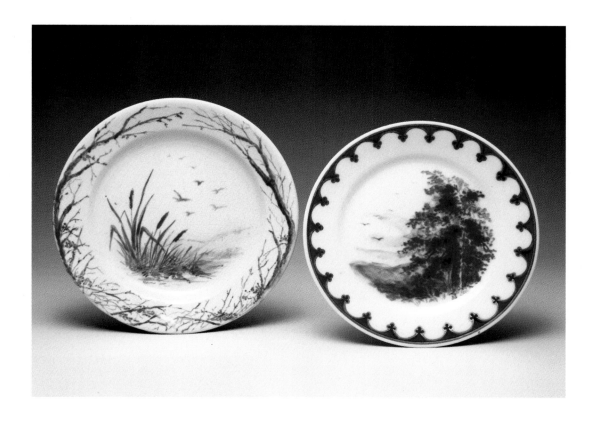

PLATE 9.

Ironstone plate (*left*, 1877) and porcelain plate (*right*, 1879) decorated by
M. Louise McLaughlin. These are two plates decorated with underglaze
blue landscapes that McLaughlin mistakenly thought that she had
decorated in 1875.

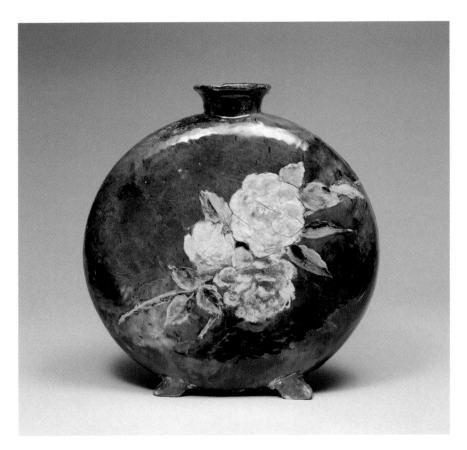

PLATE 10 A–B.

Pilgrim jar, December 20, 1877, decorated in underglaze slips by M. Louise McLaughlin. This is the first successful example of McLaughlin's underglaze slip technique, also known as Cincinnati Faience or Cincinnati Limoges. Marks on the bottom of the pilgrim jar, December 20, 1877,

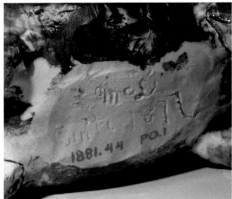

decorated in underglaze slips by M. Louise McLaughlin. These are the marks on the first successful piece of underglaze slip decoration. Typically, they are incised "McL"/"Cinti. 1877." The painted numbers are the Cincinnati Art Museum's registration numbers that were added later. Firing cracks are visible where McLaughlin added the feet to the form.

Courtesy of the Cincinnati Art Museum, Gift of the Women's Art Museum Association, 1881.44

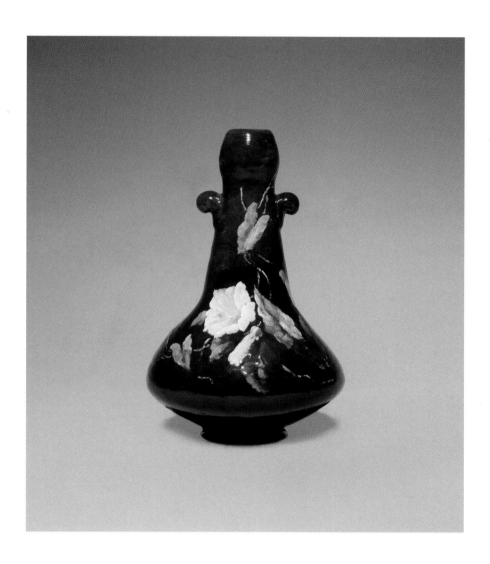

PLATE II.

Vase, 1875–81, decorated in underglaze slips by Edouard Girard for
Haviland & Company, France.

Courtesy of the Cincinnati Art Museum, Gift of Kenneth R. Trapp in Honor of
Don F. Mahan, 1984.3

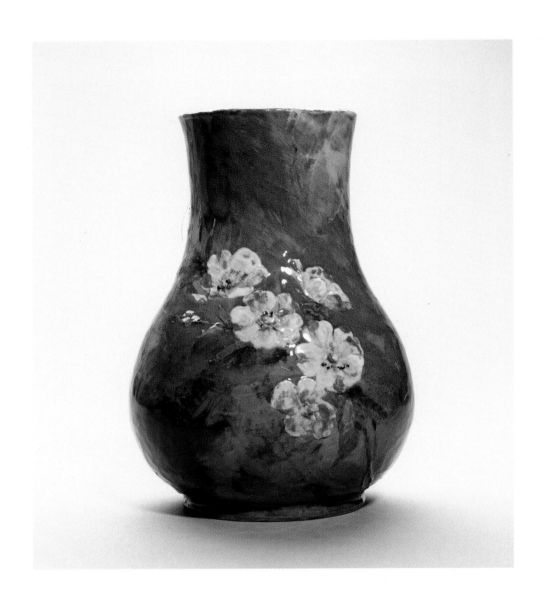

PLATE 12.

Vase, 1879, decorated in underglaze slips by M. Louise McLaughlin.

Courtesy of the Cincinnati Art Museum, Gift of M. Louise McLaughlin through the
Women's Art Museum Association, 1881.19

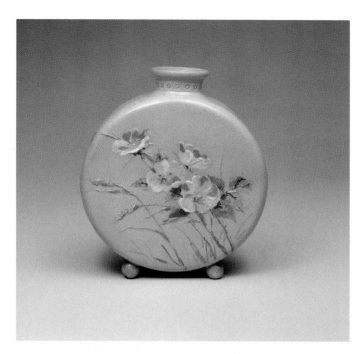

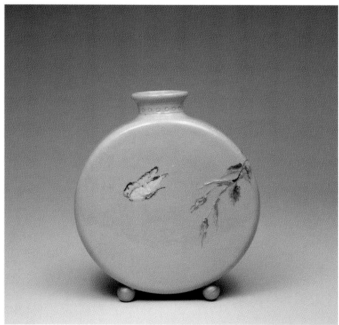

PLATE 13 A—B.

Vase *(front and back)*, 1881, decorated in underglaze slips by M. Louise McLaughlin.

Courtesy of the Cincinnati Art Museum, Gift of Theodore A. Langstroth, 1970.579

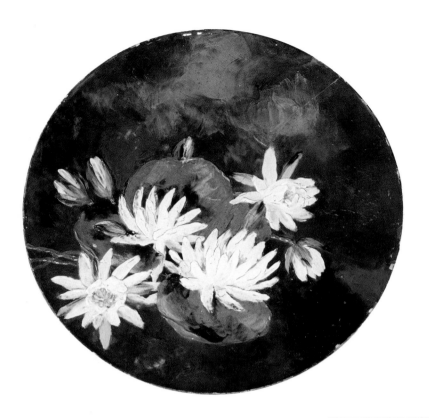

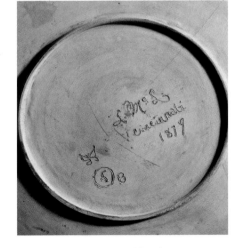

PLATE 14 A—B.
Earthenware charger, 1879, decorated in
underglaze slips by M. Louise McLaughlin.
Marks on the bottom are incised: "L.McL"/
"Cincinnati"/"1879," a butterfly, an encircled "5" and "B." Perhaps inspired by the practice
of painter James Abbott McNeill Whistler, McLaughlin often incised a butterfly on her
pieces. The encircled "5" and the "B" are esoteric notations.
Courtesy of the Cincinnati Art Museum, Gift of Jay A. and Emma Lewis, 1991.266

Vase *(front and back)*, 1881,
decorated by Cordelia A.
Plimpton, designed by her son,
L. F. Plympton. This is an
example of Plimpton's technique
whereby she inlaid clays of
different colors to form a
decoration.

Courtesy of the Cincinnati Art
Museum, Gift of the Women's
Art Museum Association, 1881.61

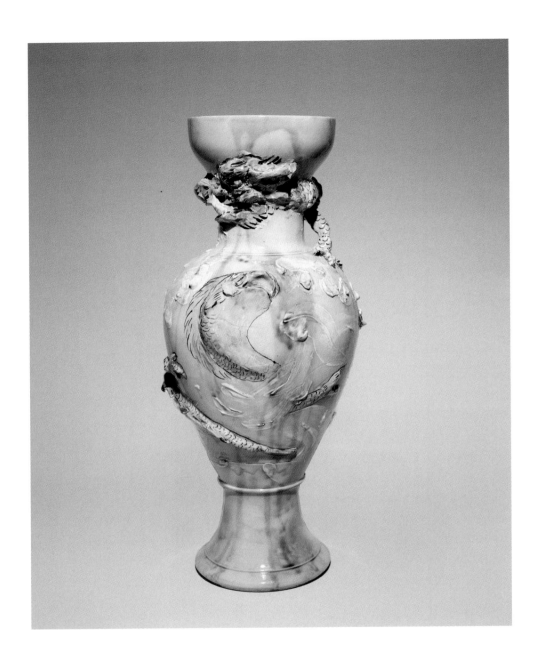

PLATE 16.

Vase, 1881, decorated in underglaze slips by Maria Longworth Nichols. This twenty-five-inch-high vase is similar to the large high relief vases Nichols was displaying in 1879.

Courtesy of the Cincinnati Art Museum, Gift of the Women's Art Museum Association, 1881.43

paints. Her first portrait attempt proved unsuccessful "when dear Lady Washington came back from her trial by fire with a fearfully jaundiced complexion, owing to an injudicious use of yellow, and a lack of knowledge that an overplus of this would eat out the other colors. To learn practically this sad fact Lady Washington was offered up as a sacrifice."[16] Later, when discussing portraits in her book on china painting, McLaughlin would caution, "Be careful not to take too much of the yellow, as, if an excess of it is used, it will devour the red when fired."[17] Eventually Lady Washington and her husband, whose likeness was depicted on the opposite side of the cup, effectively completed their trial by fire. The successful teacup (later broken and repaired) and its saucer were ultimately donated to the Cincinnati Art Museum in 1977. The portraits, no longer jaundiced, once again reveal McLaughlin's skill in depicting individuals. Even though taken from a secondary source, the likenesses are genuine, fully modeled with tints and shades offering lifelike appearances. On the cavetto of the saucer painted in red, gold, and black are the superimposed letters, "CCTP," standing for the Cincinnati Centennial Tea Party.

Louise McLaughlin always seems to have applied her skills with quickness and remarkable self-assurance. Anyone who commented on her working technique never failed to mention this. Clara Chipman Newton was perhaps the first to notice: "I remember even in those days [before the May tea party], that Miss McLaughlin dashed at her work."[18] This trait became more apparent in her underglaze decoration and her porcelain.

Cincinnati's Centennial Committee saw to it that the teacups and saucers were all fired by a Mr. Gustav Hartwig at his studio located at 345 West Fifth Street. The committee was pleased to be able to engage this china painter/decorator/teacher. Not only was his downtown location convenient, but also he was their sole source of assistance. Marie Eggers had died before she could offer help to the tea party, leaving Mr. Hartwig as the only person in Cincinnati who practiced and taught china painting.[19]

The Centennial Tea Party, as distinguished from The Martha Washington Tea Party, opened as a three-day festival Thursday night, May 20, 1875, in Exposition Hall. Triumphantly outshining anything at the previous party, it was likened to a miniature world's fair in its scope and layout. Exposition Hall was the perfect place for such a spectacle since it had already held four industrial expositions and two music festivals. The last music festival had ended only a week earlier, giving the women a brief period of time for installation. The exposition complex was composed

of three huge halls: the Main Hall, the North Hall, and Horticulture Hall. It was "gorgeously decorated for the occasion with gas jets and evergreens and flags, forming of itself a bewildering maze of light and color and shade."[20] Running along both sides of the entire length of the Main Hall was an international bazaar with booths representing the leading nations of the world. Among the countries represented were China, Japan, Turkey, Persia, England, Scotland, Ireland, France, Germany, Spain, Italy, Switzerland, and the United States. Each booth was authentically decorated and managed by approximately ten women, who dressed in clothing appropriate to the country they represented. This costuming was taken very seriously, as every woman had her outfit reviewed and described in the *Cincinnati Commercial* on May 22 and 23, and the *Cincinnati Daily Gazette* on May 22. Items sold in the booths reflected the products of the various countries. Before the event, the ladies had scoured the Queen City for objects of art and industry of the different nations to be used for either decoration or sale. For example, the Chinese and Japanese booths offered "the work of Chinese and Japanese artisans, imported by American enterprise and not to be found outside the great emporiums of the East"; and the Italian booth sported "statuettes, busts, articles recovered in the excavations of the buried cities, fine pictures and choice macaroni put up in convenient packages."[21] One enterprising soul from the German booth was able to acquire photos of the Imperial family directly from Her Majesty, the Empress Queen of Germany. The largest booth, which represented the United States, took up the entire west end of the Main Hall opposite the entrance and was divided into three sections: the Pacific Slope (featuring California), the Southern States, and the Northern States (including New England). The wall of the west end was covered entirely by an enormous painting loosely representing a bird's-eye view of the topographical features of the country. In front of the painting was a gradual elevation of ridges, or steps, covered with evergreen trees and rare plants. By design, the evergreens on the rising platform appeared to blend into the lower part of the painting, which formed a background. All this was supposed to represent the prosperity, power, and growth of the Republic. The ladies in charge of the American booth paid $200, a large sum, to "some wretched daubers named Criedland and Franks" to paint the scene.[22] Unfortunately for the ladies, the painting became the focus of one of the two criticisms of the entire Centennial Tea Party made by the newspapers. The artists, according to the press, had produced "the vilest abortion in the paint-wasting line that human eyes could be tortured with . . . no school-boy, furnished with a whitewash brush and a bucket of green paint, could

have created anything equally disgusting." Furthermore, featured on a tall pedestal in the center-front of the booth was a wax statue of Liberty, with a wax statue of George Washington slightly below and to her side. The statue of Washington was perhaps melting in the heat, since one reviewer remarked that "he has plainly been dissipating and appears to be anxious to slink behind some protecting mountain."[23]

Also in the Main Hall was a booth of "relics" and "the Department of Women's Work." The relics consisted of such patriotic tidbits as Martha Washington's writing desk, George Washington's tent flag, a piece of his carriage, a piece of his coffin, and similar items. In charge of the relics booth was Mrs. Sarah Worthington King Peter at age seventy-five. The Department of Women's Work displayed woodcarving and china painting by the ladies of Cincinnati. A few of the wood-carved examples were for sale, as were all the china-painted items. The china-painted cups and saucers decorated by Louise McLaughlin and her group were displayed and auctioned at this booth.

The North Hall of this complex was transformed into a gigantic banqueting hall that could serve up to five hundred occupants. Long tables "with their snowy cloths and glittering plated ware; the shining rows of semi-diaphanous china, and the tempting odor of multifarious viands, delicately cooked, held forth too tempting an invitation for visitors to resist."[24] The tea for the Centennial Tea Party was served in the same type of "Centennial cups" as those used at the Martha Washington Tea Party. They were also for sale. The newspapers did not chronicle the menu or the prices for the food or china, as they had for the earlier event. The ballroom above the North Hall was reserved for dancing and the serving of lighter refreshments such as ices, berries, and cakes. Horticultural Hall was furnished with a variety of attractions highlighting pictorial and scenic representations of early pioneer life. This included, but was not limited to, an Indian wigwam, an old log cabin complete with appropriate furnishings, and a crude house of the early Western farmer showing domestic life on the frontier one hundred years ago.

The Centennial Tea Party opened Thursday night and lasted from 7:00 until 11:00 P.M. Reviews were stunning. According to the *Cincinnati Daily Gazette*, "Exposition Hall presented a scene, last evening, more bewildering in its beauty, by far, than any ever conjured up by the magician's wand, in that golden era which we read of as 'once upon a time.'"[25] The *Cincinnati Commercial* remarked, "Indeed, the very air was loaded with luxury."[26] The following evening met with equal success in spite of a soft but constant rainfall throughout the day. During the Friday night festivities, the

china-painted teacups and saucers were sold at auction. Private bids were received at the Department of Women's Work on Thursday and Friday, and floor bidding began under the hammer of General Edward Noyes, former governor of Ohio (1872–74), at 9:00 P.M. Whereas the objects could be viewed at the festival prior to the auction, they also could have been seen on display in the window of a shop on Fourth Street prior to the festival. General Noyes "made a first-class auctioneer, and knocked down to good prices as musically and eloquently as he does Democratic arguments on the stump."[27] He did indeed get excellent returns, "squeezing a good deal of wine out of the grapes." Thirty-five decorated cups and saucers netted $385.00, averaging $11.54 each, at a time when the average wage earner made less than $10.00 per week. The highest bid was $25.00, a most impressive sum for the work of an amateur. The following day the *Cincinnati Daily Gazette* and the *Cincinnati Commercial* listed each china painter and the price paid for her work:[28]

No. 1, Miss M. L. McLaughlin	$ 15.00
No. 2	$ 25.00
No. 3	$ 14.50
No. 4	$ 20.00
No. 5	$ 15.00
No. 6	$ 20.00
No. 56	$ 10.00
No. 58	$ 8.00
No. 57	$ 10.00
No. 50, Mrs. E. G. Leonard	$ 10.00
No. 29	$ 6.00
No. 30	$ 8.50
No. 39	$ 6.50
No. 12, Mrs. L. B. Harrison	$ 11.00
No. 53, Mrs. William Hinkle	$ 12.00
No. 52	$ 12.00
No. 13	$ 12.00
No. 38	$ 15.00
No. 15, Miss Clara Fletcher	$ 6.00
No. 43	$ 6.00
No. 55, Miss Schooley	$ 6.00
No. 21, Miss Rauchfuss	$ 11.50
No. 37	$ 10.00
No. 45	$ 10.00
No. 22, Mrs. Maria Nichols	$ 25.00
No. 23	$ 12.00
No. 24	$ 20.00

No. 27	$10.00
No. 28, Mrs. Richard Mitchell	$10.00
No. 36	$ 9.00
No. 46	$ 8.00
No. 40, Mrs. A. B. Merriam	$ 5.00
No. 42	$12.00
No. 44, Mrs. S. S. Fisher	$ 8.00
No. 47, Miss Lincoln	$ 5.00

There is a slight problem with the reports in the newspapers. Neither Alice Holabird nor Clara Chipman Newton is listed. Alice was part of McLaughlin's group, and so was Clara. Although there is no report that Alice contributed, Clara specifically stated that she had two teacups for the occasion: "The Governor of Rhode Island bought one of these precious productions. The other was sold at auction to the highest bidder."[29] Furthermore, writing about it later, Mrs. Perry included Miss Newton, but not Miss Holabird, in her list of participating china painters.[30] Since one of Clara's teacups was "bought" and the other was "sold at auction," perhaps there was an additional means of sale besides the auction. The *Cincinnati Daily Gazette* referred to sales on both Friday and Saturday nights, but that could have been a reference to the written bids received at those times.[31] No other newspaper chronicled a sale Friday night. The omission of Clara Chipman Newton and possibly that of Alice Holabird aside, the listing offers a wealth of information. The list gives the names of nearly all the earliest china painters in Cincinnati. Many of these names were to be heard over and over again in the coming years in local as well as national ceramic circles. The list also suggests which of the ladies had the most drive and talent. In this respect it was prophetic. Louise McLaughlin contributed nine teacups and saucers, more than double that of any other participant. Grossing $137.50, her pieces garnered the largest total amount for an individual contributor. The next-largest total amount earned by an individual contributor was $67.00 for the work of Maria Longworth Nichols. Compared individually by price, the most expensive pieces were created by Louise McLaughlin and Maria Longworth Nichols. Of the two highest bids, which were $25.00 each, one went to a teacup by McLaughlin (featuring an "improved copy of the jaundiced first president"), and the other to a teacup by Nichols (pl. 5).[32] In terms of quality, therefore, the works of these two china painters were viewed equally. Not only did the auction anticipate the coming local as well as national importance of these two ladies in the field of ceramics, it also set in motion a rivalry between them that would bristle for much of the remaining century.

On Saturday, May 22, 1875, the final day of the Centennial Tea Party, Exposition Hall was opened from 2:00 until 9:00 P.M., although the gas jets were seen glimmering until 10:00. Saturday was children's day. Children were invited to receive an education viewing this miniature world's fair. One newspaper entreated, "Take, therefore, oh, ye goody aunts and precious mamas, and buy them some of that nice Philadelphia walnut candy, at the English table."[33] Another newspaper noted that the children "cut around, screamed, danced, stared, ate candy, swallowed ices, munched nuts, and let everybody know they were there."[34]

Pleas to extend the festival a few days longer were heard everywhere, but to no avail. Exposition Hall was already rented for another purpose the following Tuesday. The Centennial Tea Party closed on Saturday, May 22, to newspaper accounts that could not have been more glowing. The *Cincinnati Commercial* stated that the affair "vanished like a gorgeous dream, leaving a happy recollection without a single regret behind."[35] The *Cincinnati Daily Gazette* called the event "an exhibition of feminine taste, zeal, and enterprise, which is nothing less than astounding."[36] And the *Cincinnati Enquirer* called it "a triumph."[37] As an added honor, Mrs. E. D. Gillespie, the president of the Women's Branch of the Centennial Board, visited from Philadelphia. Extremely impressed, she thought that Cincinnati's Centennial Tea Party was the greatest success of the kind she had yet seen. In fact, she was so taken by the "Oriental" booth, which included Chinese and Japanese items, that by one account she intended to purchase it and transport it bodily to the Philadelphia Centennial.[38]

The ultimate goal, to financially aid the participation of Cincinnati women in America's Centennial Exhibition the following year in Philadelphia, was superbly achieved. With an admission fee of 50¢ from each of the thousands of attendees, the auction of the painted teacups, the sale of objects in the booths, and the sale of food and china in the banquet hall, thousands of dollars were raised. The Martha Washington Tea Party and the Centennial Tea Party together earned more than $7,000.[39]

Even with all the accolades, no one foresaw the truly profound ramifications that the Centennial Tea Party would have for women. No fewer than eleven Cincinnati newspaper articles (three were front-page), comprising twenty-five columns of print (five were front-page), chronicled their success in minute detail. Up to that time, no other city had offered such support and recognition for an event sponsored by women. The greatest ramifications were to come in the field of ceramics. As previously detailed, the popularity and success of the display and sale of painted china were reported with great enthusiasm. The Department of Women's Work, where the painted china was displayed, was the hit of the tea party. The *Cincinnati Daily*

Gazette noted that "none [of the other booths] was more interesting, or attracted more admiration."[40] This is quite a compliment considering the wealth of attractions at the fair. Such notices gave society's sanction and encouragement to women to continue their artistic pursuits.

The success of the display and sale of the teacups is often seen as the beginning of the women's porcelain painting movement in America. In 1881 Mrs. Elizabeth Perry wrote that "it was unquestionably the most extensive and satisfactory exhibit of amateur overglaze decoration made up to that time in the United States."[41] By 1894 the display of teacups at the Centennial Tea Party was regarded as "the first exhibit of decorated china" in America.[42] In 1914 Clara Chipman Newton said, "These cups . . . really represent the origin of porcelain painting by amateurs in this country."[43] It is true that in other centers, such as Chicago, Philadelphia, and New York, china painting was coming to life at about the same time. China painting was an idea about to happen, and it began happening in several different places at once. However, it was in Cincinnati that for the first time, women were rewarded through recognition on a citywide basis. This is a very important point. In May 1875, Cincinnati offered the first broad-based social recognition of china painting by women in America. This fostered growth in the industry at the earliest point of the national phenomenon. Because of the Queen City's history of female involvement in the arts (for example, Mrs. Peter's initiatives, and then Mrs. Perry's), its industrial expositions (which encouraged the industrial arts), and its growing ceramic business, it is not surprising that the first major boost in the women's china painting phenomenon came from Cincinnati. Nor is it surprising that the earliest major figure, Louise McLaughlin, was from that city. She was one of the first to receive the reward of recognition for her talent on a grand scale. Indeed, she outshined the rest. Lawrence Mendenhall, writing for *Brush and Pencil* noted, "Conspicuous among the ladies, Miss Louise McLaughlin is justly entitled to 'first honorable mention' for her enterprise and unbounded enthusiasm."[44] It is no wonder that she pursued the field with zeal. Moreover, she undoubtedly realized that there could be monetary rewards for her work. Later, the china painter would direct her skills to other areas of ceramics, but for now china painting was her source of inspiration.

Flushed with success and endowed with the social support and money necessary to continue toward their goal, Mrs. Perry and her ladies began preparing for their contribution to the Centennial Exhibition in Philadelphia. Cincinnati had given them local recognition. In Philadelphia they would seek recognition on a national level.

THE CENTENNIAL
EXHIBITION, 1876

"The Cincinnati exhibit at the Centennial attracted much attention as its features of woodcarving and china painting were novel and in advance of the women's work shown by other cities," reflected Louise McLaughlin.[1] Success at the Centennial Tea Party had foretold the future. Many of the pieces (e.g., pl. 6) displayed at that event, together with additional ones, were placed in the Women's Pavilion at the Philadelphia Centennial Exhibition in 1876, and everyone took notice. The ladies of Cincinnati outshined their counterparts across the nation. Benn Pitman, so instrumental in recognizing and developing the talents of Cincinnati women, traveled with the collection and tastefully installed it. Much to everyone's delight, the "Cincinnati Department" won an award "for a very extensive and creditable exhibit."[2] Later, Clara Chipman Newton would recall: "The exhibit [of china painting] sent to Philadelphia made a great stir in the art world as did the woodcarving, and was the cause of placing the work of Cincinnati women in a pre-eminent position."[3]

The ladies of Cincinnati recorded their exhibit in the exhaustively titled *Catalogue of Artistic Carving, China Painting, etc.: The Work of the Ladies of the School of Design of the University of Cincinnati and Other Ladies of the City, Exhibited in the Women's Pavilion of the Centennial Exhibition of 1876*. As recorded, Louise McLaughlin's contribution to the Cincinnati Department was extensive:[4]

Tray—Cupids, after Boucher
Twelve Egg Cups—Female Heads, original
Plate—Landscape, after Birket Foster
Plate—Head, after Sir Joshua Reynolds's "Simplicity"
Two Plates—Female Heads
Teapot Stand—Silhouette, after Paul Konewka
Cup and Saucer—Pink ground, with Flowers
Cup and Saucer—Pink ground, with Cupids
Cup and Saucer—Portraits of George and Martha Washington
Cup and Saucer—Portraits of George and Martha Washington, Monochrome
Teapot Stand—Oberon and Titania, after Paul Konewka
Pair Painted Slate Panels—Flowers
Oil Painting—Head, after Greuze
Hanging Cabinet—Walnut and Ebony, under the direction of H. L. and W. H. Fry
Jardinière

An examination of her entries reveals that her talents were displayed in a wide range of materials. Besides painted china, she also contributed a carved hanging cabinet (pl. 7), painted slate panels, and an oil painting. The hanging cabinet was executed under the direction of Henry L. and William H. Fry, a father and son team who offered instruction in woodcarving in Cincinnati. At this time the Frys only taught privately. Louise seems to have augmented her woodcarving class from Benn Pitman at the School of Design with private lessons from the Frys. She had displayed original designs for the cabinet at the Sixth Annual Exhibition of the School of Design in June of 1874.[5] Having completed Benn Pitman's woodcarving class at the same time, McLaughlin probably continued her lessons under the Frys in order to make the cabinet that she had designed. It was displayed at the Centennial Tea Party, and ultimately at the Centennial Exhibition in Philadelphia. The jardinière and the pair of painted slate panels could have been those she exhibited in June 1875 at the Seventh Annual Exhibition of the School of Design.[6] Perhaps a couple of the eggcups had been displayed at previous School of Design exhibits, and the George and Martha Washington teacups, along with some, if not all, of the other teacups, were undoubtedly the ones sold at auction at the Centennial Tea Party. The oil painting was probably new, but could also have been a School of Design project. It is obvious that a number of the works McLaughlin displayed at the Centennial Exhibition had already brought her recognition in Cincinnati, but perhaps half of the pieces at the fair were new.

Counting each cup and saucer as one item, there was a total of twenty-eight objects contributed by McLaughlin to the Centennial Exhibition. Of these, twenty-

seven were painted. This alone confirms McLaughlin's view of herself as a painter. Of the twenty-seven painted objects, nineteen (or 70 percent) were painted with heads or portraits. This confirms her view of herself as first and foremost a portrait painter. Furthermore, of the nineteen portraits, twelve (on the eggcups) were painted from life, while the remaining seven were painted from two-dimensional sources. Like most portrait painters, she preferred to paint from life. The choice to copy heads or full-length figures from such recognized sources as the English portraitist Sir Joshua Reynolds and the French painters François Boucher and Jean Baptiste Greuze was McLaughlin's way of connecting the fine art of oil painting on canvas, where she placed her identity, with the craft of china painting, where society placed her identity. It is safe to conclude that of all the art forms she could have pursued, Louise chose painting; and of all the subjects she could have painted, she chose portraits. Why most of these portraits were painted on china instead of on canvas has more to do with the artist's gender than with the artist's preference. As Ellen Paul Denker has shown in her study on the relationship between the fine and decorative arts in painting, "China painting was initially a way for women to paint in a medium that was acceptable in the domestic sphere."[7] In other words, in acceptable society at the time, men painted on canvas, whereas women painted on china.

Most of the Cincinnati ladies who were instrumental in the Centennial Tea Party visited the Centennial Exhibition in Philadelphia at some time during its run from May 10 to November 10. Louise McLaughlin was no exception. She attended in August.[8] Having acquired an avid interest in ceramics, she viewed the ceramics on display from the various countries of the world, especially those of France. To say that the ceramics of Haviland & Company of Limoges, France made an indelible impression on her would be an understatement.

Haviland & Company was founded in Limoges in 1842 by David Haviland, an American importer of fine china.[9] Although noted for its fine porcelain, it was not Haviland's porcelain that engendered acclaim in 1876, it was its faience. The faience represented an esoteric technique that had taken years to develop and that would alter the course of ceramic history.

Around the mid-nineteenth century, French ceramists started to revive old techniques. One technique they sought to rediscover was that of Bernard Pallisy, an eccentric sixteenth-century French potter who made colorful, sculptural pieces covered with lead glazes. The drive to emulate Pallisy led to a search for underglaze slips that would not lose their color during the glaze firing. A slip is a watery clay solution

that, when mixed with an oxide, can impart color. Until the last quarter of the nineteenth century, there were very few known oxides that would not lose their color during the intense heat needed for the glaze firing. Consequently, up to that time, decoration had traditionally been applied over the already-fired glaze. Cobalt blue, made famous by the Chinese Ming dynasty, is one example of the few oxides that did not lose their color during the glaze firing. An underglaze decoration was considered superior to an overglaze decoration in that it was permanent and would not rub off, even under everyday use of the object it adorned. Also, unlike an overglaze decoration, an underglaze decoration did not interfere with the sheen of the glaze. This gave the surface of a vessel the appearance of depth that could not be achieved otherwise. One looked *at* the surface of a vase with an overglaze decoration, whereas one looked *into* the surface of a vase with an underglaze decoration. This was decidedly considered an aesthetic advantage. To develop and improve upon the technique to produce underglaze decoration would revolutionize ceramics, and many French potters began the search.

Two French ceramists, Ernest Chaplet and his partner, Laurin, began to uncover the secrets of underglaze decoration in the early 1870s while working at Laurin's factory in Bourg la Reine, near Sceaux, just seven miles south of Paris. In the meantime, David Haviland's son, Charles, seeking to advance the artistic value of Haviland's product, set out to employ reputable artists for the firm. He hired Chaplet and purchased the secrets of Chaplet's early success at the Laurin factory. By 1873 Chaplet was working in Haviland's new experimental studio in the Paris suburb of Auteuil on the direct road leading from the capital to the Sèvres porcelain works. The Auteuil studio was begun because the Havilands "found it impossible to induce artists to leave Paris permanently to perform the work at their factories," 225 miles south in Limoges.[10] By 1875 Chaplet had advanced the underglaze technique at Auteuil to the point where the fruits of his discovery could be exhibited for the first time in Philadelphia at the 1876 Centennial Exhibition. The acclaim that it brought to Haviland & Company was sensational. In a review of the ceramics at the fair, the *American Architect and Building News* noted that the "Havilands . . . bear heavily upon faience . . . with results that are literally amazing."[11] Anyone interested in ceramics took note of this momentous discovery. In America, the Haviland product became known as *Limoges* faience, even though it was developed in Paris at the Auteuil studio, because it was incorrectly assumed that Limoges, the home base of the Haviland firm, was where the new style was brought to fruition.

Louise McLaughlin was greatly affected by what she saw, and was quick to grasp the importance of the new discovery. She wanted to work in faience, but it was produced only by Haviland, where the technique was kept a secret. As usual, she was undaunted by such a formidable hurdle: "This was a new development in the decoration under the glaze which interested me greatly, and I determined to see whether it could not be done in this country."[12] Her determination was to change the course of American ceramics. When she returned to Cincinnati from the Centennial Exhibition, she researched the necessary underglaze colors and ordered them from Lacroix's, a Paris firm.[13] It was nearly a year before they arrived. In the meantime, she decided to write a manual on china painting.

CHINA PAINTING:
A PRACTICAL MANUAL, 1877

"I remember that the writing of the manual took just two weeks," McLaughlin later recalled.[1] Although it required only two weeks of work—based, of course, on three years of experience—Louise McLaughlin's book, *China Painting: A Practical Manual for the Use of Amateurs in the Decoration of Hard Porcelain* (pl. 8), published in late September or early October 1877, had a major impact on American china painting. It was the first manual on the subject in the United States written by a woman for women. That it was for women is apparent in McLaughlin's use of the word "amateurs" in the title. "For the Use of Amateurs" could just as easily have read "for the Use of Women," since the words "amateurs" and "women" were virtually interchangeable at the time. In her study on the American china painter, Cynthia A. Brandimarte notes, "Although both men and women painted china, it was the women who were most often labeled 'amateurs.' . . . Writers who used the term did not feel the need to define it; they simply assumed that their readers knew exactly what they meant."[2] McLaughlin alludes to the fact that the book was written for women in her preface: "Having been repeatedly urged to give the results of my experience in china painting to my fellow art-students, I take this method [i.e., writing a book] of doing so."[3] Louise's "fellow art-students" were, of course, women, who were becoming increasingly attracted to china painting. It is curious, however, that although her

book was written for women, she never directly addressed the fair sex in any of its sixty-nine pages. Indeed, the pronoun references are all to men. For example, in the book she writes: "Each artist has *his* own method of making up *his* palette."[4] Perhaps the usage of the male pronoun was determined by convention, but it remains peculiar that she did not frankly recognize the female reader for whom the book was written. By obliquely noting that the book was for women, while at the same time using male gender pronouns, she at least made the pretense of including the male reader in the audience. Doing so raised the importance of the book, since a man, regarded as a professional, was deemed more important to the craft than a woman, regarded as an amateur. Louise identified more with the male professional than with the female amateur, even to the degree that she always considered herself first and foremost a painter of canvases, which was a distinctly male realm. To openly preclude a male readership from her book would have been to preclude a readership important to her own identity.

Those who "repeatedly urged" her to share her knowledge were either women promoting a means of employment or, more likely, women looking for a pastime sanctioned and encouraged by society. Louise does not appear to have been sensitive to women who needed to support themselves. She often sold her china-painted pieces, but her need for income was not critical because her brother George was supporting her. In the introduction to the book, the first sentence labels china painting as "an agreeable pastime for persons of leisure."[5] Once again McLaughlin's reference to women is at best indirect, but "persons of leisure" were, without question, women, and they were not women who needed jobs. She did not identify china painting as a job opportunity for women or as a socially acceptable means of support for ladies without an income. Perhaps she omitted the issue because to include it would have been to address women directly, something the book was obviously not designed to do. McLaughlin must have been aware of the women's employment issue. A woman's need to earn a living was a topic of concern in Cincinnati. Mrs. Sarah Worthington King Peter had championed the cause as early as 1854 with her Ladies' Academy of Fine Arts, and Mrs. Elizabeth Perry had continued Peter's crusade. In writing about the Women's Centennial Executive Committee of Cincinnati, Perry stated, "In the general aim of this committee to make a creditable addition to the work of women at the Centennial Exposition, the specialty of china-painting, then exciting some interest among the women here and in other parts of the country, was looked upon as promising a possible field of lucrative work for women."[6]

Louise McLaughlin was not oblivious to the reality that china painting was a promising field of work for women, especially since she herself would make money from it. For unknown reasons, however, she did not mention this reality in her text. Instead she chose to write a book directed toward women of leisure, thinly veiled as a manual for anyone (male or female) interested in an enjoyable pastime. Whatever her intentions, the fact remains that women in need of a profitable skill, as well as women in need of a pastime, benefited by the publication. It is not certain if men ever read it, although some probably did.

Looking at *China Painting* as an instruction manual, one finds a well-crafted, sixty-nine-page book that sold for seventy-five cents per copy. It discusses simply and thoroughly all the basic information needed for the craft. This includes chapters on materials and their cost (from ten to twelve dollars for the basic needs), firing, preparing the design, and general directions for painting flora, butterflies, landscapes, heads, monograms, etc. It also includes a discussion on laying grounds and general remarks on decoration. The information in the text is assumed to be McLaughlin's. Indeed, one reviewer states: "This work is, mainly, a record of the author's experience in painting on china during the past three years."[7] This is borne out by the fact that Louise freely offers advice based on her personal involvement in china painting. Examples are easily found: "A heavy, dark or colored outline sullies the colors used upon it, and causes much annoyance in working. . . . For my own part, I think the use of spirits of turpentine decidedly preferable. . . . Shadows should be painted a little darker than they are to appear when finished, as they are liable to become lighter in the firing. . . . Black used alone, in thin washes, is sometimes found to rub off after the firing."[8] One reviewer of the book, however, states that it was "adapted from the French work of M[onsieur]. Lacroix."[9] A. Lacroix (sometimes spelled "La Croix") was a major Paris dealer in art materials and art books. Louise was aware of Lacroix and recommends his colors at least four times in the manual.[10] In fact, she openly admits that her classification of colors according to iron content is adapted from the work of M. Lacroix. Louise knew French, and a reading of her book suggests that she was a Francophile. She recommends French porcelain, and all comparative references are to things French—that is, to Parisian facilities for firing, to French artists, to French craftsmen, to French materials, to French techniques, and to French dealers. She even uses the French names, which she translates, for all the recommended colors. Indeed, a naive reader might think that china painting was unique to France. To date, however, no manual by Lacroix or any other Frenchman

has been found that is strictly reflected in McLaughlin's book. She used and recommended Lacroix's colors and his data in regard to their classification, but beyond that all the instructional information in the book came from Louise herself.

A close analysis of the text reveals her biggest influences to have been the School of Design and Benn Pitman. The curriculum at the School of Design of the University of Cincinnati, as previously discussed, emphasized the importance of drawing. Most of the courses required over the four-year period necessary for graduation were drawing courses. Although Louise McLaughlin never admitted an appreciation of the curriculum, in her book on china painting, she cannot emphasize drawing enough: "The idea that one can successfully practice any branch of art without having previously learned to draw is false. . . . The best foundation for any art-work is a thorough knowledge of drawing. . . . To those who have the time and patience, as well as the natural ability to learn to draw, we would say: Make it your first business to acquire that knowledge."[11] Watercolor painting was also a required course at the school, beginning in the third year of study. Louise had studied watercolor painting and was quick to recognize its relationship to china painting, as noted at least nine times in her book. Some examples are: "Brushes for water-color painting may also be used on china. . . . The same rules may be applied to china painting as to water-colors, to which it bears a close resemblance. . . . If subjects for floral designs are painted from nature, it would, perhaps, be better to make the studies in water-colors, previously."[12] For the remainder of the nineteenth century and into the next, china painting manuals and periodicals would continue to acknowledge china painting's correlation to watercolor painting. Ellen Paul Denker's study on the relationship between the fine and decorative art of painting points out: "Throughout china painting manuals and periodicals [of the late nineteenth and early twentieth centuries], the relationship between canvas and watercolor painting and china painting was mentioned continually."[13] Louise was very much a part, if not the initiator, of that tradition.

When the philosophical basis of Louise McLaughlin's book is analyzed, the teachings of Benn Pitman loom large. Louise admitted, "I have many pleasant recollections . . . [of gathering] in the large room on Saturday mornings to listen to the talks of Mr. Pitman on decorative art."[14] Pitman always turned to nature as the underlying source of inspiration in art:

Careful observation, and patient delineation of the constantly changing aspects of nature, will never fail to yield the student abundant decorative material, and

Fig. 6.1. Illustration from page 57 of *China Painting: A Practical Manual,* by M. Louise McLaughlin. *Courtesy of the Cincinnati Art Museum, Mary R. Schiff Library*

such studies, and their appropriate use, will be the leading inspiration in decorative design, employed according to varying circumstances and demands, all the way from strictest conventionalism to purest realism.[15]

Like Pitman, McLaughlin extolled nature as the source of all beauty in art. In her book she writes, "There will be no true revival of any branch of art unless founded upon a study of nature and the adaption of her principles to design. . . . This [branch of art called china painting], as well as every other branch of art, finds its best inspiration and development in the study of the harmonies of color and form existing in nature."[16] Both agreed that the observation of nature was central to a successful creation. Perhaps this is why Louise was so enamored of Japanese art: It was based on an observation of nature. She held Japanese art in high esteem and in the book openly advises that "Japanese designs are excellent subjects for ceramic decorations."[17] In fact, she used a Japanese style for the cover and for the vignettes (e.g., fig. 6.1) at the end of each chapter in her book.

Neither teacher nor student excluded the art of past cultures as a source of inspiration, as long as the result was more than just a mere copy. McLaughlin insisted that "[a] revival of the art [of china painting] . . . cannot be expected from a servile copying of the old designs."[18] This echoed her mentor who said simply, "there need be no servile copying."[19] In choosing the "appropriate" decoration for a piece of china, McLaughlin used conventional, or stylized, as well as naturalistic designs.[20] Plates, plaques, or panels that were to be hung as pictures were usually reserved for heads, figures, or landscapes rendered naturally. Pieces or services intended for use were adorned with naturalistic flowers or, better still, conventional designs. Heads

or figures were not deemed appropriate for such objects. This appears to be a maturation of her philosophy since the days of her portrait eggcups and the Centennial teacups. In general, she promoted conventional designs as being "in the best taste" for objects of use. Pitman had similar ideas, which he often expressed with regard to woodcarving. According to Cecelia Scearce Chewning, Pitman's biographer, "Pitman taught that nature should be represented both realistically [i.e., naturally] and conventionally."[21] Pitman and McLaughlin both felt that when designs were placed in "principal spaces," or positions of importance, they should be rendered naturally. For Louise these positions were on china plaques and on panels to be hung on walls; for Benn they were on the prominent carved panels of doors. When designs were placed in positions of lesser importance, they should be rendered conventionally. For Louise these positions were on porcelain objects of everyday use; for Benn they were on the carved borders of door panels. Finally, both mentor and student deplored extravagance in decoration. McLaughlin cautioned, "There is a great deal in knowing when to let well enough alone. When you do not see anything more to do, stop."[22] In this she reflected Pitman, who emphasized, "Balance in decorative art is *enough* of the right kind of ornament in the right place."[23]

It can be concluded without question that the aesthetic point of view of Louise McLaughlin's treatise on china painting rests largely on the curriculum of the School of Design in general and the teachings of Benn Pitman in particular. To argue that the book is patterned after one by Lacroix or anyone else shows ignorance of McLaughlin's background. The manual, which is directed toward women of leisure, with its admiration for anything French, its love of nature, its personal advice, and its philosophical perspective, is purely the work of Louise McLaughlin. The book was so popular that it was published in no fewer than ten editions and sold over twenty thousand copies. Ruth Irwin Weidner, in her study of the early literature of china decorating, put it best when she noted that Louise McLaughlin's early guide to china painting "might be described as one which launched a movement."[24]

UNDERGLAZE SLIP
DECORATION BEGINS,
1877–1879

"It was a problem of undetermined media and methods, difficult enough for an experienced chemist and a trained artist, but overwhelming for one whose apparent qualifications for the work lay largely in a fund of enthusiasm and admiration," wrote journalist Irene Sargent with regard to Louise McLaughlin's determination to discover the secret of Haviland's underglaze slip decoration.[1] For Louise it was definitely a case of ignorance amounting to bliss. Many potters and chemists of Europe had been trying to master the technique for decades, if not centuries. Although Louise realized the importance of such a technique, she had no idea of the complexities involved or of the unending years of unsuccessful professional experiments that had already been conducted in Europe. If she had, it might have given her pause, but it probably would not have stopped her. As noted previously, she ordered underglaze colors from the Paris firm of Lacroix shortly after she returned from the Centennial Exhibition in August 1876. When she finally received the colors a year later, she set about the business of discovering the technique of underglaze slip decoration.[2]

According to the artist, she had previous experience with underglaze work. Supposedly, she decorated two plates in underglaze blue in 1875 (pl. 9). The first was painted with cattails, grasses, and birds in flight, and was reportedly fired at Tempest,

Brockman & Co. of Cincinnati. The second was decorated with a wooded landscape and was fired at the Union Porcelain Works of Greenpoint, Long Island. In 1879 Mrs. Elizabeth Perry, as president of the Women's Art Museum Association (WAMA) working toward the establishment of the Cincinnati Art Museum, accepted the two plates as gifts from the artist for the collection of the future museum. In the WAMA accession catalog for 1879, the plates are listed accordingly:

> Stone China Plate, first successful work in blue underglaze (1877) made and given by Miss M. Louise McLaughlin.

> Plate of Green Point Long Island porcelain, blue underglaze, gilt border (1879) decorated and given by Miss M. Louise McLaughlin.[3]

These two entries were written on separate paper labels and glued to the bottoms of the respective plates, obscuring their ceramic marks. In 1893, when preparing the installation and catalog for the Cincinnati Room at the World's Columbian Exposition in Chicago, Clara Chipman Newton had a problem with the dating of these plates that were part of a historical collection of Cincinnati ceramics to be displayed there. Louise wrote to her good friend to resolve the problem:

> The blue underglaze plate of mine which was selected for the Museum Collection was painted . . . in 1875. In the report of the selection of these pieces I think the date was 1878. My brother [George] noticed the error and wrote to Mrs. Perry asking her to correct it. He determined the date as he had in his letter book a copy of the letter ordering the plate from the Greenpoint Porcelain Works and this was dated Sept. 17, 1875. The plate was painted shortly after that. I had previously however made some experiments in blue underglaze at Tempest's Pottery here, and one of these specimens is I believe also in the Museum.[4]

As a result, the two underglaze blue plates were dated 1875 by Clara in the official catalog of the Cincinnati Room for the World's Columbian Exposition.[5] This is the same date given the plates by the eminent ceramic art historian Edwin AtLee Barber in his 1893 book, *The Pottery and Porcelain of the United States,* and in an 1896 article for the *Art Interchange.*[6] Barber always sought his information from primary sources when possible and he probably received the date from McLaughlin herself.

When these two plates in the collection of the Cincinnati Art Museum are examined today, it becomes obvious why both Mrs. Perry and Clara had problems with the dating. The first plate, decorated with cattails, is clearly marked on the bottom

as being from Frederick Dallas's Hamilton Road Pottery, not from Tempest, Brockmann & Co. It does not seem to be the piece referred to by McLaughlin as one of her first examples in underglaze blue. The marks on the second plate are even more stupefying. Unequivocally written in underglaze blue on the bottom in the artist's hand is "LMcL/Cincinnati/March 1879." This plate was obviously not painted in 1875. One might think there had been an unfortunate mix-up in plates somewhere along the line, but there was none. In 1893 the two plates still bore Mrs. Perry's original WAMA identification labels that obscured the ceramic marks and carried the correct dating. Had there been a mix-up of plates, McLaughlin would have noticed it at the Columbian Exposition in Chicago where the plates were displayed. Since she did not notice a problem, one may surmise that there was no mix-up.

It is difficult, therefore, to draw any safe conclusions regarding the date of McLaughlin's first experience with underglaze decoration. The artist was as emphatic in her statements about the dates as the marks are in theirs, and in spite of their disagreement, both Louise's statements and the marks refer to the same pieces. Even if Louise had confused the dates of these plates, she certainly would have remembered whether she did her first underglaze blue work before or after she began her Limoges technique. She insisted that she had done it before. In the end, the dating problem is not crucial. The thin wash of the underglaze blue oxide does not resemble the thickly applied clay slips of the Limoges style, nor does it present the same technical problems. Cobalt blue was, and is today, virtually the only high-fire color that fires true every time. That is to say, it retains its color in even the hottest kilns and does not have to be mixed with a slip to bond the decoration to the vessel. Louise herself distinguished the Limoges technique from that of the underglaze blue as "the other underglaze work."[7] Since the techniques are not crucially similar, she could have developed her Limoges technique without the practical experience of working with underglaze blue.

Once Louise received her high-fire underglaze colors from Lacroix, she had to determine which Cincinnati pottery would best suit her purpose. According to the 1877 Cincinnati Directory, there were nine potteries from which she could choose. As always, she turned to her brother George for guidance. After making various inquiries, George decided upon a pottery. In early September 1877, he took Louise to P. L. Coultry & Co. located at 55–59 Dayton Street. Louise's good friend Alice Holabird went along. Patrick Coultry had taken over the Dayton Street Pottery in 1874 and manufactured yellow ware and antique cream-colored pottery in Egyptian,

Greek, Etruscan, and Roman forms.[8] Coultry decorated his common yellow or Rockingham ware with stripes of cobalt blue and white slip under the glaze. Thus, his establishment seemed like the appropriate place for Louise to begin her experiments.

During that first visit, the artist looked for an unfired vessel that suited her purpose. There were no vases about, so she chose a simulated vase that was actually a teapot turned upside down without its spout or handle. Louise "took the soft clay thing home and with the aid of white slip colored with the foreign colors, decorated it."[9] The artist had reasoned that the number of colors used under the glaze, which were only the white slip and the blue oxide at the time, could be expanded by simply mixing the white clay slip with high-fire oxide colors. The clay slip would bond the decoration to the vessel and prevent the color from disappearing in the heat of the kiln. When the colors—with the notable exception of cobalt blue—were used without the admixture of a clay slip, they were unsuccessful in the firing. This was the problem that had puzzled potters in Europe for centuries. Louise mixed her white slip of liquid clay, which had the consistency of buttermilk, with the Lacroix high-fire oxide colors and began to paint on "the little perverted tea pot."[10] She always worked at home lest any of her secrets should be revealed, and at least at this time it was probably not ladylike to toil at the factory. Having the pieces transported back and forth involved considerable risk, but having been potted very thickly, the objects were not fragile. (Anyone today who has held an example of McLaughlin's faience can bear witness to the fact that it is thick-walled and inordinately heavy.)

The artist carefully returned her "perverted tea pot" to the pottery, where it was biscuit fired, glazed, fired a final time, and eventually drawn from the kiln in October 1877.[11] Alice Holabird was the first to whom it was shown. Louise found the results exciting: "While it was somewhat defective from the slip painting having been applied too thinly and thus revealing the yellow ground color underneath; it showed the feasibility of producing effects similar to the Haviland ware with the facilities at hand."[12]

Nothing could stop her now. In the next examples, Louise applied the under-glaze colors more thickly only to find that they cracked before or during the firing because of a shrinkage differential. That is to say, the moisture content in the slip decoration differed from that in the clay body of the vase, causing them to shrink at different rates during evaporation. The problem often occurred when the vase and the slip decoration were not equally moist when the decoration was applied. This was a major obstacle that presented somewhat of a Goldilocks dilemma: When the

slip was applied too thinly, the yellow ground of the ware was exposed; when the slip was applied too thickly, the slip cracked. Louise needed to find a solution that was just right.

The cracking of the decoration was a problem that plagued her constantly, and it marked the difference between her faience technique and that of Haviland. Later she admitted that the difficulties with the applied clay decoration probably would not have occurred if she had known and used Haviland's technique: "In this [i.e., Haviland's] process the applied clay had been previously fired and then ground into powder. In my ignorance of ceramic processes I had used unfired clay applied to a body in the wet state instead as in the other process to a thoroughly dried [i.e., biscuit fired] body."[13] McLaughlin was absolutely correct in her assessment. Haviland fired its colored slips and then ground them into a powdered base for use in decoration. Haviland decorators then painted the reconstituted slips onto a biscuit, or once-fired body, as is noted in *Céramique impressionniste: L'Atelier Haviland de Paris-Auteuil, 1873–1882:* "Indeed, at Auteuil, the decoration was probably applied, not on unfired clay, as at the house of Laurin, but on biscuit ware [fired] at 1,000° [centigrade]."[14] McLaughlin was decorating with wet slip colors on wet clay, while at Haviland artists were decorating with fired slip colors on fired clay. Because the colors and the clay at the Auteuil studio had already been fired and preshrunk, there was no problematic shrinkage when they were fired again. This remained the biggest technical difference between McLaughlin's and Haviland's faience.

Another problem that plagued the artist was the cracking or crazing of the glaze. A glaze must cool at a rate compatible with the rate of cooling of the body, or it will crack. Indeed, each element—the glaze, the decoration, and the body— must cool at a rate compatible with that of the others. The type of glaze used by McLaughlin was often referred to as enamel. In the literature of the day, the difference between a glaze and an enamel was well defined. A glaze covered the decoration and body of a clay object like a skin, without fusing with the colors or body beneath; an enamel, however, not only covered the colors and body, but also fused with them, combining their chemical structures.[15] This was a technical and esoteric point that caused knowing journalists to refer to the ware as "enameled faience," as well as "Limoges faience." It caused unknowing journalists to compare McLaughlin's "Limoges enamels" to the completely different category of medieval enamels, which had nothing to do with ceramics.

Louise was often given credit for discovering the glaze that she used, but she

always denied this.[16] The glaze that worked for her was Coultry's, not her own. Eliminating the crazing of the glaze was an enormous obstacle. Even Haviland had this problem: "Any one who goes the round of the china stores can see for himself that in almost every piece of Haviland ware is to be found many fine cracks . . . caused by contraction in cooling."[17] Louise thought that one way to solve this shrinkage differential, which would aid in eliminating cracks in the glaze as well as in the decoration, was to find a more suitable clay body. An elderly lady friend told her of a red clay that she had seen in Scioto County, Ohio, that she thought would be suitable for the artist. The elderly lady remembered that years ago she had met a geologist in the neighborhood of the deposit and he had remarked upon the fine quality of the clay. Louise procured some of this red clay, which was pronounced by the potters to be excellent. It did, indeed, work better than the yellow body, and thereafter McLaughlin used it as long as she remained at Coultry's. Most of her faience dating from early 1878 through most of 1879 exhibits this fine red body. Whether or not it helped to eliminate the crazing is not certain. It could be that the glaze was simply perfected, but almost all the red-bodied pieces are free of crazing.

Louise continued her experiments with the help of the workers at Coultry's. Sensing the importance of such a discovery, they took special pride in the work and did everything in their power to make it a success. The individual to whom Louise always gave the most credit for helping her was Joseph Bailey Sr.[18] Mr. Bailey was a Staffordshire potter who had left England in 1848 for America. After working briefly in Philadelphia and East Liverpool, Ohio, he came to Cincinnati in 1850. By 1865 he was the superintendent of Frederick Dallas's Hamilton Road Pottery, and he continued in that position until Mr. Dallas's death in 1881. He then became the superintendent at The Rookwood Pottery Company, where, with the exception of three years, he remained until his death in 1898. A polite man who seemed to enjoy working with lady amateurs—perhaps because their work was more experimental—he brought years of knowledge and experience as a potter/chemist. Even though he was working for Frederick Dallas at the time, he did not hesitate to help Louise with her far-reaching experiments at Patrick Coultry's. Later, in 1880, when McLaughlin wrote her book, *Pottery Decoration under the Glaze*, Joseph Bailey Sr. was the only person singled out as contributor to her success with his "intelligent co-operation and valuable advice."[19] Even with everything she had going for her, including a ceramic-minded city, her family, her education, her ideas, the Coultry Pottery, and so forth, Louise McLaughlin might not have successfully developed the technique for underglaze

slip decoration without the help of Joseph Bailey Sr. With his help, the empirical process of discovery continued:

> Through almost a hundred carefully made experiments, it was the old story of discouraging failure: a changing from one clay to another, a reversing of each part of the process, or a painful mastering of petty details. Each experiment was carefully recorded, and each new one made only after a study of the failures, or supposed success, of previous trials, until by a patient differentiation of disturbing elements there came gleams of partial success.[20]

Substantial success finally came in January 1878. Louise had completed the decoration of a pilgrim jar (pl. 10 a–b) on December 20, 1877. When it was drawn from its final firing in the following January, it proved to be the first successful example of her underglaze slip technique. To be sure, this flat-sided jar, displaying pink and red roses arranged in a careless, graceful manner on a gray, mottled ground, had its problems. The body sank slightly in the drying, and the glaze flowed a great deal in the firing. Along the shoulders and down the sides, there was "line popping," where the mold seam had "spit out" or become obvious in the firing. In addition, the reds were almost lost to the heat, and there were some minor cracks in the decoration. Nevertheless, this jar was a success. It was the first piece to bring McLaughlin's lofty goal to fruition. While her "little perverted tea pot" of October 1877 had proven that her theory had potential, the pilgrim jar of January 1878 fully realized that potential. This success was acknowledged by the intelligentsia of Cincinnati. Thomas S. Noble, Louise's teacher of drawing and ultimately director of the School of Design, wrote: "It has been reserved for the indefatigable energy and talent of a Cincinnati lady, Miss M. Louise McLaughlin, to discover this rare secret, and to have, after a series of experiments, produced results in color quite equal to the best Limoges [e.g., pl. 11]."[21] Noble also noted that "Miss McLaughlin had the satisfaction of knowing that she had outstripped the experimenters of Europe, who had long sought the same secret."[22]

To be sure, she still had technical problems, especially with the decoration. The kiln temperature presented yet another Goldilocks dilemma: When the kiln was too hot, the slip oxides would lose their color to the fire; when the kiln was not hot enough, the slip oxides would flake. In *Pottery Decoration*, McLaughlin did not offer a firing temperature or a range of firing temperatures that might have solved this or any of the other firing problems. She skirted the issue by simply saying, "the exact

degree can be estimated by the potter who understands the requirements of the clay."[23] Newspaper and journal articles advised Fahrenheit temperatures that range anywhere from a low but possible 1,200° to a ridiculous 9,000°.[24] The artist probably did not know the exact temperature at which her ware was fired and left the solution of the flaking decorations, as well as other technical problems, to the potter.

As Louise worked with renewed vigor, more pieces of marked success emerged. By the spring of 1878, there were enough examples for display in an exhibition. At the same time, Mrs. Elizabeth Perry and her Women's Art Museum Association were organizing just such an exhibition to raise funds for the establishment of the future Cincinnati Art Museum.[25] A generous Mr. John Cochnower placed his elegant and spacious house located at 166 West Seventh Street at the disposal of the WAMA for the exhibition. The purpose of the exhibition was "to awaken and extend an interest in the ultimate object," and thus encourage support for an art museum.[26] "Artistic, rare, and beautiful articles" were to be lent by the "Citizens of Cincinnati and its neighborhood." The Loan Exhibition, or the "urgent solicitation," as it was called, closed on June 8, 1878. The catalog listed hundreds of items, all properly categorized as paintings, sculpture, drawings, watercolors, ceramics, etc., that were seen by more than thirteen thousand viewers. Yet another triumph for Mrs. Perry and her ladies, the Loan Exhibition netted over $1,000 in entrance fees and sales of catalogs, and brought the people of Cincinnati to the realization that they needed a museum. Noted for more than just its popular and monetary success, the celebrated event marked the first time that McLaughlin's faience was publicly displayed in the city. On page 114 of the 136-page catalog, five "Cincinnati Enameled Faience" vases are listed. After the first is the notation: "Decorated by Miss M. Louise McLaughlin, under process discovered by her in October 1877; fired in kilns of P. Coultry & Co., Cincinnati. First specimen in which any successful result was obtained."[27] Some Cincinnatians who had purchased examples of Haviland's Limoges faience at the Centennial Exhibition in Philadelphia included these pieces in the Loan Exhibition. This allowed many who saw McLaughlin's faience for the first time to also see some of the objects that had inspired her. According to Clara Chipman Newton, "These few pieces of [McLaughlin's] ware, exhibited side by side with original specimens of the Limoges bought at the Centennial, created great interest."[28]

As Cincinnati was beginning to take note of McLaughlin's faience, a much larger event was taking place that would propel her to celebrity, the Exposition Universelle in Paris, France. A small number of her faience vases were placed in the exposition

that began on May 1 and continued through the summer of 1878. Matching her discovery in an international arena against Haviland's Limoges faience (fig. 7.1) was the acid test. Competing in France against the French made her accomplishment all the more impressive. McLaughlin's Cincinnati faience was very well received and won an honorable mention. One journal article noted later that "the judges . . . booked pottery of her [McLaughlin's] making for a medal, until they learned that the maker was a woman and gave her honorable mention instead."[29] The women's issue will be discussed in a later chapter, but whatever the case, she did receive world recognition for her faience.

Mrs. Edward Noyes, wife of the general who auctioned the teacups at the Centennial Tea Party, was there with her husband, who was officiating at the American exhibit. She took one of McLaughlin's faience vases to the French section to compare it to the exhibits there. To her great pleasure, she found that the finish on the Cincinnati vase was as good as anything in the French department. Moreover, "[t]he attendants at the various [French] exhibits examined her little vase very carefully, turned it over and over, and asked a great many questions. Most of them declined to believe it was done in America, and one of them said, with a shrug, 'Well, it is the real thing.'"[30] Cordelia Plimpton, who was to become another major figure in Cincinnati ceramics, also visited the Paris exposition, where she too compared McLaughlin's ceramics to the French. According to Plimpton, McLaughlin's ceramics were "exceedingly pretty, and well executed, though less bold than the French, which it most resembles."[31] In general, there was much unofficial as well as official praise for Louise McLaughlin's Cincinnati faience.

Paris was only the beginning, as her fame rolled like a wave cresting higher with each exhibition. The next big splash came right after Paris, in the fall of 1878. The Woman's Decorative Art Society of New York City held the extensive Loan Collection exhibition in October at the Academy of Design. Mr. William C. Prime, a nationally recognized authority on ceramics and author of many publications on the subject, organized the exhibit of ceramics ranging in date from the tombs of ancient Etruria to the present. Two of McLaughlin's faience vases each received a medal, out of the three or possibly four medals given out in the entire exhibit. When a correspondent asked Mr. Prime if her work was good, he responded, "Good? They are wonderful, sir. Miss McLaughlin ought to have a medal from Congress. She is the Edison of Pottery. We can not give her a medal good enough to half show the appreciation of our Society."[32] Prime fully understood the significance of what he

PEINTURES ÉMAILLÉES

ENAMELLED PAINTINGS PINTURAS ESMALTADAS

EMAILLIRTEN MALEREIN

NUMÉROS des Formes	HAUTEUR des Pièces	FLEURS PEINTES					SUJETS PEINTS					FEUILLAGES SCULPTÉS					FIGURES SCULPTÉES					DORURE (EN PLUS)		
		A	B	C	D	E	A	B	C	D	E	A	B	C	D	E	A	B	C	D	E	simple	moyenne	riche
		fr. c.	fr. c.	fr. c.	fr. c.	fr. c.	fr. c.	fr. c.	fr. c.	fr. c.	fr. c.	fr. c.	fr. c.	fr. c.	fr. c.	fr. c.	fr. c.	fr. c.	fr. c.	fr. c.	fr. c.	fr. c.	fr. c.	fr. c.
Vase, n° 45, 1re, (prix par pièce).	45 centimètres.	150 »	175 »	200 »	225 »	250 »	175 »	200 »	225 »	250 »	275 »	200 »	230 »	260 »	290 »	325 »	225 »	255 »	285 »	320 »	350 »	50 »	100 »	150 »
— 1re, —	37 —	100 »	115 »	130 »	150 »	175 »	125 »	145 »	165 »	185 »	200 »	150 »	175 »	200 »	225 »	250 »	175 »	200 »	225 »	250 »	275 »	40 »	80 »	125 »
— 2e, —	30 —	65 »	75 »	85 »	95 »	110 »	80 »	90 »	100 »	115 »	130 »	90 »	105 »	120 »	135 »	150 »	110 »	125 »	140 »	155 »	175 »	30 »	60 »	100 »
— 4e, —	19 —	24 »	28 »	32 »	36 »	40 »	28 »	33 »	38 »	43 »	48 »	33 »	38 »	43 »	48 »	55 »	40 »	45 »	50 »	55 »	60 »	15 »	30 »	50 »

Fig. 7.1. Page 77 from *Peintures émaillées,* an 1879 Haviland & Co. catalogue, showing examples of underglaze slip decoration. *Courtesy of Haviland & Co.*

was saying. Thomas Edison was sweeping the country at the time with his invention of the electric light bulb. Prime was arguing that just as Edison was fundamentally changing the lighting industry, Louise McLaughlin was fundamentally changing the ceramic industry. History has shown that his statement was accurate, and at the time, just to be mentioned in the same sentence with Edison was enough to incite recognition. The newspaper article that quoted William C. Prime concluded, "Miss McLaughlin's vases are certainly the sensation of the hour."

Because her work was recognized in Paris and New York, two of the leading ceramic art centers in the world, Louise McLaughlin became a household name in Cincinnati. Between October 5 and December 3, 1878, there were no fewer than seven major newspaper articles in the Queen City heralding her momentous discovery. They bore such titles as: "Cincinnati Ceramics: How Miss McLaughlin's Discovery Has Revolutionized Faience," "Miss McLaughlin's Triumph," and "Miss McLaughlin's Faience: A Cincinnati Young Lady Suddenly Becomes Famous." To be sure, there

had been articles written before these dates, and there would be many more to follow, but the dam of recognition burst in the fall of 1878. Local, national, and international acclaim had come to Louise McLaughlin.

None of this publicity went unnoticed by the indomitable Mrs. Elizabeth Perry. She saw a new industry for women workers in Louise McLaughlin's discovery. One day, probably in early September 1878, she and Mrs. Jane Porter Hart Dodd paid an official visit to Louise McLaughlin. Jane Porter Hart Dodd was another figure in Cincinnati ceramics who ranked after Louise McLaughlin and Maria Longworth Nichols in that second tier of "amateurs" that included such others as Cordelia A. Plimpton, Clara Chipman Newton, and Laura Fry. Mrs. Perry not only urged the artist to teach her discovery to other women, but also told her that it was her duty to do so.[33] Louise was not impressed: "I had my own views as to that however, and thought I had the right to choose my own time and my own way." Her "own time" was two years later, and her "own way," just as with china painting, was to write a manual on the subject. McLaughlin, who was not at all concerned about jobs for women, was not about to give up her secrets so soon to anyone: "The friends who knew what I was doing said it was foolish to tell all I knew. At all counts I did not think it necessary to take the public into my confidence."[34] By the time she wrote her manual in May 1880, the secret was out and she had nothing to lose. In the meantime, she was criticized for "failing to inform other women about an occupation which might be of profit to them." This incident strained her relationship with Mrs. Perry and eventually came back to haunt her.

After McLaughlin's refusal, Mrs. Perry contacted John Bennett and asked him to teach underglaze decoration in Cincinnati. John Bennett was an English-born potter who moved to New York in 1877.[35] Coming from Doulton's Lambeth faience workshop in England, he worked in the Lambeth faience technique and style, decorating on the biscuit with underglaze colors, usually in the form of thin washes (fig. 7.2). The thin washes were simply oxides not mixed with slip. Because they lacked slip, very few could retain their color in a high-fired process such as that used in McLaughlin's or Haviland's faience. The decorations, which were often conventionalized flowers and foliage outlined in black, were covered with a "soft" glaze that was fired at a temperature low enough to save the colors. The ware did not affect the heavy impasto decorations of Limoges faience until some time after McLaughlin's discovery. In a letter to Mr. Bennett, Mrs. Perry gave the reason for the request: "[I was] prompted by my great interest in the subject—and the hope that this City may become a

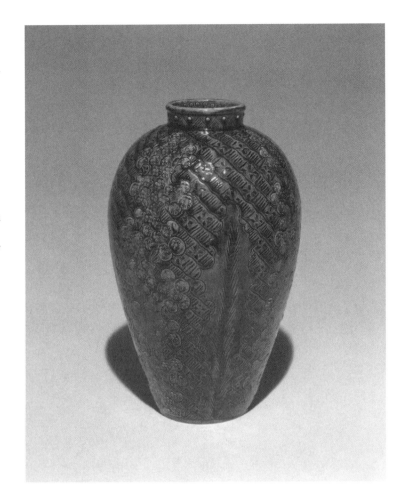

Fig. 7.2. Vase, 1879, by the John Bennett Pottery of New York, displaying the Bennett style of decoration under the glaze. *Courtesy of the Cincinnati Art Museum, Gift of Dr. Herman and Ruth Nimitz, 1984.84*

Centre [*sic*] for pottery manufacture and decoration. . . . Especially among our Ladies, there is a good deal of *Amateur* [Perry's emphasis] talent ready for direction."[36] Bennett could not decide whether or not to accept the offer. The *Cincinnati Enquirer*, October 11, quotes him as saying, "Just as I have gotten fixed here in New York I'm invited to go to Cincinnati . . . Mrs. A. F. Perry wants me to come and teach the art of making faience to a class of forty or fifty young ladies and gentlemen . . . I shall make up my mind in a few days."[37] Bennett ultimately declined the offer. Nevertheless, examples of his work were frequently displayed and sold in the Queen City, and Louise McLaughlin's product was often compared to "the Bennett style." Indeed, in *Pottery Decoration*, she wrote an entire section on the "Lambeth or Bennett Style" and explained how it differed from hers.

McLaughlin's aesthetic style in her faience ware was determined by Benn Pitman, her instructor at the School of Design of the University of Cincinnati, by the demands of the technique itself, and by the Limoges ware that inspired her. Pitman had cautioned his students to "avoid designs that are untrue to nature."[38] That McLaughlin did so seems to have been common knowledge. Virtually every contemporary article that discussed her style mentioned that it was grounded in nature. One such article stated: "Her ornamentation is peculiarly beautiful, because she copies from nature strictly making her own drawings from real flowers and leaves."[39] Another journalist commented during an interview at her house that "Miss McLaughlin paints everything from nature. The flowers on her vases are brought in from greenhouses [sic]."[40]

As in her china painting, the source of her study was nature. In her faience, however, the application of the decoration was in broad, heavy strokes, not in tight, small ones as in her china painting (e.g., pl. 12). Thomas S. Noble, Louise's drawing teacher from the School of Design and painter in his own right, noted: "The chief difference between this decoration and that of all other kinds of pottery is the heavy impasto of color and the great freedom with which the pigment seems to have been laid on."[41] Mixing the oxide colors with clay slip gave them body and produced a thick impasto similar to oil paints. As a self-proclaimed painter on canvas, Louise preferred to work with the thick impasto that produced a looser, freer style not possible in china painting. Whereas china painting was always compared to watercolor painting, underglaze slip decoration was always compared to oil painting. McLaughlin noted this as she remarked on the underglaze technique: "The finished work presents the appearance of a painting in oil to which a brilliant glaze has been applied."[42] The natural inclination of the artist, as well as the consistency of the clay slip colors, resulted in a painterly style. This was also true at Haviland, where the faience artists produced painterly, impressionistic decorations. At Haviland this underglaze style was referred to as "barbotine." The *Crockery and Glass Journal* of May 18, 1882, states that barbotine refers to "thin slip."[43] In actuality, the term was used for any slip decoration applied under the glaze in a painterly or impressionistic style, as with oil colors on canvas. Contemporary reviewers of McLaughlin's work were not always familiar with this new style and often had problems describing it. One reviewer, for example, opined, "The figures (flowers) are painted in that weird sketchy manner."[44]

In the placement of her decorations, there can be seen a marked Japanese

influence. Whether it came directly from the Japanese or via the French, who were also influenced by the Japanese, is not known. The open, asymmetrical, seemingly accidental placement of flowers, which was considered very Japanese, was also prominent in Limoges faience. Utilizing this style, McLaughlin placed flowers on vases in a careless, graceful manner, as she had earlier advised readers to do in her book on china painting.[45] A vase (pl. 13 a–b) might have three tea roses placed casually on one side and a single branch with a butterfly placed off center on the other. The shapes of the vases added to the simplicity of the decorations. They, too, were generally very simple and often made from McLaughlin's own designs.[46] The vases could be thrown or slip-molded, but at Coultry's they were usually press-molded. The pilgrim jars in particular were press-molded, and their thrown necks were added later.

What artistic goal did Louise McLaughlin ultimately have in mind for her newly developed technique? Nothing other than to paint portraits. In an 1878 interview, she held up a plaque decorated with a large face painted under the glaze, and turning to the interviewer, she said, "My idea is to paint portraits under the glaze."[47] This appealed to her because, unlike portraits on canvas or those painted on china over the glaze, portraits under the glaze were "beyond the possibility of change."[48] They could not fade, deteriorate, be altered, rubbed off, or destroyed, as long as the vessel was intact. Although records show that she did paint portraits on red and white granitewares using her Limoges technique, none have been found to date. Her faience period was brief, slightly more than seven years, and it was probably not long enough to fully develop portraiture under the glaze. She herself said, "It was my misfortune that I was not in a position to continue my experiments and to bring them to the culmination that Mrs. Storer [i.e., The Rookwood Pottery Company] was able to effect."[49] One need only look to Rookwood's sensitive portraits of Native Americans (e.g., fig. 7.3) painted ten to fifteen years later in the same underglaze technique to see how McLaughlin might have taken her faience a step beyond her French counterpart. As it was, she did not. Although the Cincinnati faience was praised as a "purely American achievement," and in technique it was, the decorative style always remained an offshoot of the French product.

Was Louise McLaughlin the first to introduce underglaze slip decoration in the United States? This question was posed many times throughout the artist's lifetime, and it was not put to rest until shortly before her death. Around the time of her discovery, written accounts took pains to note that she was the first American to develop the technique. Mrs. Perry said, "There is no doubt that in the United States we are indebted to the intelligent interest and persistence of Miss McLaughlin for

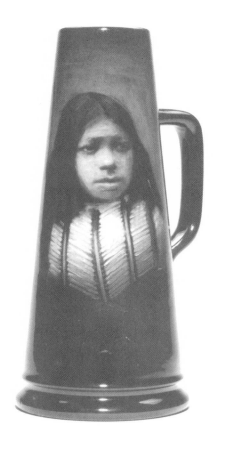

Fig. 7.3. Vase with handle, 1898, decorated by Sadie Markland for The Rookwood Pottery Company. This is an example of Rookwood's mastery of portraiture under the glaze, depicting Buffalo Hump of the Shoshone/Comanche tribe. *Courtesy of the Cincinnati Art Museum, Gift of Mary Mills Ford, 1978.288*

its accomplishment."[50] Eli Perkins, the New York correspondent who interviewed William C. Prime, was more straightforward when he remarked, "she has produced the first pottery of the kind in America."[51] This is difficult to prove because attempts to produce underglaze slip decoration were taking place elsewhere at about the same time. By 1878 John Bennett of New York was producing his brand of faience, which was patterned after Doulton's Lambeth ware. Technically, his work was not in the same category as McLaughlin's. His glazes were not as hard (i.e., fired as high) in order to retain the colors that were thin oxide washes instead of the much thicker, high-fired clay oxide slips. Since the object of the discovery was to work with unlimited colors capable of withstanding the heat of high-fired bodies and glazes, he is not considered a contender for first place. However, there are two serious contenders: Charles Volkmar of Volkmar Pottery in Greenpoint, and later, Tremont, New York; and the Robertsons of Chelsea Keramic Art Works in Chelsea, Massachusetts. Charles Volkmar was an American artist who had studied in France for

Underglaze Slip Decoration Begins 63

fourteen years and had returned to the United States in 1875.[52] Upon visiting the 1876 Centennial Exhibition in Philadelphia, he too was taken by the Limoges faience and returned to France to work for Théodore Deck, another early developer of underglaze decoration, and the Havilands. Returning to America in 1879, he built a kiln at Greenport, Long Island, and began producing faience utilizing the Haviland technique. The year 1879 places Volkmar's faience after McLaughlin's.

The Robertson family, consisting of the father, James, and his sons, Alexander, Hugh, and George, began their pottery in 1872.[53] In about 1877, they introduced a faience line called Bourg-la-Reine of Chelsea, which probably used a technique very similar to McLaughlin's. The earliest dating of this ware is uncertain, so it is difficult to determine if the Robertsons' ware preceded McLaughlin's. It was probably contemporary with hers.

Louise stated, "Mr. Volkmar may have come first and my experiments probably antedated Mr. Robertson's by a short time."[54] Actually, they were all very close in time, but ultimately, as with china painting, who did it first is not as important as who had the greatest influence. In this there is no doubt: Louise McLaughlin had the greatest influence because a pottery tradition culminating with Rookwood Pottery grew out of her faience. As far as is known, once Volkmar and the Robertsons ceased operations, their inspirations ceased also.

By November 1878, Louise McLaughlin had "painted about one hundred and thirty ornamental jugs and vases in all by her new process—that many successful ones, without counting the failures."[55] She was doing well, and 1879 promised to be a good year (pl. 14 a–b). Cincinnati faience was a highly praised and rare commodity that was soon reaching dealers in New York, Boston, and Washington, D.C. Early in 1879, it was placed on sale for the first time in Cincinnati by dealer Horace Huntington in his store "at the Race Street entrance of the Arcade."[56] Haviland faience, of course, had paved the way. The *Cincinnati Enquirer* noted on November 29, 1878, that the Limoges ware "has been the highest-priced pottery in the market—a vase eight inches in diameter and fifteen inches high often selling for from $40 to $75."[57] That this type of ware sold well was not lost on the dealers or on Louise McLaughlin. Appendix 1 displays a record made by McLaughlin of the vases she painted under the glaze in 1879.[58] As recorded, out of a total of 102 vases made, forty-six were "spoiled in firing," four were "given away," and fifty-two were considered "successful." Of the fifty-two successful pieces, twenty-four sold for a total of $370. The highest price for an individual piece was $35, the lowest price was $5, and the average price

was about $15.50. The chart does not note if the sales were by dealers, or what their percentage of the profit might have been. Whatever the case, the sales were lucrative. It was inevitable that her secret could not be kept for long; the incentive for profit was simply too great.

Early in 1879, Patrick Coultry met a young man at a wedding and engaged him in talk about pottery.[59] This resulted in a partnership to develop and produce underglaze slip decoration. The young man, Thomas Jerome Wheatley, was given use of all the facilities at Coultry's pottery for discovering the process. Until that time, only Louise McLaughlin knew the secret. Wheatley fired his first successful piece, having hit upon McLaughlin's technique, in April 1879. That he used McLaughlin's technique is not surprising. He was using the same facilities and the same staff who had helped the lady amateur. According to McLaughlin, Wheatley learned the method of decoration "from seeing my work and from the workmen."[60] Shortly thereafter, Louise's brother George saw pottery strongly resembling his sister's displayed in the window of a local dealer. Supposedly the pottery had been made in Steubenville, Ohio. George, who often visited the Coultry Pottery, immediately went to see Coultry and learned that T. J. Wheatley had made the pottery there. At first Coultry denied any knowledge of it, but later the whole Coultry/Wheatley arrangement was disclosed. Wheatley soon began to teach the underglaze slip technique at Coultry's. His initial class of students included Albert R. Valentien and Matthew A. Daly, who were to rank among the first and finest of the Rookwood decorators. There was no turning back the clock of time. By April 1879 the secret was out.

It is not known how much china-painted work Louise was producing during this period of intense activity with the underglaze technique. By her own admission, the time was "chiefly spent in experimenting on different methods of under-glaze decoration."[61] China painting, however, never lost its cachet in Cincinnati. For a few months in 1878, the eminent, English-born china painter Edward Lycett came from New York to teach his art in the Queen City.[62] It is not known if Louise McLaughlin ever attended his classes. To be sure, some of her china-painted pieces were included in the WAMA's Loan Exhibition, Paris's Exposition Universelle, and New York's Woman's Decorative Art Society Loan Collection. They were never the attraction, however, and it is difficult to determine if they were new specimens or examples that had been painted earlier. She indeed may have decorated some new examples of overglaze china, but during this period her heart was with her faience, and her best pieces of that ware were yet to come.

chapter 8

THE CINCINNATI POTTERY
CLUB BEGINS, 1879

"I never cared much for clubs," wrote Louise McLaughlin to then secretary of the American Ceramic Society, Ross C. Purdy in 1938.[1] She was reminiscing about her part in the Cincinnati Pottery Club. This club was the exception to her dictum—she not only cared for it, she was its president. Sometime in early 1879, McLaughlin "framed the idea" of a ceramic club "to promote the growth of ceramic art in Cincinnati."[2] The first written reference to the Pottery Club is found in the minutes of the board meeting of the Women's Art Museum Association for February 27, 1879.[3] The club was asked to join the WAMA in its establishment of a decorative arts store for the creation and sale of artistic work. Louise replied that the plans for the Pottery Club were indefinite at that time, but that she would be glad to cooperate with the association. By February 1879 it was known that McLaughlin was going to start a pottery club. While Louise framed the idea, she herself admitted that she "never had the facility of organizing"; so it was left to Clara Chipman Newton, "a born organizer," to put the idea into practice.[4] McLaughlin prepared and mailed the invitations to join the club.

The respondents arrived at Alice Holabird's house on Fourth Street (just around the corner from McLaughlin's) on April 1, 1879. Not only was it the first meeting

Fig. 8.1. M. Louise McLaughlin, late 1870s–early 1880s. *Courtesy of Tom White*

of the Cincinnati Pottery Club, it was also the first meeting of a women's ceramic club in the United States. Louise McLaughlin "was asked to be president," Clara Chipman Newton accepted the position of secretary, and Alice Holabird became the treasurer. These three compatible officers kept their positions throughout the eleven-year history of the club. The minutes of the first meeting record: "The purpose of the Club shall be the development of the art interests of Cincinnati in the direction of under glaze work in pottery, carving in clay, and in such other directions as may suggest themselves as practicable."[5] Other than the three officers, the names of the original members of the Cincinnati Pottery Club are questionable since those given by Secretary Clara Chipman Newton do not coincide in every instance with those given by President M. Louise McLaughlin.[6] The names that they both agree upon are: Mrs. George Dominick, Mrs. Frank R. Ellis, Miss Clara B. Fletcher, Miss

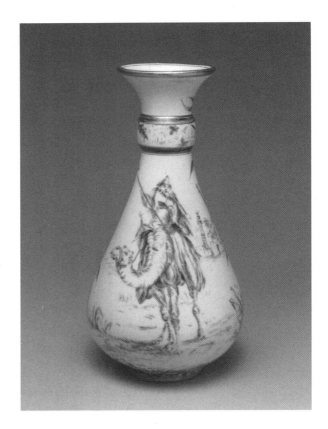

Fig. 8.2. Vase, 1879, decorated in cobalt blue underglaze with overglaze gilt accents by Jane Porter Hart Dodd. *Courtesy of the Cincinnati Art Museum, Gift of the Women's Art Museum Association, 1885.86*

Laura A. Fry, Mrs. E. G. Leonard, Miss Agnes Pitman, and Mrs. Cordelia A. Plimpton. To these Clara added Mrs. William (Jane Porter Hart) Dodd, and Mrs. A. B. Merriam. Louise did not include these two, but added Miss Frances ("Fannie") S. Banks, Mrs. James R. (Florence Carlisle) Murdoch, Mrs. Charles A. (Gertrude) Kebler, Mrs. (Helen W. Peachey) Corwine, and Miss Mary Spencer. All were members at some time or another with the exception of Jane Porter Hart Dodd, the lady who accompanied Mrs. Perry to Louise's house with Perry's ill-fated request to teach the underglaze technique to women. Mrs. Dodd has been included in many publications on the subject of the Pottery Club because of Clara Chipman Newton's records. According to Louise, however, "Mrs. Dodd was not a member but we were always good friends and I don't know how it happened that Mrs. Dodd did not join as she worked with Mrs. Nichols."[7] It is perhaps true that Mrs. Dodd was not a member of the club since it is certain that she worked with Mrs. Maria Longworth Nichols, not the Pottery Club, when both the club and Mrs. Nichols were working at the Dallas Pottery.

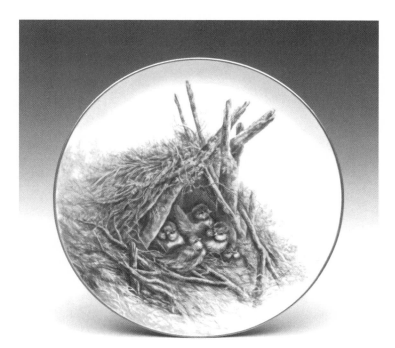

Fig. 8.3. Plaque, 1881–82, decorated over the glaze with china paints by Jane Porter Hart Dodd. *Courtesy of the Cincinnati Art Museum, Gift of the Woman's Art Museum Association, 1881.15*

The one name missing from both lists of eminent lady amateurs is, of course, Mrs. Maria Longworth Nichols. When Louise McLaughlin sent invitations to the first meeting of the Cincinnati Pottery Club, Maria Longworth Nichols was among those invited. The criteria used for selection were a marked interest and a proven ability in ceramics. The fact that the member had to be of their social group went without saying. Mrs. Nichols met the criteria admirably. She had long before demonstrated her skill as a china painter. Furthermore, the social standing and political power of the Longworth family would have enhanced the cachet of the club. McLaughlin did not know Nichols well, noting, "We were merely acquaintances."[8] But she did recognize Nichols's standing in the community and she certainly understood her abilities in ceramics. Nichols had posed the one real challenge to McLaughlin's obvious china painting skills as far back as the Centennial Tea Party. That is not to say that McLaughlin was intimidated by Nichols. At this point, Louise was the recognized leader in Cincinnati ceramics, not Maria. When Nichols did not respond to the invitation, McLaughlin simply "supposed she did not care to join." Later,

Clara Chipman Newton, who was also a good friend of Nichols, informed Louise that Mrs. Nichols had not received the invitation and chose to view it as a personal slight. Another invitation was issued, but Nichols refused the offer in a conscious decision not to mend the rift. The invitation remained open, and "*one vacancy* was carried on the membership roster for 11 years."[9]

Much has been made of the lost invitation, as if history would have been changed had the offer to join the club been successfully delivered. A closer look at the facts does not support this view. The two pampered ladies had found themselves in competition with each other long before this event. Nichols was the first to china paint, only to watch the upstart McLaughlin steal the show at the Centennial Tea Party by commanding the greatest amount of money at the auction of the painted china. McLaughlin then proceeded to write a best-selling book on the subject. And, at the time of the invitation, she was Cincinnati's darling for her discovery of under-glaze slip decoration. None of this could have been well received by Mrs. Nichols. We know that she did not take second place to anyone. Either she was in the spot-light, or she was not on stage. With this in mind, let us suppose that an invitation asking her to join Louise McLaughlin's Pottery Club had actually arrived. It is doubtful that Maria would have agreed to be a member, and therefore a *follower* of the president of the club, who was overshadowing her in one of her favorite pursuits. Had the invitation arrived safely, Nichols most probably would have initially ignored it. What logical reason could she have given for refusing to join without slighting her Pottery Club friends, especially Clara, with the implication that the club was not worth joining, or worse still, revealing a jealousy? It is likely that she put off respond-ing because "[i]t was perhaps characteristic of Mrs. Nichols that she should avoid unpleasant explanations."[10] This characteristic will become more evident when Clara's dismissal from Rookwood and Rookwood's denial of McLaughlin's influence are discussed in later chapters. Maria could not delay the answer to the invitation for long, however. Her very good friend Clara Chipman Newton would inevitably have inquired about the lack of response. It is conceivable that Maria simply would have denied receiving the offer, thus relieving her of the spoiler position and placing the onus on Louise McLaughlin. The fact that Nichols chose to maintain her hurt attitude speaks to the issue. Whether the invitation was delivered or not, Maria Longworth Nichols would probably have reacted in exactly the same manner.

In *The Book of Rookwood Pottery*, Herbert Peck states that the Cincinnati Pottery Club met three days a week at the Coultry Pottery.[11] He perhaps took this informa-tion in part from an article by Mary Gay Humphreys in an 1882 edition of the *Art*

Amateur. Humphreys states, "The first works [of the Pottery Club] were made and fired at the Coultry Pottery."[12] However, there is nothing in the records to support this claim. Clara specifically states, "Decorative Art rooms had about this time begun to take shape in other cities, our leading women [i.e. the Women's Art Museum Association] opened one here in a two story building which stood upon the present site of the Methodist Book concern [at 184 West Fourth Street]. The rooms were in the second floor, the sales-rooms in front. The Pottery Club rented the back room, and started its career."[13] Confirming Clara's statement, *King's Pocket-Book of Cincinnati* for 1880 records that the Cincinnati Pottery Club met Tuesdays and Thursdays at the Women's Art Museum Association rooms at 184 West Fourth Street.[14] The Pottery Club's objects were definitely not made at Coultry's. Clara further explained, "All our wares had to be transported from the Hamilton Road or Dallas Pottery."[15] (The Hamilton Road Pottery was another name for the Frederick Dallas Pottery.) Regarding her early Pottery Club work, Louise explicitly noted the Dallas Pottery, stating, "All my work was produced there."[16] Also, recall that in April 1879 the Pottery Club had its first meeting at Alice Holabird's, and T. J. Wheatley fired his first example of Cincinnati faience at the Coultry Pottery. Once Louise discovered that Coultry and Wheatley were conniving to capitalize on her secret of the underglaze slip technique, she left Coultry's. Coultry never fired anything for the Pottery Club.

The ladies continued renting "the back room" and divided the cost evenly among themselves. By late July, WAMA considered relocating its decorative art store to the exposition wing of the new Music Hall. The move took place sometime in late October or early November. The Pottery Club respectfully declined the offer to move, perhaps because Music Hall was not as convenient as the previous downtown location on West Fourth Street.[17] Instead, because transporting objects had been such a problem, the group began renting a room at the Frederick Dallas Pottery on November 5, 1879.[18] The room was on the second floor over the sheds where the pottery was stacked. Access was through the pottery shed, where the kilns stood. The room, measuring approximately fifteen by twenty-four feet, was simple but functional. The brick walls were whitewashed, and the room offered a total of seven windows on the east, south, and west sides for excellent lighting. Under the windows, a two-foot wide running worktable wrapped its way around three sides of the room. A few chairs, modeling stools, a stove, a hanging clock, and a washstand comprised the fittings and furniture. "Here," said Clara, "we had a royally good time."[19]

Already working at the Dallas Pottery when the Pottery Club arrived was Maria

Longworth Nichols. She had visited there in May 1879 with her good friend William Watts Taylor.[20] It was the first time she had been inside a pottery, although she was not wholly unfamiliar with such works. Her husband, George Ward Nichols, had written a book entitled *Pottery: How It Is Made* (1878) that, based largely on what he had seen at Edward Lycett's Green Street Pottery Works in New York, detailed the operations of firing, filling, and drawing the kilns. Maria had contributed some of her own sketches of "Japanese designs, figures and motifs" to the book.[21] Dallas agreed to have pieces made and fired for Mrs. Nichols and to rent her a room for use as a studio. The room was in a little brown cottage on the Dallas Pottery grounds where the famous Mrs. Frances Trollope, "amidst much to jar her feelings and shock her taste, sang the al fresco joys of the American forest and abused everything else."[22] Mrs. Trollope had lived in the little brown cottage before she wrote her scathing remarks about Cincinnati in *Domestic Manners of the Americans* (1832).[23] Joining Mrs. Nichols in this room was Mrs. William (Jane Porter Hart) Dodd. The two had been working there for five months, when the Pottery Club arrived in the fall. It is probably not coincidental that Maria rented this room in May, shortly after she chose not to join the Pottery Club.

The first work of the Pottery Club was exhibited at Cincinnati's Seventh Industrial Exposition from September 10 to October 11, 1879. During the exposition, local newspapers hailed the pottery industry for its cooperation with the School of Design, the Women's Art Museum Association, and the Pottery Club: "It is a good feature when our manufacturers not only avail themselves of home talent in decorating their wares, but also invent and improve upon their own wares for the purpose of cooperating. . . . The experiments in clays and firing that have gone on simultaneously with the experiments in colors promise the production before long of every kind of fine pottery here."[24] Members of the Cincinnati Pottery Club displayed various types of wares, including some with new concepts in decoration. Mrs. Plimpton displayed an inlay technique (pl. 15 a–b) whereby the decoration was created not with paint, but with inlaid clays of different colors. Her jardinière of light yellow clay offered a design of a butterfly hovering over reeds and grasses, all in various inlaid clays of browns, yellows, and white. It was thought that with this technique, Mrs. Plimpton "made an important advance in the ceramic art and industry of the country."[25] Plimpton also displayed vases decorated under the glaze with high relief figures. This, too, was considered novel, although she was not the only one using this technique.

Louise McLaughlin displayed twenty-five pieces of her Cincinnati faience at this

exposition. Two were plaques that she decorated with her favorite subject, painted portraits. According to the *Art Amateur*, one plaque "presented a fine likeness of George W. Jones of Cincinnati taken in court dress; another showed an ideal head. These were as life-like as if painted on canvas, though they are simply enamelled oil-painting on faience."[26] The remaining twenty-three pieces were vases of various shapes depicting floral decorations such as roses, verbena, and day lilies, "so fresh, so fair, that you almost feel that the dew is on them still."[27]

Although McLaughlin's objects continued to bring such accolades as "exquisite beauty," and "marvelously beautiful," at least one newspaper critic thought that Louise had been surpassed. Correctly recognizing that McLaughlin had discovered underglaze slip decoration, the journalist noted: "Since then a number of amateurs in this city have achieved the same results, and in one instance a greater perfection than Miss McLaughlin attained."[28] The writer then discussed "a large variety of exquisite work shown from Mrs. George Ward Nichols." In a catalog published in September 1879 by the Women's Art Union Association of Cincinnati, Maria's work was once again referred to as "exquisite."[29] The writer of this catalog dedicated seven and one-half lines of type to Nichols's work and one-half line to McLaughlin's. Maria was back in the competition, not with overglaze work, but with underglaze work to rival Louise's. Like Plimpton's, her work was decorated in high relief. There were six large vases (e.g., pl. 16), two of which were between twenty-five and thirty inches high, with various Oriental decorations: "a great dragon, for instance, with his huge tail almost encircling the jar; the sacred martin of the Japanese; a staring griffin; flights of tropical birds; a great stork, and star-eyed flowers trembling among reed grasses."[30] High relief decoration in underglaze work seemed to be the hit of the ceramic display, and Nichols displayed the best to be seen. It is curious that one newspaper and the *Art Amateur* were quick to point out that Louise McLaughlin was currently working on a decoration of flowers in high relief to be modeled under the glaze, and that it would "contribute materially to the beauty and variety of her work."[31] The rivalry between Nichols and McLaughlin was heating up once again, or perhaps it was simply continuing.

Soon both the Pottery Club and Mrs. Nichols realized that firing their objects at the Dallas Pottery was awkward. Previously, Mrs. Nichols had sent pieces to be fired at Edward Lycett's Green Street Pottery Works in New York City, and Louise McLaughlin had sent work to be fired at Thomas C. Smith and Sons Pottery in Greenpoint, Long Island. Numerous accounts say that they continued this practice

while at the Dallas Pottery from April or May until late November 1879. There is no primary source confirming that McLaughlin had done this. As noted before, McLaughlin specifically stated that all her work was fired at the Dallas Pottery. As for Mrs. Nichols, it is more difficult to determine. It is doubtful that she shipped any underglaze work to Lycett's since that was not his specialty, but she may have shipped her overglaze work to him. At least from April or May until the end of November 1879, McLaughlin's and Nichols's underglaze work had "to take its chances" in the fire along with the white granite commercial ware of the Hamilton Road Pottery. Frederick Dallas's commercial ware, or "iron-ware," was fired at such an intense heat so that plates, cups, and saucers, etc., used in such places as hotels were extremely solid and durable. They were so hard that they were virtually unbreakable, and the staff joked that "they were useful in an emergency as weapons of offense or defense."[32] While the intense heat was beneficial to the graniteware, it was harmful to the delicate colors used by the ladies. Moreover, their objects were fired at the convenience of the pottery, which meant they had to wait for a firing of the commercial ware; if there was room left in the kiln, their pieces could be included. The solution to the problem was simple, but expensive. Two kilns were built for the use of Mrs. Nichols and the Pottery Club. One, an overglaze kiln paid for by Maria, was the largest of its kind in the country. The other, an underglaze kiln paid for by Louise, was especially suited to her underglaze needs. The club, Nichols, and Dodd, as well as other lady decorators, all used the two kilns interchangeably. It was perhaps Mrs. Nichols who first decided to commission a private kiln because she was interested in overglaze work that was impossible to fire in the intense heat of the Dallas kilns. She is quoted as saying, "We must have the kiln, Mr. Dallas, build me one."[33] Her overglaze kiln was ready for its test fire on November 27, 1879. At the same time, the finishing touches were being put on McLaughlin's underglaze kiln.

Earlier in August 1879, Louise McLaughlin had conceived the idea of making the largest underglaze slip decorated vase in America. It was her intention to display it at Cincinnati's Seventh Industrial Exposition in September. That such an idea would occur to her is not surprising. In international fairs, large pieces were viewed as the ultimate marriage between art and industry. Size had become a metaphor for progress. For example, an article about the 1876 Centennial Exhibition in the *American Architect and Building News* pointed out that the largest vase displayed at the exposition was five and one-half feet in height.[34] The article went on to boast: "The proportions of this great vase are, however, vastly exceeded by the Solomon vase, since

produced by Doulton & Watts, of which more is likely to be heard in the world of art." Bigger was better. And what could be better than to produce the biggest example of faience, the highest-priced type of art pottery in the United States?

There was another reason that could have inspired Louise to build the biggest vase. In Cincinnati's 1879 Industrial Exposition, which ran from September 10 to October 11, Maria Longworth Nichols exhibited two underglaze slip decorated vases that were between twenty-five and thirty inches in height. Louise had a vase of similar proportions in the exposition, but it was not bigger.[35] Nichols had no doubt been working on her vases in her room at the Dallas Pottery during the previous summer. Almost certainly Louise would have heard about them from mutual friends working at the pottery. If this were the case, perhaps in August Louise realized that two of Nichols's vases were as big as, if not bigger than, the one she was entering in the show. It would not have been surprising for Louise, feeling the heat of competition, to rush to build the biggest vase for the exposition that would open September 10.

With the help of Joseph Bailey Sr., molds were produced and casting began. Louise soon realized that such an undertaking could not be achieved in the few short weeks before the exposition. In the wet state, her largest of all vases measured forty-four inches in height and nineteen inches in diameter.[36] Tall vases are always difficult to fire, but the real challenge arises with the increase in diameter. The chances of a firing problem, such as slumping, increase geometrically for every fraction of an inch increase in diameter. A nineteen-inch-wide vase would not likely succeed. Once the first example was decorated in the wet state, it took at least two to three weeks to dry properly before it could be fired for the first time.[37] This length of time was necessary for the vase to dry evenly and completely, so that it would not crack in the firing. In addition, the handling of such a large vase in all its stages from slip casting, to decorating, to firing, to dipping in the glaze, to firing a final time, demanded the greatest skill and care. On November 27, one journalist visiting the Dallas Pottery noted:

> Miss McLaughlin will this week begin a vase larger than any yet made in the country, which she will decorate by her peculiar process. This fabulous jar,
>
> > *Huge as were those wherein the maid*
> > *Margiana found the Forty Thieves,*
> > *Concealed in midnight ambuscade,*
>
> will illustrate the best work of this artist, and all her hopes and all her fears are fixed upon the successful firing of it.[38]

This was certainly not McLaughlin's first attempt to make the large vase, but it was the first attempt using her commissioned kiln. Most likely, the failure of previous attempts contributed to her decision to commission her own underglaze kiln. The journalist's reference to the Forty Thieves was inspired by the name given the vase by Clara Chipman Newton:

> I remember going one day to the [Pottery Club] rooms [at Dallas's], and as I opened the door, I saw Miss McLaughlin standing on a table, applying clay with a hugh [sic] brush, to the largest vase I had ever seen. I was still young enough to have an intimate touch with The Arabian Nights, so exclaimed, "Why, Louise, that's an Ali Baba Vase." Ali Baba it became, and today is still Ali Baba to the initiated.[39]

It was not until early February 1880, six months after the idea was conceived, that success came with the fifth vase (pl. 17) in the series.[40] After its final firing, the white clay form was thirty-seven inches high and sixteen and one-half inches wide. Its capacity was twenty-two gallons, double the capacity of any piece of glazed work then manufactured in the United States. Incised on the bottom was Louise's typical signature, "L. McL./Cinti 1880." For the decoration, McLaughlin applied a ground color of sage green, blending to a cloud-like greenish-white. Upon this, she painted Chinese hibiscus flowers in dark red and yellow with green stems and leaves. The colors were "intended to harmonize with the prevailing tones in Eastlake paper-hangings."[41] The Englishman Charles Locke Eastlake was very popular in America at the time for his 1872 version of *Hints on Household Taste,* which described how a correct household interior should look. The oviform shape of the vase, as well as the casual, almost accidental placement of the hibiscus flowers, were Japanese in-spiration. Upon its successful completion, the Ali Baba was displayed for a few days in the window of Isbell & Co. on Fourth Street. It was said to be "without question the finest piece of pottery with the finest decoration ever made in the country."[42] According to one newspaper source, there were three successful Ali Baba vases in all.[43] The first one, as just described, is in the collection of the Cincinnati Art Museum. A second one, which can be seen in a photograph of the Pottery Club's first reception, is described as having a ground color "of exquisite blue, with a design of lilies of the Nile, with leaves of natural size."[44] A third Ali Baba vase can be seen in a vintage photograph (fig. 8.4) of the parlor in McLaughlin's house in Mt. Auburn, a suburb of Cincinnati. When the Pottery Club moved to the Rookwood

Fig. 8.4. The parlor of M. Louise McLaughlin's home displaying the third version of the "Ali Baba" vase. *Courtesy of the Cincinnati Art Museum, Theodore A. Langstroth Collection, Mary R. Schiff Library*

Pottery, McLaughlin took the Ali Baba mold with her. When the Pottery Club was evicted from Rookwood, she requested that this and other molds belonging to her be taken to her Mt. Auburn home. Some of the molds were never returned, and "[t]he large mold of the Ali Baba was lost as only half of it is buried in the garden of my house on Mt. Auburn."[45] As far as anyone knows, it remains in its grave today.

"A WILD CERAMIC ORGY,"

1880

"If Socrates were living in Cincinnati, it would make a great difference to him from what sort of ware he drank his hemlock," wrote Calista (Alice) Halsey, a former Pitman student who was teaching woodcarving in St. Louis, Missouri.[1] Miss Halsey made her point well: Cincinnati had become a very sophisticated ceramic city. The *Art Amateur* agreed when it reported in February 1880, "The serious business of life in Cincinnati is ceramic art."[2] Everyone in the Queen City, it seemed, was immersed in ceramics. By 1880 Louise McLaughlin had published a book on china painting and was about to publish another on her underglaze slip technique. She was a national figure in ceramic art, and her Pottery Club was well underway. George Ward Nichols had published his book on pottery and how it is made, and the School of Design was training female students who listened to society's call to decorate ceramics. T. J. Wheatley was teaching underglaze slip decoration at Patrick Coultry's until April 1880, when he opened his own works. And Frederick Dallas's Hamilton Road Pottery was bulging with lady amateurs. Commenting on this era in the *Art Amateur*, Mary Gay Humphreys noted, "a whirlwind of petticoats had invaded the potteries. . . . Every woman who could find a corner in a pottery installed herself there."[3] Frederick Dallas alone was firing the work of more than two hundred amateurs, all

but two of whom were women.[4] By late 1879 even the men had formed their own organization, the Cincinnati Ceramic Decorators Club, to perfect the decoration of pottery.[5]

With so many people involved in ceramics, it is not surprising that there was a wide range of talent. Those with outstanding skills such as McLaughlin, Nichols, Plimpton, and Newton were far outnumbered by the hundreds whose faceless names and initials we find on works today. Both china painters and those working in the faience technique produced their fair share of less-than-quality pieces. One writer, weary of it all, wondered why so many china painters were "covering up our dinner and tea service with bad pictures of impossible landscape, with meaningless repetitions of stenciled figures on diapered patterns in crude pigments to weary the eye with their fatiguing sameness."[6] Another thought that too many people without backgrounds in art were producing china painting: "Must we not before long have sumptuary laws—at least a law that citizens and citizenesses shall not make and bake vases and jars and plaques till they can at least draw?"[7] The underglaze decorators were also making some "fearful" things. Decorations modeled in high relief on the surface of vessels were prevalent in Cincinnati. Such decorations, no doubt influenced by Haviland, approached the absurd when made by less-than-masterful hands. Vases, while still wet, were rolled over conglomerations of dry clay fragments until their surfaces were pocked with pebbled chunks. They might also display three-dimensional birds, branches, and nests (with eggs), or even realistically colored bunches of fruit hanging off the sides. Louise McLaughlin herself commented, "For a time it was a wild ceramic orgy during which much perfectly good clay was spoiled and numerous freaks created."[8]

Fortunately, no movement is ever judged by its worst pieces, but rather by its best. In the Queen City there were many excellent examples to instill pride in Cincinnati ceramics. Mrs. Perry pointed out in *Harper's Weekly:* "It is a characteristic of the Cincinnati art pottery that it is not amateurish."[9] That McLaughlin and Nichols, two of the founders of American art pottery, were working in the city gives credence to Perry's statement. Sometimes, however, the quality of the work was recognized in a backhanded way. Lilian Whiting, writing for the *Art Amateur*, noted, "Cincinnati pottery is becoming largely a collection of costly bric-a-brac, charming to possess, interesting to study, but only salable to wealthy people."[10]

No matter how the quality was viewed, by 1890 ceramics had become the rage in Cincinnati. Men were engaged in such activities as teaching, writing books and

articles, founding and managing potteries, and forming a club to promote quality ceramics. Women were mostly students of the subject, but they also wrote books and articles, taught, formed clubs, and, as stated earlier, one woman even founded a pottery. It is important to emphasize that it was the women, not the men, who started the movement. However, one major reason that it became so successful was that it benefited the men as well. Ceramics offered women an admirable pastime and employment potential, but it was the men who reaped the financial rewards of a growth industry. Cincinnati had become so famous for its ceramics that decorative work was being sent from New York, Iowa, Kentucky, Michigan, Minnesota, and Indiana to be fired there.[11] Both men and women had something to gain, as did the city itself, which benefited from the industry's profits. All this had become obvious by 1880, probably the most important year in the history of Cincinnati ceramics. That year set the stage for at least the next two decades of the industry in the city. In 1880 the Cincinnati Pottery Club reached new heights of success, local potteries began vying for superiority, Louise McLaughlin published her book on underglaze decoration, and Maria Longworth Nichols founded The Rookwood Pottery Company.

The Cincinnati Pottery Club was exceedingly well received by Cincinnatians. Women throughout the city wanted to join the club. In fact, their visits to the Dallas Pottery were so numerous that they began to interfere with production. In order to correct the problem without discouraging popular support, on January 17, 1880, the Pottery Club placed the following notice in the *Cincinnati Gazette* announcing itself, offering a complete list of its *limited* membership, and outlining a solution to the counterproductive visits:

The Cincinnati Pottery Club

The club meets at the pottery of Mr. Fred. Dallas, on Hamilton road. [*sic*] Its membership is limited to twelve active and three honorary members. The following named ladies belong to the club, its list being full: Miss M. Louise McLaughlin, President; Miss Clara C. Newton, Secretary; Miss Alice Holabird, Treasurer; Mrs. Geo. Dominick, Mrs. Chas. Kebler, Mrs. Frank R. Ellis, Mrs. E. G. Leonard, Mrs. Walter Field, Mrs. A. B. Merriam, Miss Clara Fletcher, Miss Agnes Pitman, Mrs. M. V. Keenan. Honorary members: Miss Laura Fry, Miss Caroline Lord, Miss Elizabeth Nourse.

A reception to which cards of admission will be issued, is to be held once in three months at the pottery. The first is expected to take place about the middle of March. No visitors are admitted at other times except in the case of strangers

visiting the city who can obtain a written order for admission from some member of the club.[12]

A reception held every three months would discourage random visits, display the club's progress, and appease public curiosity. Since the pottery could only accommodate a limited number, invitations to the receptions would be restricted to the upper echelons of Cincinnati society who were wealthy and could afford the product. In the end, the receptions were held once a year instead of once every three months.

The first reception was held on Wednesday, May 5, 1880, from 10:00 A.M. to 4:00 P.M. at Frederick Dallas's Hamilton Road Pottery.[13] That it was held during the week was insignificant. The wealthy were not subject to restrictive daily work schedules and could attend on any day. The reception was not held at night for practical reasons. Photographs show that there were no lighting devices such as gas jets to illuminate the room. Electric lighting, still in its earliest stages of development in the United States, was not yet a standard feature. The daytime sun provided ideal lighting without the dimness or hazards of fire by candlelight. Invitations were "strictly limited to five hundred," and issued about ten days before the event (fig. 9.1).[14] They were decorated with an etching by Miss McLaughlin and were highly sought after, probably more for social than aesthetic reasons.

Fig. 9.1. Invitation to the Cincinnati Pottery Club Reception, 1880, etching by M. Louise McLaughlin, 1880. *Courtesy of the Cincinnati Art Museum, Gift of Theodore A. Langstroth, 1986.87*

Luckily, the weather on May 5 was ideal. The "Sacred Twelve," as the ladies of the club called themselves, served as hostesses while Joseph Bailey Jr., the manager's son, received the cards at the door. To get to the club's studio "to view the results of the first year's work," attendees had to pass through "labyrinthine passages of the dusty old pottery," including the building that housed the kilns.[15] To interest and entertain the visitors, the kilns were set in all their various stages of production. Some were being filled with pottery, some were being fired, and some were being drawn. After viewing the interesting metamorphosis of the clay, the guests reached a stairway on the far wall. Climbing the steep, narrow wooden stairs, the art lovers and the very fashionable of the city entered the club's studio, the exhibition room (figs. 9.2, 9.3, 9.4, and 9.5). The whitewashed brick walls had been decorated with Persian rugs. The seven windows (three on the back wall, two on each of the side walls) were "thrown widely open to the wandering breezes and the fair May sunshine," and great masses of palms, fragrant white lilies, dogwood, and crab apple blossoms dotted the room and sweetened the air.[16] Ceramic plaques were hung on the walls, and the rest of the display was arranged on the two-foot wide worktable that wrapped its way around three sides of the room: "On this were placed vases of all kinds, tea-sets and choco-late sets, salad dishes, pitchers, toilet jars, plates, cups and saucers, an oat-meal or bul-lion bowl, croquet, luncheon sets, and ornamental articles."[17]

Louise McLaughlin exhibited thirty-six objects at the first reception. From photographs taken of the entire installation and from an engraving of a select group of objects that appeared in *Harper's Weekly,* it seems as though nearly all her work was in her underglaze technique.[18] One portrait plaque might have been painted over the glaze. Although some of her objects in the exhibition incorporated low relief decoration, they did not display the high relief decoration that her rival, Maria Longworth Nichols, was engaged in at the time. Although it had been reported the previous fall during the Cincinnati Industrial Exposition that McLaughlin was working on a decoration of flowers in high relief, none appeared in the reception exhibition. Among her objects in the display were a pilgrim vase decorated on one side with a winter landscape that was "as perfect a snow scene as one would wish to see"; a pair of pilgrim vases with sprays of pink apple blossoms on softly shaded blue grounds; a jar in "dead-leaf brown" with low relief decorations of bamboo highlighted in gold; a portrait plaque (seen in fig. 9.3) displaying the image of per-haps Cora McLaughlin, her brother James's daughter; a "balloon vase in blue"; and a plaque with a rustic landscape.[19] Her pièce de résistance was the Ali Baba vase. The first one that had been made successfully, with the sage green ground and Chinese

Fig. 9.2. A view of the display at the Cincinnati Pottery Club's first reception held at the Frederick Dallas Pottery on Wednesday, May 5, 1880, from 10:00 A.M. until 4:00 P.M. (left side of south wall). *Courtesy of the Cincinnati Historical Society Library*

Fig. 9.3. A view of the display at the Cincinnati Pottery Club's first reception held at the Frederick Dallas Pottery on Wednesday, May 5, 1880, from 10:00 A.M. until 4:00 P.M. On the far right is the first version of the "Ali Baba" vase (right side of south wall). *Courtesy of the Cincinnati Historical Society Library*

Fig. 9.4. A view of the display at the Cincinnati Pottery Club's first reception held at the Frederick Dallas Pottery on Wednesday, May 5, 1880, from 10:00 A.M. until 4:00 P.M. (west wall). *Courtesy of the Cincinnati Historical Society Library*

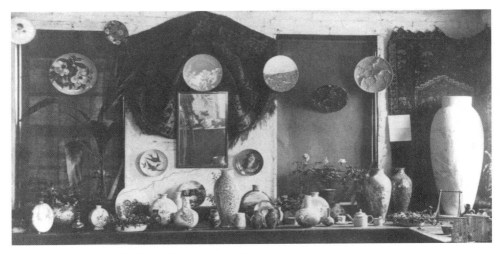

Fig. 9.5. A view of the display at the Cincinnati Pottery Club's first reception held at the Frederick Dallas Pottery on Wednesday, May 5, 1880, from 10:00 A.M. until 4:00 P.M. On the right is the biscuit fired, second version of the "Ali Baba" vase. It has been decorated and biscuit fired awaiting glazing and the final or glaze firing (east wall). *Courtesy of the Cincinnati Historical Society Library*

hibiscus flowers, was set on the worktable in the southwest corner of the room (seen in fig. 9.3). A second Ali Baba vase (seen in fig. 9.5), with life-sized lilies of the Nile on a blue ground, was placed in the southeast corner of the room as a counterbalance. From a newspaper article and a photograph of the exhibit, we know that the latter vase had only been biscuit fired; it still needed to be glazed and fired a final time.[20]

The rest of the ladies in the Pottery Club displayed a wide range of ceramic decorations, many taken from books and journals of the time. Mrs. E. G. Leonard exhibited an overglaze plaque showing three horses' heads drinking from a trough (seen in fig. 9.2). For this design she was inspired by an oil painting by J. F. Herring illustrated in *Pictures at South Kensington,* a book in George McLaughlin's library.[21] On another one of her overglaze plaques called "The Gleaner," she painted an ideal-ized portrait of a woman bearing a sheaf (seen in fig. 9.2). The woman is decidedly Pre-Raphaelite in appearance and was probably inspired by a leading Pre-Raphaelite painter. Today Mrs. Leonard receives little recognition for being one of the finest china decorators in the country (figs. 9.6 and 9.7).

Alice Holabird displayed underglaze decorations that were created using the Bennett or Lambeth technique. Her floral decorations were painted on the biscuit ware in thin oxide washes and then outlined in black. Mrs. Frank Rhodes (Mary) Ellis displayed underglaze as well as overglaze work; the latter was "after the old Meissen."[22] Mrs. George Dominick worked in relief (fig. 9.8) similar to that being done by Maria Longworth Nichols, who was working in another building on the grounds. Mrs. Dominick displayed a vase with fishes tangled in a net that seemed to have been modeled in clay and thrown over them. In this technique, an actual net is coated with slip and placed over the relief of fishes. In the firing the net burns away, leaving the slip in the shape of the net. Mrs. Walter Field showed vases of white clay decorated with high and low relief petals of the snowball flower. Clara Chip-man Newton exhibited a wide range of techniques in her pieces, including some in the Bennett style, some in low relief decoration, and some with underglaze slip decoration. Miss Elizabeth ("Lizzie") Nourse showed a plaque with three owls "full of spirit" sitting on a bank, and Miss Laura Fry painted a plaque with a flight of swallows (seen in fig. 9.5). Fry worked well in any technique, including sgraffito (fig. 9.9). Miss Agnes Pitman showed two "Japanese tea sets" along with a plaque mod-eled with bats caught in a net or web (seen in fig. 9.5), and Mrs. M. V. Keenan orna-mented a vase with a five-leafed ivy under the glaze. Mrs. Charles Kebler exhibited a large vase (seen in fig. 9.4) with horses and a chariot decorated over the glaze, and

Fig. 9.6. Plaque, 1882, decorated over the glaze with china paints by Mrs. E. G. Leonard. *Courtesy of the Cincinnati Art Museum, Gift of the Women's Art Museum Association, 1881.60*

Fig. 9.7. Jardinière, 1882, decorated under the glaze by Mrs. E. G. Leonard. *Courtesy of the Cincinnati Art Museum, Gift of the Women's Art Museum Association, 1881.63*

Mrs. A. B. Merriam painted a vase with herons. Merriam was an excellent china painter (fig. 9.10). Miss Florence Carlisle (later Mrs. James R. Murdock), having just entered the club, did not have any work to display, while Miss Clara Belle Fletcher did not exhibit any work because at the time she was preoccupied with her studies in sculpture. Caroline Lord, an honorary member, also did not exhibit but the reason is unknown.

This is but a sampling of the approximately 175 pieces of work that the Cincinnati Pottery Club exhibited at its first reception. Many of the same pieces had also been exhibited at the 1879 Cincinnati Industrial Exposition. In general, each lady pursued her own specialty, offering a wide variety of techniques and decorations. The *Cincinnati Commercial* noted, "New designs in decoration have multiplied themselves; new methods of treatment have been evolved; new degrees of color, originality of form, and the ability to treat old material in new ways, are among the things found out by the persevering Pottery Club."[23]

Society turned out in droves for the first reception. The Hamilton Road Pottery had never seen such a sight. Clara Chipman Newton recorded that during the event "old Mr. Dallas," full of triumph and excitement, dashed into the room in which a small group of the Sacred Twelve were standing to say that carriages were parked up and down both sides of the street and far around the corner. According to Newton, for Mr. Dallas this was "the outer and visible expression of the inward and spiritual grace he had previously doubted the members of the club possessing. Perhaps he had his reasons for the doubt. There are times where women's patience may bend to the breaking point over ruined treasures of ones [sic] hand and brain, and there were many such ruins."[24] The Pottery Club reception was a new experience in marketing for Frederick Dallas. In a room under the club's studio, he had set out a "brave array" of his pottery's wares. The success of the reception could only add to his reputation and sales, for those that came to see the spectacle were the richest and most powerful of the city. Among them were: General Alfred Traber Goshorn, director general of the 1876 Philadelphia Centennial Exhibition and future first director of the Cincinnati Art Museum; Maria Longworth Nichols and her husband, Colonel George Ward Nichols; Mrs. Elizabeth Perry and her husband, Judge Aaron F. Perry, who brought a guest, Miss Waite, a daughter of the Chief Justice; Professor Benn Pitman; and Mr. Henry Fry. Even Mrs. Frederick Dallas came to see what was happening at her husband's pottery. After the departure of most of the guests, the Dallas employees, numbering between eighty and one hundred, went to the studio to look at what they had seen pass through all its various stages.

Fig. 9.8. Vase, 1879, decorated in relief with applied flowers by Mrs. George Dominick. *Courtesy of the Cincinnati Art Museum, Gift of Mrs. George Dominick through the Women's Art Museum Association, 1881.40*

Fig. 9.9. Pitcher, 1881, decorated with ducks in an aquatic land-scape in the sgraffito technique by Laura Ann Fry. With the sgraffito technique, two layers of differently colored slips are applied to the vessel and the decoration is obtained by scratching through the top layer to reveal the layer underneath. *Courtesy of the Cincinnati Art Museum, Gift of the Women's Art Museum Association, 1881.48*

Fig. 9.10. Plaque, 1882, decorated over the glaze with china paints by Mrs. A. B. Merriam. *Courtesy of the Cincinnati Art Museum, Gift of the Women's Art Museum Association, 1882.238*

The reception was not only a popular triumph, but a financial success as well. The Pottery Club sold enough objects to cover all its costs for the previous winter. The club would continue to receive public approval throughout its eleven-year existence. Clara noted, "For once in the history of Cincinnati, our public was with us."[25]

The Cincinnati Pottery Club had several additional exhibitions in 1880. In late spring, its members joined President Perry and her Women's Art Museum Association and exhibited work at a reception held by WAMA in the new decorative art rooms in Music Hall. The aim was to raise money for and to arouse interest in the future art museum. Lilian Whiting, writing for the *Art Amateur,* was impressed: "Could this display have been transferred to New York or London, the interest excited by it would have been equally marked."[26] This was not the only exhibition that the Pottery Club would share with WAMA. Louise agreed to participate on these occasions because she was trying, as she said, "[t]o protect my interests in the hands of the Association."[27] She had angered Mrs. Perry, the leader of women in the arts in Cincinnati, by refusing to teach the underglaze slip technique to the fair sex. Perry was powerful, and Louise could not afford to lose her support. In the end, she lost it anyway.

The next exhibition for the Pottery Club was Cincinnati's Eighth Industrial Exposition, held from September 8 to October 9, 1880. Club members displayed 172 pieces; most had been exhibited before.[28] Louise McLaughlin entered fifty-four objects, five of which were noted as being "overglaze." For this exhibition, the Pottery Club printed a special eight-page pamphlet listing their entries. The pamphlet is interesting because it offers prices for those objects being sold. Of McLaughlin's five overglaze pieces, only one was for sale: catalog #91, a plate priced at $9.00. The remainder of her works was wide-ranging in price. Catalog #80, a small vase carved and covered with green glaze, commanded $3.00. Most cost between $10.00 and $20.00, although four pieces (catalog #13, 68, 66, 8) were decorated with gold and priced at $25.00, $35.00, $45.00, and $50.00, respectively. The most expensive work was her Ali Baba vase (catalog #65), for sale at $150.00. McLaughlin's work generally commanded higher prices than that of the others in the club, probably due to her celebrity as well as her talent.

The final exhibition of 1880 did not take place in Cincinnati, but in Buffalo, New York. Some ladies in Buffalo had started their own decorative art rooms and invited Cincinnati to exhibit and sell. All was well received and each member of the Pottery Club had "some triumph to record."[29]

Sometime before May 1880, George McLaughlin, his sister Louise, and their mother Mary, moved from their family home at 115 Central Avenue in downtown Cincinnati, just below the Grand Hotel, to 1 Chapel Street in Walnut Hills, a newly developing suburb.[30] The move must have been momentous, because the family had been living on Central Avenue for about fifty years.[31] It is not known what prompted the move. At the time all art events and activities took place in the city. Furthermore, Frederick Dallas's Hamilton Road Pottery, located at the corner of Dunlap Street and McMicken Avenue, was closer and more accessible to the city address than to the Walnut Hills location. The address on Chapel Street was one and a half times farther from the pottery, and there were no main arteries to facilitate a buggy ride or a horse-drawn trolley. Perhaps it had become fashionable to move to the suburbs, where the air was not so polluted—Cincinnati was notorious for its pollution—or perhaps the elderly family servants had died. This latter possibility is suggested by a newspaper interview with Louise and George on November 29, 1878: "Mr. McLaughlin says he can not move out of his old house, because the family servants, now old, gray-bearded and feeble, could not live in a new-fashioned house, where they would have to go up stairs. The old servant that opened the door must have

been eighty years old." For whatever reason, the move was a life event for Louise. She left her downtown location and the home she had known for all thirty-three years of her life.

On June 21, 1880, T. J. Wheatley applied for a patent on McLaughlin's underglaze slip technique that he had learned while at the Coultry Pottery.[32] The patent was issued on September 28, and shortly thereafter Wheatley notified his rivals that they must stop work immediately on the Limoges technique because only he had legal permission to produce it. This injunction weighed against the Coultry Pottery, the Dallas Pottery, the nascent Rookwood Pottery, and against the hundreds of amateurs who worked in the underglaze technique. No one took it seriously. Shortly before October 7, Mrs. Nichols was visited by the press at an old schoolhouse that she was converting into the Rookwood Pottery. When asked if she was afraid of Wheatley instituting proceedings against her, she responded emphatically, "I don't care if he does. . . . I shall go on building my pottery, and I hope to have the first fire in the kiln in a month's time."[33] During the course of the interview, she also admitted, "Miss McLaughlin used to do Limoges work before Mr. Wheatley ever thought of such a thing." Later, Maria Longworth Nichols would conveniently deny that McLaughlin was the inventor of the technique. At this time, however, no one doubted the identity of the originator. A local newspaper was quick to point out that "Miss McLaughlin, of this city, has, by unanimous consent, been awarded the honor of being the first in this country to successfully solve the problem [of the underglaze slip technique]." The foreman at Coultry's thought that Wheatley was wasting his money on the patent because nobody would pay attention to it, and no court in the country would find a verdict for him. Speaking for his sister, George McLaughlin ridiculed Wheatley's claim. As a lawyer, George had advised his sister not to patent her method because the admixture of clay slip and color, which was the basis of her technique, was not new in ceramics and therefore could not be defended as unique. While the admixture was not new, Louise's underglaze process, which utilized the admixture, was. She herself said, "It was an application of pottery with 'slip' known from time immemorial but which introduced such possibilities as to color and handling that it was really a new discovery."[34] Later, she would regret her brother's advice, when she was again challenged as the discoverer of the process by another patent filed by The Rookwood Pottery Company. But at present everyone vied against Wheatley by pointing to Louise McLaughlin as the originator. No one stopped using the process, and Wheatley never chose to defend his patent.

The one event in 1880 that was to alter Louise McLaughlin's ceramic career more than any other was Maria Longworth Nichols's decision to found her own pottery. There have been many reasons given for its founding. The *Cincinnati Daily Gazette* for September 13, 1880, said that Mrs. Nichols was starting her own pottery to eliminate the inconvenience of the "great distance" she had to travel from her home to the Dallas Pottery and to exercise her own taste in the choice of forms.[35] Both of these reasons were no doubt contributing factors. Rose Angela Boehle, O.S.U., in her book, *Maria,* proposes that Nichols "wanted to give employment to the young women who were graduating from the Art Academy."[36] The Art Academy did not exist at the time, but perhaps one could offer this argument for the women of the School of Design. However, any argument suggesting that Nichols was sincerely concerned about the fortunes of other women is difficult to accept. Nothing in her character supports this feminist spin on the reasons for Rookwood's inception. Indeed, in 1883 Maria did not hesitate to say, "[M]y somewhat expensive experience convinces me that to rely upon women's work for the decorative department of Rookwood would be to fail entirely."[37] If Maria ever possessed a concern about employment for women, she did not have it for long.

Although some of the motives offered for Rookwood's inception are more convincing than others, most of those put forward probably contributed in some way. Louise had her own idea why Maria started Rookwood. At that time, it was commonly accepted that Colonel and Mrs. Nichols were not happily married. This view persists even today in Cincinnati's oral tradition. However, Maria's father, Joseph Longworth, would not sanction a divorce and accordingly appeased his daughter by funding Rookwood. This supplied Maria with a daily pastime away from her husband. McLaughlin states:

> The fact that she was not happily married to George Ward Nichols, afterward manager of the College of Music, was the original cause of the starting of the Rookwood Pottery. Her father Joseph Longworth . . . did not approve of divorce and his influence and authority and his efforts to assist his daughter prevented her from divorcing Nichols.[38]

One motive that has never been thoroughly explored concerns Maria's relationship with Louise McLaughlin and the Pottery Club. Louise did not sense that she or the Pottery Club had anything to do with Rookwood's inception, in spite of the fact that she was keenly aware of Nichols's competitive drive. In the spring of 1880,

when the idea of her own pottery was fermenting, Maria Nichols had but one rival to her ceramic prowess—Louise McLaughlin. McLaughlin's famous Ali Baba vase and the unqualified success of the Pottery Club's first reception in May of that year obscured any headway Nichols might have made in their rivalry during Cincinnati's Seventh Industrial Exposition of 1879. If she had her own pottery, she would have complete control of the product and thus would be in a position to surpass *all* competition. Having convinced her father to underwrite the factory, she began organizing Rookwood in late April 1880.[39] There is an adage that says, "When you can't beat them, join them." For Maria the reverse was true: "When you can't join them, beat them." That was what she was doing, and in the end she won. When the first kiln was drawn on Thanksgiving Day, 1880, the tide began to turn in her favor. As Clara Chipman Newton noted, "from that time on the Pottery Club distinctly suffered."[40] Nichols hired most of the skilled labor from Dallas's plant to work in her pottery; this was an immediate blow to the club. Fortunately, Joseph Bailey Sr. chose to stay with Mr. Dallas and the ladies. That kept hope alive, but time was running out. When Maria Longworth Nichols was asked why she started the Rookwood Pottery, she simply said, "My principal object is my own gratification."[41] There is no reason to doubt this statement, or to doubt that one of Maria's objectives was the elimination of Louise McLaughlin as a ceramic rival.

chapter 10

POTTERY DECORATION
UNDER THE GLAZE, 1880

"No one interested in pottery decoration, whether as an amateur or professionally, can afford to be without this little manual," advised the *Art Amateur* in a review of Louise McLaughlin's *Pottery Decoration under the Glaze* (pl. 18).[1] Published during the week of August 16, 1880, the manual was a record of McLaughlin's more than two years of experience in underglaze decoration. This book, which sold for one dollar, disclosed no secrets. The underglaze slip technique for pottery decoration, discovered by McLaughlin and held secret by her for a time, had become common knowledge in Cincinnati by August 1880. There was no longer any advantage in withholding the information. In fact, it was now to her advantage to openly disclose her knowledge and become the first American to publish a book on the subject. It is not known when McLaughlin decided to write the book. The fact that the preface is dated May 1880 suggests she had finished the manuscript by then, so she probably had begun writing in April or early May 1880. Louise had written the earlier sixty-nine-page manual *China Painting* in two weeks, so the ninety-five-page *Pottery Decoration* probably did not take much longer than that, perhaps a month at most.

By April/May of 1880, Wheatley, his students, the Pottery Club, Maria Longworth Nichols, and her friends were all using the technique. As stated earlier, T. J. Wheatley had uncovered McLaughlin's technique as early as April 1879 and had

begun classes of instruction on the subject shortly thereafter. Since by April 1880 Wheatley had been using the method for a year, it is difficult to believe that he was the spark that incited her to write the book. He did not apply for his patent on the method until June 21, almost a full month after the manuscript was completed. It was not the reprehensible Wheatley, or his students, or Louise's friends in the Pottery Club, or the numerous other amateurs taking advantage of her discovery that motivated her writing; if anything, it was the fact that her rival, Maria Longworth Nichols, was founding an *art* pottery that would exploit Louise's underglaze method. Maria Longworth Nichols began converting the old schoolhouse on Eastern Avenue into the Rookwood Pottery in late April 1880, about the same time Louise began writing the manual. It is difficult to believe that these two events were purely coincidental. For Louise to write a book on pottery decoration under the glaze was yet another form of one-upmanship in their contest for ceramic leadership. Such a book also would strengthen McLaughlin's claim as the discoverer of the technique and, in a small way, would appease the powerful Mrs. Elizabeth Perry, who, as far back as September 1878, had wanted Louise to teach the underglaze slip method to women. Now women could read McLaughlin's book and teach themselves to decorate under the glaze.

Pottery Decoration under the Glaze is organized in much the same way as the earlier *China Painting*. Neither book has an index, which detracts from their otherwise well-structured formats. Like *China Painting*, *Pottery Decoration* is written clearly and concisely without the burden of superfluous information. All the basic facts needed to decorate under the glaze are offered, including a discussion of clay composition, colors, methods of applying the colors to greenware or to the biscuit, firing, and instructions for modeling, incising and carving decorations. According to the preface, the information is based on more than two years of experience "chiefly spent in experimenting on different methods of under-glaze decoration."[2] Nothing in the book is based on theory. It is important to realize that the various processes of underglaze decoration are more complex and technical than those of overglaze decoration and require the active participation of a potter and a pottery to glaze and fire the object once the decorator has finished his or her work. Because of this, Louise was not as self-assured in writing this book as she was in *China Painting*. In the preface she says, "It has been with some hesitation that I have undertaken to write a manual on the decoration of pottery under the glaze. This feeling was caused by the fear that I should not be able to treat the subject in as comprehensive, as well as comprehensible, a manner as it deserved." She chose to write it anyway and gives her reason

for doing so: "I have learned some things which may be of use to others, and have thought that a treatise upon the subject from an unprofessional, yet practical standpoint, might have its place in the literature of ceramics which has now become so extensive." She then goes on to express her sense of indebtedness to the potters, especially Joseph Bailey Sr., "whose intelligent co-operation and valuable advice have been of the greatest service."[3] To successfully produce underglaze decoration, especially underglaze slip decoration, an amateur had to be connected with a potter and, by extension, a pottery. This requirement limited the number of amateur participants in the field since such a setup was not always practical. Maria Longworth Nichols solved this problem by simply building a pottery for her needs, but few others could take this approach. Eventually, McLaughlin herself discontinued underglaze decoration because she lacked the active assistance of a potter and a pottery. Because Louise left the field within eight years and because the number of decorators in the underglaze technique was inherently limited, *Pottery Decoration*, although well received, was never updated and reissued in the same way as *China Painting*, which was reprinted no fewer than ten times over a period of twenty-seven years.

Louise McLaughlin's educational background and training are once again evident in *Pottery Decoration*. She maintains her affirmation of drawing: "I would like here to insist . . . upon the necessity of a thorough and serious study of drawing. . . . The best preparation for the work of decorating pottery . . . is a thorough knowledge of drawing."[4] Remaining true to Benn Pitman's ideals, she still encourages the use of nature as a source of decoration: "Floral decorations seem to be the best adapted to vases, or other objects having rounded surfaces."[5] The book's cover and the vignettes used throughout were all designed by the author. These reflect a strong Japanese influence, as did the ones she had designed for *China Painting*. Once again, it is impossible to determine whether the Japanese influence came directly from Japan or via France, for her book shows that McLaughlin's French loyalties had not diminished. In a discussion of the fluxes to be mixed with color oxides, she translates directly from the *Encyclopédie-Roret*; she recommends French colors, especially those by Lacroix, and offers the French names for all of them; and she even advocates a slab of French plate glass as the best palette to be used. However, in the rare instance when a material (such as a type of white paint that was sometimes used on the biscuit) was not made by Lacroix, McLaughlin recommends the English manufacturer Messrs. Hancock & Sons of Worcester as a retailer.

The audience that Louise McLaughlin addresses in *Pottery Decoration* is not specifically female or male. She wrote the book thinking that it might be of use to

"others," more specifically, to "the student of ceramic decoration."[6] This book was not targeted for lady amateurs only; men were given equal consideration. Most underglaze techniques were new to the United States; consequently, even the professional male decorator could take advantage of McLaughlin's book as an uncommon source of information on the subject. Throughout the manual it is almost impossible to determine a gender for the intended audience, masked or otherwise. The author did not use gender pronouns, nor did she directly or indirectly address a particular sex in the book's composition.

The only gender-related issue in *Pottery Decoration* is indirect. Underglaze decoration was considered a higher form of art than china painting because it was more closely connected with men and was analogized with the male-dominated field of oil painting. McLaughlin reflects this in her book when she says that the underglaze method is "at once so artistic, and so thoroughly in accord with the modern school, as to awaken a profound interest in the minds of all lovers of art."[7] By the "modern school" she means Impressionist painting with its oil colors freely applied in a heavy impasto manner on canvas. She distinguishes her underglaze slip technique from all others because the use of the clay slip mixed with the color oxides produces "a thick *impasto* in the painting."[8] "Colors," she said, "may be daubed upon pottery, as they are, alas! upon canvas."[9] Because of this characteristic, her method of underglaze decoration offered "facilities for the production of works of art unequaled by any method heretofore in use."[10]

As discussed in previous chapters, china painting was always likened to watercolor painting, whereas underglaze slip decoration was always likened to oil painting on canvas. These analogies are related to gender. Women watercolored; men oil painted on canvas. Comparing underglaze slip decoration to a male endeavor raised its stature in the hierarchy of ceramic decoration. It cannot be rationally argued that underglaze slip decoration offered a greater qualitative potential than china painting. European porcelain painters earlier in the century had proven that anything that could be painted on canvas could be painted on porcelain. And, except for some technical difficulties that would eventually be overcome, underglaze decorators were proving the same thing with underglaze decoration. The difference in attitude toward the art lay with the gender of the artist. Moreover, the gender distinction rested with more than just an analogy to the male realm of oil painting. The underglaze process actively engaged both men and women, whereas the overglaze process of china painting engaged women almost exclusively. As discussed earlier, the underglaze slip technique demanded the active participation of a potter and a pottery as well as the

decorator. The potter and the owner of the pottery were almost always male. China decorators did not need these active counterparts. Indeed, china painters purchased their glazed blanks from retailers, and they could buy and easily operate their own muffle kilns, thus never needing the assistance of a potter or a pottery to produce their product. In the underglaze technique, men performed the glazing and firing when the decoration was completed; in china painting, the object was already glazed when the decorator began, and the decorator could fire it herself. The male sex was seen as integral to the underglaze process; in china painting it was not.

Another gender distinction that can be made is that underglaze slip decoration was a dirtier pursuit than china painting. Instead of working with clean, glazed porcelain and little dabs of china paint in the pristine environment of the home, the underglaze decorator worked with a grubby, wet clay form and brushes charged with heavy, dripping-wet clay slip in the dusty and often grimy environment of a pottery. In short, the process of underglaze slip decoration was less ladylike than that of china painting. It was seen as more suited to the male gender. Because the underglaze slip technique was likened to the male-dominated field of oil painting; because men were viewed as being integrally connected with the underglaze slip technique, and not with the overglaze technique of china painting; and because the underglaze process was not as delicate or ladylike as the overglaze process, underglaze decoration was considered a higher form of art than china painting. The rationale for this was simple: whenever an art form was perceived to be connected with men, it was regarded as higher in stature than an art form perceived to be connected with women.

In general, Louise McLaughlin's *Pottery Decoration* is a compendium of all the various forms of decoration under the glaze in use throughout the Western world as of 1880. In addition to her own underglaze slip technique, which she notes is "similar in effects to what is known as the Haviland, or Limoges faience," she describes barbotine, the Bennett or Lambeth technique of underglaze painting on the biscuit, modeling in relief (including the pâte-sur-pâte method), and incising and carving in clay.[11] Louise McLaughlin's *Pottery Decoration under the Glaze* offers an excellent understanding of ceramic techniques for all the types of underglaze decoration at the time. Solely the product of her own experience, the book added to the author's stature as an artist/writer, and was no doubt welcomed by professionals as well as amateurs in the field.

THE POTTERY CLUB,
1881–1890

"The spacious rooms of 'The Literary [Club]' were crowded with a representative assembly of Cincinnati's best people—the beauty, wealth and society of the Queen City of the West."[1] This is how the *Cincinnati Enquirer* of April 30, 1881, described the previous day's glamorous attendance at the second annual reception of the Cincinnati Pottery Club.[2] For the event, which was scheduled from 12:00 until 6:00 P.M. on Friday, McLaughlin again designed the cards of invitation (fig. 11.1). She embellished each with the figure of a young woman artist with brush in one hand and palette in the other at work before a large vase. It is not surprising that this motif, especially the depiction of the large vase, came one year after the reception in which the Ali Baba vase was hailed as a tour de force in ceramics. Clara Devereux's review of the second reception in the *Art Amateur* incorporated the design into the ornamented first letter of the article. Indeed, the *Art Amateur* liked the motif so much that the magazine used the design for several articles totally unrelated to the Pottery Club over the next several years.[3]

Approximately nine hundred cards were issued and more than one thousand people attended the 1881 reception. No one was quite sure where the extra one hundred people came from, but no one cared. The light and airy rooms of the Literary Club at 24 West Fourth Street in downtown Cincinnati were chosen instead of

Fig. 11.1. Invitation to the Cincinnati Pottery Club Reception, 1881, etching by M. Louise McLaughlin, 1881. *Courtesy of the Cincinnati Art Museum, Gift of Theodore A. Langstroth, 1986.88*

the Pottery Club's studio at the Frederick Dallas Pottery because increased interest in the work demanded more commodious quarters. Also, downtown Cincinnati was a more convenient location.

By April 29, 1881, the Pottery Club membership had grown to sixteen. The three officers remained the same: Louise McLaughlin was president, Clara Chipman Newton was secretary, and Alice Holabird continued as treasurer. The other members were: Mrs. E. G. Leonard, Mrs. George Dominick, Mrs. Charles Kebler, Mrs. Walter H. Field, Miss Laura Fry, Miss Florence Carlisle, Miss Fannie Banks, Miss Clara Fletcher, Miss Elizabeth Nourse, Miss Agnes Pitman, Miss Julia Rice, Mrs. A. H. McGuffey, and Mrs. A. H. Hinkle. The last three were "new arrivals." Agnes Pitman did not exhibit at the second reception because she was leaving for England early the following week and did not have sufficient time to prepare her ceramic work. In all, two hundred pieces were exhibited. Limoges faience, work in the Bennett style, relief work in clay, incised decoration, and "some exquisitely finished overglaze work" in the manner of Dresden ware were on display. Nearly every reviewer noted a marked improvement over the previous year, even though the reviews for the previous year had all been superlative. There were no attempts at novelty, either technical or

aesthetic. Instead, there was an increased mastery of decoration with advances in the purity of color and the delicacy of modeling. Significantly, relatively few examples of Limoges work were displayed. The ladies were now directing their attention to the Bennett style of underglaze decoration. The thin wash of painting on the biscuit had become more desirable than the thick impasto painting on greenware. Although no definitive reason was given for the shift, the artists probably preferred this more delicate style of underglaze decoration because brighter colors resulted from the lower fired Bennett technique, and the loss ratio was probably not as high as in the Limoges style.

Not all the pieces were fired at Frederick Dallas's Hamilton Road Pottery; some were "burned at Mrs. Nichols's pottery."[4] It is a testament to the infancy of The Rookwood Pottery Company that it was still being referred to as "Mrs. Nichols's Pottery." Which ladies fired their work there, or what type of work was fired is unknown. Certainly Clara Chipman Newton, Rookwood's secretary, and Laura Fry, who began working as a decorator for Rookwood in 1881, could have fired their pieces at the fledgling works. Even at Rookwood, Maria Longworth Nichols always seems to have kept one eye on Louise McLaughlin. Shortly after McLaughlin's Ali Baba triumph in the spring of 1880, Nichols determined to work on her version of a monumental vase. Completed late in 1880, the "Aladdin Vase" (fig. 11.2) was thirty inches high and eighteen and one-half inches wide (the Ali Baba was thirty-seven inches by seventeen inches). The Aladdin Vase is recorded as shape #1 in *The Rookwood Shape Book* (1883–1900), and is noted as being sold that year to Tiffany & Company.[5] As the competition continued, each of the two doyennes of Cincinnati ceramics always knew what the other was doing through their mutual friends.

At the second reception of the Pottery Club, Louise McLaughlin exhibited twenty-five pieces. The most acclaimed were large, cream-bodied vases that displayed pale blue landscapes and floral panels mottled over the glaze with gold. She also displayed one of her rare examples of high relief work in a large vase of the close-grained, red-brown Ohio clay decorated with branches of a lighter red clay. And, of course, there was a portrait plaque, eighteen inches in diameter, depicting a young girl "painted with exquisite taste, [with] a large Gainsborough hat framing the face and showing to great advantage against the gold background."[6] The formula of a "Gainsborough hat framing the face" against "a gold background" became somewhat of a trademark of McLaughlin's overglaze portraiture for the next few years (e.g., pl. 19).

Fig. 11.2. The "Aladdin" vase, 1881, decorated by Maria Longworth Nichols. This is one of several versions produced by The Rookwood Pottery Company. It is noted as shape number one in Rookwood's shape book.
Courtesy of the Cincinnati Historical Society Library

Almost certainly, this schematic formula was influenced by the French ceramist, Théodore Deck. Deck's exhibit at the 1878 Exposition Universelle in Paris was one of the most important in the French ceramic section and drew much publicity. His new gold ground ware, on which gold grounds were applied to portrait plaques painted by various salon artists, was featured for the first time.[7] Although McLaughlin did not attend this exposition, she had entered her own ceramics, would have read all the reviews regarding ceramic displays, and therefore would have learned of Deck's new gold ground ware (e.g., pl. 20). She would have been particularly interested in the French ceramics because the ceramics that she entered, the underglaze slipware, was in competition with that of the French. At any rate, McLaughlin's portrait plaque displayed at the reception was mounted in a carved oak frame from the studio of Henry and William Fry, the grandfather and father, respectively, of Pottery Club member Laura Fry.

Cincinnati newspapers took great pains to list the most important people in attendance at the Pottery Club's second reception. Colonel and Mrs. George Ward

Nichols were there, as well as Benn Pitman, Alfred Traber Goshorn (who was soon to be the first director of the Cincinnati Art Museum), Joseph Longworth (Maria's father), Mr. and Mrs. Aaron F. Perry, Judge and Mrs. Alphonso Taft, Mr. and Mrs. Charles Taft, painters Henry F. Farny and C. T. Webber, School of Design instructors Thomas S. Noble and Louis Rebisso, and others, such as Mrs. William Porter Hart Dodd, philanthropists Charles West and Reuben Springer, and Mr. Bellamy Storer (Maria's future husband). Since the newspapers listed hundreds of names, no doubt a guest registry was at their disposal. By 7:00 P.M., when the doors finally closed to the last visitor, almost all of the two hundred pieces on display were sold. Again flushed with success, the Pottery Club began its third year, which was to hold the key to its future direction.

On June 9, 1881, barely a month after the second reception, old Mr. Dallas died.[8] Frederick Dallas's death effectively brought an end to the Hamilton Road Pottery. Superintendent Joseph Bailey Sr., no longer restricted by his self-imposed loyalty to his employer, left to work with his son at Maria's Rookwood Pottery. Without the skilled labor of Joseph Bailey and that of others who left, and without the managerial prowess of Frederick Dallas, the Hamilton Road Pottery limped along until it finally closed in July 1882.[9] The Cincinnati Pottery Club was never the same in spirit or product. The first order of business after Bailey left in 1881 was to find another pottery at which to work. Probably due to the intercession of Clara Chipman Newton, the Pottery Club rented a room from Maria Longworth Nichols at her Rookwood Pottery (fig. 11.3). It was the only ceramic works in town dedicated to art pottery and, what is more important, Joseph Bailey Sr., the club's technical mentor, now worked there. Maria Longworth Nichols did not lose in the arrangement. When founding Rookwood, she had been quick to point out: "I hope to make the pottery pay expenses."[10] Renting a room to the Pottery Club served this purpose. The fact that she could now monitor the club's progress on a daily basis probably pleased her also.

Louise McLaughlin was affected by two deaths during the summer of 1881. Besides Frederick Dallas's death on June 9, Louise's mother, Mary Ann Robinson McLaughlin, died on Monday, July 11 at the age of seventy-three years. None of her obituary notices offers a cause of death.[11] She was buried two days later, on July 13, in a private service. Louise was thirty-three years old when her mother died, and their relationship remains a mystery. The daughter rarely commented on either parent. Based on the opening quote of this book, Mary Ann McLaughlin was not a socialite,

Fig. 11.3. Pottery sheds behind the old schoolhouse on Eastern Avenue. Maria Longworth Nichols converted the old schoolhouse into the Rookwood Pottery. Tops of the kilns can be seen rising from the sheds. The Cincinnati Pottery Club met from 1881 to 1882 on the second floor of the building in the center of the photo. In 1882 the Cincinnati Pottery Club was evicted by The Rookwood Pottery Company. *Courtesy of the Cincinnati Historical Society Library*

but rather a quiet Victorian lady totally contented with serving her family. Her death went virtually unnoticed by society. What influence it may have had on her daughter will probably never be known. Louise and her brother George continued living together, with George serving as the provider and Louise handling the domestic duties.

The Pottery Club continued its existence at Rookwood, but as Clara Chipman Newton noted, "The tender grace of earlier days never came back."[12] Even though members were producing less and less Limoges faience, the club was still considered a contender in that field. An article entitled "Haviland Faience" in the December 1882 issue of the *Art Amateur* mentions only one other market of underglaze slip decoration besides Haviland, namely, "the ceramic amateurs of Cincinnati."[13] The author did not hesitate to take a biased, probably sexist, dig at Haviland's only rivals: "The daubed atrocities committed by some young ladies who think that they are

Fig. 11.4. Oscar Wilde.
Reproduced from the Collections of the Library of Congress, LC-USZ62–85840

rivaling the Haviland ware because they are using similar materials are greatly to be deplored." Despite such criticism, the work of "the ceramic amateurs of Cincinnati" still had national recognition.

In 1882 Irish-born writer, wit, and proponent of the Aesthetic Movement, Oscar Wilde (fig. 11.4), was visiting the United States for the New York production of his first play, *Vera, or The Nihilists*.[14] On February 20, en route to Louisville, he spent a day in Cincinnati in order to find material to incorporate into his talk, "The Decorative Arts," to be given in Cincinnati on the twenty-third.[15] He first stopped at Robert Clarke & Company, McLaughlin's publisher, where he selected various books, including one by McLaughlin, presumably her treatise on underglaze slip decoration. He then visited Rookwood, where he reviewed the products of Mrs. Nichols's pottery and the Cincinnati Pottery Club. When he arrived at the pottery, Clara Chipman Newton noted that, even though she had read of his vagaries, she was not prepared for this man who was wearing a calla-lily-leaf-green overcoat and shrimp-pink necktie, "shuddering visibly over a [Rookwood] vase which he was pronouncing 'too branchy.'"[16] Later he visited Mrs. Nichols at her home on Grandin Road to discuss pottery. Unfortunately, their discussion was never recorded.

He delivered his lecture, "The Decorative Arts," at the Grand Opera House at 2:30 P.M. on Thursday, February 23, to a packed house of more than one thousand people "composed mostly of aesthetic ladies."[17] Two of the "aesthetic ladies" were Louise McLaughlin and Maria Longworth Nichols.[18] During his lecture Oscar Wilde noted, "I saw some work at Mrs. Nichols' pottery that looked as if the one who decorated it had five minutes to catch a train, and had decorated two vases within that time." The work in question could easily have been by Mrs. Nichols since her style of decoration was always very sketchy. The only lady whose work he admired was Louise McLaughlin: "Such work as Miss McLaughlin's . . . is most beautiful and delightful." According to Clara, Mrs. Nichols received the lecture with a sense of humor.[19] However, the founder of Rookwood could not have been too happy that Louise McLaughlin's work was pronounced better than hers. The next day, before leaving for St. Louis, Oscar Wilde had lunch with Mrs. Nichols. It is a great loss that history does not record the luncheon conversation.

The annual Pottery Club receptions continued to be quite popular. The 1882 event, held on May 12, again at the Literary Club, displayed the professional growth of the "amateur" ceramists. According to the *Crockery and Glass Journal*, the workers were "no longer experimenting; they have learned their art, and are now expressing it with careful spontaneity."[20] In retrospect, it is easy to see that what was not displayed was as important to the club's future direction as what was. The article continues, "The attempt to make Limoges faience has happily come to an end almost, and the abominable daubing that some of our ladies used to try to make us believe was artistic has been quietly dropped. Only those who have real ability to paint Limoges continue at it—no thanks to the critics." McLaughlin's underglaze slip technique seems to have run its course. The originator was still using it (pl. 21), but the others were utilizing the Bennett style of underglaze decoration or decorating over the glaze. China painting was growing in popularity among the Pottery Club members once again. Even McLaughlin, who was still engaged in her underglaze technique, was beginning to produce more china-painted pieces (pl. 22). The reason for this is unclear. Perhaps the situation at Rookwood was simply not as conducive to underglaze production as the arrangement at the Dallas Pottery had been. Whereas the Dallas Pottery had produced primarily commercial ware and was not financially threatened by the art pottery produced by the Pottery Club, the Rookwood Pottery was primarily an art pottery whose product was in direct competition with the product of McLaughlin's group. The relationship between the club and Rookwood was always fragile at best, as evidenced in the September 21, 1882 issue of the *Crockery and*

Glass Journal, which announced: "The ladies [of the Pottery Club] have been informed that they can no longer make their ware at the Rookwood Pottery."[21] The reasons given were quite pointed: "Their products have brought the fame of the place into disrepute." It further claimed that it hurts the trade that the managers of the pottery themselves might get, although this reason is not given publicly. These two reasons seem to be contradictory. On the one hand, their work was so poor as to bring the "fame" of Rookwood, such as it was in 1882, into disrepute; on the other hand, their work was good enough to command a share of the market that Rookwood was trying to win. Publicly, Rookwood was saying that the Pottery Club's product was not as good as its own; privately, Rookwood saw the club's output as serious competition. The Pottery Club was selling approximately two hundred pieces annually at its receptions. This was a major share of the local market. It was not in Rookwood's best interest to promote the club. In *The Book of Rookwood Pottery,* Herbert Peck offers a detailed outline of Rookwood's finances for 1882.[22] The Pottery was struggling to balance its books. It could not afford to accommodate McLaughlin's group for long.

According to Peck, the Pottery Club did not leave Rookwood in September 1882, but rather sometime in 1885.[23] This date does not accord with the *Crockery and Glass* article, and causes much confusion. No Pottery Club members address this dating problem in their writings. Clara Chipman Newton simply states that "for three or four years the doors of Rookwood were open to us, but things were never quite the same."[24] The Pottery Club was no doubt evicted from Rookwood by the end of 1882. Even though club members were no longer on the premises, they could still send for Rookwood blanks, "but transporting them proved a very risky business and was gradually given up."[25] The fact that reviews of the Pottery Club's annual reception in 1883 noted that "[t]hey have practically stopped making Limoges, and are doing a good deal of over glaze work," seems to confirm the 1882 eviction.[26] It was noted the previous year that the Limoges ware had fallen off, but the ladies were still producing objects in the Bennett style of underglaze decoration. By the May 1 reception of 1883, very little work using the underglaze technique was being produced. Only the stalwarts of underglaze slip decoration, such as Louise McLaughlin, continued to send for blanks that would be fired at Rookwood after decoration.

In the spring of 1883, Maria Longworth Nichols hired her good friend William Watts Taylor as business manager of Rookwood.[27] By 1885 he decided that the presence of the Rookwood name on pieces produced by the Pottery Club created confusion in the market. Because of this, and no doubt because of the competition that works by the Pottery Club created, Taylor stopped the sale of Rookwood blanks

to any outsider.[28] This effectively eliminated any serious competition in art pottery decorated under the glaze. Very few of Louise McLaughlin's Limoges examples date from the 1883–85 period, when she had to send for Rookwood blanks; beyond that period, there were none. When Clara Chipman Newton wrote that the doors of Rookwood were open to the Pottery Club for three or four years, she was obviously referring to the use of Rookwood's blanks and kilns, not to the use of one of its studios. Eighteen eighty-five was the last year for the Pottery Club's production of underglaze decoration of any kind. What Louise McLaughlin began late in 1877 came to an end in 1885. Maria Longworth Nichols had at last defeated her rival in the race for superiority in pottery decoration under the glaze. Clara Chipman Newton later recounted the situation: "The fortunes of war were ours; we accepted them with what grace we could summon and turned our attention to over-the-glaze painting."[29]

From 1885 until its end in 1890, the Pottery Club returned exclusively to china painting. Even before eviction from the Rookwood Pottery, the work had been leaning in that direction. McLaughlin, too, was shifting her interests (fig. 11.5). After she published *Pottery Decoration under the Glaze* in 1880, all her publications for the rest of the decade were devoted to decoration over the glaze. From December 1882 until November 1883, she wrote a series of twenty articles for the *Art Amateur* magazine entitled "Hints to China Painters."[30] This series is typical of McLaughlin's style of writing in that it espouses her philosophy and at the same time offers technical advice. For example, in the first article, "The Importance of Drawing," she once again espouses drawing as the *sine qua non* of china painting; in the second article, "Suggestions for Plaques and Tiles," she very technically discusses the application of paints. All twenty articles in the series exemplify McLaughlin's code of china painting.

In 1883 Louise McLaughlin published twelve of these articles nearly word-for-word in book form with the slightly veiled title, *Suggestions to China Painters.* The ninety-four-page compilation was intended as a follow-up to *China Painting.* McLaughlin used it to promote her nature-or-nothing philosophy of decoration: "Nothing worthy [of] the name of art can be produced without careful and reverent study of natural forms."[31] Forever the protégé of Benn Pitman, Louise McLaughlin continued to proclaim, "The only true inspiration is given by the study of nature." Even in the chapter entitled "Lessons to be Derived from Japanese Art," the author insists: "The chief source of inspiration [of the Japanese] is found to come from a loving and observant study of nature."[32] Benn Pitman's philosophies lived on in Louise McLaughlin throughout her life. As a supplementary treatise to *China Painting,*

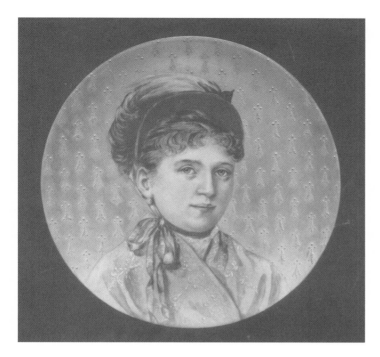

Fig. 11.5. Porcelain plaque: Portrait of Katherine Elizabeth Davis (Mrs. Anthony Howard Hinkle) by M. Louise McLaughlin. This is an example of china-painted portraiture.

Suggestions is less elementary in character and offers china painters the results of McLaughlin's later experiments (pl. 23). Like the previous book, it was written for lady amateurs without specifically saying so. The original 1883 version was popular enough to be revised and published again in 1890, but there were no new editions after that year. The first version was finished in December 1883, slightly more than a year after the Pottery Club was evicted from Rookwood. This is not coincidental. Spending more time on china painting because of the eviction, McLaughlin once again turned her overglaze experience into a manual.

The most important book written by the artist-writer during this renewed period of overglaze decoration was the revision of her signature work, *China Painting*. This book, more than any other, was synonymous with the name of Louise McLaughlin. By the fall of 1880, three years and at least three editions after its first publication, nine thousand copies had been sold.[33] When the 1889 revised edition was published, the title page noted that the issue had sold more than fifteen thousand.[34] The revised edition was 103 pages, whereas the original edition, with four printings through 1882, was only sixty-nine pages. Comparing the contents of the original with those of the revised book shows the evolution of china painting in America. Absent from the 1889 version is the description of how to depict drapery; the design style

of a draped background was evidently no longer fashionable. What is added to the new edition is instruction in the use of mat colors, metallic decoration (pl. 24), burnishing, and the use of paste for raised gold (pl. 25). The metallic look and the mat look, which were now possible because of progress in the development of colors, were the rage. They were inspired partly by Japanese multi-metal forms, and partly by Royal Worcester's ivory (pl. 26) and metal (pl. 27) imitations that were sweeping the country at the time.[35] In 1886 the Cincinnati Art Museum purchased a collection of such examples from Royal Worcester, which was placed on permanent display in the museum for Cincinnati china painters to see.

Just as interesting as the 1889 version itself are the many advertisements in the unpaged section at the end of the publication. The Osgood Art School of New York advertised "Home Instruction in Royal Worcester Decoration"; A. Sartorius & Co. of the same city was selling A. Lacroix's tube colors; and J. Marsching & Co., also of New York, was selling Lacroix's tubes as well as Royal Dresden china colors. A quarter-page spread noted that, in Cincinnati, Clara Chipman Newton was offering classes in "China, Royal Worcester, Water Color, Tapestry, and Decorative Oil Painting." Clara was always busy making a living for herself. A group calling itself the Associated Artists of Cincinnati, with Louise McLaughlin as president and Clara Chipman Newton as secretary, advertised that it was receiving orders for "Decorated Porcelain, suitable for Wedding Gifts, and other special occasions. Etchings on Metal, Tapestry Paintings, Embroideries in Original Designs, Decorative work in Oil and Water Color, Wedding Certificates, Menus, and Illuminations, on Paper and Vellum, in various Styles." Obviously, Louise did not shrink from earning money any more than Clara. This tantalizing one-page ad suggests that a group of women were banding together to market their skills. To date, all that is known of them is in this advertisement. Louise's brother, James W. McLaughlin, had a one-page ad promoting his architectural firm, and the publisher, Robert Clarke, had his own page advertising "Miss McLaughlin's Art Books," which by 1889 were *China Painting, Suggestions to China Painters, Pottery Decoration,* and *Painting in Oil,* an 1888 manual for oil painting on canvas. On the last page of the advertising section was an announcement of the gold medal won at the 1889 Exposition Universelle in Paris by none other than the The Rookwood Pottery Company. Rookwood was quick to point out that all its decorations were "entirely under-glaze." This seems to be the ultimate irony: Eviction from the Rookwood Pottery was the reason Louise McLaughlin was again working wholly in overglaze decoration, and probably the reason she revised *China Painting,* the very book in which Rookwood was proclaiming its underglaze prowess.

The Cincinnati Pottery Club continued to exhibit early in the decade. In February 1882, the club once again exhibited for Mrs. Elizabeth Perry in another Museum Association show.[36] On display was a historical review of Cincinnati pottery, including McLaughlin's underglaze blue examples, her Limoges work, and work by her in the Bennett style, all representing her *oeuvre* from 1877 to the present. Probably the most prestigious exhibition for the club came in the spring of 1883. A representative selection of work was sent to Howell and James in London and exhibited at the famous London Emporium of Art.[37] Alice Holabird had the honor of a lifetime when one of her carved pieces was purchased by the Prince of Wales (the future King Edward). Clara Chipman Newton noted, "Had she been an English girl, her fortune would have been made." The next exhibition for the Pottery Club, other than the annual receptions (fig. 11.6), was the second Philadelphia Exhibition of American Art Industry held at the Philadelphia Museum in November 1889.[38] The noted New York critic Russell Sturgis reported:

> Cincinnati carries off the honors. The work exhibited comes nearer to supplying the demand for china that is tasteful and fitted for daily use than anything probably in the whole exhibit. . . . Before leaving the mention of these pieces it must be stated that there is nothing amateurish about the work. I do not know these ladies, but their influence must be great in the community in which they live.[39]

At least one Cincinnati Pottery Club exhibit was not well received. A show was sent to Denver and was returned as "not having at all filled the expectations of the Denverites."[40] It seems that a jealous rivalry colored the opinions of the ladies of Denver. When Clara Devereux heard of it, she penned a very funny article about the "attitude of the wild and woolley [sic] west" toward the products of the "effete east."

For the most part, the Cincinnati Pottery Club was content to exhibit its wares at the club's annual receptions. The May 16, 1884, reception was held in the rooms of the Railway Club at the Ortiz Restaurant in downtown Cincinnati.[41] This exhibition is significant because it marks the first time that products other than ceramics were exhibited by the group. Included were etchings, stained woods, repoussé work in brass and copper, paintings in oil and watercolors, as well as ceramic work. Louise McLaughlin contributed no fewer than a dozen objects, including etchings on brass and copper plaques, panels, bowls, jugs, vases, trays, and one mirror frame. Some of her Limoges faience was displayed, but it was her etched copper (pls. 28 and 29) and brass pieces that garnered favor from the reviewers. McLaughlin particularly liked working in metals, and ultimately won a silver medal for her etchings on silver

Fig. 11.6. Invitation to the Cincinnati Pottery Club Reception, 1883, etching by M. Louise McLaughlin, 1883. *Courtesy of the Cincinnati Art Museum, Gift of Theodore A. Langstroth, 1986.90*

and copper at the 1889 Exposition Universelle in Paris. For the entire ten years that the club held receptions, the invitations (e.g., fig. 11.7) were created from designs on copper plates etched by the president of the club.

Louise was still experimenting with china painting techniques. Several of her pieces in the 1885 reception were decorated over the glaze in a "rich orange effect" in such a manner as to "perfectly simulate underglaze" work. One cannot help but wonder if the orange underglaze effect was inspired by Rookwood's standard ware with its amber-tinted glaze over slip decorations. At the December 17, 1886, reception there were nineteen members of the Pottery Club, each of whom was expected to contribute twenty-four pieces to the exhibit. China-painted ceramics were still exhibited, but these were no longer the main focus. Any art form produced by the members could be exhibited. For the last half of the decade, the "fashionable crush" of people continued to attend the receptions. The 1886, 1887, and 1888 events were held right before the Christmas holidays in the hopes that sales would be enhanced by those looking for holiday gifts.

On April 2, 1889 the Cincinnati Pottery Club members celebrated the tenth anniversary of the organization, with a *"déjeuner à la fourchette"* at the Queen City Club

Fig. 11.7. Invitation to the Cincinnati Pottery Club Reception, 1885, etching by M. Louise McLaughlin, 1885. *Courtesy of the Cincinnati Art Museum, Gift of Theodore A. Langstroth, 1968.89*

Figure 11.8. M. Louise McLaughlin (*right*) in her parlor, with an unidentified woman. To the left is the third "Ali Baba" vase. On the table is an oil lamp china-painted by McLaughlin. *Courtesy of the Cincinnati Art Museum, Theodore A. Langstroth Collection, Mary R. Schiff Library*

(fig. 11.9).[42] For the luncheon, attended by sixteen of the club's twenty members, the ladies arrived at noon in holiday attire with a bonnet framing each happy face. The round table at which they sat was decorated in the center with a pyramid of daffodils and ferns surrounded by six garden hats, out of which swept more daffodils and ferns in graceful trailing branches. Against the garden hats rested eighteen of the finest china-painted plates in the country, one by each of the participants and two by absent members. Streaming from the plates to the outer edge of the table were broad bands of daffodil-yellow satin ribbon on which Clara Chipman Newton had lettered the name of each occupant around the "festival board." The menu included lamb chops, spring chicken, fresh tomatoes, and new peas, which were served in courses with chocolate and coffee. The dessert was meringue that turned out to have cotton where the egg should have been, reminding everyone that their anniversary fell on April 1.

The exquisitely painted china plates that decorated the table had been contributed by members of the club. The waiter passed around a plate of envelopes containing the names of the members on handsomely decorated cards. Each lady drew an envelope. The plate painted by the artist whose name was on the card was won by the person who chose it. It is lucky that no member drew her own card. Laura Fry drew Louise McLaughlin's plate, which exhibited a spectacular spray of chrysanthemums surrounded by a deep red and gold border. Alice Holabird's plate presented an "artistic scheme" of raised gold and silver decoration, while Clara Chipman Newton's masterpiece displayed original designs in gold and bronze tints on a cream-colored ground. In almost all cases, metallic effects in gold and silver exemplified the vogue in painted china. A photographer was on hand to capture the day, as the members cherished their souvenirs of the festive and happy occasion. They did not realize that it was to be their last anniversary celebration.

The tenth reception was held on March 27, 1890, at the Lincoln Club, the site of the final four receptions. Sales from the event were so few that the Pottery Club was forced to rethink its future. Of the 375 pieces exhibited, 304 were for sale.[43] Only thirty-eight objects sold. The total value of the 304 pieces for sale was $1,900; the return on the thirty-eight objects sold was $288. The country was passing through a period of financial depression, and Cincinnatians were not able to patronize the arts in the manner to which the club was accustomed. It is also possible that the Cincinnati market was saturated with painted china and other household goods. By now there were twenty-three ladies in the Pottery Club, and they all decided that further growth seemed impossible without public support. Consequently, in a meet-

Fig. 11.9. Tenth Anniversary Celebration of the Cincinnati Pottery Club, April 2, 1889, at the Queen City Club. *Left to right:* 1) Mrs. A. H. McGuffey; 2) Mrs. Walter Field; 3) Miss Clara Chipman Newton; 4) Mrs. A. H. Lewis; 5) Mrs. H. C. Yergason; 6) Mrs. E. G. Rathbone; 7) Mrs. A. H. Hinkle; 8) Miss M. Louise McLaughlin; 9) Mrs. George Dominick; 10) Miss Alice Holabird; 11) Mrs. J. R. Murdock (Miss Florence Carlisle); 12) Miss Julia Rice; 13) Miss H. W. Peachey; 14) Miss F. S. Banks; 15) Mrs. G. H. Sykes; Hidden: Miss Laura A. Fry. *Courtesy of the Cincinnati Historical Society Library*

ing shortly after the reception, the Cincinnati Pottery Club was disbanded after a glorious eleven-year existence. Although it was not the first women's club in America, it was the first women's pottery club in America. As such, it was the nucleus from which many others sprang. Throughout its existence it was nationally recognized as a force in American ceramics. In spite of its sad demise, the Cincinnati Pottery Club was proud of its preeminent position in the history of American ceramics, as well as sensitive to its influence in the growth of the women's movement. Its place in history was fully recognized when it was asked to come together once more to present an exhibit of its ceramics in the Woman's Building at the 1893 World's Columbian Exposition in Chicago.

INTERIM YEARS,
1890—1898

"About 1885, I gave up work in pottery and actually refrained from dabbling in wet clay for nearly ten years," recounted Louise McLaughlin in a 1914 lecture to the Porcelain League.[1] Eighteen eighty-five was the year that Rookwood stopped McLaughlin's group from firing its wares at the pottery. That effectively ended Louise's work in underglaze slip decoration. From then on, for almost a decade, her ceramic output was limited to painting on porcelain blanks. By 1890, if not sooner, china painting was no longer a challenge for her, and it did not consume much of her time. Always involved with many art forms at once, she was now mostly occupied with etchings on metals and with her favorite art of portrait painting in oil on canvas. She also added photography, especially photographic portraiture (fig. 12.2 and 12.3), to her repertoire.

On September 15, 1885, Colonel George Ward Nichols died of tuberculosis at the age of fifty-four.[2] His widow, Maria Longworth Nichols, was thirty-six years old at the time. Six months later, on March 20, 1886, she married the thirty-nine-year-old bachelor and successful lawyer, Bellamy Storer Jr.[3] Bellamy belonged to a prestigious Cincinnati family and had a promising political career ahead of him. With the death of her first husband and the onset of her second marriage, Maria spent less and less time at Rookwood. This supports McLaughlin's opinion that Maria founded Rookwood in order to give herself a reason to escape from her troubled

Fig. 12.1. M. Louise McLaughlin at home. *Courtesy of the Cincinnati Art Museum, Theodore A. Langstroth Collection, Mary R. Schiff Library*

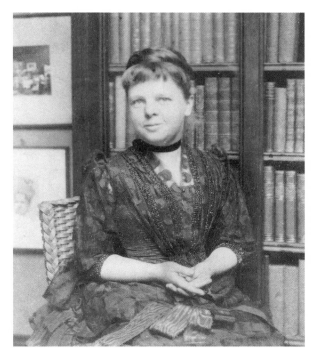

Fig. 12.2. Clara Chipman Newton in Louise McLaughlin's studio, ca. 1890. The photograph is probably by M. Louise McLaughlin. *Courtesy of the Cincinnati Historical Society Library*

Fig. 12.3. M. Louise McLaughlin, ca. 1890. *Courtesy of the Cincinnati Historical Society Library*

first marriage. Whatever the case, by 1890, with Louise now china painting only rarely and with Maria spending less time at her pottery, the rivalry between the two cooled somewhat, although it never totally disappeared.

In 1890 strained relations between the Art Academy and "a certain circle of society people," led by Mrs. Maria Longworth (Nichols) Storer, reached a breaking point.[4] Mrs. Storer, whose father was a major underwriter of the academy from which she drafted decorators for her pottery, did not believe that the academy was managed properly, and arranged to have her name placed in nomination for a seat on the board of directors. It was thought that she would "infuse new energy and spirit into the management." Her nomination was rejected, probably because the board feared her financial and political power and, no doubt, because she was a woman. In another instance of "when you can't join them, beat them," Maria Storer decided to found her own art school to rival the Art Academy. To that end, she sent for Cincinnati native Frank Duveneck in Boston, who was considered one of the finest artist-teachers in the nation.

Fig. 12.4. Oil on canvas painting by M. Louise McLaughlin. *Courtesy of Tom White*

On November 1, 1890, the first Duveneck painting class began. Maria Longworth Storer and Louise McLaughlin both took the course. It was probably the only time they were ever in a class together. Also in the class was Miss Mary Sheerer, who would soon become director of the Newcomb Pottery in New Orleans. Instruction in the life class (that is, art concentrating on the human form) was given on days that would not interfere with academy work, since many of the forty students in the new class also attended the academy. The studio, located on the top floor of the Cincinnati Art Museum "over the Rotunda," was open daily from 9:00 A.M. to 4:00 P.M., with a model posing both mornings and afternoons. Students paid one hundred dollars in two advance payments for the six-month course. Although Louise was generally reluctant to give credit to her teachers for her artistic growth, she did not hesitate to acknowledge that Duveneck "was the only teacher who had any influence on my artistic development" (fig. 12.4).[5] Because Duveneck's paintings displayed a sketchy, impasto style, it is often written that he influenced McLaughlin's

Fig. 12.5. M. Louise McLaughlin's studio in her home on Park Avenue, where she lived from 1887 to 1892. *Courtesy of the Cincinnati Art Museum, Theodore A. Langstroth Collection, Mary R. Schiff Library*

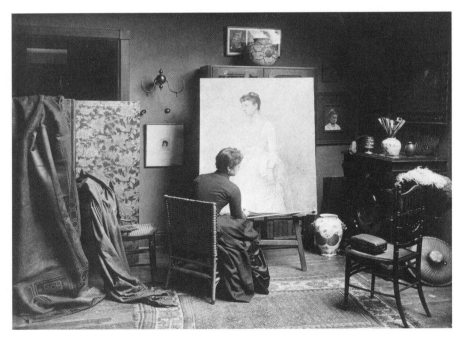

Fig. 12.6. Mary Louise McLaughlin in her studio in 1888, when she was forty-one years old. The studio was in her home on Park Avenue. The large portrait in front of her depicts Clara Chipman Newton. *Courtesy of the Cincinnati Art Museum, Gift of Theodore A. Langstroth (Library Transfer), 1986.85*

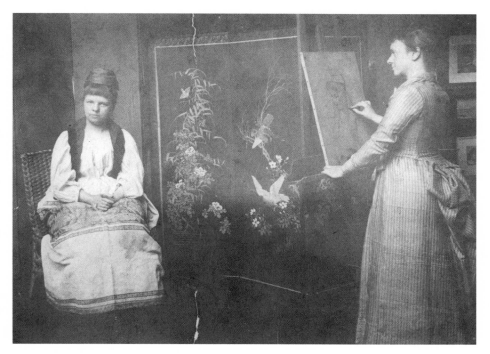

Fig. 12.7. M. Louise McLaughlin *(right)* in her studio with Clara Chipman Newton, ca. 1890.
Courtesy of the Cincinnati Historical Society Library

underglaze slip decoration. This is obviously impossible because, by the time she took Duveneck's course, she had not produced any faience for five years.

It is also sometimes written that Louise McLaughlin taught an art class. She emphatically said, "I have never taught anything."[6] She often invited a few of her friends from the Duveneck class to meet at her home and draw from a model. In 1887 she and her brother George had moved to a house they had built on Park Avenue, a ten-minute walk from the museum. The upper story of this house was lit by a skylight and was used as a studio by McLaughlin (fig. 12.5, 12.6, and 12.7). Here she and her classmates, both male and female, would practice, but there was no teacher. Louise was often asked to teach, especially pottery decoration, but she always refused: "I was intent only on learning and missed a good opportunity for financial return by refusing, but I was *not* a teacher."

In November 1892 Louise McLaughlin had what was probably the most important exhibition of her career. It was a one-woman show held at Frederick Keppel & Co. in New York City.[7] The versatility of the artist was revealed in oil paintings,

watercolors, woodcarvings, etchings, dry points, art pottery, and etched decoration on metal. Of the art pottery, twenty-three objects were painted porcelain, five were examples of the underglaze slip technique, and one was a modeled tile. The art pottery comprised only about one-fourth of the exhibition. The catalog stated that it was Louise McLaughlin's discoveries in underglaze slip decoration that were the foundation of Rookwood Pottery. This point was soon to be challenged, but at the time of this exhibition, it was commonly accepted without opposition. The catalog also corrected the "general opinion" that Miss McLaughlin had a business interest in The Rookwood Pottery Company. Her methods were followed there, but she had never been an employee. The Rookwood blanks that McLaughlin used when the Pottery Club was firing at Maria's firm had the pottery's name impressed on the bottoms. Consequently, there were many Rookwood-marked vases with Louise's name on them, a state of affairs that generated confusion. Clarification of the matter was important to her.

The catalog also emphasized that Miss McLaughlin was a lady of independent means who had never been forced to produce "pot boilers," or pieces that sacrificed artistic integrity for the sake of marketability. She was totally "untrammeled by the sordid necessities which have forced so many artists to play false to their own artistic conscience." It seems curious that this information was included unless one knows that Louise's provider, her brother George, was dealing with the failure of his business at the time. Perhaps she wanted to assure the Cincinnati social community, where no secrets were sacred, that she and her brother were doing well. That Rookwood was founded on McLaughlin's methods, that she was not associated with the Rookwood firm, and that she was not in need of money, were three major points in a one-page catalog essay. All three presaged events in the year to come.

Eighteen ninety-three was probably the worst year of Louise McLaughlin's life. Part of the heartache revolved around the World's Columbian Exposition in Chicago, and an understanding of the events leading up to this affair is necessary to explain its great effect upon the artist. Louise McLaughlin's involvement with the exposition began with an apparently trivial incident in 1891. Lida Rose McCabe reported in a Cincinnati newspaper that in February of that year, the National Ceramic Association was organized in Chicago.[8] The purpose of the association was to advance the ceramic arts and secure the finest possible ceramic exhibit at the 1893 exposition. The president of this association was Louise McLaughlin. With her as officers were Mrs. Benjamin Harrison as first vice president, and Miss Mary J. Lyster as secretary.

"Amateurs," defined as anyone who had not served a professional apprenticeship, were eligible for membership, men as well as women, for an annual fee of one dollar and fifty cents. The money was to be used to distribute practical information among the members. The association's exhibit was to be displayed in the Liberal Arts Building, with "specimen work" sent to the Woman's Building. In spite of all this planning, nothing seems to have materialized. When questioned about the association in 1938, Louise McLaughlin simply stated, "I do not remember Miss McCabe. . . . I think [the National Ceramic Association] must have been abandoned because of their other interests and the death of the Vice President Mrs. Benjamin Harrison. . . . It seems a strange confession to make that I do not know anything about a society to which I was assigned as President but I am sorry to say it is true."[9] If the National Ceramic Association continued at all, it was without the knowledge of its president. It is not surprising that McLaughlin would have been asked to be the titular head of this Chicago-based club. Her name alone would have added a cachet to any ceramic organization. If the association had a meaningful history, Louise McLaughlin did not play an active part in it. She did, however, play an active part in the reorganization of the Cincinnati Pottery Club for its display at the Chicago World's Fair. This Cincinnati contribution was to be the source of much controversy that would once again heat up the rivalry between her and Maria Longworth Storer.

In the spring and summer of 1890, Mrs. Storer was preoccupied with her husband's congressional campaign.[10] The campaign was successful, and Bellamy Storer Jr. was elected to the 52nd Congress that convened on March 4, 1891. Involved with his campaign and election, Maria totally lost interest in the Rookwood Pottery, and according to William Percival Jervis in an article for *Pottery, Glass & Brass Salesman*, in 1891 she gave the company as a present to her manager and good friend, William Watts Taylor.[11] This date is questionable since, in Rookwood's annual report to the stockholders for the year ending January 31, 1891, Taylor records that "the business was taken over as it stood on February 1, 1890."[12] This would have been about the time that Maria left Rookwood to further her husband's political career. Taylor immediately took action to incorporate the firm, and on May 1, 1890, William Watts Taylor received 380 of the 490 shares of stock issued by the company. Whatever the actual date of the gift of the Rookwood Pottery to Taylor, it is important to note that Taylor was a consummate businessman. Under his direction, Rookwood took great pains to patent all of its techniques in order to keep competitors at a disadvantage. One of the methods that it patented was Louise McLaughlin's technique for

pottery decoration under the glaze. Louise was unaware of this until much later in life, but the first instance in which she felt its effect was at the Chicago World's Fair.

In 1891, when the Columbian Exposition was being organized in Chicago, it was decided to have a Woman's Building to display the contributions of women to art and industry. Mrs. Potter Palmer, a leader in the organization of the Woman's Building, wrote to Louise McLaughlin and Clara Chipman Newton urging the necessity of an exhibit by the Cincinnati Pottery Club because of the quality of its work and the importance of the club in women's history.[13] McLaughlin called the club together once more to plan an exhibit that would accompany other arts in the Cincinnati Room of the Woman's Building at the World's Columbian Exposition. The women of Cincinnati, including the Pottery Club members, were galvanized into action to make the Cincinnati Room the finest one in the Woman's Building. It was a tribute to Cincinnati that it was the only city in the world to be honored with a room of its own. The president of the Women's Columbian Exposition Association of Cincinnati was Mrs. Elizabeth Perry.[14] Because of ill health, Mrs. Perry soon became honorary president and Miss Annie Laws assumed the presidency, but Mrs. Perry was still a power to be reckoned with.

The Cincinnati Room was a great central room on the second floor, overlooking the main entrance. Clara Chipman Newton was in charge of arranging all the exhibits in the room, including paintings, sculpture, ceramics, woodcarving, art needlework, and books written by Cincinnati women. Clara and her committee worked at unpacking the china in the chilly room on "one long cold day."[15] Clara was right to insist that the frigid weather in Chicago was "no half-way affair." After many cold hours without food, Annie Laws and some others went foraging. They returned "triumphant" with huge bread-and-butter sandwiches and bottles of beer. With no glasses from which to drink the beer, the pragmatic group used the china-painted cups and saucers that were to be displayed in the exhibit. "We drank to the health of the unsuspecting owners, and to the success of the Exposition," Clara later recounted. The china, which "could never tell how it had fallen from its high estate," was then carefully washed and placed in the glass display cases. In the end, the installation was considered a grand success.

The Cincinnati Pottery Club exhibit totaled 280 objects.[16] Louise McLaughlin contributed no fewer than sixty-eight of them: forty-four were ceramics, twenty-one were etchings on metal, two were oil portraits on canvas, and one was an embroidered table cover. Of her ceramics, eleven comprised a "Historical Collection" represent-

ing the beginnings of art pottery in Cincinnati. This included her two underglaze blue plates with the questionable 1875 dates, one 1876 Martha Washington teacup, and three eggcups painted with portraits. Also included were her first example of underglaze slip decoration (the upside down teapot from 1877), four additional faience vases, and a carved vase. The remaining thirty-three ceramic objects by McLaughlin were examples of painted porcelain, most with gold and silver decorations. Cincinnati newspapers were very impressed with the show. The *Cincinnati Enquirer* noted, "The Pottery exhibit is something wonderful, especially the work of Miss Louise McLaughlin, President of the Pottery Club."[17] With the exception of the Historical Collection, virtually all objects were for sale. McLaughlin sold twenty works, including eight ceramic examples, for a total of $192.50.[18] The most expensive item that Louise sold was the embroidered table cover for $40.00. Her ceramics sold from a low of $3.00 for a "pink and silver" plate to a high of $20.00 for a jardinière. The average price paid for her ceramics was between $8.00 and $15.00 each.

The Cincinnati Pottery Club's exhibit at the World's Columbian Exposition was the final display in the club's history. McLaughlin's group was never reactivated, although many of its members soon organized a similar organization called the Porcelain League. When, in September 1893, the Chicago Art Institute hosted the Ceramic Congress, the Cincinnati Pottery Club was noted "again and again" for its preeminent position as the model that generated many similar organizations.[19] Clara Chipman Newton later wrote:

> Perhaps the Columbian Exposition was a fitting port in which to bring the good ship "Cincinnati Pottery Club" to anchor. Its crew had like Columbus, voyaged into the unknown. The thousand little ripples the vessel had made, had broadened into a great and far reaching circle which had more influence than we at the time realized possible over the Ceramic Art of the Country.[20]

Louise McLaughlin attended the Chicago fair the week of June 23, 1893.[21] While there, for the first time, she saw the catalog for the Cincinnati Room that had been written by Clara Chipman Newton. In the section under "Pottery," Clara recounted the history of art pottery in Cincinnati and wrote that Louise McLaughlin "discovered the method of decorating under the glaze that is still used as the foundation principle of the work at the Rookwood Pottery."[22] This little piece of information was to cause the final explosive burst of animosity between Louise McLaughlin and Maria Longworth Storer. While at the fair, Louise was told that William Watts

Taylor, the former manager and current president and treasurer of The Rookwood Pottery Company, objected to Clara's statement. At a meeting in Chicago, the Conference Committee of the Women's Columbian Exposition Association of Cincinnati, against the objections of Miss Newton and Miss McLaughlin, voted to withdraw the statement if Taylor would pay the expense of reprinting the catalog.[23] Mrs. Elizabeth Perry was behind the vote. On June 30, when McLaughlin returned to Cincinnati, she immediately wrote to Taylor, "I am very much surprised to hear that you have taken it upon yourself to dispute a statement which is so obviously true."[24] She proceeded to argue, correctly, that the proof was in the process. *Her* process, not Volkmar's or Bennett's, was in use at Rookwood. Moreover, her book *Pottery Decoration under the Glaze* was in print before The Rookwood Pottery Company was opened. Louise's book was published in August 1880, and, even though Maria began converting the old schoolhouse into a pottery in April, she did not draw its first kiln until late November of that year. And if this were not proof enough, T. J. Wheatley had learned the process at Coultry's and began teaching it to others, including Albert Robert Valentien, who was the first "regularly employed" decorator at Rookwood.[25] Even the foreman at the Dallas Pottery, Joseph Bailey Sr., who had helped Louise in her experiments, was now employed by Rookwood. McLaughlin found it incredible that Taylor would not accept her part in the discovery of the underglaze slip technique used by The Rookwood Pottery Company. Trying to be gracious she said:

> It was my misfortune that I was not in a position to continue my experiments and to bring them to the culmination that Mrs. Storer was able to effect. I have accepted the situation philosophically, however, and have never had any feeling except of pride and pleasure that in the Rookwood Pottery it has been possible to produce what I have had no hesitation in saying is the most artistic pottery in the world.[26]

She then made her closing point:

> Considering the fact, however, that in its original inception, you owe the idea to me that my experiments educated the workmen who now handle the Rookwood wares, and that it is essentially my process that produces them, it would seem that common justice would demand that you should acknowledge the source. Justice is all I ask, I do not expect gratitude.

Two days later she wrote to Clara Chipman Newton to thank her for her support in the matter and to bemoan Mrs. Perry's position: "As for Mrs. Perry, no one should know better than she, the truth in regard to the point in question."[27] McLaughlin was correct. Mrs. Perry had visited Louise, urging her to teach her underglaze slip technique to women long before Maria ever thought of a pottery of her own. Louise now felt Perry's long-delayed wrath for refusing her request. Perry conveniently seemed to have forgotten that in the May 29, 1880, issue of *Harper's Weekly*, she had emphatically stated, "Miss McLaughlin was the first to discover the secret of Limoges."[28] Did she also forget that in the May 1881 issue of *Harper's New Monthly Magazine* she wrote, "It is said that unsuccessful efforts have been made in different parts of Europe to imitate the faience of Limoges. However this may be, there is no doubt that in the United States we are indebted to the intelligent interest and persistence of Miss McLaughlin for its accomplishment."[29] It strains credulity that she forgot. Louise knew immediately why Perry was siding with Mrs. Storer: "The old animus remains."[30] It should also be noted that Mrs. Perry was a feminist with a power base among the wealthy women of Cincinnati. In taking sides with Mrs. Storer, she was aligning herself with a congressman's wife, who was a social leader and the richest woman in Cincinnati. Storer was more important to Perry than McLaughlin, even though the founder of Rookwood Pottery was no more a feminist than was McLaughlin, the discoverer of underglaze slip decoration.

On July 3, William Watts Taylor politely responded to Louise McLaughlin's letter. He did not choose to pay for a reprinting of the catalog. He was only representing Mrs. Storer's belief and did not wish to continue the matter "for the obvious reason that I was not personally connected with Rookwood at the time and further that I might be easily misunderstood as detracting from your well known services to decorative art. It is possible to have, as I do, the highest admiration for your talent and artistic achievement in so many directions while not admitting Rookwood in any way to have them."[31] In effect, by replying that he was simply representing his employer's belief, he removed himself from the line of battle between McLaughlin and Storer. As for his compliment, it could have been as genuine as it was politic. Herbert Peck, in *The Book of Rookwood Pottery*, states that Taylor "formed a dislike for Miss McLaughlin" prior to closing Rookwood's doors to her Pottery Club.[32] Actually, the decision to stop firing the club's wares was more of a business decision than the outcome of any personal vendetta. Taylor's actions where McLaughlin was concerned were always marked with professionalism and respect, even after she was

forced to leave Rookwood. The company's letterpress books that record Taylor's business correspondence bear this out. When asked in February of 1892 about McLaughlin's book on china painting, Taylor wrote that it was "practical and good and we presume would give full directions about using gold."[33] In another letter Taylor was asked to suggest judges for the 1889 Philadelphia Exhibition of American Art Industry. He responded, "I believe that Miss M. Louise McLaughlin (whose works in china painting etc. are well known) would be the most competent person you could secure."[34] Unlike Mrs. Storer, Taylor was never in personal competition with McLaughlin. His interests were purely of a business nature, and his objection was purely a business matter. Public recognition of McLaughlin as the founder of underglaze slip decoration, then in use by Rookwood, would void his pottery's patent on the technique. It is quite possible that when his firm acquired the patent, he sincerely thought that Rookwood had developed the technique. Apparently that was what he was led to believe by Mrs. Storer. Being astute, he quickly bowed out of the controversy, allowing the two women to fight it out between themselves.

When McLaughlin was informed by Taylor that he was carrying out what he knew to be Mrs. Storer's belief in the matter, she immediately wrote to her old adversary. In a letter of July 9, to "My dear Mrs. Storer," McLaughlin claimed that Rookwood was "indebted to me for the original idea and that my process is the foundation principle of that now in use there. . . . Any true history of the introduction of this pottery into Cincinnati must give me credit for having furnished the idea upon which the industry has been founded."[35] One can just imagine the surge of emotion that Maria experienced upon reading the letter. Because she was in Europe, she did not respond until September 3, after she had returned to Washington, D.C. "I must set you right—I have always admired your work as a decorator—but the method of decorating wet clay with slip was familiar to me in ceramic books, in Gallé's work at Nancy, in pieces done at Limoges and imported by Briggs of Boston as early as 1874 or 5, and in the Philadelphia Exposition of '76."[36] Her claim was absurd. At the time, there were no books that discussed the process of underglaze slip decoration. Furthermore, the work by Gallé and that done by Haviland, in Paris (which was thought, erroneously, to have been done in Limoges) were created by a method different from that used at Rookwood. As if this claim were not preposterous enough, Storer continued, "I have really never known how or where your work was done and I must plead guilty to not having read your book on underglaze decoration." She knew exactly how and where McLaughlin's work was done. Indeed, she practically monitored it while at the Dallas Pottery, not to mention while the

Pottery Club was renting a room at Rookwood. Storer completed her letter with a well-placed knife: "Your reputation can rest so well upon what you yourself have done, that it is not necessary that you or anyone else for you, should seek it in outside things with which you have had absolutely no connection." Like Mrs. Perry, Maria seems to have had a convenient memory. When she was interviewed by the *Cincinnati Daily Gazette* for an article of October 7, 1880, she had said, "Miss McLaughlin used to do Limoges work before Mr. Wheatley ever thought of such a thing."[37] And, of course, Mr. Wheatley was doing Limoges work before Mrs. Storer.

Louise McLaughlin responded immediately to the attack. Refuting Storer's letter point by point, she concluded, "That the process referred to is the foundation principle of the Rookwood ware cannot be *denied*. . . . I am not disposed to admit the justice of your objection to the statement of the fact."[38] The battle raged on when Storer responded on September 14, "There is not the slightest doubt that you painted clay before I did—so did the [ancient] Egyptians—I still think that having started overglaze painting in '73, I would have gone on just as I have gone with my books and foreign work to help me. I really think that if you had never painted, the Rookwood Pottery would have been the same."[39] McLaughlin would not desist without the final thrust. In a responding letter of September 16, she pointed out that the reference to the ancient Egyptians was hardly fair since they did not produce anything that resembled Rookwood.[40] Furthermore, she argued, "That the Rookwood Pottery should have followed my introduction of it [i.e., underglaze slip decoration] here is a coincidence which admits of but one history of the matter. But, unfortunately I cannot now take back my part in the affair in order to prove the truth of my assertion and so it must stand. I cannot consent to efface myself or to be effaced from the history of the time." This was the last time that the two ladies ever actively engaged in their rivalry. The battle, indeed the war, was over, and it was left to history to determine the winner.

If Louise McLaughlin was deeply hurt by Maria Storer's claims, she was genuinely angered by the fact that Mrs. Elizabeth Perry sympathized with the Rookwood founder. During the course of her correspondence with Storer, Louise was informed that her letter to Taylor had been shown to Mrs. Perry.[41] This pleased her because Mrs. Perry's involvement gave her the opportunity to ask Perry for an explanation. On August 18, 1893, she shot a letter off to "My dear Mrs. Perry":

> When, as in this case its [i.e., underglaze slip decoration's] origin can be so distinctly traced, it seems to me that common courtesy should indicate an acknowl-

edgement instead of a denial of facts. . . . In view of these facts, I have been surprised and pained to learn that one who should know the history of that time as well as yourself should not be inclined to give the credit where it justly belongs. . . . I beg to ask an explanation of your point of view.[42]

On September 4 Mrs. Perry responded that her opinion in the matter was of no value to either McLaughlin or Storer.[43] The question, she felt, was one of a purely personal interest between the two. Having made that pusillanimous point, she then went on to say that she was unaware that McLaughlin claimed to have discovered the underglaze slip technique that was the founding principle of Rookwood, stating, "It was a thorough surprise to me." Her letter was the epitome of politeness and absurdity as she continued to argue that "you have both done so much there is no need of, nor room for rivalry between you." Then she drove home her blatantly biased point of view: "My judgement [sic] and belief has always been that the processes used at Rookwood were independently adopted, were the result of individual experiment, judgement and taste on the part of the foundress, and not borrowed from, or even resulting from the experiments being made by others at the same time, in the same line of work." Barely able to contain herself, Louise replied on September 8. She pointed out that Storer had copied her own process "so closely that even the defects due to my inexperience were retained." Again she insisted that it was not coincidental that it was *her* underglaze process, not Volkmar's or Bennett's, that was in use at Rookwood. In the end, she felt that the acknowledgement of her part in the introduction of the industry to Cincinnati was nothing more than an act of courtesy that she deserved. Mrs. Perry never bothered to respond to this letter, and the two ladies never dealt with each other again.

To be female and to have Perry and Storer against you in Cincinnati's art world was a detriment. Louise McLaughlin felt the pain of losing the recognition that she deserved. Writing to Clara she lamented, "It is very unpleasant for me to press my claims to recognition and I feel sometimes that the time may come when I shall be so tired of the matter that I shall cease to take the trouble to do so."[44] Clara's position throughout the noisy stir was squarely with McLaughlin. She, too, had felt the sting of Maria Storer when she was dismissed from Rookwood on May 31, 1884, approximately one year after William Watts Taylor was hired.[45] But Clara was able to remain objective in the matter. Since her propriety was impeccable, she did not burn any bridges when she was forced to leave Rookwood. Although her friendship with "Ia" was not as strong as before, it was not altogether lost. As a close friend of both

Maria and Louise during the foundation of the history of art pottery in Cincinnati, and as secretary of both Rookwood and the Pottery Club, Clara knew the history of underglaze slip decoration in Cincinnati better than anyone. She wrote her catalog essay in a truthful manner and continued to defend it against two of the most powerful women in Cincinnati. While Louise and Clara had always been good friends, their friendship quickened because of this event and remained strong until their deaths.

McLaughlin was genuinely saddened by her apparent loss of recognition in the history of Cincinnati faience. It was a blow that hit her hard, but not as hard as life's next incident. The early 1890s brought a financial depression to the United States. Louise's brother George (fig. 12.8), who was president of the Fireman's Insurance Company of Cincinnati, was struggling to keep his firm alive. A 1920 history of fire insurance companies in Cincinnati paints a bleak picture for that business. In 1871 there were thirty-three local companies; in 1873 the number declined to twenty-three; by 1920 the decline was so marked that there were only two such companies left, and they were operating under one management.[46] Fire insurance was a business field with inherently poor prospects. Specific information on George's Fireman's Insurance Company of Cincinnati is not available, but the Cincinnati Directory lists the firm for the last time in 1892. Apparently it failed early that year or late in 1891. In 1892, Cincinnati's society register, *Who's Who?*, lists M. Louise McLaughlin and her other brother, James McLaughlin, but not George. George seems to have lost his place in society that year. The Cincinnati Directory notes that by 1893 he had opened his own accounting business, George McLaughlin & Co., in room 45 of the Johnston Building in downtown Cincinnati, the same building in which James McLaughlin's architectural firm was located. Some work obviously came his way. The Board of Review of the City of Cincinnati issued a report made by Special Examiner George McLaughlin on December 2, 1892, regarding the affairs of the City Waterworks.[47]

Still, things did not seem to be going well. In 1892, for an unknown reason, perhaps financial, Louise and George moved from their home on Park Avenue to one in Seminary Block, located on the Lane Seminary grounds in Walnut Hills. Louise became alarmed as her brother progressively grew despondent over his business affairs.[48] Late in September 1893, she became fearful about his state of mind. To calm her fears George promised, "I will never commit suicide," but his depression seemed to be driving him to desperation.[49] On Wednesday, October 11, Louise went to see a Dr. Forchheimer and asked if he would call on her brother that evening, for she felt

Fig. 12.8. George McLaughlin in his office. *Courtesy of Rosemary and Don Burke*

that George was in very serious condition. Dr. Forchheimer agreed to do so, and Louise started for home. At the same time, approximately 6:15 P.M., George, "in a fit of temporary aberration," took a revolver from his room and went to the dining room, where he stood in the middle of the floor. He unbuttoned the lower buttons of his vest, placed the muzzle of the .42 caliber Colt against his right side, and fired a shot. He then turned, throwing the revolver under the table, and staggered through the hall to the foot of the stairs. Louise heard the report as she was returning through the side door, and rushed inside to see her brother fall moaning to the floor. The servants heard a thump and two shrieks as they hastened to the hall. Not fully understanding his true condition since the bullet wound was under his vest and there was no sign of blood, the three endeavored to raise the suffering man and then, abandoning that effort, placed a pillow under his head. They sent for Rev. Morse, who lived next door, and for Dr. Caldwell, a physician who lived nearby. Rev. Morse tried

to talk to George, but it was too late. Dr. Caldwell came a few moments later, only to find that George had no pulse. At that point, one of the servants came crying into the hall with the revolver in her hand. The gun was still smoking. With that, Dr. Caldwell threw open the vest and found that the shirt just above the waistband was burned with powder and marked by a circular hole. The undershirt was also powder-stained, but displayed only a slight trace of blood. The bullet had entered the right side, penetrating the liver and causing death in a few minutes. The hemorrhaging had been nearly all internal.

Coroner Querner thought it curious that a man would shoot himself in the right side since chances are against such a wound being fatal. However, after visiting McLaughlin's home the next day and talking to Louise and the servants, he declared the death to be a suicide. Sixty-two years old at the time of his death, George had a private burial at 2:30 p.m. that Friday, October 13, 1893.

Louise was devastated. She and George had been inseparable. One newspaper reported:

> A steadfast devotion to his sister, Miss Louise McLaughlin, also an artist of attainments, was a feature of his character which was much commented upon by those who loved to study the delightful characteristics of his nature. It seemed that he lived for her alone, and his entire efforts were put forth that her every wish might be gratified, and so deep was affection between these two that neither ever married.[50]

George had meant everything to Louise. He had been the mentor of her art career. He had taken her to the Coultry Pottery, where she had first seen blue bands being painted under the glaze on yellow ware and had thought she might be able to do something similar. He had accompanied her whenever she was interviewed by a reporter. When there was a dating problem with Louise's underglaze blue plates, George had checked his records of shipment for the correct dates. When there was the "War Among the Potters" at the time of Wheatley's patent claims, George had been interviewed instead of Louise for her side of the story. In short, George had promoted her art, managed all her business, pressed all her claims, and solved all her problems. It was significant that he had not defended her position in the latest dispute regarding her recognition as the discoverer of the technique that was the founding principle of Rookwood Pottery. Normally, he, not Louise, would have sent the letters of defense to those in question. Obviously, he had been in no mental

condition at the time for such an exercise. Now Louise was forty-six years old and by herself for the first time in her life. It was a shattering experience.

McLaughlin's strong-willed nature helped her through her brother's suicide, but afterwards she neither joined nor led any art group again. On January 10, 1894, some members of the old Pottery Club, along with some of the more recent china painters, formed the Porcelain League.[51] The League's records show that Louise McLaughlin never joined the group, even though she was always listed as an honorary member.[52] Instead, for the first time since she was forced to stop working with her underglaze slip technique in 1885, McLaughlin began once again to work in wet clay. She decided to try out a method of decorating with inlays of clay. The idea for the method seems to have occurred to her in 1893. In a letter to Mrs. Potter Palmer, dated October 31, 1894, Louise wrote, "Last year, however, whether it was that the controversy with the Rookwood recalled the subject or not, a new idea occurred to me."[53] Louise was familiar with inlaid clay decorations from her knowledge of Faience d'Oiron or de Saint-Porchaire, a sixteenth-century lead-glazed earthenware with inlaid decoration associated with the French towns of the same name. This ware, which is particularly rare, is made of a light, cream-colored body decorated with inlays of more deeply colored clays in very intricate patterns. The secret of the technique, which seemed impossible in clay, died with the inventor. The product, if not the process, was copied in the nineteenth century and called Henry II ware. McLaughlin saw copies in the Boston Museum.[54] She later wrote, "It was always a mystery how such delicate work as these inlays in the clay could be done." Just as with the Limoges faience, she decided to solve the mystery.

This time the work was carried out at the Brockman Pottery, originally Tempest, Brockman & Company, where Louise had fired her first underglaze blue work in the 1870s.[55] Still smarting from the denial of her part in the invention of the underglaze slip technique, McLaughlin was not going to be caught legally defenseless again. On September 25, 1894, the undaunted ceramist received a patent for the inlay technique that she had devised. It was the only patent for which she ever applied. To date, no objects that represent this technique are known; however, patent no. 526669 explains the process.[56] The decoration that is to appear on the surface of a vase is painted in reverse with slip on the interior of the mold. The composition soon becomes dry by the mold's absorption, and the vase is then formed by pouring in the liquid clay. Once the mold has absorbed sufficient moisture from the liquid clay to cause a deposit of the desired thickness on its inner surface, the surplus liquid is poured out.

Fig. 12.9. Ceramic tile, 1886, decorated by M. Louise McLaughlin. Made by the Kensington Art Tile Co., Newport, Kentucky. *Courtesy of the Cincinnati Art Museum, Gift of Theodore A. Langstroth, 1970.607*

When dry, the vase is removed. The decoration originally on the inner surface of the mold will have become incorporated into the body of the ware. Edwin AtLee Barber illustrates one such vase in a later edition of his *Pottery and Porcelain of the United States.*[57] Along the upper edge of the vase, where one can view a cross section of the body, it is obvious that the decoration was inlaid into the clay rather than painted on its surface. This is perhaps the only way to detect the inlay technique.

In 1895 McLaughlin submitted examples of her new inlay work to the Cotton States and International Exposition in Atlanta, Georgia, where she was awarded a gold medal for her new process of pottery painting. Shortly thereafter she discontinued working in this method because, not owning her own pottery, she was unable to control the entire process. When the patent expired in 1917, McLaughlin did not choose to renew it.

The only other ceramic work Louise pursued was at the Kensington Art Tile Company in Newport, Kentucky, across the Ohio River from Cincinnati. Little is known of her work there, except that she designed some tiles sometime after 1885 and before 1898. Her few existing examples (fig. 12.9) display portraits or figures in relief under a tinted glaze. Louise no doubt designed and carved the images from which the molds were made. It was later with her work in porcelain that she made her own

Fig. 12.10. The home of M. Louise McLaughlin at 2558 Eden Avenue, Mt. Auburn, Cincinnati. It was behind this house that she had her porcelain kiln. *Courtesy of the Cincinnati Art Museum, Theodore A. Langstroth Collection, Mary R. Schiff Library*

molds, but she had taken an active interest in them as far back as her first under-glaze slip work at Coultry's, where she designed the molds she used. Later, when discussing her inlay technique, she made a point of saying that she molded her vases, that is, she poured the liquid clay into the mold herself.[58] Her experience with designing and pouring her own molds served her well, since it paved the way for her future in porcelain.

After her brother's death, Louise McLaughlin began to occupy herself with, among other things, writing a book that had nothing to do with ceramics. *The Second Madame,* published in 1895, was a biographical sketch of Elizabeth Charlotte, Duchess of Orleans. McLaughlin had always shared an interest in history with her brother George. *The Second Madame* was the first of several history books she was to write.

The only ceramic work Louise produced between 1895 and 1898 was china paint-ing. In 1897 McLaughlin traveled to New York to be a judge in the National China

Painters' Competition. A newspaper account of the event states, "Miss McLaughlin expressed great admiration for the Royal Copenhagen Porcelain and stated she was experimenting to see if these same effects could be had in Belleek china, which is not subjected to such heat as the Danish porcelain."[59] Evidently, McLaughlin was experimenting with her china painting by adapting Royal Copenhagen compositions on Belleek blanks. Her admiration for Royal Copenhagen continued when she herself began working in porcelain one year later.

In 1894, shortly after her brother George died, she moved to 6 Oak Street near Gilbert Avenue, and by 1897 she was renting a house (fig. 12.10) at 2558 Eden Avenue in Mt. Auburn, not far from her brother James's home. It was at her Eden Avenue address that she decided to make porcelain. The decade of the 1890s had been painful for Louise McLaughlin. It was only fitting that she should end it with a new beginning, this time in porcelain. At the time of her death, she considered her work in porcelain to have been the most important in her ceramic career.

chapter 13

LOSANTI WARE:
PORCELAIN, 1898–1906

"It was early in the year 1898 that I went about the consummation of a long-felt desire to work in clay again. . . . My ambition was no less than the making of porcelain," wrote Louise McLaughlin in the Losanti Record Book, her personal ledger chronicling the shapes, glazes, bodies, and porcelain objects that she produced from 1898 to 1904.[1] She discussed her desire to work again in clay with Charles Fergus Binns, English-born ceramist and teacher, when he visited her early in 1898.[2] Charles Fergus Binns had left the Royal Worcester Porcelain Works in England for better prospects in America.[3] Arriving in New York by October 1897, he spent the next winter touring the United States, lecturing, writing, and trying to find a job. He was, no doubt, investigating the job possibilities in Cincinnati, when he accepted an invitation to dine with Louise McLaughlin. Binns knew her reputation as well as her work, which he had seen at the World's Columbian Exposition in Chicago. The dinner conversation inevitably turned to ceramics. Louise, now fifty years old, wanted to get back into the field, but was not certain which direction to take. Although still china painting, she did not see this as equal to working in wet clay. "Why do not *you* try to reproduce the *grand feu* of the old French and Oriental porcelains?" Binns asked.[4] With this, he planted the seed from which the history of American studio

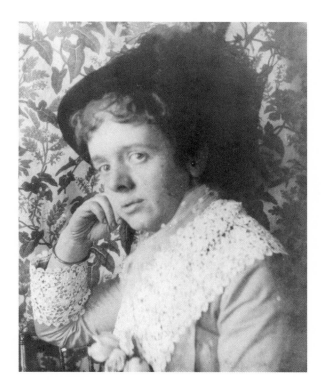

Fig. 13.1. M. Louise
McLaughlin, 1890s.
Courtesy of Tom White

porcelain took its course. It is a tribute to McLaughlin that the eminent ceramist
would suggest that she try something so problematic that it had yet to be attempted
in the United States. She had no sense of the difficulties inherent in Binns's sugges-
tion: "I knew little what I was undertaking, and perhaps it was better not to have
realized too many difficulties that would bar the way. Had I realized then, it is prob-
able that the Losanti ware would never have existed. As it was, I set to work, brave
in the strength of ignorance of what was before me."[5]

The first order of business was to obtain a kiln in which the very high tem-
peratures needed for porcelain could be obtained.[6] She tested two small gas kilns,
only to find that it was impossible to reach the heat necessary for melting even the
softest porcelain glazes.[7] Natural gas, or petroleum, which according to the artist
would have solved all her problems, had not yet been brought to Cincinnati. Louise
wanted an electric kiln but could not afford the $1,000 to have it made.[8] Instead,
she took the advice of a potter and decided to have a small brick kiln, fueled by
coal, built in her backyard (fig. 13.2). Before the snow was off the ground that winter,
a carpenter was employed to build a small frame house that would serve as a shel-
ter for the kiln and a workroom for Louise. Once the little house was built, the brick

Fig. 13.2. Digging ground to build the backyard kiln. *Courtesy of Tom White*

kiln was erected. When all was completed, the little kiln room, measuring eight by twelve feet, enclosed the kiln whose chimney projected through its roof. The little workroom attached was ten by twelve feet. The kiln (fig. 13.3), which was rectangular in form and had an arched roof, was about twenty-seven inches at the highest part of the arch and about twenty inches high at the sides. The space of the kiln floor that was to receive the saggars, or containers that held the porcelain during firing, was about twenty by twenty inches. Depending on the size of the objects, McLaughlin could fire from six to twenty-four pieces at a time.[9]

All was ready for the first firing when the potter, a Mr. Scott, and his assistant arrived early in the morning on St. Patrick's Day, March 17, 1898. The first trial was simply to demonstrate that the kiln would draw. Anthracitic coal was the fuel of choice to limit the emission of smoke that might annoy the neighbors. From the start the kiln became choked with coal, sending up a column of smoke that clouded the surrounding area. Irate neighbors complained and requested in writing that hence-

Fig. 13.3. M. Louise McLaughlin making porcelain in her backyard. She broke the unsuccessful pieces with a hammer. *Courtesy of the Cincinnati Historical Society Library, Ross C. Purdy Collection*

forth McLaughlin use anthracite. Since that was the coal that had caused the smoke in the first place, the artist decided to try soft coal for the next test, which would include the firing of clay objects.

McLaughlin had given the potter a formula for porcelain that she had obtained from printed letters (*Lettres édifiantes et curieuses*) written between 1712 and 1724 by the Jesuit Père d'Entrecolles.[10] D'Entrecolles gave an intimate picture of the life and industry of the great Chinese porcelain center Ching-tê Chên, including a generalized formula for Chinese porcelain, which he said was made in the proportions of six parts of petuntse to four of kaolin. McLaughlin thought the proportions were similar to those used by Sèvres, the French national porcelain manufacturer. The d'Entrecolles formula was the only printed technical information available to her. For every step in the complex and mysterious process of producing porcelain, she had to rely on her own ingenuity. Eventually, she even had to devise her own clay body when the formula, for which she mistakenly transposed the proportion of the

materials, proved unworkable. Today, with innumerable books, articles, and courses on the subject, it is difficult to imagine making porcelain with virtually *no* technical information whatsoever. Since Louise was the first studio potter to work in porcelain in the United States, she could not even seek the advice of colleagues, although she did consult with Binns at a later stage. For the time being, she had to rely on the potter and the d'Entrecolles clay formula. The potter informed her that he had taken liberties with the formula, but did not say how he had changed it. He placed Louise's objects in the saggars, filled the kiln, and returned the next morning with his assistant to begin the firing.

After working with the kiln the entire day, they could not achieve the prescribed temperature. The potter, deciding that something was wrong with the kiln, sent for the builder, who arrived in an inebriated state sometime after 9:00 P.M. Since the kiln was choked with fuel, the potter and the kiln builder left it to settle while they went for a drink. When they returned by 10:00 P.M., Louise implored them to give up their efforts and go home. The kiln builder, however, was determined to prove that his kiln was constructed properly, if it took all night. At dawn Louise awoke to see the two men stealing away. They had left a note on the workbench proclaiming the kiln to be in working order.

The firing had continued so long that the objects were over-fired, and being too hard to receive the glaze, they were discarded as useless. The castaway pieces exhibited a curious blue tint in the clay. The potter had changed the d'Entrecolles formula by adding blue coloring to the mixture. He believed that porcelain should have a blue cast to its appearance, and so proceeded to help it along. The next specimens, prepared without the objectionable coloring matter, were set in saggars, placed in the oven, and biscuit fired. Later they were sprayed with glaze and set for the glaze firing.

This time the soft coal used instead of the anthracite created a dense black smoke that guaranteed trouble with the neighbors. "I knew I should hear from it again and my expectations were more than realized," wrote McLaughlin.[11] The neighbors, some with whom McLaughlin had previously enjoyed very friendly relations, believed they were being poisoned with noxious vapors and complained, not to Louise, but to the owners of their houses, to lawyers, and to the smoke inspector. Fortunately, on the day the smoke inspector visited McLaughlin, she was not using the kiln and he could not take any action.[12]

With the first glaze firing came a "ceramic cataclysm." The potter had taken liberties with the clay formula once again, inadvertently adding too much feldspar.

Consequently, when the kiln was drawn and the saggars opened, the contents were found to have melted into formless heaps that had to be chopped out with a hatchet.

All varieties of disaster continued. Pieces melted and "kissed" while bending toward each other, causing them to stick together by their glazed surfaces. In other instances, glazes melted and ran down to form thick masses at the bases of objects, attaching them to the saggars. One time the potter and his assistant broke four pieces simply filling, or setting, the kiln. Still Louise persisted.

The kiln was now being fired at night because it was easier to procure a man who performed that service at a pottery on his off-nights. Also, the firing, which lasted from seventeen to eighteen hours, could not be completed without using at least part of a night, and the neighbors were not as likely to see the smoke at that time.

On the close and murky evening of June 2, a glaze firing began that blanketed the neighborhood with a pall of smoke. Once again the neighbors complained, and this time they also threatened to call the police. Since this firing was the first to hold real promise, Louise hoped that their threat was hollow. It was, and when the kiln was opened the next day around noon, progress was at hand. McLaughlin's detailed record of her porcelain production in the Losanti Record Book begins with this first successful glaze firing of June 3, 1898. The vases were covered with a cuprous oxide (i.e., copper) glaze that affects green, blue, or red, depending on other ingredients in the glaze and the atmosphere in the kiln. The Chinese used copper glazes to produce their famous *sang de boeuf*, or oxblood, and peach bloom specimens. That June 3, McLaughlin got some oxblood effects in several of the pieces and some greens and blues in others. One of the vases, which will be discussed later, was purchased by the French ceramist Paul Jeanneney at the Paris Exposition of 1900.

To prevent a showdown with the neighbors, Louise knew that before she could fire another kiln, an alternate fuel had to be discovered or she would have to give up her experiment: "I was placed in the unfortunate position of one who finds it difficult to go forward and impossible to retreat."[13] She decided to try Connellsville coke. Coke is a coal from which most of the gases have been removed by heating. It burns with intense heat, produces little smoke, and was a common industrial fuel at the time. When McLaughlin tried it, the coke met every desire. There was absolutely no smoke after the wood used for the kindling had burned out. Moreover, the heat was so intense that the firing time was shortened from approximately eighteen hours to ten hours or fewer, which made it possible to begin and end a glaze firing in one day.

During the next several firings, the same body was used while experiments were being made with additional clay mixtures. The potter had changed the primary body so much that McLaughlin no longer knew its formula, nor did she know the composition of the new ones. The potter, who had promised to give her the formulas, never did. With his secret knowledge, he felt that he was indispensable. In fact, he had such a sense of security that he thought nothing of charging the artist four times the price of the materials he used. Realizing this, McLaughlin dismissed him and ultimately developed her own formula, referred to as "New body No. 1," which she first used in a firing of October 7, 1898. With the potter's dismissal, she also began formulating her own glazes. She soon realized that making the glazes herself enabled her to alter and better control their effects.

Louise McLaughlin eventually relied on no one but herself for her porcelain production. Managing and determining every aspect of her ware from conception to creation ranked her among the first studio potters in America and as the first one to work in porcelain. In spite of her independence, she was always quick to admit that she had invaluable assistance from her companion and housekeeper of forty-seven years, Margaret "Maggie" Hickey.[14] Hickey was an Irish immigrant who joined her sister in this country and began to work for McLaughlin around 1885. Maggie was about twenty years old at the time. While she lacked formal education, her natural intelligence was considerable. She was soon able to assist McLaughlin in every aspect of the porcelain process. By the winter of 1898–99 she was doing all the casting of the ware, and by the fall of 1901 she was also managing all the firing. At the time of Hickey's death in 1932, she was still working for McLaughlin.

A tedious series of experiments on clay bodies and glazes continued for about a year before there were any meaningful results. During this period dozens of bodies and glazes were tried.[15] Seemingly every flaw that fire could produce showed itself (plate 31). In the meantime, McLaughlin's porcelain was exhibited for the first time during the summer of 1899 at the Sixth Annual Exhibition of American Art at the Cincinnati Art Museum.[16] Twenty pieces made of the original clay and glaze mixed by the potter were on display. In August of that year the first national recognition of her work in porcelain appeared in the new magazine, *Keramic Studio*.[17] Adelaide Alsop Robineau, editor of *Keramic Studio* and later a porcelain maker in her own right, published parts of a letter from McLaughlin describing her new porcelain ware.[18] Rather optimistically, McLaughlin related that she had just about passed the experimental stage, and since all of her showpieces were currently on display at the

Cincinnati Art Museum, she regretfully could not exhibit in New York until autumn at the earliest. Continuing, she congratulated Robineau on her new magazine and wished her every success. Robineau used the article to return the compliment: "We publish portions of Miss McLaughlin's letter that our subscribers may enjoy the anticipation of hearing more about the new ware from the hands and brain of this indefatigable worker, the pioneer, one may say, of keramics in America. We wish her the success that she deserves, and we will hail with delight her exhibit when it reaches New York." Labeling McLaughlin as *the* pioneer of American ceramics was quite true. She received kudos that today demonstrates a sense of the artist's stature at the time. It is significant that Louise was no longer being compared to the founder of Rookwood. Maria Storer had been out of the field for almost ten years and, furthermore, she had never worked in porcelain. It is curious that the one artist to whom McLaughlin would eventually be most compared with regard to her porcelain was Adelaide Alsop Robineau. However, there was never any deleterious rivalry between them. In fact, they held much respect for each other.

From the middle of June to the middle of August 1899, Louise vacationed at some undisclosed seashore. When she returned, she finally began to realize positive results in her experiments with a new body and glaze. By the following February, she was able to send a display incorporating a few examples of the new body and glaze to the Exposition Universelle in Paris. Her exhibit, which was under the auspices of the Mineral Painters' League, was very well received. One connoisseur was particularly impressed. Paul Jeanneney, noted French ceramist and collector of oriental ceramics, returned four or five times to McLaughlin's display to see if he could get a reduced price on a vase.[19] He "fondled & petted" all of her pieces, finding it difficult to put them back. Finally he agreed to pay the considerable price of eighteen dollars for a vase that he said he had to have in his collection because he had nothing like it. As a collector of oriental porcelain, he immediately recognized the unique quality of McLaughlin's work. According to the Losanti Record Book, the vase he purchased was covered with a cuprous oxide glaze and drawn from the kiln on June 3, 1898.[20] It was then sprayed with a mixture of cuprous oxide and about the same quantity of French chalk, all of which was allowed to run down the vase in streaks. When re-fired, it produced a brilliant green glaze dripping with dark green streaks edged in blue. One can appreciate Jeanneney's obsession with the vase.

From May 19 to July 9, 1900, McLaughlin exhibited twenty-five pieces in the Seventh Annual Exhibition of American Art at the Cincinnati Art Museum.[21] The

works were simply described in the catalog as "Decorated porcelains." The exhibition at the Cincinnati Art Museum and the one in Paris suggest that her success rate increased with each firing (plate 32). The loss ratio in her work will be detailed later, but these exhibitions demonstrate that in two years she progressed from having zero knowledge of porcelain to displaying her work in multiple exhibitions, including an international exposition. This was a remarkable feat by any standard.

McLaughlin's one valuable source of technical help proved to be the man who suggested that she make porcelain in the first place, Charles Fergus Binns. She particularly sought his assistance in matters of bodies and glazes. From February 6 to 7, 1900, Binns visited Cincinnati to see the Rookwood exhibit that was being prepared for the Paris exposition. While in the Queen City, he also visited McLaughlin, no doubt wondering how her porcelain was progressing. Since she had just sent pieces to Paris before he called, she had very little to show him. Nevertheless, Louise later remembered, "My conversation with him was long and very interesting to me, and it was from his suggestion that I decided to try to harden the body of my ware to escape the warping that had bothered me."[22] From this point on, she actively sought his opinion. After his visit she sent him some samples of her porcelain as soon as they could be made. On June 1 she wrote Binns saying that she did not tell him the compositions of the samples because she wanted to know his opinion of the bodies strictly from appearance.[23] After detailing their formulas, she simply asked, "Will you please tell me whether you think the whiter sample more as the color of porcelain should be?" At this point she was concerned with how porcelain "should" look. Should it be translucent? Should it be heavy or light? Should it have a bluish tint; be gray, white, or creamy? Binns's response is not known, but based on other letters, he presumably told her that the cream-colored body was not desirable. As an Englishman he was used to the bluish-white tint of English porcelain.

Early in April 1901, twelve pieces were sent to Henry Deakin, art dealer and connoisseur of oriental porcelain in Chicago. Responding on April 10, Deakin wrote that he was most agreeably surprised.[24] He even went so far as to say that one example "almost reached the perfection of the old Chinese glazes." For the sale of the twelve pieces, he priced three at ten dollars each, three at seven dollars each, and six at three dollars each. Writing to McLaughlin again on April 24, Deakin expressed his desire to handle her work in Chicago and the Northwest.[25] He also counseled, "I think 'Mr. Binns' is in error regarding the 'cream color' in soft paste for this tint is most desirable in all soft paste glazes." Finally, he encouraged her to produce a

22

Figure 13.4. Page 22 from M. Louise McLaughlin's Losanti Record Book showing various shapes she used in making porcelain. *Courtesy of the Cincinnati Art Museum, Mary R. Schiff Library, Gift of Mr. and Mrs. James Todd*

large vase from sixteen to twenty inches high, imitative of the old Chinese. If she would agree to this, he would send her a photo from which to work. McLaughlin probably did not produce a sixteen-to-twenty-inch vase. None of her porcelain is known to be that large. The largest recorded shape in her Losanti Record Book is twelve inches high. Her kiln was simply not big enough to produce successful pieces of that size, and besides, Binns had advised her to keep her objects small to insure a greater technical success rate.

On May 26, 1901, about six weeks after Deakin's letter, McLaughlin wrote to Binns with her decisions regarding his and Deakin's conflicting advice on the body color and size of her ware.[26] With regard to the color of the body she said, "I remember you objected to the creamy matt color of the body and told me it should be changed by a reducing fire to a bluish white. . . . I have concluded that I like this [cream-colored] body best because of its translucency and also that the color is agreeable, so whether it is the traditional color for porcelain or not I have concluded

Fig. 13.5. M. Louise McLaughlin's porcelain. *Courtesy of the Cincinnati Historical Society Library, Ross C. Purdy Collection*

to use it." The artist followed Deakin's advice on body color, but chose Binns's on size, saying, "I took your advice . . . confining myself to smaller forms."

McLaughlin also took Binns's advice regarding molds: "As to the molds, I took your advice and made them myself." She had designed molds and cast her own objects from molds throughout her ceramic career, but prior to this she had never constructed them. It proved difficult at first, but she soon learned by trial and error. Whether or not the method she eventually devised for making the molds was standard is not known, but that is of little consequence. At this point in her porcelain career, she was no longer concerned with what was considered correct, or standard, but rather with what worked. For example, the fact that her cream-colored body fired well was more important to her than the fact that it did not display the bluish-white tint of other porcelains. Binns must have found her maverick ways curious, and she seems to have sensed this when she wrote him saying, "Altogether my methods would set a practical potter frantic but . . . I feel emboldened to set tradition at defiance and follow any method which proves practicable."

1901

376 Small vase 43
Lined mat slip cov-
ed with Purple of Cassus.
Design of Chrysanthemum
in scroll outband
cut through the body & the
lining.

Pink lining did not
show through.
The coral design not
pink enough to be effective.
From S. Dorothy.

This firing was so unfortunate
that I almost felt like giving
up.

Fig. 13.6. Page 164 from M. Louise McLaughlin's Losanti Record Book where she writes, "This firing was so unfortunate that I almost felt like giving up." *Courtesy of the Cincinnati Art Museum, Mary R. Schiff Library, Gift of Mr. and Mrs. James Todd*

In May 1901 an exhibit of twenty-seven vases, once again under the auspices of the Mineral Painters' League, was sent to the Pan-American Exposition in Buffalo, New York. This exposition was significant for McLaughlin because it marked a high point in her porcelain career. The pieces in the display were produced by her new one-fire method. In Europe the common practice was to make porcelain in two firings, a biscuit firing and an even hotter glaze firing. The Chinese, on the other hand, fired their porcelain only once in a glaze firing. Desiring to discover the secrets of the Chinese, Louise followed their example. On November 17, 1900, she tried the one-fire method and was rewarded with favorable results. By March 1901, after a number of unsuccessful firings (fig. 13.6), she achieved her best results up to that time in terms of body and glaze with the old Chinese method. Pieces representing the height of this achievement were sent to Buffalo's Pan-American Exposition. McLaughlin's display was well received. A bronze medal was awarded to the porcelain ware and more than half of the pieces were sold.

In the July 1901 issue of Robineau's *Keramic Studio*, a letter from McLaughlin was printed reminding everyone that, contrary to a previous article stating that "no

attempt has been made in America to produce anything in the way of porcelain except table ware," she was working in true porcelain of a purely decorative character, firing it at a temperature of about 2,300° Fahrenheit.[27] Further, she had twenty-seven pieces on display in Buffalo. Because *Keramic Studio* had previously published a letter from McLaughlin in August 1899 stating that she was making decorative porcelain, it is curious that Robineau would later publish an article stating that there was no porcelain except tableware being made in America. Perhaps, since McLaughlin had never sent an exhibition of her work to New York in the fall of 1899 as she had suggested she would do, Robineau forgot about her. That slight was corrected when the editor asked McLaughlin to contribute an illustrated account of her work that was to appear in the December 1901 issue of *Keramic Studio*.[28] The title of this article was the same as the name she had chosen for her porcelain, "Losanti Ware."

The naming of the ware came in the latter part of 1900. At that time McLaughlin applied to the art dealership of Messrs. Burly & Co. of Chicago seeking an agency to represent her ware. Mr. Burly ultimately turned her down, and shortly thereafter she became represented by Henry Deakin. However, during the course of negotiations with Burly, he told the porcelain artist that the ware must have a name. Indeed, "Mr. Burly . . . insisted upon that as a necessity. . . . All manufactories of pottery are known by names, and how should this be known if not by a name."[29] "Losanti" is a reference to Cincinnati's original name, Losantiville. McLaughlin thought this appropriate for a ware made in Cincinnati. The earliest documented piece marked with the Losanti name was taken from a firing of December 18, 1900.[30] Although it is possible that there might be earlier pieces so marked, certainly from this date on, "Losanti" was painted in underglaze blue on the bottoms of all her vases (fig 13.7).

In November 1901, the Association of Allied Arts in New York exhibited twelve examples of McLaughlin's porcelain. The comments of Nicola di Renzi Monachesi, who reviewed the exhibit for *Art Interchange*, exemplify the general attitude toward the Losanti ware.[31] She found that the vases were "unpretentious," but upon examination proved to be "exceedingly interesting." This was always the case with McLaughlin's porcelain. Her vases were usually small, averaging between five and seven inches in height. In this respect they were not commanding, especially when placed in exhibitions where most pieces were larger. Upon inspection, however, the ware became engaging. To begin with, it was porcelain. That made it different from any other studio ware in an exhibition. McLaughlin was still the only studio potter working in porcelain at the time. After recognition of the material came a different set of stan-

Fig. 13.7. Porcelain vase (detail of mark), 1901, and porcelain vase (detail of mark), ca. 1895–1900, by M. Louise McLaughlin. These are examples of M. Louise McLaughlin's porcelain marks. *Courtesy of the Cincinnati Art Museum, Gift of Theodore A. Langstroth, 1970.582 and 1970.644 (left to right)*

dards. Whereas pottery was lauded when it was large, bold, and strikingly ornate, porcelain was praised for its delicacy of form and subtlety of decoration. This dichotomy was probably due to the influence of the Chinese porcelain aesthetic that encouraged fineness and elegance, and the difficulties inherent in working with the more sophisticated material.

People who were not familiar with porcelain were not impressed with the Losanti ware. Monachesi, a member of the ceramic intelligentsia, fully understood the objects she was reviewing: "They are remarkable for simplicity in outline. . . . They are mostly painted with one tint, or where more than one is employed, they are soft and harmonious." She also commented that the body was "smooth to the touch, and of beautiful texture." Unlike pottery, porcelain always incited commentary on the quality of its clay body. The decoration of the vases consisted of boldly carved floral relief ornament. Monachesi pronounced this decoration "graceful, artistic, and professionally executed." She particularly liked those vases with translucent, glaze-filled perforations around the top (fig. 13.8). This so-called rice-grain technique was

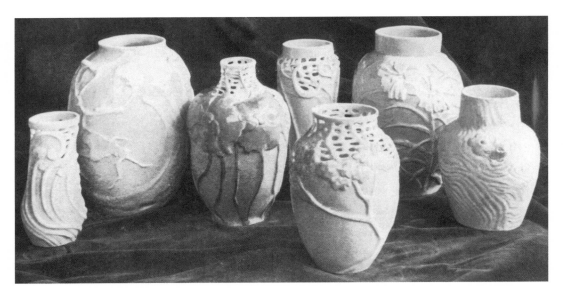

Fig. 13.8. M. Louise McLaughlin's porcelain, including her rice grain technique.
Courtesy of the Cincinnati Historical Society Library, Ross C. Purdy Collection

expertly used in the West by the porcelain manufactory of Bing and Grøndahl of Copenhagen, as well as in the Orient. Louise could have been influenced by either source, but her use of the technique, especially in the curvilinear quality of the glaze-filled openwork, is more akin to that used by the Copenhagen firm.[32] She was familiar with the porcelain produced in Copenhagen, which included that of the Royal Copenhagen Porcelain Factory as well as Bing and Grøndhal, and found it so accomplished that "there is nothing left to be desired."[33] It was, she thought, "a class apart." McLaughlin experimented with the rice-grain technique as early as January 1900, and was still perfecting it by May of the following year. In a letter to Charles Fergus Binns dated May 26, 1901, she commented on some rice-grain vases that she thought defective but holding promise for "something which can be accomplished in [the] future."[34] Generally, her mature rice-grain decorations did not begin to appear until later in 1901, and they became especially prominent in 1902.

In December 1901 she entered an exhibit of the Keramic Society in New York at the Waldorf-Astoria Hotel. Marshal Fry of the Fry Art Company handled McLaughlin's work for the Keramic Society, and in a letter of December 13, 1901, he reported to her on the exhibit.[35] Unfortunately, the society did not have the success in sales that it had had in past years. Only two of McLaughlin's works sold, one for

ten dollars and one for four dollars. There was good news, however: "Your exhibit attracted much attention not only from the public but from connoisseurs like Prof. Binns of Alfred [University] & Mr. [Henry] Belknap, and your little collection added very greatly to the artistic success of the affair." Louise had to have been pleased that Binns and Belknap saw the show. Henry Belknap was a partner in the art dealership of Taft and Belknap of New York. This firm had shortly before offered to act as Louise's New York agency, and the remaining ten pieces not sold at the Keramic Society exhibit were forwarded to Taft and Belknap for future disposition. With these ten vases, plus twenty more sent in the new year on January 31, and an additional thirty-one pieces sent on March 7, Taft and Belknap had sixty-one examples of Losanti ware from which to choose twenty for the Esposizione Internazionale d'Arte Decorativa Moderna in Turin, Italy. Again, McLaughlin's pieces were well received, and Taft and Belknap were pleased with their representation.

By 1902 McLaughlin's porcelain had attained its full maturity. She had mastered every step in the production process from making the molds to firing the kiln and, after experimenting with eighteen bodies and forty-five glazes, she had settled on the body and glaze that offered the best results.[36] Reporting to Binns in June 1901 she said, "I have been so busy in experimenting with bodies and glazes that I confess I have not paid as much attention to forms and decoration as I should. Now that I have satisfied myself as to the composition of the body and glaze . . . I expect to pay more attention to decoration."[37]

She did indeed begin to pay more attention to decoration. Her rice graining became more complex and integral to the overall scheme of decoration, and her carved relief with swirling compositional lines began to reflect the influence of the Art Nouveau movement. It should be noted that Edward Colonna, designer and decorative artist noted for his Art Nouveau style, had married Olive Louise McLaughlin, James McLaughlin's third child. Colonna, however, does not seem to have had any influence on the work of his Aunt Louise. By the time Louise was working in porcelain, her niece and nephew were divorced, and Colonna was living in Paris. More likely, Louise was influenced by the two porcelain firms she most respected, Bing and Grøndhal, and Royal Copenhagen. Neither Danish firm took the Art Nouveau style to the extreme that was customary in France, and Louise agreed with this philosophy: "The movement known as 'L'Art Nouveau' will and must have influence, but it cannot be followed without reason or moderation, except to the detriment and degradation of the Beautiful."[38] The shapes of her vases were simple and

Fig. 13.9. Page 165 from M. Louise McLaughlin's Losanti Record Book discussing pieces fired on October 30, 1901. *Courtesy of the Cincinnati Art Museum, Mary R. Schiff Library, Gift of Mr. and Mrs. James Todd*

Fig. 13.10. Page 180 from M. Louise McLaughlin's Losanti Record Book showing "Number of pieces made in 1901—233/ Number of saleable pieces—50/ Number pieces sold—15/ amount of sales—$126.00/ less commission." *Courtesy of the Cincinnati Art Museum, Mary R. Schiff Library, Gift of Mr. and Mrs. James Todd*

conventional, never reflecting the unexpected bulges and curves so common in Art Nouveau. While her relief-carved decorations began to include swirling lines, they were always sedate compared to the whiplash curves of the French product.

Her carving, whether in high or low relief, appears to have been done rapidly. It is not known if Louise used a humidor to keep her vases moist while storing or carving them. She had used a humidor for her Limoges work, and even described how to build one in *Pottery Decoration Under the Glaze*.[39] When porcelain is too moist, it is too soft to carve; when it is too dry, it is brittle and flakes upon carving. Keeping it properly moist over a sufficient period of time for carving was very difficult. Porcelain dries very rapidly, and a vase could easily become too dry before the carved decoration was completed. As noted in previous chapters, McLaughlin had a habit of working very quickly, which no doubt helped her in carving her Losanti ware. Still, her carved decorations sometimes reveal brittle edges and lines that do not flow in smooth curves, suggesting that the vase was becoming too dry and that the artist was racing to complete the carving before the clay became brittle.

Nineteen hundred two also brought McLaughlin's porcelain decorations painted under the glaze to their height. Early in her porcelain career she began using an atomizer to spray on colors. It is curious that she had never used this spraying device before she worked with porcelain, even though her good friend and Pottery Club colleague, Laura Fry, had developed it in 1883.[40] Louise's early examples exhibit an uneven spray of color that was eventually corrected. She also painted her decorations onto vases with brushes charged with slip. McLaughlin still used Lacroix colors because they "always stood whatever fire they were subjected to even when I used them on my porcelain."[41] The applied colors were always true to the natural forms they depicted. Sometimes Louise painted the flowers of her relief decorations with appropriate hues, but generally she kept them free from color except for the glaze.

She developed one unusual technique for slip decoration on her porcelain that she described in a vase dating from a firing of June 15, 1902.[42] A ground of "Rouge T." and slip was sprayed on the lower part of the vessel where a red flower head was to be depicted. Once dry, the pattern of the decoration, a peony, was incised and the ground around it removed. The stems and leaves were then painted with a brush in Bailey green, and the vase was sprayed with three coats of glaze 46. Rouge T. was a Lacroix color highly recommended by McLaughlin in her book, *Pottery Decoration*, because it could "be relied upon to produce as good a scarlet as is possible under the glaze."[43] The color red was particularly difficult to produce in underglaze

ceramics, and the effect of Rouge T. in the porcelain was always more of a pink or coral than a "scarlet."

Because Edwin AtLee Barber was preparing a revised edition of his 1893 book, *The Pottery and Porcelain of the United States,* scheduled to be published in 1901, McLaughlin sent him four examples of Losanti ware. One example, taken from a glaze firing of May 17, 1900, was decorated with an inlaid design of cobalt and black.[44] Barber thought this vase was particularly interesting: "The effect is decidedly Japanesque, both in the style of decoration and in the appearance of the porcelain."[45] It is not surprising that McLaughlin was applying her patented inlaid technique to porcelain. It was, after all, a method that involved a mold and could be used for cast pottery as well as cast porcelain. To date, no such examples are known to exist.

The one other type of decoration that should be mentioned is the lustre glaze. McLaughlin often sought the dull, metallic finish of lustre glazes that could be produced with copper oxides. The problem was that the decoration could never be controlled; more often than not, the effect was serendipitous. A lustre vase was among the four porcelain examples sent to Barber in May 1900. The ceramic art historian was fully aware of its significance: "The little metallic piece suggests great possibilities. The dull metal lustre is very attractive, and if you can discover the cause and succeed in controlling the application of the principle, you will have something of great interest and value." McLaughlin was still trying to master lustre glazes as late as 1906. They were among her final experiments.

On Sunday, April 13, 1902, the *New York Times* ran an article on American pottery and porcelain in which Losanti ware was one of the products featured.[46] It concluded that McLaughlin's work was "very remarkable, not merely because porcelain is so rare a product in the United States, but because of its intrinsic beauty and the variety of its design." Perhaps it was this review that set the following events in motion shortly thereafter. On June 24, 1902, Henry Belknap wrote to McLaughlin to relate "the first piece of real good fortune connected with your affairs."[47] Russell Sturgis, the well-known art critic, architect, and author, had just purchased twelve Losanti vases and complimented the artist most highly upon her work as a whole. According to the dealer, Sturgis had been to the Taft and Belknap gallery many times before, but only on this last visit did he "awake to the beauty of your work." Belknap was ecstatic since Sturgis was preparing to write an article on American potteries, which meant that Losanti ware would receive a "most favorable notice." Belknap was perfectly aware of the critic's stature: "There is no one in New York whose opinion is looked upon as more valuable than that of Mr. Sturgis."

Fig. 13.11. Page 181 from M. Louise McLaughlin's Losanti Record Book showing that the "Third series marked numbered from '1' began on January 15, 1902." *Courtesy of the Cincinnati Art Museum, Mary R. Schiff Library, Gift of Mr. and Mrs. James Todd*

The following day, June 25, Sturgis wrote to McLaughlin, telling her of his impending article and asking for permission to photo-illustrate at least one and, perhaps, two groups of her work.[48] Referring to the Losanti ware, he offered one criticism: "There is room for greater restraint and severity of design; but that comes by practice and thought." He then asked her if the materials she used for the clay and glaze really were from the Ohio Valley and ended the letter congratulating McLaughlin on the "artistic success" of her work.

Before Sturgis's article was published, he sent two of the vases to his "old friend" Alexandre Sandier, art director of Sèvres.[49] In a letter of October 5, 1902, Sturgis quoted Sandier's comments to McLaughlin: "I find them very well made and very artistic. They are obviously of porcelain, but of a clay that is not free of impurities. I am sure that one would arrive at very good results with this material, taking a little more care in its preparation."[50] To have Russell Sturgis and Alexandre Sandier comment favorably on your porcelain was like a gift from the gods.

When Sturgis's article was finally published in the November 1902 issue of *Scribner's Magazine,* he noted that McLaughlin's clay was from the Ohio Valley and that the Losanti ware was "a real porcelain of American origin and carried out with

extraordinary delicacy, forethought, and purpose."[51] He felt that the flower painting in the vases was "very well imagined indeed, severe and decorative." In addition, the color in the painted relief forms was appropriately "subdued and quiet." Not all of his criticism was positive. He thought that the glaze had "not succeeded perfectly" in one vase, and the bluish green passing into blue in another was "not perfectly managed." In the end he concluded, "The pieces are not perfect in form nor flawless in coloring, but full of interest." In short, it was a favorable review.

The following year, 1903, was a good one for McLaughlin. She placed pieces in exhibitions at the Worcester Art Museum in Worcester, Massachusetts, in the annual exhibit of American art at the Cincinnati Art Museum, in an Arts and Crafts show in Syracuse, and in an exhibit of the Guild of Arts and Crafts in New York. In April, 1903, Binns saw one of McLaughlin's latest exhibits and graciously wrote to say how greatly pleased he was with the advances she had made.[52] To hear such favorable remarks from someone she respected must have pleased her tremendously. *Keramic Studio,* with its editor Adelaide Alsop Robineau, was still following and praising McLaughlin's work. Commenting in May 1903 on the exhibit of the Guild of Arts and Crafts of New York, the magazine noted, "Miss McLaughlin so far leads, her examples of hard fire porcelains being very choice and entirely different from anything shown."[53] One month later, in a review of the pottery at the Arts and Crafts exhibit held in the Craftsman building in Syracuse, the magazine's comments were even stronger: "As yet she has no rival in this country in the making of true porcelain."[54] The article then went on to strike a mildly disapproving chord: "The only criticism that we would make is that the relief decoration is sometimes a little heavy and not always interesting." Continuing, it explained that this was because McLaughlin had in the past concentrated almost exclusively on the development of bodies and glazes, but now she was turning her attention to decoration. This criticism was the only negative remark, however slight, that *Keramic Studio* ever made about McLaughlin's porcelain, and even then it was couched in a positive review. Scholars often use this quote to demonstrate that Robineau did not think highly of Losanti ware. This argument does not stand the test when the quote is placed in the broader context of the article, and it especially fails when the article is, in turn, placed in the still broader context of all that was written about McLaughlin in *Keramic Studio.*

The positive relationship between McLaughlin and *Keramic Studio* never waned. Early in 1904, Cincinnati's porcelain artist became interested in mat and crystalline glazes and wrote to confer with the managers of the magazine. Samuel Robineau,

Adelaide's husband and partner in the publication, responded on April 14 with firing suggestions and three pages of Taxile Doat's formulas.[55] Doat was a French ceramist who worked at Sèvres and wrote a treatise on porcelain entitled *Grand Feu Ceramics*. Samuel Robineau translated the treatise and published it both in book form and as a series of articles in *Keramic Studio*. The formulas that Samuel Robineau sent McLaughlin were to be published in the July and August edition of the magazine. If Louise ever produced any mat or crystalline glazed porcelain, it has been lost to history. To date no pieces have surfaced.

The biggest event of 1904 was the Louisiana Purchase Exposition held in St. Louis. *Keramic Studio* published a delayed review of the ceramics there, and once again hailed McLaughlin's porcelain: "Her exhibit in the Fine Arts Building of St. Louis was creditable in the extreme."[56] The pieces were similar to those shown at the Pan-American Exposition with glazed openwork and carved decorations, but there was more of an emphasis on color, especially the pink and coral reds, created no doubt with the Rouge T. oxide. The review went on to sound an unhappy note of impending doom for McLaughlin's porcelains: "It is with regret that we hear that she does not at present intend to push her work farther on account of trouble with her kiln and because of her other interests, for Miss McLaughlin expresses herself by means of many mediums, the metal work at present absorbing her attention."

The St. Louis Exposition was the last major exhibition of McLaughlin's active porcelain career. The little kiln in the backyard could no longer stand the strain of firing. It was in serious need of repair and had developed many cracks. The pieces fired by 1904 were "smoked," or exhibiting dull colors and impurities due to smoke gathering in the oven. In two or three of the last firings, McLaughlin used wood as fuel trying to improve upon the colors, but this did not help. The last firing occurred late in March or early in April 1904. Louise had to decide whether to put forth the time and money to rebuild the kiln or to have it torn down. In a very real sense, this meant that she had to decide whether or not to continue working with porcelain. The desire was there, but the money was not. The sales of her porcelain were falling off. The product was not selling well in New York, and efforts to place it for sale in Denver, Kansas City, and Louisville were unsuccessful. While she was a woman of independent means, her funds were not unlimited. Unlike her old nemesis, Maria Storer, McLaughlin could not afford to build her own industrial-sized pottery, which is what she needed to take her porcelain to its next stage of development. Writing at the time she said:

I find myself . . . hampered by the lack of means which would enable me to carry on the actual work in a better manner, and altogether discouraged by the fact that while I have spent money I could ill afford to lose in these experiments, it seems that I am not to be reimbursed or enabled to spend more by any returns from the sales of the production. I had thought that the very small production could be disposed of, but it seems that I was mistaken and that it is impossible even to carry on the very smallest pottery without the production of commercial wares to pay expenses.[57]

Postponing the inevitable decision, McLaughlin bought a very small Revelation Kiln, a new high fire, coal oil kiln on the market, and began experimenting with it. She placed it in the third story of her house with its exhaust pipe running through the roof, and first used it about the middle of June 1904. It set fire to the roof on June 20, and was therefore removed to the backyard shed. She continued her experiments (namely, with lustre glazes) in this kiln even though it was so small that only one piece could be fired at a time. Realizing that a meaningful porcelain career could not continue in this manner, McLaughlin bowed to fate and had her backyard brick kiln leveled in the fall of 1904. With this symbolic gesture, the production of Losanti ware effectively came to an end although the artist sporadically continued experiments with the Revelation Kiln for about two years. On November 13, 1906, Samuel Robineau responded to another inquiry from McLaughlin with a chatty letter discussing porcelain bodies.[58] This is the last indication of any active interest in porcelain by the maker of Losanti ware.

McLaughlin kept statistics on her output and sales from 1898 to 1904. She did not keep statistics for 1905 and 1906, probably because her output was negligible. Based on her statistics, she made a total of 1,239 pieces of porcelain during the active six-year history of Losanti ware.[59] Of these, only about 322 were saleable and approximately fifty-three examples sold for less than a total of $450. It is no wonder that she could "ill afford" to continue.

Losanti ware was never compared to other porcelains during the time it was actively produced from 1898 to 1904. One reason is that, for the most part, there was no other studio porcelain being exhibited in the United States with which to compare it. Later historians compare McLaughlin's work to that of Adelaide Alsop Robineau, since both were female and both were important to the early history of American studio porcelain, but the comparison is unwarranted. Robineau began making porcelain in 1902, and even though her products and McLaughlin's overlapped chrono-

Fig. 13.12. M. Louise McLaughlin, ca. 1900.
Courtesy of the Cincinnati Historical Society Library

logically for about two years, they were not comparable technically or aesthetically. Robineau had advantages that enabled her to create a more sophisticated aesthetic. First of all, McLaughlin began with almost no technical knowledge of or practical experience in the subject, while Robineau began after a course of study under Charles Fergus Binns at Alfred and after obtaining Doat's treatise on porcelain that her husband translated.[60] Second, the Cincinnati ceramist had but a little kiln in her backyard, while the Syracuse ceramist had a well-appointed pottery at her command. Third, McLaughlin's ware, which was cast, was small and delicate, whereas Robineau's ware, which was thrown, was larger and bold. Any stylistic similarity at all in their work stems from the fact that they both admired Danish porcelain. To compare their products is to serve neither. McLaughlin always respected Robineau's work. Commenting in a letter to Ross C. Purdy on March 9, 1938, Louise wrote that Robineau "really was the maker of creditable porcelain."[61]

During the years 1904–6, McLaughlin continued to exhibit her porcelain, but, except for the Louisiana Purchase Exposition, all her exhibits were in Cincinnati at the Art Museum or at the Cincinnati Woman's Club. Generally, the pieces exhibited were not new, but rather were taken from her personal collection of Losanti ware. This was especially true for exhibitions after 1906.

Her work in porcelain followed the same path as her work in underglaze slip decoration: She was the first to enter the field in America; she achieved her primary goal of discovery and then bowed out because of a lack of facilities, contenting herself with letting others develop it to its fullest. Unlike china painting and underglaze slip decoration, McLaughlin never wrote a book about porcelain. The subject was too complex to tackle with experience limited to a little backyard kiln. Moreover, McLaughlin's art interests had now become absorbed with making Arts and Crafts jewelry.

THE REMAINING YEARS,

1907–1939

"In this age of specialization I fear that the frequent changes from one form of expression to another will be considered very reprehensible. . . . To me it seems conducive to mental and bodily health."[1] Louise McLaughlin, then sixty-six years old, spoke these words to the Porcelain League on April 25, 1914, as she accounted for her varied artistic career. Throughout her life the artist pursued her ceramic endeavors while she worked in other art forms. She painted, engraved, worked with metals, carved furniture, created lace and embroidery, worked with watercolors, and by 1906 she was engaged in making Art Nouveau jewelry. The two art forms that she never relinquished were oil painting on canvas and china painting. As discussed earlier, her personal identity as an artist rested with her oil painting, especially with portraits. Her professional identity, however, rested with her ceramics, especially with china painting, since her fame resulted from the books she devoted to that branch of the field. *China Painting* was by far the best seller of all her manuals, including *Pottery Decoration under the Glaze* (1880), *Suggestions to China Painters* (1883, 1890), *Painting in Oil* (1888), and *The China Painter's Handbook* (1917). It was an immediate success when first published in 1877, and by 1889, the year of the first revised edition, it had sold more than fifteen thousand copies.[2] In 1904 it was reissued in a volume that combined

Fig. 14.1. Luncheon of the Porcelain League at the house of Mrs. Kellogg celebrating the League's twentieth anniversary, 1914. *Left to right:* *1) Miss Anna Boyé; *2) Mrs. J. R. Murdock; *3) Miss Clara Chipman Newton; 4) Mrs. Russell Chapman; *5) Miss Clara Fletcher; 6) Miss Elizabeth Kellogg; *7) Mrs. H. C. Yergason; 8) Mrs. Lulu Smith; *9) Miss Alice Holabird; 10) Mrs. E. C. Mills; 11) Miss Abbey Gray; 12) Mrs. Robert Burton; *13) Mrs. George Dominick; 14) Mrs. Edwin E. Kellogg; 15) Miss Carrie Clemner; 16) Mrs. Ida H. Halloway; *17) Miss M. Louise McLaughlin; 18) Miss Anna Riis. *Cincinnati Pottery Club members. Courtesy of the Cincinnati Historical Society Library*

China Painting with McLaughlin's *Suggestions to China Painters.* The title page of this issue declared that twenty thousand copies had been sold.[3] When last published in 1914, *China Painting* had been purchased by more than twenty-one thousand readers.[4] Spanning the history of china painting from the late Victorian period to World War I, the book was in print longer than any other china painting manual of its era. Throughout the published lifetime of the manual, Louise McLaughlin worked at china painting, although her most notable period was probably from 1882 to 1890 during the Pottery Club era. Within her three-pronged ceramic career, she ranked her contributions to china painting third after porcelain and pottery decoration under the glaze. Still, Louise persisted in china painting because, unlike porcelain or pottery

decoration under the glaze, it was the one ceramic pursuit in which she did not need the facilities of a well-appointed pottery.

During her senior years, McLaughlin continued to exhibit in Cincinnati with the Women's Art Club. This organization was founded in 1892 because the Cincinnati Art Club, which had been founded two years earlier, refused to accept women members. The purpose of the women's group was "to stimulate its members to greater efforts in their work and to increase a general art interest."[5] McLaughlin exhibited with the Women's Art Club in nineteen exhibitions from 1904 until 1931. Only in three of these exhibits, in 1904, 1906, and 1910, did she display ceramics, and then it was solely porcelain examples taken from her personal collection.

In 1917 she published her last book on ceramics, *The China Painter's Handbook*, a thirty-page manual that taught readers how to treat conventional floral designs. It was the first in a "Practical Series" of booklets by various authors on such diverse

Fig. 14.3. The home of M. Louise McLaughlin, 4011 Sherwood Ave., Madisonville, Cincinnati. In 1912 McLaughlin moved to this house. McLaughlin herself designed the house, which was built by her architect brother James. It was her last address. *Courtesy of the Cincinnati Art Museum, Mary R. Schiff Library, The Cincinnati Artists Files*

topics as the kitchen garden, the art of designing ornament, and architecture. The book was never reissued and no sales record remains to document its success on the market.

In 1912 McLaughlin moved from 2558 Eden Avenue in the suburb of Mount Auburn to her final address at 4011 Sherwood Avenue (fig. 14.3) in Madisonville, another Cincinnati suburb. She designed the house, and it was built by her architect brother James. The simple plan, which placed all living needs on the ground floor, was ideal for the artist who was then sixty-five years old.

On March 4, 1923, Louise's brother, James McLaughlin, died at the age of eighty-eight at his retirement home in New York City. His obituaries hailed him as one of Cincinnati's most important architects. With his death, Louise lost her last immediate relative. As with the deaths of her parents and brother George, there is no recorded information revealing McLaughlin's feelings of bereavement, but she undoubtedly felt the loss. She was seventy-five years old when her second brother passed away.

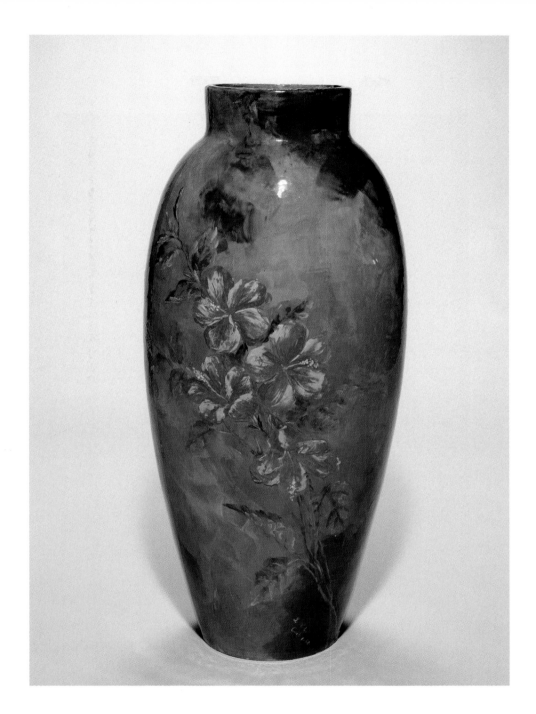

PLATE 17.
"Ali Baba" Vase, 1880, decorated in underglaze slips by M. Louise McLaughlin. When created, the "Ali Baba" vase was the largest vase ever made with an underglaze slip decoration. It measures thirty-seven and one-half inches high by seventeen inches at the widest diameter.

Cincinnati Art Museum, Gift of the Women's Art Museum Association, 1881.239

PLATE 18.
Cover of *Pottery Decoration under the Glaze* by M. Louise McLaughlin.
Courtesy of the Cincinnati Art Museum, Mary R. Schiff Library

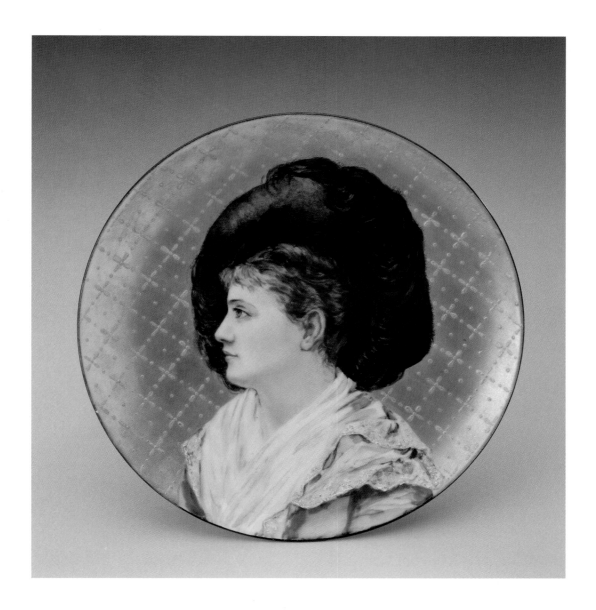

PLATE 19.

Porcelain plaque, 1882, decorated by M. Louise McLaughlin. This is an example
of china-painted portraiture. The sitter is Esther McLaughlin, James McLaughlin's
daughter. James was the architect brother of M. Louise McLaughlin. The porcelain
blank was made by Haviland & Co. of France.

Courtesy of the Cincinnati Art Museum, Gift of the Women's Art Museum Association, 1881.54

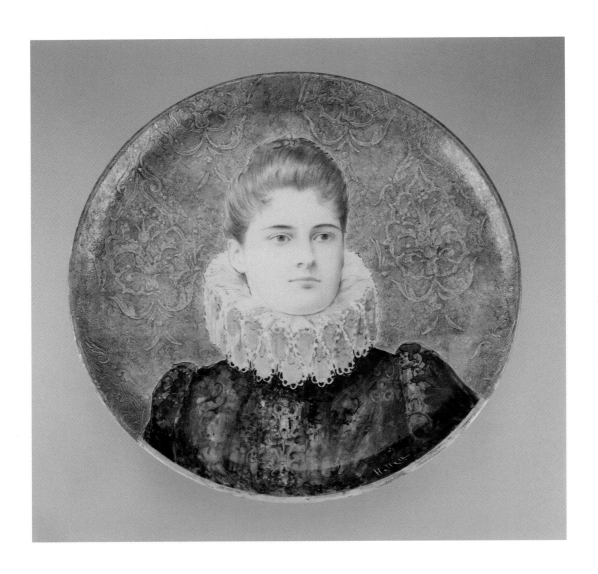

PLATE 20.

Portrait plaque, 1882–89. Plaque and gold background by Joseph Théodore Deck
(1823–1891), portrait by Paul César Helleu (1859–1927). Deck, a Frenchman, became
famous for portrait plaques with gold backgrounds at the 1878 *Exposition Universelle* in
Paris. His schematic formula influenced McLaughlin's portrait plaques.

Courtesy of the Cincinnati Art Museum, Gift of Mr. and Mrs. Robert Briggs Ehrman in memory
of their mothers, Isabel Pickering Beckurts and Mary Bartholomew Ehrman, by exchange, 2000.108

PLATE 21.

Vase, 1881, decorated in underglaze slips by M. Louise McLaughlin.

Courtesy of the Cincinnati Art Museum, Gift of Women's Art Museum Association, 1881.51

PLATE 22.
Porcelain vase, 1882, decorated by M. Louise McLaughlin. This is an example of china painting after enamelware by Longwy of France.
Courtesy of the Cincinnati Art Museum, Gift of the Women's Art Museum Association, 1881.56

PLATE 23.

Porcelain demitasse cup, 1888, decorated by M. Louise McLaughlin.
This is an example of china painting with flat gilt decoration.
Courtesy of the Cincinnati Art Museum, Gift of Theodore A. Langstroth, 1970.601

PLATE 24.

Porcelain cups and saucers, 1889–90, decorated by M. Louise McLaughlin.
These are examples of china painting with raised and flat gilt decoration
using mat colors, metallic decoration, and raised and flat gilt decoration
with some burnishing.

Courtesy of the Cincinnati Art Museum, Gift of Miss Florence Murdock, 1946.78, 1946.79,
1946.77 *(left to right)*

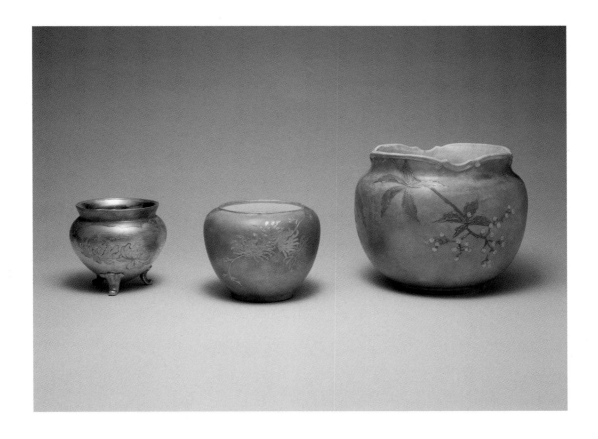

PLATE 25.

Porcelain vases, 1894, decorated by M. Louise McLaughlin. These are
examples of china painting with metallic and raised gilt decoration inspired
partly by Japanese multi-metal forms and partly by Royal Worcester's ivory
and metal imitations in the "Oriental" or Near Eastern style.

Courtesy of the Cincinnati Art Museum, Gift of Theodore A. Langstroth, 1970.684,
1970.640, 1970.639 *(left to right)*

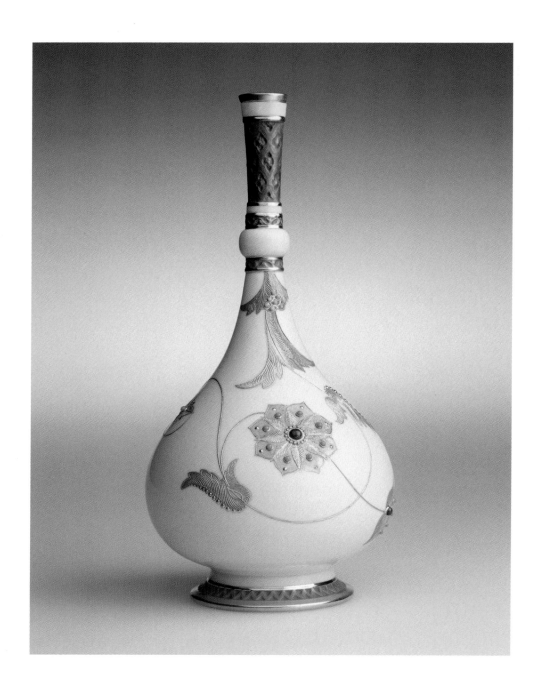

PLATE 26.

Ivory porcelain "Persian" vase, 1883, Worcester Royal Porcelain Co., Ltd.

Courtesy of the Cincinnati Art Museum, Museum purchase, 1887.12

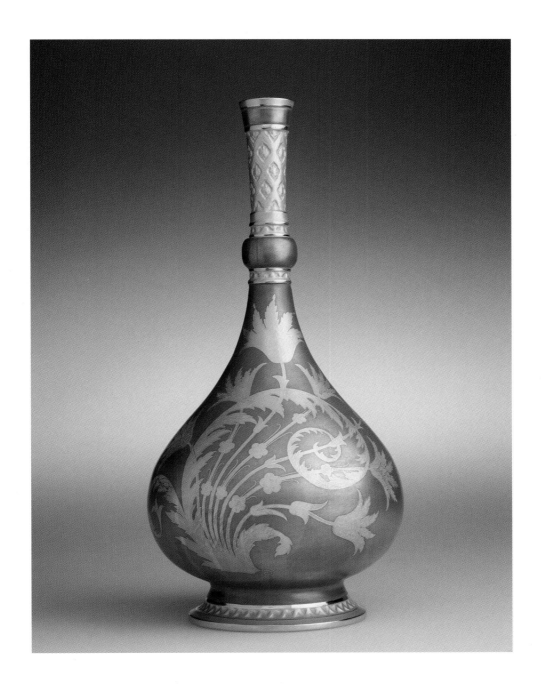

PLATE 27.

Porcelain "Persian" vase, 1883, by Charles H. Deakin, gilder,
Worcester Royal Porcelain Co., Ltd.

Courtesy of the Cincinnati Art Museum, Museum purchase, 1887.13

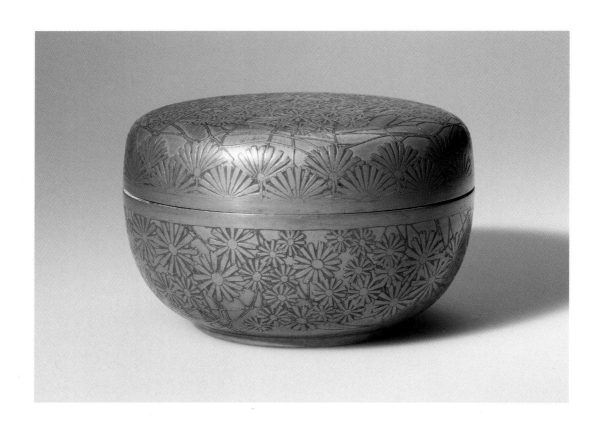

PLATE 28.
Copper bowl and cover, 1884, by M. Louise McLaughlin.
Courtesy of the Cincinnati Art Museum, Gift of M. Louise McLaughlin, 1937.13

PLATE 29.
Copper etched plate, "Girl Reading," 1883, by M. Louise McLaughlin.
Courtesy of the Cincinnati Art Museum, Gift of Theodore A. Langstroth, 1970.512

PLATE 30.

Porcelain lamp, 1882, decorated by M. Louise McLaughlin. This is a china-painted lamp with brass foot and fittings. The lamp originally had a shade over the glass chimney. It can be seen in situ on a table in McLaughlin's parlor in figure 11.8.

Courtesy of the Cincinnati Art Museum, Gift of Theodore A. Langstroth, 1970.682

PLATE 31.

Porcelain vases, 1890–1905, by M. Louise McLaughlin. These are examples of Louise McLaughlin's porcelain pieces that fired unsuccessfully.

Courtesy of the Cincinnati Art Museum, Gift of Theodore A. Langstroth, 1970.597, 1970.564, 1970.559, 1970.644, 1970.561 *(left to right)*

PLATE 32.

Porcelain vases by M. Louise McLaughlin. These are successful examples of Louise McLaughlin's porcelain.

Courtesy of the Cincinnati Art Museum, Gift of the Porcelain League of Cincinnati, 1914.4, 1914.5; and Gift of Theodore A. Langstroth, 1970.582, 1970.583 (*left to right*)

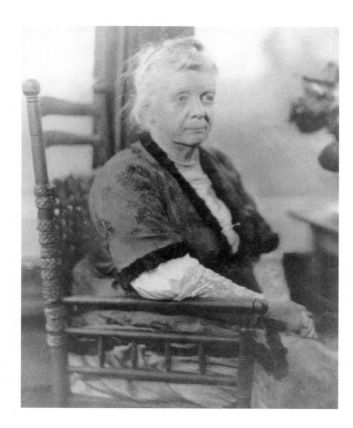

Fig. 14.4. M. Louise McLaughlin, 1922, age seventy-five. *Courtesy of the Cincinnati Historical Society Library*

During the year of James's death, McLaughlin published *An Epitome of History.*[6] It was a history of the world condensed into parallel columns on government, religion and philosophy, literature, science, and the arts. According to the author, the purpose of the book was to present a practical knowledge of history in a form that "he who runs may read." McLaughlin was very proud of this publication: "[It is] among all my work the one that, with the invention of the porcelain, seems to me the most worthy of attention."[7] The book is a culmination of her lifelong interest in history and politics. By the time of her death in 1939, she had finished another book entitled *Efficiency vs. War,* which dealt with seventeen major military battles; it was not published.

Age was taking its toll on McLaughlin. Margaret Hickey, McLaughlin's companion and housekeeper of forty-seven years, died in 1932. In 1934 Miss Grace W. Hazard, then sixty-five years old, assumed Hickey's position.[8] (Hazard always affectionately referred to McLaughlin as "Ma.") In 1933 Louise wrote, "It is hard enough to be old without everybody thinking you are going to die."[9] On May 22, 1937, the

artist, then almost ninety, wrote to Florence Murdock saying, "I find I do not get things done as I used to, and there have been so many dark days when it seemed difficult to write."[10] While her body was failing her mind was still very acute. In the same letter to Florence Murdock, she did not hesitate to express her strong Republican loyalties. Democrat President Franklin Roosevelt wanted to "pack" the U. S. Supreme Court with new appointees so that a majority would support his programs. McLaughlin found this intolerable: "I am still worried about our political questions, especially about the judiciary but now it really seems that our would-be-dictator is going to be defeated and I'm hoping things will go right."

As the famed artist grew older, Cincinnati newspapers began to take note of her. In 1935 her eighty-eighth birthday was announced in the "Woman's World" section of the *Cincinnati Times-Star,* along with the fact that she was completing a new book, *Efficiency vs. War.*[11] In 1936, on her eighty-ninth birthday, one newspaper article proclaimed her diversified talent in various art forms and wished her a "felicitous day."[12] One year later, on September 29, 1937, Glenn Thompson of the *Cincinnati Enquirer* chronicled her day and briefly reviewed her life's accomplishments.[13] McLaughlin's ninetieth birthday activities included some embroidery and work on her book, *Efficiency vs. War.* She had one chapter yet to finish. Later, after a game of 500 rummy with Hazard, McLaughlin retired at about 10:30 P.M. The journalist noted that the artist's accomplishments included six books in addition to her work in china painting, pottery decoration under the glaze, and porcelain, not to mention paintings in oil, metalwork, woodcarving, and needlework. He pointed to her advanced age by stating, "She has outlived all her close relatives—even also the talking parrot, Teddy (fig. 14.5), which, until a year ago, had been a companion for 38 years." McLaughlin was very attached to Teddy the parrot. When he died she had him placed in a cement box to prevent dogs and insects from disturbing his remains, which were buried in her backyard.[14]

By chance, Glenn Thompson's article regarding McLaughlin's ninetieth birthday was read by Ross C. Purdy, secretary of the American Ceramic Society and editor of the Society's *Bulletin.*[15] He was familiar with the work of Maria Longworth Storer, Adelaide Alsop Robineau, and even Clara Chipman Newton, but he did not know about McLaughlin's career. Since he lived in Columbus, Ohio, he asked his daughter, Lois Purdy, who lived in Cincinnati, to investigate this ceramist for firsthand information. Lois Purdy researched her subject at the Cincinnati Art Museum library (later called the Mary R. Schiff Library), and through Mary Sheerer—the originator

Fig. 14.5. Teddy, the talking parrot, 1923. This photograph was taken from a gelatin silver print by Bachrack. Teddy was M. Louise McLaughlin's beloved companion for thirty-eight years. When he died, she had him placed in a cement box to prevent dogs and insects from disturbing his remains that were buried in her backyard. *Courtesy of the Cincinnati Art Museum, Gift of Mr. and Mrs. Robert Todd*

of the famous Newcomb College pottery, who was then living in Cincinnati— arranged a meeting with McLaughlin. In the meantime Ross Purdy wrote to the artist, telling her of his interest in her work and informing her that his daughter would be calling. Lois Purdy visited McLaughlin on January 23, 1938, and expressed Ross Purdy's desire to make her an honorary member of the American Ceramic Society and to publish an article on the history of her work in the *American Ceramic Society Bulletin.*

Between January 24 and October 22 of that year, McLaughlin wrote no fewer than nine extensive letters to Purdy detailing her ceramic career. During this time she also sent him her personal scrapbook of clippings, articles, letters, etc., regarding her work that she had collected over the years. The scrapbook was in poor condition. Many of the newspaper clippings were brittle and disintegrating, and few were correctly marked as to their sources and dates. Other material was loosely folded into the book, but nothing was in any semblance of order. Purdy graciously accepted McLaughlin's scrapbook and carefully organized the material into a new book that saved much of the disintegrating information, although the original sources and

dates for the newspaper and magazine articles remained lost because of the artist's original carelessness in clipping the material. Purdy eventually donated the new scrapbook and the letters that she sent him to the Cincinnati Historical Society Library. It is this material that has supplied much of the substance for this publication.

Throughout her letters to Purdy, the artist bemoaned porcelain's lowered status in the field of ceramics. By 1938, forty years after her initial discovery, porcelain was no longer in vogue. Potters were now more interested in the aesthetics of pottery, especially stoneware. For example, McLaughlin sent five pieces of porcelain for a 1938 memorial exhibition in Syracuse to honor Adelaide Alsop Robineau, who had died in 1929. The judges accepted only two.[16] Insulted by this perceived slight, the Cincinnati ceramist withdrew her entries and lamented, "my connection with this part of ceramic work seems to be forgotten." Virtually all of the selections by the judges were of pottery, a decision that was farcical in an exhibition dedicated to the memory of a porcelain artist. McLaughlin felt disgruntled and unappreciated: "The ceramic work upon which I based my reputation as a ceramist is forgotten even during my lifetime." In a letter to Purdy of April 5, 1938, she expressed a refrain found in most of her letters to the editor of the *American Ceramic Society Bulletin:* "My only regret is that I am too old to continue to work actively in bringing it [i.e., porcelain] up to its former position in ceramic art."[17] In spite of porcelain's lowered status at the time, McLaughlin said over and over again, "I prefer . . . to rest my reputation as a ceramist upon the porcelain."[18] She felt that her porcelain was far more important than anything else she did in ceramics. Purdy agreed: "Your accomplishments [in porcelain] independent of aid from potters experienced in the French porcelain production and from published information make you, in my opinion, rank much higher than those of any other ceramist in America."[19]

Because of Purdy's work on her behalf, McLaughlin was accepted as an honorary member of the American Ceramic Society at the society's convention held in New Orleans in March 1938. An exhibition of her ceramic work was placed on display for the occasion. Even though she was too feeble to attend the convention, McLaughlin accepted the honorary membership "with great pleasure."[20] The society recognized her as the first American ceramist to work in pottery decoration under the glaze as well as in studio porcelain. It even recognized her influence as the founder of the underglaze slip technique used at Rookwood. It had been forty-five years since Maria Longworth Storer had denied McLaughlin her rightful recognition for discovering the principles of underglaze slip decoration upon which The Rookwood Pottery

Company was based. Now the American Ceramic Society proclaimed McLaughlin's rightful position in Rookwood's success. At last she had won the final battle of contention with Storer. Unfortunately, Storer did not live to hear the news since she had died in 1932, but victory was sweet even if delayed. McLaughlin wrote to Purdy:

> I especially appreciated the recognition of the convention as Mr. Burt [the superintendent] of the Rookwood seems to have gotten to the point of claiming precedence of the Rookwood as the first idea-wise. . . . I do object to the unfair way that Mr. Burt took to give the impression that they were the first to think of it. I don't know whether he attended the convention but I hope he will hear of the action it took.

As if to sweeten her victory even more, the memorial exhibition in honor of Adelaide Alsop Robineau, originally shown in Syracuse, was in New Orleans at the same time as the convention. The judges of that exhibit must have noticed that the prestigious American Ceramic Society was now honoring the artist whose porcelain objects they had refused for their tribute to Robineau. McLaughlin also mentioned this to Purdy:

> I am glad that the Syracuse Museum exhibit from which my exhibit had been withdrawn was in New Orleans at the same time. I feared that the Directors of the Museum thought me unreasonable in objecting to their disregard of porcelain. This I think was strange in a memorial exhibition for a maker of porcelain and shows the trend of modern fashion in the art. I think it is time to protest.

For McLaughlin nothing was more rewarding than recognition of her professional accomplishments by her peers, especially since she had struggled throughout her life to retain her rightful position in American ceramic history. Success at last was indeed sweet.

The aging ceramic artist continued to fill her days with embroidery and work on the manuscript, *Efficiency vs. War.* Hitler was emerging as a force in Europe, and Roosevelt was still working to extricate the United States from the throes of the Great Depression. These current affairs held McLaughlin's interest: "I know I spend too much time reading the papers, but things are so interesting now and one wants to know what is going on although it makes one angry."[21] Her anti-Roosevelt sentiment never waned: "The offer of this administration to do something for art was resented by the artists as it was thought to be worded in such a way as to further the

schemes of the government toward dictatorship. We have to be on our guard about the matters that can be used politically to curb the freedom of individuals."[22]

By January 1939 Louise McLaughlin was ninety-one years old. She had not left her house in Madisonville since 1920, fearing she might catch cold or injure her health.[23] She also never climbed a stairway within her house for the same number of years, not wanting to chance a fall that might break a bone. On Monday, January 16, 1939, at 6:30 P.M., McLaughlin died of a heart attack while going about her daily routine.[24] Her remains were taken to the Thomas Funeral Home, where a quiet burial was arranged. The three Cincinnati newspapers, the *Enquirer*, the *Post*, and the *Times-Star*, as well as the *New York Times*, ran no fewer than six articles on her death.[25] All six hailed her as a ceramic artist—not a portrait painter, a wood-carver, an etcher, a worker in metal or jewelry, a needleworker, or a watercolorist. That was because her most recognized achievements were in the field of ceramics.

McLaughlin left an estate valued at approximately $6,000—$5,000 in realty and $1,000 in personal property.[26] She had been financially comfortable, but even in the end she was by no means wealthy. She bequeathed eighteen pieces of porcelain dating from 1897 to 1904 to the Cincinnati Art Museum. The Women's Art Museum Association had already given the museum small collections of her painted china and pottery decorated under the glaze. Evidently McLaughlin did not think it necessary to leave any of those types of items to the museum since it already had examples. She also bequeathed to the Cincinnati Art Museum some examples of metalwork, a portrait of her brother George, the cabinet that she had carved for the 1876 Centennial Exhibition, an embroidered tapestry, a sampler by her mother, a collection of dolls, a collection of etchings and sketches by the Rookwood artist/potter Alfred Brennan, and a collection of pieces of Irish lace executed by Margaret Hickey. Her will was contested for years by various members of the family and by Grace Hazard, her last companion. As a consequence, the museum never received its portion of the bequest, and the eighteen pieces of porcelain are, for the most part, lost to history. Earlier in her life, the *New York Sun* had paid an apt tribute to Louise McLaughlin, who, it said, "All her life long has been a dreamer of dreams and a seeker after an elusive ideal that keeps dancing like a will-o-the-wisp just beyond her reach."[27] The socially conservative, well-bred Victorian artist was, indeed, a "dreamer of dreams," and American ceramic history is richer because of it.

Since her death, one point of debate that has constantly shadowed any discussion of McLaughlin or her work is the woman's issue. It remains for feminist scholars to

treat McLaughlin in detail; however, even though this book is not a feminist treatise, a few points should be made.

Without question, a prejudicial sexism followed McLaughlin throughout her career. The fact that she became an amateur china painter instead of a professional portrait painter is, in itself, a manifestation of gender discrimination. As Cynthia A. Brandimarte points out in "Darling Dabblers: American China Painters and Their Work, 1870–1920": "Historically, male artists created fine art, while most women artists dabbled in handicrafts and decorative arts."[28] Because of her sex, society did not reward McLaughlin for her portraits on canvas, but rather for her work in ceramics, initially for painted china. Consequently, Louise looked to her ceramic endeavors for recognition in the arts.

A point made over and over again in contemporary literature regarding McLaughlin was that she did not have to work for a living. As discussed in an earlier chapter, the 1892 Frederick Keppel catalog remarked how McLaughlin was "untrammeled by the sordid necessities" of earning a living. Although emphasized at the time for other reasons, this piece of information was not new in 1892. It was noted throughout McLaughlin's career. Even as early as 1878, Calista Halsey frankly wrote, "fortune has kindly seen to it that this American girl is not under the necessity of doing this work for a living."[29] This was important to McLaughlin's status in society. Anthea Callen points out in "Sexual Division of Labor in the Arts and Crafts Movement" that "[f]or middle-class women, work and especially paid work, meant a serious loss in social status in a society in which 'lady' and 'work' were a contradiction in terms."[30] Always the "lady," Louise never "worked" for a living even though she eagerly sought remuneration for her art.

Recognition for McLaughlin's art was, at least in part, predicated on her status as an amateur. The fact that she did not have to earn a living gave her work the amateur distinction of a pastime rather than the professional distinction of a livelihood. This amateur status was important to her standing as a woman artist. Lois Marie Fink points out in "Introduction: From Amateur to Professional: American Women and Careers in the Arts" that "[n]ineteenth-century Americans regarded the arts as a proper sphere for women—so long as they retained amateur status. . . . Professionalism, however, carried a taint that moved women beyond traditional bounds of propriety to a realm that was just this side of immorality."[31] As long as McLaughlin retained her amateur status and remained in ceramics, she conformed to society's accepted definition of a woman artist, namely a nonprofessional in the decorative

arts. While Louise may have had the talent to compete with men for money and acclaim in the fine arts, she never challenged the status quo. She was, above all, an unquestioning product of her society.

That the Cincinnati ceramist did not challenge the status quo does not mean that she did not feel the sting of discrimination. For example, her work was always qualified by the fact that it was by a woman. The 1892 Frederick Keppel catalog felt the need to point out that "Miss McLaughlin is a living refutation of the assertion that women never invent or originate."[32] And in 1878, the *Cincinnati Commercial* noted, "The lady displayed a patience in her scientific experimenting which, it must be said, is as rare as it is praiseworthy in a woman."[33] Vicious attacks came from glib, sexist journalists who found it necessary to make a joke out of the serious endeavors of women artists. The following was written to announce that the Cincinnati Pottery Club had been informed that it could no longer make its ware at the Rookwood Pottery: "The aesthetic world of Cincinnati is quite awry at present, and all on account of Eliza, or ladies with equally prozy names. They are about to receive the first cruel blow to their fond hopes—and naturally enough it comes from the fair hand of one of their own sex. We all know that the dear creatures are extremists or nothing."[34] It is not coincidental that the sounds in "Eliza" combine those in Maria and Louise, the two major figures in the reported event. While other published articles may not be quite so glib, they are nonetheless just as cutting: "Try to sell one of your pretty [painted porcelain] 'services,' my dear young amateur, at any of the leading shops or sales-rooms, and you will find that they are not what you have fondly believed them to be. You are not a Dieul, nor a Hélène de Haugest-Genlis, nor a Longlacé, Béranger, or a Bracquemond in embryo, or indeed anything more than a humble imitator of any one of these giants in the ceramic world."[35]

Worse than the verbal jabs were the prejudicial actions taken by judges at expositions. As has been noted, at the 1878 Paris Exposition Universelle, McLaughlin's underglaze work was chosen for a medal until the judges learned that it was made by a woman and gave it an honorable mention instead. While this instance is recorded, the number of unrecorded instances of biased judges is probably staggering.

Without question, McLaughlin was sensitive to all this, including the fact that the fine arts were not open to her as a woman. It is true that some exceptional women broke through the sexist barrier. The most notable where McLaughlin is concerned is Cecilia Beaux.[36] Although Beaux was ten years younger than McLaughlin, their careers were almost chronologically parallel. The Cincinnati artist's career began in

1874, when she was twenty-seven years old. Beaux's earliest commercial work also was produced in 1874, when she was seventeen, and she first studied china painting in the late 1870s. A serious comparison of these two would be revealing. Both came from socially well-placed families of limited finances; both grew up in cosmopolitan, industrial cities—one in Cincinnati, the other in Philadelphia; both had good art educations; both painted portraits on china; and each considered herself primarily a portrait painter on canvas. Yet Beaux broke the sexist barrier to become accepted in the male realm of professional painters, and McLaughlin did not. Perhaps this was because Beaux had a female mentor who helped to show her the way and because she had to work for a living; or perhaps it was because Beaux was a far better portrait painter. Whatever the case, what is important here is their attitude: Both saw china painting as a lower form of art. In fact Beaux considered it "the lowest depth [she] ever reached."[37] Each believed she was uniquely gifted, and each was ambivalent toward the plight of other women in the arts. McLaughlin could never be accused of being a feminist. If Elizabeth Perry can serve as an example, Louise irritated feminists. The Cincinnati ceramist firmly believed that by publishing her ceramic manuals, she contributed her fair share to the cause. Her "duty" to women's progress, she thought, began and ended with these books. However, she did contribute to women's causes in other ways. The Cincinnati Pottery Club, for example, which McLaughlin founded in 1879, was the first ceramic club for women in the nation and it served as a model for all others thereafter. In its own way, it combined with other women's clubs to transform womanhood "by providing an intellectual and social self-improvement program outside the realm of the household."[38]

If McLaughlin was not a feminist by definition, certainly her life's contributions to ceramics serve as an example of excellence that can be admired by men as well as women in the field. When considering these contributions, her work must be divided into three branches of ceramics: china painting, pottery decoration under the glaze, and porcelain. As previously stated, she probably held the least influence in the one area of which she was most proud, namely porcelain. Unlike the other two branches, she did not write a manual on the subject; consequently, her work in porcelain was never as well known. By example she might have influenced others to enter the field, particularly Adelaide Alsop Robineau, but this has yet to be proven. Robineau's inspiration could have come from her first porcelain teacher, Charles Fergus Binns, who earlier had inspired McLaughlin. Whatever the case, no porcelain tradition or body of work seems to reflect a Cincinnati connection.

Pottery decoration under the glaze, ranked by McLaughlin as her second most important contribution, is another story. Discovering the technique sought after throughout Europe and America was a major accomplishment. With it, she sparked the creation of a ceramic industry in Cincinnati that ultimately resulted in the world-class Rookwood Pottery Company. Her manual on the subject undoubtedly inspired others, and in general, created a ceramic legacy in the United States that is still being researched today for the riches it holds.

Finally, the contribution that she favored the least, china painting, is probably her greatest legacy. Research currently underway suggests that china painting was the door that opened the way for women to enter the arts, and was even the inspiration for the rise of the Arts and Crafts Movement. Louise McLaughlin's influence in this part of American ceramic history is major because her three manuals, with their combined six editions, spanned the age from 1877 to 1917 and sold more than twenty thousand copies. While statistics speak for themselves, the changes in society brought about by the vast numbers of women china painters who were afforded self-expression, self-improvement, and intellectual stimulation for the first time, left a legacy still vital today.

As for the aesthetic quality of McLaughlin's body of ceramic work, history has yet to draw any firm conclusions. For the most part, however, it was left to Rookwood to perfect aesthetically her underglaze slip technique, and to Robineau to bring porcelain to artistic excellence. That is not to say that McLaughlin did not create beautiful porcelain or remarkable underglaze decoration. She simply did not stay in either branch long enough to realize the full potential of her discoveries. She did, however, remain with china painting long enough to achieve excellence. Because china painting is the least researched of the three branches, however, it is difficult to determine the quality of her work in relation to the national norm. Almost certainly it ranks very high, if not superior to most other work of its kind.

The ultimate problem in judging McLaughlin's ceramic *oeuvre* is that so little of it has surfaced with history. According to her records, she left approximately 322 successful pieces of porcelain. Only about twenty are known today. In 1879 she produced fifty-two examples of underglaze slip decorated ware. Considering that this was a prosperous year and that she worked in this branch unevenly for seven years, she probably left about three hundred pieces at best. Perhaps twenty-five or thirty are known today. As for her *oeuvre* of painted china, there is no way to offer an informed estimate of its scope; there are no annual production records, and she produced

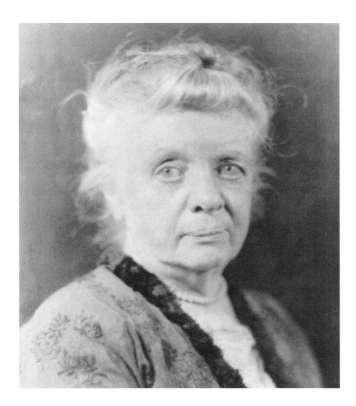

Fig. 14.6. M. Louise McLaughlin, 1922, age seventy-five. This photograph was taken from a gelatin silver print by Bachrack. *Courtesy of the Cincinnati Art Museum, Gift of Mr. and Mrs. Robert Todd*

painted china sporadically from 1874 to about 1917, if not longer. The Cincinnati Art Museum holds approximately thirty such examples, and only a few are known to be in private collections. A renewed interest in her work would certainly bring many pieces from all three branches to the fore. Until then, it must remain enough to recognize and appreciate Louise McLaughlin as one of the major figures in American ceramic history who helped to establish the artist/potter tradition in America. She proved that every aspect in the process of ceramics from conception to creation, including the technical as well as the aesthetic components, are within the domain of any artist who is bold enough to be a dreamer of dreams.

appendix 1

Record of Underglaze Slip
Decorated Vases Made in 1879

Month	No.	Spoiled in Firing	Successful Pieces	Sold	Total Price
Jan.	15	8	6	6	$82.00
Feb.	14	7	6	3	$70.00
Mar.	8		8	4	$60.00
Apr.	3	1	2	2	$27.00
May	2	2			
June	6	3	3	3	$70.00
July	14	3	11	6	$101.00
Aug.	10	5	5		
Sept.	5	3	1		
Oct.	11	7	4		
Nov.	7	4	3		
Dec.	7	4	3		
Total	102	46	52	24	$410.00

When the number of pieces spoiled in firing plus the number of successful pieces do not equal the total number for the month, it is because the artist did not include the pieces that she gave away in either of these two columns.

This information is taken from a one-page record made by the artist that was eventually donated by Mr. and Mrs. James Todd to the Mary R. Schiff Library, Cincinnati Art Museum.

appendix 2

Cincinnati Pottery Club Annual Receptions

No.	Date/Time	Place	Address
1	May 5, 1880 Wed. 10 A.M.–4 P.M.	Frederick Dallas Pottery	Hamilton Rd. (later McMicken Ave.) and Dunlap St.
2	Apr. 29, 1881 Fri. 12–6 P.M.	The Literary Club	24 West 4th St.
3	May 12, 1882 Fri. 11 A.M.–5 P.M.	The Literary Club	
4	May 1, 1883 Tues. 12–6 P.M.	The Literary Club	
5	May 16, 1884 Fri. 12–6 P.M.	The Railway Club	The Ortiz Restaurant Sycamore and 4th Sts.
6	May 29, 1885 Fri. 3–9 P.M.	The Ohio Club	The Ortiz Restaurant
7	Dec. 17, 1886 Fri. 11 A.M.–5 P.M.	Lincoln Club	Race and 8th Sts.
8	Dec. 21, 1887 Wed. 11 A.M.–5 P.M.	Lincoln Club	
9	Dec. 6, 1888 Thurs. 11 A.M.–5 P.M.	Lincoln Club	
10	Mar. 27, 1890 Thurs. 11 A.M.–5 P.M.	Lincoln Club	

Members of the Cincinnati Pottery Club

Banks, Miss Frances "Fannie" S., 1881–90

Boyé, Miss, 1890

Camacho, Mrs. Simon Bolivar, 1888–90

Carlisle, Miss Florence (Mrs. James R. Murdoch by 1885), 1879–90

Devereux, Miss Louise, 1890

Dodd, Mrs. William (Jane Porter Hart). Although sometimes listed, she was never a
 member, according to McLaughlin.

Dominick, Mrs. George, 1879–90

Eaton, Miss Frances "Fannie" Gladys, 1885–87

Eckstein, Mrs. Frederick, Jr., 1886–87

Ellis, Mrs. Frank R. (Mary Rhodes), 1879–80

Field, Mrs. Walter H. (Abbie M.), 1879–90

Fletcher, Miss Clara Belle, 1879–85

Fry, Miss Laura Ann, 1879–90

Hinkle, Miss A. H., 1881–90

Holabird, Miss Alice Belle, Treas., 1879–90

Kebler, Mrs. Charles A. (Florence), 1879–1886. She died around 1887 and was
 the only club member to be "called away to the other shore" during the club's
 existence. She and Mrs. Lewis were the daughters of Mrs. E. G. Leonard.

Keenan, Mrs. Mary Virginia, 1879–80, 1882–84. The records do not show her as a
 member in 1881, but they may be incomplete.

Leach, Miss Lea. She is mentioned in the Langstroth Collection, but she has never been confirmed as a member and her dates are unknown.

Leonard, Mrs. E. G. (Henrietta D.), 1879–90

Leonard, Mrs. Louis C., 1887–90

Lewis, Mrs. A. H., 1887–90. She and Mrs. Kebler were the daughters of Mrs. E. G. Leonard.

Lord, Miss Caroline, 1885–86

McGuffey, Mrs. Alexander H., 1881–90

McLaughlin, Miss M. Louise, Pres., 1879–90

Merriam, Mrs. Andrew B. (Amanda Charlotte Billings), 1879–80

Millikin, Mrs. J. H., 1884

Newton, Miss Clara Chipman, Sec., 1879–90

Nourse, Miss Elizabeth, 1879–81, 1884–90

Peachey, Miss Helen W. (Mrs. Corwine), 1883–90

Pitman, Miss Agnes A., 1879–81, 1883. It is possible that she may have been a member in 1882, but it cannot be confirmed.

Plimpton, Mrs. Cordelia A. Although never listed, she was an original member according to McLaughlin. Her dates are unknown.

Rathbone, Mrs. Estes G., 1885–90

Rice, Mrs. Julia Hall, 1881–90

Spencer, Miss Mary. Although never listed, she was an original member, according to McLaughlin. Her dates are unknown.

Sykes, Mrs. G. S. (Annie Gooding), 1887–90

Yergason, Mrs. H. C., 1887–90

appendix 4

Exhibitions That Include the Ceramics
of M. Louise McLaughlin

1875 Martha Washington International Centennial Tea Party, Cincinnati

1875 Seventh Annual Exhibition of the School of Design of the University of
 Cincinnati, Cincinnati

1875 Sixth Industrial Exposition, Cincinnati

1876 Eighth Annual Exhibition of the School of Design of the University of
 Cincinnati, Cincinnati

1876 The Centennial Exhibition, Philadelphia

1877 Ninth Annual Exhibition of the School of Design of the University of
 Cincinnati, Cincinnati

1878 Exposition Universelle, Paris, France

1878 Loan Exhibition, prepared by the Women's Art Museum Association,
 Cincinnati

1878 Loan Exhibition of the Woman's Decorative Art Society, New York

1878 An Exhibition at Tiffany's, New York

1879 Seventh Industrial Exposition, Cincinnati

1880 Women's Art Museum Association Exhibition, College of Music,
 Cincinnati

1880 Eighth Industrial Exposition, Cincinnati

1880 Exhibition in "The Decorative Art Rooms," Buffalo

1882 Exhibition of objects belonging to the Cincinnati Art Museum, Exposition
 Building, Cincinnati

1883	The Spring Exhibition of the London Emporium of Art, Messrs. Howell & James, London, England
1889	Exhibition of American Art Industry, Philadelphia Museum, Philadelphia
1892	The Work of Miss Mary Louise McLaughlin, Frederick Keppel & Co., New York
1893	World's Columbian Exposition, Chicago
1895	Cotton States and International Exposition, Atlanta
1899	Sixth Annual Exhibition of American Art, Cincinnati Art Museum, Cincinnati
1900	Exposition Universelle, Paris, France
1900	Seventh Annual Exhibition of American Art, Cincinnati Art Museum, Cincinnati
1901	Pan-American Exposition, Buffalo
1901	The Association of Allied Arts, New York
1901	The Keramic Society, New York
1902	*Esposizione Internazionale d'Arte Decorativa Moderna*, Turin, Italy
1903	Worcester Art Museum Exhibit, Worcester
1903	Tenth Annual Exhibition of American Art, Cincinnati Art Museum, Cincinnati
1903	Exhibition by the Guild of Arts and Crafts, The Guild House, New York
1903	Exhibition of Arts and Crafts, The Craftsman Building, Syracuse
1904	Eleventh Annual Exhibition of American Art, Cincinnati Art Museum, Cincinnati
1904	Ninth Annual Exhibition of the Society of Western Artists, Cincinnati Art Museum, Cincinnati
1904	Louisiana Purchase Exposition, St. Louis
1904	The Cincinnati Women's Club, Cincinnati
1905	Twelfth Annual Exhibition of American Art, Cincinnati Art Museum, Cincinnati
1906	Fourteenth Annual Exhibition of the Woman's Art Club, Cincinnati
1907	National Arts and Crafts Society Exhibit, New York
1910	Exhibition of the Women's Art Club, Cincinnati Art Museum, Cincinnati
1938	Exhibition of the Work of Louise McLaughlin, American Ceramic Society, Columbus, Ohio, and New Orleans
1972	The Arts and Crafts Movement in America, 1876–1916, Princeton

1976	The Ladies, God Bless 'Em: The Women's Art Movement in Cincinnati in the Nineteenth Century, Cincinnati Art Museum, Cincinnati
1978	American Art Pottery, 1875–1930, Delaware Art Museum, Delaware
1987	The Art That Is Life: The Arts and Crafts Movement in America, 1875–1920, the Boston Museum of Fine Arts, Boston
1989	American Porcelain, 1770–1920, the Metropolitan Museum of Art, New York

A "Nashville Exhibit" is noted in McLaughlin's records, but no information for this exhibition has been found.

appendix 5

Losanti Ware Statistics, 1898–1904

Year	Number Made	Saleable	Gifts	Sold	Price
1898	ca. 100	8	2	2	$22.00
1899	117	8	?	2	$20.00
1900	213	35	19	4	$24.00
1901	233	50	10	15	$126.00
1902	265	151	15	ca. 15	$127.82
1903–04	314	ca. 70	?	ca. 15	ca. $125.00
Total	1,239	ca. 322	46+	ca. 53	ca. $444.82
Total %	100%	ca. 26%	3.7%+	ca. 4%	?

This information is culled from McLaughlin's Losanti Record Book, given by Mr. and Mrs. James Todd to the Mary R. Schiff Library, Cincinnati Art Museum.

appendix 6

Ceramic Marks

China-Painted Pieces

McLaughlin's marks on painted china are always painted over the glaze. More often than not, she used iron red paint, but she also used other colors, such as black, blue-gray, and gold.

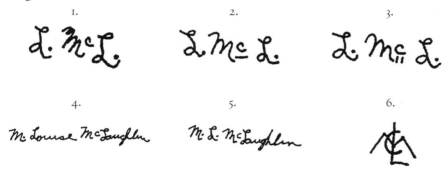

McLaughlin almost always signed her name to the pieces she created. These are various ways in which her name can be found. The most common is number three. Number six probably dates from 1890 or later.

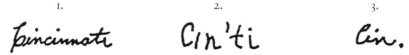

The city of Cincinnati is almost always noted on her china-painted work. Number two is the most common form seen.

1. 2. 3. 4.

1877 1879 15 D 1880 March 1875

McLaughlin commonly placed the year on her pieces, as in examples one and two. Sometimes she also included the month and the day, as in numbers three and four.

Other marks are esoteric. A number in a triangle possibly represents the cone, or temperature, at which the piece was fired by McLaughlin. Pyrometric cones were small, thin pyramids of ceramic materials designed to bend and melt at designated temperatures. They indicated to the ceramist when the kiln had reached a certain temperature. To date, only the numbers one, two, and three have been found in triangles on McLaughlin's painted china. Numbers without triangles probably relate to lost records in which results were noted for future reference.

Underglaze Slip Decorated Pieces (Cincinnati Faience)

McLaughlin's marks on these pieces are almost always incised, but sometimes they are painted under the glaze. Both techniques indicate that the pieces were decorated before they were fired.

1. 2.

This is the most often found signature and it is commonly accompanied by a butterfly.

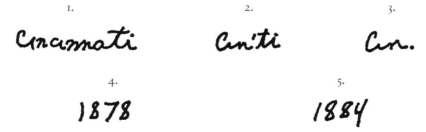

1. 2. 3.

Cincinnati Cin'ti Cin.

4. 5.

1878 1884

The city and year are designated just as they are on the china-painted work.

The Cincinnati Pottery Club is sometimes noted.

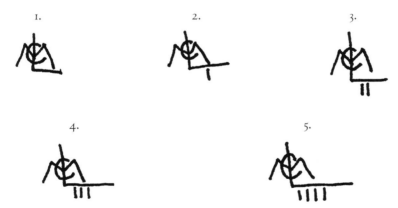

Esoteric numbers relate to lost records in which results were noted for future reference.

Porcelain Pieces (Losanti Ware)

McLaughlin's porcelain marks are either incised or painted in blue. As a rule, the name "Losanti" is painted in blue, while all other marks are incised.

The artist's superimposed initials, L M C, are found incised on virtually all her porcelain. The number of notches below the horizontal bar of the "L" in the artist's cipher helps to date the piece. See the Chart of Dates and Numbers at the end of this appendix for more information.

This incised mark was placed on pieces dating between January 17 and February 8, 1900.

As with McLaughlin's china-painted pieces, the number within a triangle probably denotes the cone, or temperature, at which the piece was fired. This mark is always incised in the porcelain. The most common numbers within the triangles found on the porcelain are seven, eight, and nine, although five and six are also possible.

1.

Losanti

2.

The Losanti name was painted in blue on objects beginning in the latter part of 1900. The earliest documented piece found with such a mark is dated December 18 of that year. Mark number two is probably the later of the two marks to evolve. No doubt it is meant to mimic Chinese calligraphy.

203 5 81 249 54 7

Numbers incised on the pieces correspond to records that were kept for future reference. The Losanti Record Book gives information on the numbered pieces made between 1898 and 1902. The following chart of dates and numbers is based on what little information is known and therefore is offered with the caution that a study of marks must be made on more objects to confirm its validity.

Chart of Dates and Numbers

Dates	Numbers Used	Notches under the Artist's Cipher or Other Marks Used for Dating
May (?)–Aug 27, 1898	1–71 (last number uncertain)	
Oct. 7–Dec 7, 1898	1a–22a	
Feb. 4–May (?), 1899	1–74	
Mid-Nov.–Dec., 1899	1c–43c	
Jan. 17–Feb. 8, 1900	1–14 (last number uncertain)	M. C. M.
Mar. (?)–Dec. 22, 1900	1–99	One Notch
Jan. 26–Dec. 14, 1901	200–431	Two Notches
Jan. 15–Dec. 9, 1902	1–262	Three Notches
1903	?	Four Notches
1904	?	Five Notches?

Notes

Chapter 1

1. M. Louise McLaughlin to Olive Louise McLaughlin, January 18, 1933. Collection of Coille McLaughlin Hooven.

2. M. Louise McLaughlin to Ross C. Purdy, May 16, 1938, Ross C. Purdy Collection, Cincinnati Historical Society Library, Cincinnati (hereafter RCPC/CHSL). Unless otherwise noted, all other family statistics used here and in the following accounts are taken from the Vital Statistics File of the Cincinnati Historical Society Library, Cincinnati Directories, and from family records in the Collection of Coille McLaughlin Hooven.

3. M. Louise McLaughlin, untitled, unpublished paper (read at the meeting of the Porcelain League, Cincinnati, April 25, 1914), 2 (hereafter Porcelain League). In the Artist File of the Mary R. Schiff Library, Cincinnati Art Museum, Cincinnati (hereafter MRSL/CAM).

4. Glenn Thompson, "Fame as Ceramic Artist Lingers," *Cincinnati Enquirer*, September 29, 1937, p. 12, col. 3.

5. M. Louise McLaughlin to Olive Louise McLaughlin, January 18, 1933. Collection of Coille McLaughlin Hooven. The following quote is also from this source.

6. For examples, see *Report of the Board of Commissioners of the Cincinnati Industrial Exposition* (Cincinnati: private publication, 1873), 243; and *Loan Collection Exhibition* (Cincinnati: private publication, 1878), 115–16.

7. George McLaughlin, *Art Work of Cincinnati* (Chicago: W. H. Parish Publishing Company, 1893). McLaughlin's two-part essay, "Cincinnati Artists of the Munich School," is in *American Art Review* 2 (1880): 1–4, 45–50. Articles that he wrote for the *Cincinnati Tribune* include such titles as "Pictures from Paris: French and American Paintings in Contrast," July 7, 1893, p. 4, cols. 6–7; "The Ceramic Arts: American Progress in the Past Seventeen Years," August 9, 1893, p. 4, cols. 4–5; "World's Fair Art: Among the Austrian and Belgian Paintings," August 8, 1893, p. 4, cols. 4–5; "World's Fair Art: Scandinavia Appears at a Disadvantage with Germany and Austria," August 22, 1893, p. 4, cols. 2–3; and "English Painters," August 28, 1893, p. 4, cols. 4–5.

8. This and the following information about James W. McLaughlin is taken from the previously listed sources cited in note 2, as well as from the following three sources: *Biographical Encyclopedia of Ohio of the Nineteenth Century* (Cincinnati: Galaxy Publishing Company, 1876), 205; Charles Theodore Greve, *Centennial History of Cincinnati and Representative Citizens*, vol. 2 (Chicago: Biographical Publishing Company, 1904), 616–17; and "Architects Who Planned Permanent Buildings of Early Cincinnati, Recalled," *Cincinnati Enquirer Sunday Magazine*, December 2, 1923, 6–7, 10.

9. Thompson, p. 12, cols. 1–3.

10. Charles Cist, *Cincinnati in 1851* (Cincinnati: n.p., 1851), 45.

11. Charles Cist, *Cincinnati in 1859* (Cincinnati: n.p., 1859), 240.

12. For a detailed discussion of Cincinnati's Industrial Expositions, see Philip D. Spiess II, "The Cincinnati Industrial Expositions (1870–1888): Propaganda or Progress?" (master's thesis, University of Delaware, 1970).

13. Robert C. Vitz, "Seventy Years of Cincinnati Art: 1790–1860," *Cincinnati Historical Society Bulletin* 25 (January 1967): 50–51. The following information regarding Cincinnati's art organizations and galleries is also taken from this source, 67–69.

14. For a more detailed discussion of the Ladies' Academy of Fine Arts, see Heather Pentland, "Sarah Worthington King Peter and the Cincinnati Ladies' Academy of Fine Arts," *Cincinnati Historical Society Bulletin* 39 (Spring 1981): 7–16. The following information is taken from this source.

15. For a brief but enlightening history of the Art Academy of Cincinnati, see Cecelia Scearce Chewning, "Benn Pitman, Craftsman and Crusader: The Americanization of the Decorative Arts" (master's thesis, University of Cincinnati, 1988), 62–63.

16. "Topics of the Time: Cincinnati," *Scribner's Monthly* 10 (August 1875): 510.

Chapter 2

1. McLaughlin, Porcelain League, 3. Unless otherwise noted all information regarding her formal education is taken from this source.

2. McLaughlin, Porcelain League, 2. The following quote is also from this source.

3. Unless otherwise noted, information about Miss Appleton and her school is taken from correspondence, account books, bankbooks, a list of pupils, and notes in the Elizabeth Appleton Collections of the Cincinnati Historical Society Library, Cincinnati.

4. Elizabeth W. [Williams] Perry, *A Sketch of the Women's Art Museum Association of Cincinnati, 1877–86* (Cincinnati: Robert Clarke & Co., 1886), 18.

5. Sarah Metcalf Phipps (text), and Clara Chipman Newton (illustrations), "A tribute of love and esteem from the pupils of Miss Elizabeth Haven Appleton read at a meeting held in her memory at the rooms of the Historical Society of Thursday, February 19, 1891," unpublished manuscript, Cincinnati Historical Society Library.

6. Unless otherwise noted, the following information regarding the School of Design is taken from the following sources: Robert C. Vitz, *The Queen and the Arts: Cultural Life in*

Nineteenth-Century Cincinnati (Kent, Ohio: Kent State University Press, 1989); *Catalogue of Works of Art, Belonging to the School of Design of the University of Cincinnati* (Cincinnati: n.p., 1875); *School of Design* (Cincinnati: n.p., 1875); and *Catalogue of the University of Cincinnati for the Academic Year 1877–'8* (Cincinnati: n.p., 1877). The last three publications are in the Archives and Rare Books Department of the University of Cincinnati Libraries.

7. McLaughlin, Porcelain League, 3.

8. Ibid., 3.

9. Ibid., 2–3.

10. Information regarding her participation in the school's exhibitions is taken from *School of Design of the University of Cincinnati Annual Catalogue 1873–74* (Cincinnati: n.p., 1874); and the catalogs for the *Fourth, Sixth, Seventh, Eighth, and Ninth Annual Exhibition of the School of Design of the University of Cincinnati* (Cincinnati: n.p., 1873, 1874, 1875, 1876, and 1877, respectively).

11. *Catalogue of the University of Cincinnati for the Academic Year 1877–'8* (Cincinnati: n.p., 1877), Appendix II. The following quotes are taken from this source, 102.

Chapter 3

1. McLaughlin, Porcelain League, 5. Unless otherwise noted, the following account of the china painting class is taken from this paper as well as Herbert Peck, *The Book of Rookwood Pottery*, 2d ed. (Cincinnati: Herbert Peck Books, 1986), 4; "Pottery," unpublished manuscript (Cincinnati: 1890), Cincinnati Historical Society Library. This manuscript is edited and published as "Overture of Cincinnati Ceramics," *Bulletin of the Cincinnati Historical Society* 25 (January 1967): 70–84; Clara Chipman Newton, untitled, unpublished paper read at the Porcelain League Breakfast in Honor of its 20th Birthday, January 10, 1914, (hereafter, Porcelain League Breakfast), Clara Chipman Newton Papers, Cincinnati Historical Society Library (hereafter CCNP/CHSL); Clara Chipman Newton, "Early Days at Rookwood Pottery," unpublished manuscript (transcribed by Kenneth R. Trapp), CCNP/CHSL, 14–16; Elizabeth W. Perry, "Decorative Pottery of Cincinnati," *Harper's New Monthly Magazine* 62 (May 1881): 834–45; Adelaide M. Forsyth, "Ceramic Art in America and Its Pioneers," *Ceramic and Glass Teachers' Guide* 1 (January 1894): 4–5+; Lawrence Mendenhall, "Cincinnati's Contribution to American Ceramic Art," *Brush and Pencil* 17 (February 1906): 47–61.

2. The following information about Maria Longworth Nichols is taken from Rose Angela Boehle, O.S.U., *Maria Longworth* (Dayton: Landfall Press, Inc., 1990).

3. Boehle, 81.

4. M. Louise McLaughlin to Mr. Ross C. Purdy, March 9, 1939, RCPC/CHSL.

5. Unless otherwise noted, all information regarding Benn Pitman was taken from Cecelia Scearce Chewning, "Benn Pitman, Craftsman and Crusader: The Americanization of the Decorative Arts" (master's thesis, University of Cincinnati, 1988).

6. M. Louise McLaughlin to Ross C. Purdy, January 24, 1938, RCPC/CHSL.

7. Vitz, *The Queen and the Arts*, 190.

8. Information on Clara Chipman Newton is taken from Carol Macht, *The Ladies, God*

Bless 'Em: The Women's Movement in Cincinnati in the Nineteenth Century (Cincinnati: Cincinnati Art Museum, 1976), CCNP/CHSL.

9. The first quote is taken from a letter by M. Louise McLaughlin to Ross C. Purdy, April 20, 1938, RCPC/CHSL. The second quote is taken from a letter by M. Louise McLaughlin to Ross C. Purdy, January 24, 1938, RCPC/CHSL. The following quote is taken from "Clara Chipman Newton: A Memorial Tribute" (Cincinnati: n.p., 1938), 15.

10. This quote and the following quote by Benn Pitman are taken from "Cincinnati Ceramics: How Miss McLaughlin's Discovery Has Revolutionized Faience," *Cincinnati Enquirer*, November 27, 1878, p. 8, col. 5.

11. Newton, Porcelain League Breakfast, unpaged [1].

12. M. Louise McLaughlin, *China Painting: A Practical Manual for the Use of Amateurs in the Decoration of Hard Porcelain* (Cincinnati: Robert Clarke Co., 1877), 15.

13. Newton, "Early Days at Rookwood Pottery," 14.

14. William McLaughlin's death notices are taken from "Deaths: McLaughlin," *Cincinnati Commercial*, May 18, 1874, p. 5, col. 3; "Deaths: McLaughlin," *Cincinnati Enquirer*, May 19, 1874, p. 5, col. 2; and "Died: McLaughlin," *Cincinnati Daily Gazette*, May 18, 1874, p. 5, col. 3.

15. Vitz, *The Queen and the Arts*, 189.

16. *Catalogue of the Seventh Annual Exhibition of the School of Design of the University of Cincinnati* (Cincinnati: n.p., 1875), 23.

17. All information about this exhibition is taken from *Report of the Board of Commissioners of the Cincinnati Industrial Exposition* (Cincinnati: n.p., 1875), 250–53.

18. E. H. Austerlitz, *Cincinnati from 1800 to 1875* (Cincinnati: Block & Company, 1875), 105.

19. Newton, Porcelain League Breakfast, unpaged [2].

20. "Cincinnati Ceramics: How Miss McLaughlin's Discovery Has Revolutionized Faience," *Cincinnati Enquirer*, November 27, 1878, p. 8, col. 5.

21. Mendenhall, 51.

22. McLaughlin, Porcelain League, 4.

Chapter 4

1. Newton, "Early Days at Rookwood Pottery," 14.

2. Unless otherwise noted, information regarding the Martha Washington Tea Party is taken from "Centennial Contributions," *Cincinnati Enquirer*, October 9, 1874, p. 8, col. 2; "The Female Centennial," *Cincinnati Enquirer*, November 24, 1874, p. 8, col. 2; "The Martha Washington Party," *Cincinnati Enquirer*, February 23, 1875, p. 4, col. 4.

3. "The Female Centennial." Unless otherwise noted, all subsequent information and quotes regarding the Women's Branch of the Centennial Board are taken from this source.

4. Unless otherwise noted, all information regarding Mrs. Perry is taken from Macht, 65.

5. "The Martha Washington Party." Unless otherwise noted, all subsequent quotes regarding this event will be taken from this source.

6. Louise M. (Mrs. Alphonso) Taft to Mrs. Elizabeth Williams (Mrs. Aaron F.) Perry,

December 7, 1874, Papers of the Women's Art Museum Association and the Women's Centennial Committee of Cincinnati 1874–1882, Cincinnati Historical Society Library (hereafter WAMA/CHSL).

7. Louise M. (Mrs. Alphonso) Taft to Elizabeth Williams (Mrs. Aaron F.) Perry, December 7, 1874, WAMA/CHSL.

8. Unless otherwise noted, this and the following information regarding the Centennial Tea Party is taken from "The Centennial Fair," *Cincinnati Enquirer*, May 20, 1875, p. 8, col. 1; "Centennial Glory: Bewildering Beauty in Exposition Hall," *Cincinnati Daily Gazette*, May 21, 1875, p. 4, cols. 5–6; p. 5, col. 1; "Centennial Glory: The Rain Does Not Drown Out the Fire of Patriotism," *Cincinnati Daily Gazette*, May 22, 1875, p. 4, cols. 3–6; "The Centennial Tea Party: Patriotic Work of the Ladies of Cincinnati," *Cincinnati Commercial*, May 21, 1875, p. 1, col. 6; p. 2, cols. 1–2; "Centennial Tea Party: Its Continued Success as an Attraction and an Enterprise," *Cincinnati Commercial*, May 22, 1875, p. 1, col. 6; p. 2, col. 1; "The Centennial Tea Party: Children's Day," *Cincinnati Commercial*, May 23, 1875, p. 1, cols. 3–5; "The Centennial Tea Party: It Closes in the Full Tide of Success," *Cincinnati Daily Gazette*, May 24, 1875, p. 8, cols. 3–4; "Ladies Centennial-Tea Party," *Cincinnati Commercial*, May 20, 1875, p. 8, col. 1; "1776–1876: The Grand Opening of the Festival Tonight," *Cincinnati Daily Gazette*, May 20, 1875, p. 4, col. 4; "The Tea-Fight," *Cincinnati Enquirer*, May 22, 1875, p. 4, cols. 5–6; "The Women's Work: Centennial Tea at Exposition Hall," *Cincinnati Enquirer*, May 21, 1875, p. 8, cols. 1–3.

9. Perry, "Decorative Pottery of Cincinnati," 834.

10. Unless otherwise noted, the following information regarding the preparation of the teacups is taken from Newton, Porcelain League Breakfast; Newton, "Early Days at Rookwood Pottery."

11. Newton, "Early Days at Rookwood Pottery," 15.

12. Newton, Porcelain League Breakfast, unpaged [2].

13. Ibid., unpaged [3].

14. Newton, "Early Days at Rookwood Pottery," 15. The following quote is also from this source.

15. McLaughlin, Porcelain League, 4.

16. Newton, Porcelain League Breakfast, unpaged [3].

17. McLaughlin, *China Painting*, 51.

18. Newton, "Early Days at Rookwood Pottery," 15.

19. Perry, "Decorative Pottery of Cincinnati," 834.

20. "The Women's Work: Centennial Tea at Exposition Hall," p. 8, col. 1.

21. "The Centennial Tea Party: Children's Day," p. 1, col. 1.

22. Unless otherwise noted, all quotes related to this painting are taken from "The Centennial Fair," p. 8, col. 1.

23. "Centennial Glory: Bewildering Beauty in Exposition Hall," p. 4, col. 5.

24. "Women's Work: Centennial Tea at Exposition Hall," p. 8, col. 2.

25. "Centennial Glory: Bewildering Beauty in Exposition Hall," p. 4, col. 5.

26. "The Centennial Tea Party: Patriotic Work of the Ladies of Cincinnati," p. 2, col. 1.

27. "The Centennial Tea Party: Children's Day," p. 1, col. 4. The following quote is also from this source.

28. "Centennial Glory: The Rain Does Not Drown Out the Fires of Patriotism," p. 4, col. 6; "Centennial Tea Party: Its Continued Success as an Attraction and an Enterprise," p. 2, col. 1.

29. Newton, "Early Days at Rookwood Pottery," 15.

30. Perry, "Decorative Pottery of Cincinnati," 834. It is not known why Miss Alice Holabird, one of the original four to meet outside of Benn Pitman's woodcarving classroom, is not mentioned.

31. "The Centennial Tea Party: It Closes in the Full Tide of Success," p. 8, col. 3.

32. The quote is taken from Newton, "Early Days at Rookwood Pottery," 15.

33. "Centennial Tea Party: Its Continued Success as an Attraction and an Enterprise," p. 2, col. 1.

34. "The Centennial Tea Party: Children's Day," p. 1, col. 5.

35. "The Centennial Tea Party: Children's Day," p. 1, col. 5.

36. "Centennial Glory: Bewildering Beauty in Exposition Hall," p. 4, col. 5.

37. "The Women's Work: Centennial Tea at Exposition Hall," p. 8, col. 1.

38. "Centennial Glory: The Rain Does Not Drown Out the Fires of Patriotism," p. 4, col. 6.

39. Lea J. Brinker, "Women's Role in the Development of Art as an Institution in Nineteenth-Century Cincinnati" (master's thesis, University of Cincinnati, 1970), 36.

40. "The Centennial Tea Party: It Closes in the Full Tide of Success," p. 8, col. 3.

41. Perry, "Decorative Pottery of Cincinnati," 835.

42. Forsyth, 5.

43. Newton, Porcelain League Breakfast, unpaged [3].

44. Mendenhall, 51.

Chapter 5

1. McLaughlin, Porcelain League, 6.

2. The notification of this award, dated February 15, 1877, is in the University of Cincinnati Libraries, Archives and Rare Books Department, filed under the School of Design, International Exhibition, Philadelphia, 1876.

3. Newton, Porcelain League Breakfast, unpaged [3].

4. *Catalogue of Artistic Carving, China Painting, etc.: The Work of the Ladies of the School of Design of the University of Cincinnati and Other Ladies of the City, Exhibited in the Women's Pavilion of the Centennial Exhibition of 1876* (Cincinnati: n.p., 1876), 7–8.

5. *Catalogue of the Sixth Annual Exhibition of the School of Design of the University of Cincinnati* (Cincinnati: n.p., 1874), 25.

6. *Catalogue of the Seventh Annual Exhibition of the School of Design of the University of Cincinnati* (Cincinnati: n.p., 1875), 16.

7. Ellen Paul Denker, "The Grammar of Nature: Arts & Crafts China Painting," *The Substance of Style: New Perspectives on the American Arts and Crafts Movement* (Winterthur, Delaware: Henry Francis duPont Winterthur Museum, 1996), 281–300.

8. M. Louise McLaughlin to Ross C. Purdy, January 24,1938, RCPC/CHSL.

9. Unless otherwise noted, all information regarding Haviland's faience will be taken from Jean and Laurens D'Albis, *Céramique impressioniste: L'Atelier Haviland de Paris-Auteuil 1873–1882* (Paris: 1974); and T. S. N. [Thomas S. Noble], "Ceramics: An Important Discovery by a Cincinnati Lady," *Cincinnati Daily Gazette,* March 21,1878, p. 8, col. 1.

10. Noble, p. 8, col. 1.

11. "Ceramics at Philadelphia.—I," *American Architect and Building News* 1 (July 29, 1876): 244.

12. M. Louise McLaughlin to Ross C. Purdy, January 24, 1938, RCPC/CHSL.

13. This and the information in the following sentence are taken from a letter by M. Louise McLaughlin to Ross C. Purdy, January 24, 1938, RCPC/CHSL. The information that the firm that sold her the colors was Lacroix's is taken from a letter by M. Louise McLaughlin to Clara Chipman Newton, April 6, 1893, CCNC/CHSL.

Chapter 6

1. McLaughlin, Porcelain League, 6.

2. Cynthia A. Brandimarte, "Somebody's Aunt and Nobody's Mother: The American China Painter and Her Work, 1870–1920," *Winterthur Portfolio* 23 (Winter 1988): 204–5.

3. McLaughlin, *China Painting*, iii.

4. Ibid., 32. Emphasis added.

5. Ibid., v.

6. Perry, "Decorative Pottery of Cincinnati," 834.

7. Untitled newspaper clipping, *New Covenant,* Chicago, undated. Found in the Ross C. Purdy Scrapbook, unpaged, RCPC/CHSL.

8. McLaughlin, *China Painting,* 23, 25, 30, and 37, respectively.

9. Unidentified newspaper clipping entitled "Porcelain-painting," found in the Ross C. Purdy Scrapbook, unpaged, RCPC/CHSL. Noted in pencil is "Tribune Oct. 20/77." The city is unidentified. It is not a Cincinnati newspaper.

10. McLaughlin, *China Painting,* 15 for a recommendation of Lacroix colors; 17–19 for a list of Lacroix colors; 34 for a classification of Lacroix colors; and 63 for a recommendation of Lacroix's powdered colors.

11. Ibid., v, vi.

12. Ibid., 15–16, 27, 45.

13. Denker, unpublished manuscript, 5.

14. McLaughlin, Porcelain League, 4.

15. Benn Pitman, *A Plea for American Decorative Art* (Cincinnati: C. J. Krehbiel & Co., 1895), 11.

16. McLaughlin, *China Painting*, vii, 68, respectively.

17. Ibid., 67.

18. Ibid., vii.

19. Pitman, *A Plea*, 10.

20. McLaughlin, *China Painting*, 66–69. The following discussion of the appropriateness of a design is taken from these pages.

21. Chewning, 80. Louise McLaughlin used the term "naturalistic," Benn Pitman used "realistic." The point being made by both was the same: naturalism and realism were true to nature, whereas the conventional stylized nature. The following information is taken from this source, 86.

22. McLaughlin, *China Painting*, 55.

23. Pitman as quoted in Chewning, 87. Author's italics.

24. Ruth Irwin Weidner, "The Early Literature of China Decorating," *American Ceramics* 2 (Spring 1983): 31.

Chapter 7

1. Irene Sargent, "Some Potters and Their Products," *Craftsman* 4 (August 1903): 332.

2. Unless otherwise noted, the following account is taken from M. Louise McLaughlin to Clara Chipman Newton, April 6, 1893, CCNP/CHSL; M. Louise McLaughlin to Ross C. Purdy, January 24, 1938, RCPC/CHSL; McLaughlin, Porcelain League; "Cincinnati Faience—An Exact Statement as to the Discovery," *Cincinnati Enquirer*, December 3, 1878, p. 8, col. 6.; Newton, Porcelain League Breakfast.

3. *Accession Catalogue: Women's Art Museum Association of Cincinnati*, 102, WAMA/CHSL.

4. M. Louise McLaughlin to Clara Chipman Newton, April 6, 1893, CCNP/CHSL.

5. *Catalogue: Exhibit in Cincinnati Room, Columbian Exposition 1492–1892* (Cincinnati: Robert Clarke Co., 1893), 21, cat. 95–96.

6. Edwin AtLee Barber, *The Pottery and Porcelain of the United States* (New York: G. P. Putnam's Sons, 1893), 275–76; "Cincinnati Women Art Workers," *Art Interchange* 36 (February 1896): 29.

7. M. Louise McLaughlin to Clara Chipman Newton, April 6, 1893, CCNP/CHSL.

8. Paul Evans, *Art Pottery of the United States: An Encyclopedia of Producers and Their Marks*, 2d ed. (New York: Feingold & Lewis Publishing Corp., 1987), 66.

9. M. Louise McLaughlin to Ross C. Purdy, January 24, 1938, RCPC/CHSL.

10. M. Louise McLaughlin to Clara Chipman Newton, April 6, 1893, CCNP/CHSL.

11. In her paper read to the Porcelain League, she states that the first piece came from the kiln in October of 1877, whereas in her January 24, 1938 letter to Ross C. Purdy, she states that it came out in September of that year. The timing here is not crucial and the earlier recollection is used.

12. McLaughlin, Porcelain League, 6. This vase was given to what is now called the Philadelphia Museum of Art where it was ultimately deaccessioned.

13. McLaughlin, Porcelain League, 7.

14. D'Albis, unpaged. *"En effet, à Auteuil, le décor était probablement appliqué, non pas sur pâte crue, comme chez Laurin, mais sur biscuit à 1000°."*

15. "The Contributors' Club," *Atlantic Monthly* 44 (October 1879): 544. This same article was reprinted as "The Cincinnati Faience," *Crockery and Glass Journal* 10 (October 23, 1879): 19, and also as "Cincinnati Faience: Miss Louise M'Laughlin's Discoveries," *Cincinnati Daily Gazette*, September 18, 1879, p. 8, col. 3. The latter two articles note that it is taken from *Atlantic Monthly*.

16. For example, one interviewer quotes her as saying that the glaze "is my discovery." This is found in "Miss M'Laughlin's Faience: A Cincinnati Young Lady Suddenly Becomes Famous," *Cincinnati Enquirer*, November 29, 1878, p. 8, col. 3. Later this is denied in "Cincinnati Faience—An Exact Statement as to the Discovery," *Cincinnati Enquirer*, December 3, 1878, p. 6, col. 6.

17. "The Contributors' Club," 545.

18. The following information on Joseph Bailey Sr. is taken from Elizabeth Cameron, *Encyclopedia of Pottery & Porcelain, 1900–1960* (New York: Facts On File Publications, 1986), 32.

19. M. Louise McLaughlin, *Pottery Decoration under the Glaze* (Cincinnati: Robert Clarke & Co., 1880), vi.

20. "Cincinnati Faience: Miss Louise M'Laughlin's Discoveries," p. 8, col. 3.

21. Noble, p. 8, col. 1.

22. "Rookwood Pottery," *Round the World* (Cincinnati: Benzinger Bros., 1906), 74.

23. McLaughlin, *Pottery Decoration*, 67.

24. For example, in "Miss M'Laughlin's Faience: A Cincinnati Young Lady Suddenly Becomes Famous," p. 8, col. 3, Louise is quoted as saying that the temperatures range from 1,200° to 2,000°. "The Contributor's Club," 545, offers the ridiculous 9,000°, a temperature about four and a half times greater than that necessary for porcelain, the highest fired clay body.

25. Unless otherwise noted, information regarding the exhibition is taken from WAMA/CHSL; Elizabeth W. Perry, *A Sketch of the Women's Art Museum Association of Cincinnati 1877–1886* (Cincinnati: Robert Clarke & Co., 1886); *Loan Collection Exhibition* (Cincinnati: n.p., May 1878); "Women's Art Museum Association: Annual Meeting and Election of Officers," *Cincinnati Daily Gazette*, June 18, 1878, p. 8, col. 3; "Cincinnati Art: What is Said in England of the Cincinnati Loan Collection, and What is Said in Paris of Miss McLaughlin's Faience," *Cincinnati Daily Gazette*, October 5, 1878, p. 8, col. 3.

26. "Women's Art Museum Association: Annual Meeting and Election of Officers," p. 8, col. 3. Quotes in the following sentence are from this source also.

27. *Loan Collection Exhibition*, 114; the catalog numbers for the pieces are 19, 20, 20½, 21, and 21½.

28. Newton, "Early Days at Rookwood Pottery," 16.

29. "Personalities," *Hampton-Columbian Magazine* (January 1912): 835.

30. "Cincinnati Art: What is Said . . . ," p. 8, col. 3.

31. C. A. P. [Cordelia A. Plimpton], "The Exposition of 1878," *Cincinnati Commercial*, July 21, 1878, p. 1, col. 1.

32. "Letter from Eli Perkins: Cincinnati Bears Off the Palm!" *Cincinnati Enquirer*, October 20, 1878, p. 10, col. 6. The following quote is also from this source.

33. This information and the following quote are taken from a letter by M. Louise McLaughlin to Clara Chipman Newton, July 2, 1893, CCNP/CHSL.

34. M. Louise McLaughlin to Ross C. Purdy, January 24, 1938, RCPC/CHSL. The following quote is also from this source.

35. Unless otherwise noted, information on Bennett is taken from Evans, 353–54; and McLaughlin, *Pottery Decoration*, 85–92.

36. Elizabeth Williams Perry, a letter to John Bennett, September 20, 1878, WAMA/CHSL. The entire series of letters concerning the matter are in the WAMA records.

37. "New York Letter: Bennett's Faience," *Cincinnati Enquirer*, October 11, 1878, p. 2, col. 4.

38. Benn Pitman, "Practical Woodcarving and Designing, IX," *Art Amateur* 20 (December 1888): 18.

39. "Miss McLaughlin's Art Discovery," *Cincinnati Commercial*, November 7, 1878, p. 4, col. 5.

40. "Miss M'Laughlin's Faience: A Cincinnati Young Lady Suddenly Becomes Famous," *Cincinnati Enquirer*, November 29, 1878, p. 8, col. 3.

41. Noble, p. 8, col. 1.

42. McLaughlin, *Pottery Decoration*, 41.

43. Charles F. Binns, "Barbotine," *Crockery and Glass Journal* 15 (May 18, 1882): 27.

44. "Letter From Eli Perkins: Cincinnati Bears Off the Palm!" p. 10, col. 6.

45. McLaughlin, *China Painting*, 45.

46. Perry, "Decorative Pottery of Cincinnati," 835.

47. "Miss M'Laughlin's Faience: A Cincinnati Young Lady Suddenly Becomes Famous," p. 8, col. 3.

48. McLaughlin, *Pottery Decoration*, 39.

49. M. Louise McLaughlin to William Watts Taylor, June 30, 1893, CCNP/CHSL.

50. Perry, "Decorative Pottery of Cincinnati," 835.

51. "Letter From Eli Perkins: Cincinnati Bears Off the Palm!" p. 10, col. 6.

52. Unless otherwise noted, all information on Volkmar is taken from Evans, 310–15.

53. Unless otherwise noted, all information on the Robertsons is taken from Cameron, 78.

54. McLaughlin, Porcelain League, 7.

55. "Miss McLaughlin's Art Discovery," p. 4, col. 6.

56. "War among the Potters," *Cincinnati Daily Gazette*, October 7, 1880, p. 8, col. 4.

57. "Miss M'Laughlin's Faience: A Cincinnati Young Lady Suddenly Becomes Famous," p. 8, col. 3.

58. This record is in the Mary R. Schiff Library of the Cincinnati Art Museum. It was one of twenty pieces of ephemera donated by Mr. and Mrs. James Todd.

59. Unless otherwise noted, information regarding the Coultry/Wheatley development of underglaze slip decoration is taken from a letter by M. Louise McLaughlin to Ross C. Purdy, January 24, 1938, RCPC/CHSL.

60. M. Louise McLaughlin to William Watts Taylor, June 30, 1893, CCNP/CHSL.

61. McLaughlin, *Pottery Decoration*, v.

62. Edwin AtLee Barber, "The Pioneer of China Painting in America," *Ceramic Monthly* 2 (September 1895): 15.

Chapter 8

1. M. Louise McLaughlin to Ross C. Purdy, August 9, 1938, RCPC/CHSL.

2. The first quote is taken from a letter by M. Louise McLaughlin to Ross C. Purdy, August 13, 1938, RCPC/CHSL. The second quote is taken from "Pottery," which was published as "Overture of Cincinnati Ceramics," 78.

3. Women's Art Museum Association Meetings of Trustees, unpaged, found under the minutes for February 27, 1879, WAMA/CHSL. The following information is also from this source.

4. The first quote is from a letter by M. Louise McLaughlin to Ross C. Purdy, August 13, 1938, RCPC/CHSL; the second quote is from a letter by M. Louise McLaughlin to Ross C. Purdy, August 9, 1938, RCPC/CHSL. Besides these two sources, information regarding the Cincinnati Pottery Club is taken from a letter by M. Louise McLaughlin to Ross C. Purdy, June 23, 1938, RCPC/CHSL; Newton, "Early Days at Rookwood Pottery"; Clara Chipman Newton, "The Cincinnati Pottery Club," a manuscript, CCNP/CHSL, edited and published in the *Bulletin of the American Ceramic Society* 19 (September 1940): 345–51; Newton, Porcelain League Breakfast.

5. Newton, "The Cincinnati Pottery Club," 11. This version differs slightly from that published in the *Bulletin of the American Ceramic Society*, 348.

6. The names given by Clara Chipman Newton are found in Newton, "The Cincinnati Pottery Club," 10; the names given by Louise McLaughlin are found in a letter by M. Louise McLaughlin to Ross C. Purdy, April 20, 1938, RCPC/CHSL.

7. M. Louise McLaughlin, a letter to Ross C. Purdy, June 23, 1938, RCPC/CHSL.

8. M. Louise McLaughlin, a letter to Ross C. Purdy, April 20, 1938, RCPC/CHSL. The next quote is also from this same source.

9. Peck, 5.

10. M. Louise McLaughlin, a letter to Ross C. Purdy, April 20, 1938, RCPC/CHSL.

11. Peck, 5.

12. Mary Gay Humphreys, "The Cincinnati Pottery Club," *Art Amateur* 8 (December 1882): 21.

13. Newton, Porcelain League Breakfast, unpaged [4].

14. Moses King, ed. *King's Pocket-Book of Cincinnati* (Cambridge, Mass.: n.p., 1880), 67.

15. Newton, Porcelain League Breakfast, unpaged [4–5].

16. M. Louise McLaughlin to Maria Longworth [Nichols] Storer, September 4, 1893, CCNP/CHSL.

17. Women's Art Museum Association Meetings of Trustees, unpublished record, unpaged, found under the listing for November 19, 1879, WAMA/CHSL.

18. The date of occupancy is taken from "The Cincinnati Pottery Club," *American Art Review* 1 (November 1879): 87. The following information regarding the room is taken from: Newton, Porcelain League Breakfast, unpaged [5]; Peck, 5–6; and Perry, "Decorative Pottery of Cincinnati," 836.

19. Newton, Porcelain League Breakfast, unpaged [5].

20. Peck, 5. The following is also taken from Mr. Peck's account.

21. As quoted in Peck, 6.

22. "At the Potter's Wheel," *Cincinnati Gazette*, November 27, 1879, p. 6, col. 4.

23. Herbert Peck states that the Pottery Club occupied Mrs. Trollope's old residence, but both Clara Chipman Newton and Louise McLaughlin state that it was Mrs. Nichols, not the Pottery Club, who used Trollope's cottage.

24. "A Neglected Mine of Wealth," *Cincinnati Commercial*, September 27, 1879, p. 6, col. 4.

25. "Cincinnati Pottery: Some Notable Products of Western Civilization—The Works of Two [*sic*] Ladies—Mrs. Nichols, Miss McLaughlin, and Mrs. Plimpton," *Cincinnati Enquirer*, October 14, 1879, p. 9, col. 2.

26. Lilian Whiting, "The Cincinnati Exposition," *Art Amateur* 1 (November 1879): 120.

27. "Decorative Art: Miss McLaughlin's Exhibit," *Cincinnati Commercial*, September 16, 1879, p. 3, col. 5.

28. "Cincinnati Pottery: Some Notable Products of Western Civilization—The Works of Two [*sic*] Ladies—Mrs. Nichols, Miss McLaughlin, and Mrs. Plimpton," p. 9, col. 2.

29. A photocopy of this catalogue entitled *Cincinnati Industrial Exposition 1879: Cincinnati Exhibit of Decorative Art* can be found in the Mary R. Schiff Library of the Cincinnati Art Museum, filed with the *Catalogue of Paintings, Engravings, Sculpture and Household Art, in the Seventh Cincinnati Industrial Exposition, 1879.* There is no cover page and the four pages of text are unnumbered. The following quote is from the photocopy, unpaged [3].

30. Whiting, 120. The size of two of the vases is taken from *Cincinnati Industrial Exposition 1879: Cincinnati Exhibit of Decorative Art,* unpaged [3].

31. "Decorative Art: Miss McLaughlin's Exhibit," p. 3, col. 5; and Whiting, 120. Both sources used the same quote.

32. Elizabeth W. Perry, "Cincinnati Art Pottery," *Harper's Weekly* (May 29, 1880): 342.

33. As quoted in "At the Potter's Wheel," *Cincinnati Daily Gazette*, November 27, 1879, p. 6, col. 4. The following account of the kilns is also from this source.

34. "Ceramics at Philadelphia–IV," *American Architect and Building News* 1 (August 19, 1876): 269. The following quote is also from this source.

35. *Cincinnati Industrial Exposition 1879: Cincinnati Exhibit of Decorative Art,* unpaged [3]. The exact size is not given, but it was considered "one of the same" when compared to Nichols's two large vases.

36. "The Ali Baba Vase," *Cincinnati Commercial,* February 6, 1880, p. 8, col. 4.

37. "A Great Vase," from an unidentified newspaper clipping found in the Ross C. Purdy Scrapbook, unpaged, RCPC/CHSL.

38. "At the Potter's Wheel," p. 6, col. 4.

39. Newton, Porcelain League Breakfast, unpaged [5]. In another version by Newton entitled "The Cincinnati Pottery Club," 13, CCNP/CHSL, McLaughlin was mounted on a chair, not a table, laying on the background color "very much after the fashion of a scene painter."

40. "The Ali Baba Vase," p. 8, col. 4. The following statistical information is also from this source.

41. "The Ali Baba Vase," *Art Amateur* 2 (March 1880): 79.

42. "A Great Ceramic Work," from an unidentified newspaper clipping found in the Ross C. Purdy Scrapbook, unpaged, RPC/CHSL.

43. "Art Notes: Miss M. Louise M'Laughlin," *Cincinnati Commercial Tribune,* December 23, 1906, p. 10, col. 5.

44. "An Interesting Piece of Pottery," noted as being from the *Baltimore American,* November 25, 1900, and found in the Ross C. Purdy Scrapbook, unpaged, RCPC/CHSL. This vase is currently in a private collection. A color illustration of it can be seen in *In Pursuit of Beauty: Americans and the Aesthetic Movement* (New York: Metropolitan Museum of Art and Rizzoli International Publications, Inc., 1986), Fig. 7.29.

45. M. Louise McLaughlin to Ross C. Purdy, January 24, 1938, RCPC/CHSL.

Chapter 9

1. C. H. [Calista Halsey], "Miss McLaughlin's Triumph," *Cincinnati Daily Times,* November 29, 1878, p. 2, col. 5.

2. "Cincinnati Ceramics," *Art Amateur* 2 (February 1880): 55.

3. Humphreys, 20, 21.

4. Perry, "Decorative Pottery of Cincinnati," 843.

5. "Cincinnati Potteries," *Crockery and Glass Journal* 10 (November 20, 1879): 28.

6. "The Decorative Arts," *Cincinnati Star,* May 5, 1880, p. 4, col. 1.

7. "Bricks without Straw," *Cincinnati Daily Gazette,* October 16, 1880, p. 10, col. 3.

8. McLaughlin, Porcelain League, 9.

9. Elizabeth W. Perry, "Cincinnati Art Pottery," *Harper's Weekly* (May 29, 1990): 342.

10. Lilian Whiting, "Ceramic Progress in Cincinnati," *Art Amateur* 3 (June 1880): 32–33.

11. Perry, "Decorative Pottery of Cincinnati," 842.

12. The following is taken from "The Cincinnati Pottery Club," *Cincinnati Gazette,* January 17, 1880, p. 8, col. 2. It is reproduced in its entirety.

13. Unless otherwise noted, the following account of the first reception of the Cincinnati Pottery Club is taken from: "Pottery Club Reception," *Cincinnati Commercial,* May 6, 1880, p. 3, cols. 3–4; "Art in Pottery," *Cincinnati Enquirer,* May 6, 1880, p. 8, col. 5; "Ceramic Art: The Reception Yesterday of the Pottery Club—An Aesthetic Reunion," *Cincinnati Times-Star,* May 6, 1880, p. 8, col. 2; Newton, "The Cincinnati Pottery Club," "Early Days at Rookwood Pottery," and the Porcelain League Breakfast; McLaughlin, "The Cincinnati Pottery Club," CCNP/CHSL, and the Porcelain League. Newspaper accounts noted that the reception lasted from 12:00 until 4:00 P.M. In "The Cincinnati Pottery Club," Clara Chipman Newton said it was from 12:00 until 5:00 P.M. The invitation noted that it was from 10:00 A.M. until 4:00 P.M.

14. Newton, "The Cincinnati Pottery Club," 12. Newspapers and magazines quoted the number of invitations from 300 to 375. However, since secretary of the club Clara Chipman Newton would have issued them, her account is the one accepted.

15. McLaughlin, Porcelain League, 9.

16. "Pottery Club Reception," p. 3, col. 1.

17. "Pottery Club Reception," p. 3, col. 3.

18. The photographs are in the Cincinnati Historical Society's photographic collection for the Cincinnati Pottery Club; the *Harper's Weekly* engraving accompanies Elizabeth Perry's "Cincinnati Art Pottery," 341.

19. Lilian Whiting, "The Cincinnati Pottery Club," *Art Amateur* 3 (June 1880): 11.

20. The newspaper article is "Ceramic Art: The Reception Yesterday of the Pottery Club—An Aesthetic Reunion," p. 8, col. 2.

21. Sue Brunsman, "The European Origins of Early Cincinnati Art Pottery, 1870–1900" (master's thesis, University of Cincinnati, 1973).

22. Whiting, "The Cincinnati Pottery Club," 11.

23. "Pottery Club Reception," p. 3, col. 3.

24. Newton, Porcelain League Breakfast, unpaged [5–6].

25. Ibid., unpaged [5].

26. Whiting, "Ceramic Progress in Cincinnati," 32.

27. M. Louise McLaughlin to Clara Chipman Newton, July 2, 1893, CCNP/CHSL.

28. *Eighth Cincinnati Industrial Exposition: Exhibit of the Cincinnati Pottery Club 1880* (Cincinnati: n.p., 1880). The following information is taken from pp. 3–8 of this source.

29. "Cincinnati Faience at Buffalo," *Cincinnati Daily Gazette,* November 2, 1880, p. 8, col. 2.

30. We know that it was before May because McLaughlin signs the preface to her book, *Pottery Decoration,* with "Walnut Hills/Cincinnati, May, 1880."

31. "Miss M'Laughlin's Faience: A Cincinnati Young Lady Suddenly Becomes Famous," p. 8, col. 3. The following information regarding the family servants is also from this source.

32. Unless otherwise noted, all information regarding Wheatley's patent and the ensuing consequences is taken from: "War among the Potters," p. 8, cols. 4–5; and "A Ceramic

Claimant," an unidentified article found in the Ross C. Purdy Scrapbook, unpaged, RCPC/CHSL. A notation written at the top of this article notes, "New York, Nov 1880/Montague Marks."

33. "War among the Potters," p. 8, col. 4. The following two quotes are also from this source.

34. M. Louise McLaughlin to Ross C. Purdy, January 24, 1938, RCPC/CHSL.

35. "Mrs. Nichols' Pottery," *Cincinnati Daily Gazette,* September 13, 1880, p. 6, col. 3.

36. Boehle, 70.

37. "Women as Potters," *Cincinnati Commercial Gazette,* March 20, 1883, p. 8, col. 3.

38. M. Louise McLaughlin to Ross C. Purdy, February 25, 1938, RCPC/CHSL.

39. Peck, 8.

40. Clara Chipman Newton, "The Cincinnati Pottery Club," *Bulletin of the American Ceramic Society* 19 (September 1940), 349. This source is used here instead of the original manuscript that is cited in previous endnotes because the pertinent page is missing in the original.

41. "War among the Potters," p. 8, col. 4.

Chapter 10

1. "Hints for Underglaze Work," *Art Amateur* 4 (December 1880): 15.

2. McLaughlin, *Pottery Decoration,* v. The next two quotes are also from this source.

3. Ibid., vi.

4. Ibid., viii, xi.

5. Ibid., 63.

6. Ibid., v, 95.

7. Ibid., 37.

8. Ibid., 42.

9. Ibid., 38.

10. Ibid., 37.

11. The quote is taken from McLaughlin, *Pottery Decoration,* 41.

Chapter 11

1. "The Pottery Club: A Brilliant and Artistic Reception," *Cincinnati Enquirer,* April 30, 1881, p. 4, col. 3.

2. Unless otherwise noted, information regarding the Pottery Club's second reception is taken from: "The Pottery Club: A Brilliant and Artistic Reception," *Cincinnati Enquirer,* April 30, 1881, p. 4, cols. 3–5; "Oldest of the Arts: Brilliant Reception by the Pottery Club," *Cincinnati Commercial,* April 30, 1881, p. 4, cols. 6–7; "Art and Artists: More about the Pottery Club Reception," *Cincinnati Commercial,* May 1, 1881, p. 2, col. 3; "Cincinnati Faience: The Pottery Club Receives a Host of Its Friends," *Cincinnati Daily Gazette,* April 30, 1881, p. 10,

cols. 1–2; Clara Devereux, "Annual Exhibition of the Cincinnati Pottery Club," *Art Amateur* 5 (June 1881): 18.

3. See for example: "The New Haviland 'Grès,'" *Art Amateur* 10 (January 1884), 38; and "Cincinnati Pottery at the Bartholdi Exhibition," *Art Amateur* 10 (February 1884): 69.

4. "Art and Artists: More About the Pottery Club Reception," *Cincinnati Commercial*, May 1, 1881, p. 2, col. 3.

5. The Rookwood Shape Book (1883–1900), 1, the Rookwood Collection, Cincinnati Historical Society Library. According to this source a total of six Aladdin vases were made in all between 1880 and 1884.

6. Devereux, 18.

7. *Théodore Deck: Céramiste*, exhibition catalog with essay by Bernard Bumpus (Great Britain: H. Blairman & Sons Ltd. and Halsam & Whiteway Ltd., 2000), 22. For an illustrated example of the same formula used by Deck, see Mary Gay Humphreys, "Volkmar Faience," *Art Amateur* 8 (January 1883): 42.

8. Peck, 15.

9. "The Potteries: Cincinnati," *Crockery and Glass Journal* 16 (July 27, 1882): 28.

10. "War among the Potters," p. 8, col. 4.

11. "Died: Mary A. McLaughlin," *Cincinnati Daily Gazette*, July 13, 1881, p. 5, col. 4; "Deaths: Mary A. McLaughlin," *Cincinnati Enquirer*, July 13, 1881, p. 5, col. 6; "Died: Mary A. McLaughlin," *Cincinnati Daily Gazette*, July 12, 1881, p. 7, col. 5.

12. Newton, "The Cincinnati Pottery Club," *Bulletin of the American Ceramic Society*, 349.

13. "Haviland Faience," *Art Amateur* 8 (December 1882): 1. The following quote is also from this source.

14. For a detailed discussion of Oscar Wilde's trip to the United States, see: Lloyd Lewis and Henry Justin Smith, *Oscar Wilde Discovers America [1882]* (New York: Harcourt Brace and Company, 1936); and Oscar Wilde, *Decorative Art in America: A Lecture*, together with letters, reviews and interviews, edited with an introduction by R. B. Glaenzer (New York: Brentano's, 1906).

15. For a detailed discussion of Oscar Wilde's trip to Cincinnati, see Robert Herron, "Have Lily, Will Travel: Oscar Wilde in Cincinnati," *Cincinnati Historical and Philosophical Bulletin* 15 (July 1957): 215–33.

16. Newton, "Early Days at Rookwood Pottery," 6.

17. "Cincinnati Reports," *Crockery and Glass Journal* 15 (March 2, 1882): 6.

18. "The Aesthete: Oscar Wilde On 'Decorative Art,'" *Cincinnati Enquirer*, February 24, 1882, p. 8, cols. 4–5. This extensive article offered a list of all the important people who attended the event. Unless otherwise noted, all quotes taken from Oscar Wilde's lecture are from this source.

19. Newton, "Early Days at Rookwood Pottery," 6.

20. "Cincinnati Reports," *Crockery and Glass Journal* 15 (May 18, 1882): 44. The following quote is also from this source.

21. "Cincinnati Reports," *Crockery and Glass Journal* 16 (September 21, 1882): 46. The following quote is also from this source.

22. Peck, 19–21.

23. Ibid., 35.

24. Newton, "The Cincinnati Pottery Club," *Bulletin of the American Ceramic Society*, 349.

25. Newton, the Porcelain League Breakfast, unpaged [6].

26. "Cincinnati Pottery Club: Annual Reception at the Literary Club Rooms To-Day," *Cincinnati Times-Star*, May 1, 1883, p. 3, col. 1.

27. Peck, 25.

28. Ibid., 35. This part of Peck's information appears to be correct.

29. Newton, "The Pottery Club," *Bulletin of the American Ceramic Society*, 349.

30. M. Louise McLaughlin, "Hints to China Painters: I. The Importance of Drawing," *Art Amateur* 8 (December 1882): 19; "Hints to China Painters: II. Suggestions for a Plaque and Tiles," *Art Amateur* 8 (December 1882): 19–20; "Hints to China Painters: III. Colors," *Art Amateur* 8 (January 1883): 41; "Hints to China Painters: IV. Decoration of the Cup and Saucer," *Art Amateur* 8 (January 1883): 41; "Hints to China Painters: V. Preparing Gold and Silver for Porcelain Decoration," *Art Amateur* 8 (February 1883): 71; "Hints to China Painters: VI. Decoration of the Jug," *Art Amateur* 8 (February 1883): 72; "Hints to China Painters: VII. Technique," *Art Amateur* 8 (March 1883): 88; "Hints to China Painters: VIII. Decoration of the Plaque," *Art Amateur* 8 (March 1883): 88; "Hints to China Painters: IX. Designs," *Art Amateur* 8 (April 1883): 111; "Hints to China Painters: X. Decoration of the Plates," *Art Amateur* 8 (April 1883): 111; "Hints to China Painters: XI. Lessons to be Derived from Japanese Art," *Art Amateur* 8 (May 1883): 139; "Hints to China Painters: XII. Coloring of the Japanesque Design," *Art Amateur* 8 (May 1883): 139; "Hints to China Painters: XIII. Palettes for Flower Painting," *Art Amateur* 9 (June 1883): 18–19; "Hints to China Painters: XIV. Decoration of Plaque and Panel," *Art Amateur* 9 (June 1883): 19; "Hints to China Painters: XV. Painting a Head," *Art Amateur* 9 (July 1883): 37; "Hints to China Painters: XVI. Colors for the Design of a Head," *Art Amateur* 9 (July 1883): 37; "Hints to China Painters: XVII. Lettering," *Art Amateur* 9 (August 1883): 64; "Hints to China Painters: XVIII. Firing," *Art Amateur* 9 (September 1883): 83; "Hints to China Painters: XIX. The Use of Metallic Paints Upon Porcelain," *Art Amateur* 9 (October 1883): 105–106; "Hints to China Painters: XX. The Use of Relief Colors," *Art Amateur* 9 (November 1883): 123.

31. M. Louise McLaughlin, *Suggestions to China Painters* (Cincinnati: Robert Clarke & Co., 1890), 20. The following quote is also from this source.

32. McLaughlin, *Suggestions*, 25.

33. An untitled, unidentified newspaper review of *Pottery Decoration under the Glaze*, found in the Ross C. Purdy Scrapbook, unpaged, RCPC/CHSL.

34. M. Louise McLaughlin, *China Painting* (Cincinnati: Robert Clarke & Co., 1889), title page.

35. For a detailed discussion of such works, see Anita J. Ellis, "Royal Worcester's Imi-

tations," *Antique Collector* (June 1986): 82–89. This was also published in *The Complete Antique Collector* (London: Edbury Press, 1988), 148–55.

36. Information regarding the show is taken from "The Museum Association: A Walk through the Department of Cincinnati Decorated Pottery," *Cincinnati Daily Gazette,* February 10, 1882, p. 3, cols. 3–4.

37. Information regarding this exhibit is taken from "The Pottery Club: Specimens of Cincinnati Work for Exhibition in London," *Cincinnati Commercial Gazette,* March 18, 1883, p. 2, col. 2; and Newton, "The Cincinnati Pottery Club," 349. The quote used is taken from the Newton source.

38. Information regarding this exhibit is taken from: L. W. Miller, "Industrial Art: The Exhibition of Art Industry at Philadelphia," *Art Amateur* 21 (November 1889): 134; "The Exhibition at Philadelphia," *Art Amateur* 21 (November 1889): 125; and Newton, "The Cincinnati Pottery Club," *Bulletin of the American Ceramic Society,* 349.

39. As quoted in Newton, "The Cincinnati Pottery Club," *Bulletin of the American Ceramic Society,* 349.

40. Newton, Porcelain League Breakfast, unpaged [7]. The following information is also taken from this source.

41. Information regarding this reception is taken from: "Pottery Club Reception: Splendid Exhibit at the Ortiz," *Cincinnati Commercial Gazette,* May 17, 1884, extra sheets, p. 1, col. 2; "The Pottery Club Reception: A Delightfully Artistic Affair at the Ortiz," *Cincinnati Enquirer,* May 17, 1884, p. 4, col. 4; "An Artistic Affair: Annual Reception To-Day by the Pottery Club," unidentified Cincinnati newspaper, May 16, 1884, found in the Theodore A. Langstroth Collection of the Mary R. Schiff Library, Cincinnati Art Museum.

42. All information regarding this event is taken from "Pretty Artists: Gather about the Round-Table in Celebration of the Tenth Pottery Club Anniversary," *Cincinnati Enquirer,* April 2, 1889, p. 4, col. 7.

43. This and the following statistics are taken from "The Annual Report of the Cincinnati Pottery Club, 1890," unpaged, CCNP/CHSL.

Chapter 12

1. McLaughlin, Porcelain League, 10.
2. Boehle, 77.
3. Ibid., 81.
4. Information regarding the new art school is taken from: "A New Art School: Mrs. Storer's Plans for a Rival to the Art Academy," *Cincinnati Commercial Gazette,* May 18, 1890, p. 1, col. 4; "Under Favorable Auspices: The New Painting Class Begins Its Work," *Cincinnati Times-Star,* October 22, 1890, p. 8, col. 5; and "The Duveneck Class," an unidentified Cincinnati newspaper article found in the Cincinnati Art Museum Scrapbook, vol. 1, 88, Cincinnati Art Museum Archives.

5. McLaughlin, Porcelain League, 3.

6. M. Louise McLaughlin to Ross C. Purdy, May 16, 1938, RCPC/CHSL. The following information and quote is also from this source.

7. The catalog for this exhibition can be found in the Theodore A. Langstroth Collection, MRSL/CAM. Unless otherwise noted, all information regarding this show is taken from this source.

8. Lida Rose McCabe, "The Ceramic Movement: Work in Which Ten Thousand American Women Are Engaged," unidentified Cincinnati newspaper, 1891, found in the RCPC/CHSL. The article was also published as: Lida Rose McCabe, "National Ceramic Association Founded 1891," *Bulletin of the American Ceramic Society* 17 (September 1938): 372–73. Unless otherwise noted, all information and quotes regarding this association are taken from this source.

9. M. Louise McLaughlin to Ross C. Purdy, July 25, 1938, RCPC/CHSL.

10. Boehle, 90. The following information is also from this source.

11. P. W. [*sic*] [William Percival] Jervis, "Women Potters of America," *Pottery, Glass & Brass Salesman* 16 (December 13, 1917): 93.

12. Rookwood Corporate Minutes, 153, in the collection of Rita and Arthur Townley. The following information concerning Taylor's shares of stock is also from this source, 4.

13. Newton, "The Cincinnati Pottery Club," 16, CCNP/CHSL.

14. For the record book, including membership lists, minutes of meetings, and newspaper clippings of this organization, see the collection of the Women's Columbian Exposition Association of Cincinnati, in the Cincinnati Historical Society Library, hereafter WCEAC/CHSL. Unless otherwise noted, all information regarding the association will be taken from this source.

15. Newton, Porcelain League Breakfast, unpaged [7–8]. Unless otherwise noted, the following information and quotes are from this source.

16. All figures and descriptions of the Pottery Club exhibit are taken from the Women's Columbian Exposition Association of Cincinnati record book, vol. 1, 8–27.

17. "The Woman's Building: Cincinnati the Only City in the World Honored with a Special Room," *Cincinnati Enquirer Supplement*, April 30, 1893, p. 17. col. 8.

18. The Women's Columbian Exposition Association of Cincinnati, vol. 9, unbound ruled paper entitled "Money Received," 1, WCEAC/CHSL. The following information is also from this source.

19. All information regarding this congress is taken from Newton, "The Pottery Club," *Bulletin of the American Ceramic Society*, 350.

20. Newton, Porcelain League Breakfast, unpaged [8].

21. The record book of the Women's Columbian Exposition Association of Cincinnati, vol. 4, 33, WCEAC/CHSL.

22. Clara Chipman Newton, *Catalogue: Exhibit in Cincinnati Room, Columbian Exposition 1492–1892* (Cincinnati: Robert Clarke & Co., 1893), 19.

23. M. Louise McLaughlin to Clara Chipman Newton, July 2, 1893, CCNP/CHSL.

24. M. Louise McLaughlin to William Watts Taylor, June 30, 1893, CCNP/CHSL. The following information is also from this correspondence.

25. For information on Valentien, see Peck, 16 and 147.

26. M. Louise McLaughlin to William Watts Taylor, June 30, 1893, CCNP/CHSL. The following quote is also from this source.

27. M. Louise McLaughlin to Clara Chipman Newton, July 2, 1893, CCNP/CHSL.

28. Perry, "Cincinnati Art Pottery," 342.

29. Perry, "Decorative Pottery of Cincinnati," 835.

30. M. Louise McLaughlin to Clara Chipman Newton, July 2, 1893, CCNP/CHSL.

31. William Watts Taylor to M. Louise McLaughlin, July 3, 1893, CCNP/CHSL.

32. Peck, 25.

33. William Watts Taylor to Charles Marseilles, February 20, 1892, Letterpress Book 1891–92, Rookwood Pottery Collection, Mitchell Memorial Library, Mississippi State University (hereafter MML/MSU).

34. William Watts Taylor to T. Hackley, October 9, 1888, Letterpress Book 1888–89, Rookwood Pottery Collection, MML/MSU.

35. M. Louise McLaughlin to Maria Longworth Storer, July 9, 1893, CCNP/CHSL.

36. Maria Longworth Storer to M. Louise McLaughlin, September 3, 1893, CCNP/CHSL. The following two quotes are also from this source.

37. "War among the Potters," p. 8, col. 4.

38. M. Louise McLaughlin to Maria Longworth Storer, September 4, 1893, CCNP/CHSL.

39. Maria Longworth Storer to M. Louise McLaughlin, September 14, 1893, CCNP/CHSL.

40. M. Louise McLaughlin to Maria Longworth Storer, September 16, 1893, CCNP/CHSL. The following quote is also from this source.

41. M. Louise McLaughlin to Miss Sams [?], August 17, 1893, CCN/CHSL.

42. M. Louise McLaughlin to Elizabeth Perry, August 18, 1893, CCNP/CHSL.

43. Elizabeth W. Perry to M. Louise McLaughlin, September 4, 1893, CCNP/CHSL. The following information and quotes are from this source.

44. M. Louise McLaughlin to Clara Chipman Newton, April 6, 1893, CCNP/CHSL.

45. Clara Chipman Newton to Maria Longworth Nichols, May 31, 1884, CCNP/CHSL.

46. L. J. Bonar, *A Sketch and Some Sketches on Fire Insurance* (Mansfield, Ohio: n.p., 1920), 136.

47. George McLaughlin, *The Board of Review of the City of Cincinnati Report of George McLaughlin, Special Examiner, in Regard to the Affairs of the City Waterworks* (Cincinnati: The Commercial Gazette Job Print, 1892).

48. Information regarding George McLaughlin's death is taken from: "Sad Suicide of George McLaughlin," *Cincinnati Commercial Gazette*, October 12, 1893, p. 8, col. 1; "George

M'Laughlin: In a Fit of Despondency He Kills Himself," *Cincinnati Tribune*, October 12, 1893, p. 2, col. 5; "A Brother's Promise," *Cincinnati Commercial Gazette*, October 13, 1893, p. 2, col. 6; and "Died: McLaughlin—Suddenly," *Cincinnati Commercial Gazette*, October 13, 1893, p. 5, col. 6.

49. As quoted in "A Brother's Promise," p. 2, col. 6.

50. "Sad Suicide of George McLaughlin," p. 8, col. 1.

51. Newton, Porcelain League Breakfast, unpaged [8].

52. Porcelain League Minutes, 175, CCNP/CHSL.

53. M. Louise McLaughlin to Mrs. Potter Palmer, October 31, 1894, Mr. and Mrs. James Todd Collection, MRSL/CAM.

54. M. Louise McLaughlin to Ross C. Purdy, April 25, 1938, RCPC/CHSL. The following quote is also from this source.

55. That the work was carried out at the Brockman Pottery is noted in McLaughlin, Porcelain League, 10.

56. The official patent granted to Louise McLaughlin is in the Mr. and Mrs. James Todd Collection, MRSL/CAM. The following information is taken from this source.

57. Edwin AtLee Barber, *The Pottery and Porcelain of the United States* (rev. ed. 1901; reprint, New York: Feingold & Lewis, 1976), 511. Barber also illustrates an example with a mention of the inlay technique in "China Painting in America," *Ladies Home Journal* (March 1901): 1.

58. M. Louise McLaughlin to Mrs. Potter Palmer, October 3, 1894, Mr. and Mrs. James Todd Collection, MRSL/CAM.

59. "How a Clifton Girl Won the First Prize at the National China Painters' Competition," *Cincinnati Times-Star*, November 19, 1897, p. 10, col. 1.

Chapter 13

1. M. Louise McLaughlin, "History of Losanti Ware," Losanti Record Book, unpaged [1]. The Losanti Record Book is unpaged until page 17, when the ledger begins noting page numbers starting with "1." The Mr. and Mrs. James Todd Collection, MRSL/CAM. Unless otherwise noted, the history of her Losanti ware is taken from this source, beginning with the unpaged number one to paged number 19.

2. Harriet Cushman Wilkie, "Some American Porcelains," *Modern Priscilla* 20 (February 1907): 1. All information pertaining to Binns's visit with McLaughlin is taken from this source.

3. Susan R. Strong, "The Searching Flame," *American Ceramics* 1 (Summer 1982): 45. The following information is also from this source.

4. As quoted in Wilkie, 1.

5. McLaughlin, "History of Losanti Ware," unpaged [1].

6. Unless otherwise noted, all information regarding McLaughlin's kiln, including its construction, the fuels used, and its first successful firing is taken from McLaughlin, "History of Losanti Ware," unpaged [1–11].

7. McLaughlin, Porcelain League, 14. The following information about natural gas is also from this source.

8. M. Louise McLaughlin to Ross C. Purdy, October 22, 1938, RCPC/CHSL.

9. M. Louise McLaughlin, "Losanti Ware," *Craftsman* 3 (December 1902): 187.

10. All information on d'Entrecolles is taken from the *Encyclopedia of World Art,* vol. 3 (New York: McGraw-Hill Book Company, Inc., 1960), 191.

11. McLaughlin, "History of Losanti Ware," unpaged [7].

12. "Neighbors' Objections to Kiln Fumes," *Cincinnati Times-Star,* Evening Edition, January 27, 1939, p. 9, col. 1.

13. McLaughlin, Porcelain League, 14.

14. M. Louise McLaughlin to Ross C. Purdy, April 25, 1938, RCPPC/CHSL. All information about Hickey is taken from this source.

15. McLaughlin, Porcelain League, 17.

16. *The Sixth Annual Exhibition of American Art,* Cincinnati Art Museum (Cincinnati: n.p., 1899), 15.

17. M. Louise McLaughlin, a letter to the editor, *Keramic Studio* 1 (August 1899): 65. The following information and quote are also taken from this source.

18. For a better understanding of the life and work of Adelaide Alsop Robineau and her husband, who was her partner in her ceramic endeavors, see Peg Weiss, ed., *Adelaide Alsop Robineau: Glory in Porcelain* (Syracuse: Syracuse University Press, 1981).

19. An unidentified, handwritten report of Paul Jeanneney's visit to Louise McLaughlin's display at the 1900 Exposition Universelle, Ross C. Purdy Scrapbook, unpaged, RCPC/CHSL. Unless otherwise noted, information regarding this incident is taken from this source.

20. McLaughlin, Losanti Record Book, 43. The technical description of the vase is from this source.

21. *The Seventh Annual Exhibition of American Art,* Cincinnati Art Museum (Cincinnati: n.p., 1900), 16.

22. McLaughlin, "History of the Losanti Ware," 10.

23. M. Louise McLaughlin to Charles Fergus Binns, June 1, 1900, Charles Fergus Binns Papers, American Archives of Art (hereafter CFBP/AAA). The following quote is also from this source.

24. Henry Deakin to M. Louise McLaughlin, April 10, 1901, Ross C. Purdy Scrapbook, unpaged, RCPC/CHSL. The following quote is also from this source.

25. Henry Deakin, a letter to M. Louise McLaughlin, April 24, 1901, Ross C. Purdy Scrapbook, unpaged, RCPC/CHSL. The following quote is also from this source.

26. M. Louise McLaughlin to Charles Fergus Binns, May 26, 1901, CFBP/AAA. Until otherwise noted, the following quotes are also from this source.

27. M. Louise McLaughlin, a letter to the editor, *Keramic Studio* 3 (July 1901): 49.

28. M. Louise McLaughlin, "Losanti Ware," *Keramic Studio* 3 (December 1901): 178–79.

29. M. Louise McLaughlin to Charles Fergus Binns, June 6, 1901, CFBP/AAA.

30. The piece is a vase (1970.606) in the collection of the Cincinnati Art Museum, Gift of Theodore A. Langstroth.

31. Mrs. [Nicola di Renzi] Monachesi, "Miss M. Louise McLaughlin and Her New 'Losanti' Ware," *Art Interchange* 48 (January 1902): 11. All information regarding Mrs. Monachesi's review is taken from this source.

32. See, for example, Alice Cooney Frelinghuysen, *American Porcelain 1770–1920* (New York: The Metropolitan Museum of Art, 1989), cat. nos. 107 and 273.

33. M. Louise McLaughlin to Charles Fergus Binns, June 6, 1901, CFBP/AAA. The following quote is also from this source.

34. M. Louise McLaughlin to Charles Fergus Binns, May 26, 1901, CFBP/AAA.

35. Marshal Fry to M. Louise McLaughlin, December 13, 1901, Ross C. Purdy Scrapbook, unpaged, RCPC/CHSL. The following information and quote are also from this source.

36. The number of bodies and glazes is taken from those listed in McLaughlin, Losanti Record Book, 31–36.

37. M. Louise McLaughlin to Charles Fergus Binns, June 6, 1901, CFBC/AAA.

38. M. Louise McLaughlin, "Losanti Ware," *Craftsman* 3 (December 1902): 187.

39. McLaughlin, *Pottery Decoration under the Glaze*, 46.

40. M. Louise McLaughlin to Mr. Smith [?], June 29, 1938, RCPC/CHSL.

41. M. Louise McLaughlin to Ross C. Purdy, January 24, 1938, RCPC/CHSL.

42. McLaughlin, Losanti Record Book, 183. The vase can be seen in Frelinghuysen, cat. nos. 106 and 270. Frelinghuysen refers to the coloring agent as "Rouge S." instead of the correct "Rouge T." This minor error in her outstanding book on American porcelain is understandable, since the source of the information is McLaughlin's handwritten Losanti Record Book, and the artist's handwriting is an unforgivable bane to anyone researching her work.

43. McLaughlin, *Pottery Decoration*, 34. The author never offers the significance of the "T." in the color "Rouge T."

44. McLaughlin, Losanti Record Book, 82.

45. Edwin AtLee Barber to M. Louise McLaughlin, May 30, 1900, Ross C. Purdy Scrapbook, unpaged, RCPC/CHSL. The following quote is also from this source.

46. "American Pottery and Porcelain: New Forms and Colors from the Rookwood, Merrimac, Newcomb, and Losanti Kilns," *New York Times*, April 13, 1902, p. 9, cols. 4–6. The following quote is from this source, col. 5.

47. Henry W. Belknap to M. Louise McLaughlin, June 24, 1902, Ross C. Purdy Scrapbook, unpaged, RCPC/CHSL. Unless otherwise noted, the following quotes are also taken from this source.

48. Russell Sturgis to M. Louise McLaughlin, June 25, 1902, Ross C. Purdy Scrapbook, unpaged, RCPC/CHSL. The following quote is also from this source.

49. Russell Sturgis to M. Louise McLaughlin, October 5, 1902, Ross C. Purdy Scrapbook, unpaged, RCPC/CHSL.

50. As quoted in Russell Sturgis to M. Louise McLaughlin, October 5, 1902, Ross C.

Purdy Collection, unpaged, RCPC/CHSL. *"Je les trouve très bien composès et très artistique. Ils sont évidement [sic] en porcelain, mais d'une pâte qui n'est pas très bien lavée. Je suis sûr qu'on arriverait à de très bons resultats avec cette matière, en appertant un peu plus de soin dans la fabrication."*

51. Russell Sturgis, "The Field of Art: American Pottery," *Scribner's Magazine* 32 (November 1902): 638–39. It should be noted that Sturgis was the art editor for the magazine. The Ohio Valley clay that McLaughlin used was Kentucky ball clay. The following quotes from this article are taken from p. 639.

52. Charles Fergus Binns to M. Louise McLaughlin, April 22, 1903, Ross C. Purdy Scrapbook, unpaged, RCPC/CHSL.

53. "The Guild of Arts and Crafts of New York," *Keramic Studio* 5 (May 1903): 23.

54. "Pottery at the Arts and Crafts Exhibit, Craftsman Building, Syracuse," *Keramic Studio* 5 (June 1903): 36. The following quote is also from this source.

55. Samuel Robineau to M. Louise McLaughlin, April 14, 1904, the Mr. and Mrs. James Todd Collection, MRSL/CAM.

56. "Louisiana Purchase Exposition Ceramics (continued)," *Keramic Studio* 6 (March 1905): 251. The following quote is also taken from this source, 252.

57. McLaughlin, Losanti Record Book, 19.

58. Samuel Robineau to M. Louise McLaughlin, November 13, 1906, Ross C. Purdy Scrapbook, unpaged, RCPC/CHSL.

59. This and the following statistics are culled from information throughout McLaughlin's Losanti Record Book.

60. Martin Eidelberg, "Robineau's Early Designs," *Adelaide Alsop Robineau: Glory in Porcelain*, Peg Weiss, ed. (Syracuse: Syracuse University Press, 1981), 73, 75.

61. M. Louise McLaughlin to Ross C. Purdy, March 9, 1938, RCPC/CHSL.

Chapter 14

1. McLaughlin, Porcelain League, 1.

2. McLaughlin, *China Painting*, 1889 ed., title page.

3. McLaughlin, *China Painting*, 1904 ed., title page.

4. McLaughlin, *China Painting*, 1914 ed., title page.

5. Women's Art Club Papers 1892–1972, unpaged, Cincinnati Historical Society Library. Unless otherwise noted, the following information is taken from catalogs included in this source.

6. M. Louise McLaughlin, *An Epitome of History* (Boston: The Stratford Company, 1923). The following quote is taken as quoted in the foreword of this book.

7. As quoted in "L'Art décoratif: Louise Mac Langhlin [sic]," an unidentified French periodical found in the Ross C. Purdy Scrapbook, unpaged, RCPC/CHSL. *"Parmi tous mes travaux celui qui, avec l'invention de la porcelaine, me semble le plus digne d'attention."*

8. "Neighbors' Objections to Kiln Fumes," *Cincinnati Times-Star*, January 27, 1939, p. 9, col. 1. The following information about Grace Hazard is also from this source.

9. M. Louise McLaughlin to Olive Louise McLaughlin, January 18, 1933, collection of Coille McLaughlin Hooven.

10. M. Louise McLaughlin to Florence Murdock, May 22, 1937, CCNP/CHSL. The following quote is also from this source.

11. "Completing New Book," *Cincinnati Times-Star*, October 10, 1935, p. 15, cols. 7–8.

12. Untitled, unidentified newspaper article, Ross C. Purdy Scrapbook, unpaged, RCPCC/CHSL.

13. Thompson, p. 12, cols. 1–3. The following information and quote are taken from this source.

14. "Neighbors' Objections to Kiln Fumes," p. 9, col. 4.

15. Ross C. Purdy to the Committee on Honorary Membership Nomination of the American Ceramic Society, including Dr. Alexander Silverman, Dr. M. E. Holmes, R. Guy Cowan, March 9, 1938, Ross C. Purdy Scrapbook, unpaged, RCPC/CHSL. The following information is also from this source. Purdy eventually became the president of the American Ceramic Society.

16. M. Louise McLaughlin to Ross C. Purdy, March 9, 1938, RCPC/CHSL. Unless otherwise noted, the following information and quotes are also from this source.

17. M. Louise McLaughlin to Ross C. Purdy, April 5, 1938, RCPC/CHSL.

18. M. Louise McLaughlin to Ross C. Purdy, March 14, 1938, RCPC/CHSL.

19. Ross C. Purdy to M. Louise McLaughlin, March 4, 1938, Ross C. Purdy Scrapbook, unpaged, RCPC/CHSL.

20. M. Louise McLaughlin to Ross C. Purdy, April 5, 1938, RCPC/CHSL. The following two quotes are also from this source.

21. M. Louise McLaughlin to Florence Murdock, May 22, 1937, CCNP/CHSL.

22. M. Louise McLaughlin to Ross C. Purdy, June 23, 1938, RCPC/CHSL.

23. "Famed Artist Never Left House, or Climbed Stair, in Nineteen Years," *Cincinnati Times-Star*, January 17, 1939, p. 9, col. 1. The following information is also from this source.

24. Ross C. Purdy, a letter to Dr. Alexander Silverman, January 17, 1939, RCPC/CHSL. This letter gives the time of her death.

25. "Famed Artist Never Left House, or Climbed Stair, in Nineteen Years"; "Neighbors' Objections to Kiln Fumes"; "Aged Ceramic Artist Dies"; "Louise McLaughlin Known to Patrons in Every Nation," *Cincinnati Enquirer*, January 17, 1939, p. 1, cols. 6–7; "Cincinnati's First Ceramic Artist," *Cincinnati Enquirer*, January 19, 1939, p. 6, cols. 2–4; "Miss M. Louise McLaughlin, Ceramics Authority, Is Dead," *Cincinnati Post*, January 17, 1939, p. 9, cols. 3–4; "Miss M'Laughlin, China Painter, 91," *New York Times*, January 18, 1939, p. 19, col. 5.

26. Last Will and Testament of Mary Louise McLaughlin, Estate no. 138459, Docket 114, p. 330, Probate Court, Hamilton County Court House, Room 515.

27. "An Art Center For 100 Years," *New York Sun*, February 3, 1912, found in the Cincinnati Art Museum Scrapbook, vol. 4, 131, Cincinnati Art Museum Archives.

28. Cynthia A. Brandimarte, "Darling Dabblers: American China Painters and Their Work, 1870–1920," *American Ceramic Circle Journal* 6 (1988): 9.

29. C. H. [Calista Halsey], p. 2, col. 5.

30. Anthea Callen, "Sexual Division of Labor in the Arts and Crafts Movement," *Woman's Art Journal* 5 (Fall 1984/Winter 1985): 2.

31. Lois Marie Fink, "Introduction: From Amateur to Professional: American Women and Careers in the Arts," *Women's Studies* 14 (1988): 301.

32. *Catalogue of an Exhibition of Paintings in Oil, Water Colors, Etchings, Drypoints, Art Pottery, and Etched Decoration on Metal: The Work of M. Louise McLaughlin* (New York: Frederick Keppel & Co., 1892), 2.

33. "Miss McLaughlin's Art Discovery," *Cincinnati Commercial*, November 7, 1878, p. 4, col. 5.

34. "Cincinnati Reports," *Crockery and Glass Journal* 16 (September 21, 1882): 46.

35. "Porcelain-Painting," *Harper's New Monthly Magazine* 61 (November 1880): 904.

36. For a good discussion of Beaux, see Tara L. Tappert, "Cecilia Beaux: A Career as a Portraitist," *Women's Studies* 14 (1988): 389–411. The following information regarding Cecilia Beaux is taken from this source.

37. As quoted in Tappert, 397.

38. Karen J. Blair, *The Clubwoman as Feminist: True Womanhood Redefined, 1868–1914* (New York: Holmes & Meier Publishers, Inc., 1980), 5.

Bibliography

Primary Sources—Books

Barber, Edwin AtLee. *The Pottery and Porcelain of the United States.* New York: G. P. Putnam's Sons, 1893. Rev. ed., 1901; reprint, New York: Feingold & Lewis, 1976.

Blanchard, Mary Warner. *Oscar Wilde's America: Counterculture in the Gilded Age.* New Haven: Yale University Press, 1998.

Elliot, Charles Wyllys. *Pottery and Porcelain: From Early Times Down to the Philadelphia Exhibition of 1876.* New York: D. Appleton and Company, 1878.

Elliott, Maud Howe, ed. *Art and Handicraft in the Woman's Building of the World's Columbian Exposition Chicago 1893.* New York: Goupil & Co., 1893.

Evans, Paul. *Art Pottery of the United States: An Encyclopedia of Producers and Their Marks.* 2d ed. New York: Charles Scribner's Sons, 1987.

McLaughlin, Mary Louise. *The China Painter's Handbook.* Cincinnati: n.p., 1917.

——————. *China Painting: A Practical Manual for the Use of Amateurs in the Decoration of Hard Porcelain.* Cincinnati: Robert Clarke and Company, 1877, 1889, 1904; Stewart & Kidd Co., 1914 [ca. 1911].

——————. *An Epitome of History from Pre-historic Times to the End of the Great War.* Boston: The Stratford Co., 1923.

——————. *Painting in Oil: A Manual for the Use of Students.* Cincinnati: Robert Clarke and Company, 1888.

——————. *Pottery Decoration under the Glaze.* Cincinnati: Robert Clarke and Company, 1880.

——————. *The Second Madame: A Memoir of Elizabeth Charlotte, Duchesse d'Orléans.* New York: G. P. Putnam's Sons, 1895.

——————. *Suggestions to China Painters.* Cincinnati: Robert Clarke and Company, 1883 and rev. ed., 1890.

Norton, Frank H. *Illustrated Historical Register of the Centennial Exhibition, Philadelphia, 1876, and of the Exposition Universelle, Paris, 1878.* New York: American News Co., 1879.

Peck, Herbert. *The Book of Rookwood Pottery.* 2d ed. Cincinnati: Herbert Peck Books, 1986.

Perry, Elizabeth Williams (Mrs. Aaron F.). *A Sketch of the Women's Art Museum Association of Cincinnati, 1877–1886.* Cincinnati: Robert Clarke & Co., 1886.

Pitman, Benn. *A Plea for American Decorative Art.* Cincinnati: Krehbiel and Co., 1895.

Primary Sources—Exhibition Catalogs

Annual Exhibition of American Art. Cincinnati: Cincinnati Art Museum, 1898–1900, 1903–1905.

Annual Exhibition of the School of Design of the University of Cincinnati. Cincinnati: University of Cincinnati, 1873–1877.

Annual Exhibition of the Society of Western Artists. Cincinnati: Cincinnati Art Museum, 1904.

The Annual Spring Exhibition in the Art Museum. Cincinnati: Cincinnati Art Museum, 1896–1898.

Catalogue of Artistic Carving, China Painting, etc.: The Work of the Ladies of the School of Design of the University of Cincinnati and Other Ladies of the City, Exhibited in the Women's Pavilion of the Centennial Exhibition of 1876. Cincinnati: 1876.

Catalogue of an Exhibition of Paintings in Oil, Water Colors, Wood Carvings, Etchings, Drypoints, Art Pottery, and Etched Decoration on Metal: The Work of Miss Mary Louise McLaughlin, of Cincinnati. New York: Frederick Keppel & Co., 1892.

Cincinnati Industrial Exposition 1879: Cincinnati Exhibit of Decorative Art. N.p., 1879.

Clark, Robert Judson, ed. *The Arts and Crafts Movement in America, 1876–1916.* Princeton: Princeton University Press, 1972.

Final Report of the Ohio State Board of Centennial Managers (Women's Pavilion). Columbus, Ohio: Norris and Myers, 1877.

Frelinghuysen, Alice Cooney. *American Porcelain, 1770–1920.* New York: The Metropolitan Museum of Art, 1989.

Kaplan, Wendy. *The Art That Is Life: The Arts and Crafts Movement in America, 1875–1920.* Boston: Little, Brown and Company, 1987.

Keen, Kirsten Hoving. *American Art Pottery, 1875–1930.* Wilmington, Delaware: Delaware Art Museum, 1978.

Loan Collection Exhibition, Prepared by the Women's Art Museum Association of Cincinnati. Cincinnati: n.p., 1878.

Macht, Carol. *The Ladies, God Bless 'Em: The Women's Art Movement in Cincinnati in the Nineteenth Century.* Cincinnati: Cincinnati Art Museum, 1976.

Official Catalogue of Exhibitors: Universal Exposition, St. Louis, U.S.A., 1904 (Department B, Art). St. Louis: The Official Catalogue Company, Inc., 1904.

Report of the Board of Commissioners of the Cincinnati Industrial Exposition. Cincinnati: n.p., 1872–1882.

Woman's Art Club Exhibition. Cincinnati: Cincinnati Art Museum, 1909, 1910.

Primary Sources—Journals/Magazines

"The Ali Baba Vase." *Art Amateur* 2 (March 1880): 79.

"Art Education—Cincinnati." *American Art Review* 2 (1881): 136.

Barber, Edwin AtLee. "China Painting in America." *Ladies' Home Journal* (March 1901): 1.

———. "Cincinnati Women Art Workers." *Art Interchange* 36 (February 1896): 29–30.

"Cincinnati Exposition." *Crockery and Glass Journal* 10 (October 16, 1879): 10.

"The Cincinnati Faience." *Crockery and Glass Journal* 10 (October 23, 1879): 19.

"Cincinnati Potteries." *Crockery and Glass Journal* 10 (November 20, 1879): 28.

"The Cincinnati Pottery Club." *Crockery and Glass Journal* 11 (January 29, 1880): 14.

"The Cincinnati Pottery Club's Exhibit at the World's Fair." *Art Amateur* 28 (May 1893): 163.

"Cincinnati Reports." *Crockery and Glass Journal* 15 (March 2, 1882): 6.

"Cincinnati Reports." *Crockery and Glass Journal* 15 (May 18, 1882): 44.

"Cincinnati Reports." *Crockery and Glass Journal* 16 (September 21, 1882): 46.

"Clubs and Societies—Cincinnati Pottery Club." *American Art Review* 2 (1881): 89.

"The Contributors' Club." *Atlantic Monthly* 44 (October 1879): 543–46.

"Correspondence of Mary Louise McLaughlin." *Bulletin of the American Ceramic Society* 17 (May 1938): 224–25.

Denker, Ellen Paul. "Keeping the Fire Alive: China Painting and the Arts & Crafts Movement." *Arts & Crafts Quarterly* 4 (Winter 1992): 6–11.

Devereux, Clara. "Annual Exhibition of the Cincinnati Pottery Club." *Art Amateur* 5 (June 1881): 18.

Evans, Paul. "Cincinnati Faience: An Overall Perspective." *Spinning Wheel* 28 (September 1972): 16–18.

"The Exhibition at Philadelphia." *Art Amateur* 21 (November 1889): 125.

"Exhibition of the New York Society." *Keramic Studio* 7 (June 1905): 25–28.

"The Faience Discovery." *Crockery and Glass Journal* 7 (April 18, 1878): 16+.

Forsyth, M. Adelaide. "Ceramic Art in America and Its Pioneers." *Ceramic and Glass Teachers' Guide* 1 (January 1894): 4–5+.

"Fortieth Anniversary of Miss McLaughlin Beginning Porcelain Making Recognized by Honorary Membership." *Bulletin of the American Ceramic Society* 17 (May 1938): 225.

"The Guild of Arts and Crafts of New York." *Keramic Studio* 5 (May 1903): 23–24.

"Hints for Underglaze Work." *Art Amateur* 4 (December 1880): 15.

Humphreys, Mary Gay. "The Cincinnati Pottery Club." *Art Amateur* 8 (December 1882): 20–21.

"Identification of Cincinnati Pottery Club and Porcelain League Gifts to the American Ceramic Society." *Bulletin of the American Ceramic Society* 19 (September 1940): 253.

"An Important Ceramic Discovery." *Crockery and Glass Journal* 7 (April 11, 1878): 30.

Kellog, L. Steele. "China Painting." *Art Amateur* 21 (November 1889): 122.

Levin, Elaine. "Mary Louise McLaughlin and the Cincinnati Art Pottery Movement," *American Craft* 42 (December 1982/January 1983): 28–30+.

"Louisiana Purchase Exposition Ceramics (continued)." *Keramic Studio* 6 (March 1905): 251–52.

"Mary Louise McLaughlin." *Bulletin of the American Ceramic Society* 17 (May 1938): 217.

McCabe, Lida Rose. "National Ceramic Association Founded 1891." *Bulletin of the American Ceramic Society* 17 (September 1938): 372–73.

McLaughlin, Mary Louise. "Artistic Decorative Pottery." *Art Amateur* 2 (December 1879): 16.

———. "The Beginnings of the War: A Review of the Antecedent Causes and the Thirteen Critical Days." *Current History* (December 1917): 481–93.

———. "Cincinnati Pottery Club." *Bulletin of the American Ceramic Society* 18 (November 1939): 444.

———. "Hints to China Painters: I. The Importance of Drawing." *Art Amateur* 8 (December 1882): 19.

———. "Hints to China Painters: II. Suggestions for a Plaque and Tiles." *Art Amateur* 8 (December 1882): 19–20.

———. "Hints to China Painters: III. Colors." *Art Amateur* 8 (January 1883): 41.

———. "Hints to China Painters: IV. Decoration of the Cup and Saucer." *Art Amateur* 8 (January 1883): 41.

———. "Hints to China Painters: V. Preparing Gold and Silver for Porcelain Decoration." *Art Amateur* 8 (February 1883): 71.

———. "Hints to China Painters: VI. Decoration of the Jug." *Art Amateur* 8 (February 1883): 72.

———. "Hints to China Painters: VII. Technique." *Art Amateur* 8 (March 1883): 88.

———. "Hints to China Painters: VIII. Decoration of the Plaque." *Art Amateur* 8 (March 1883): 88.

———. "Hints to China Painters: IX. Designs." *Art Amateur* 8 (April 1883): 111.

———. "Hints to China Painters: X. Decoration of the Plates." *Art Amateur* 8 (April 1883): 111.

———. "Hints to China Painters: XI. Lessons to be Derived from Japanese Art." *Art Amateur* 8 (May 1883): 139.

———. "Hints to China Painters: XII. Coloring of the Japanesque Design" *Art Amateur* 8 (May 1883): 139.

———. "Hints to China Painters: XIII. Palettes for Flower Painting." *Art Amateur* 9 (June 1883): 18–19.

———. "Hints to China Painters: XIV. Decoration of Plaque and Panel." *Art Amateur* 9 (June 1883): 19.

———. "Hints to China Painters: XV. Painting a Head." *Art Amateur* 9 (July 1883): 37.

———. "Hints to China Painters: XVI. Colors for the Design of a Head." *Art Amateur* 9 (July 1883): 37.

———. "Hints to China Painters: XVII. Lettering." *Art Amateur* 9 (August 1883): 64.

———. "Hints to China Painters: XVIII. Firing." *Art Amateur* 9 (September 1883): 83.

———. "Hints to China Painters: XIX. The Use of Metallic Paints Upon Porcelain." *Art Amateur* 9 (October 1883): 105–6.

———. "Hints to China Painters: XX. The Use of Relief Colors." *Art Amateur* 9 (November 1883): 123.

———. Letter to the editor. *Keramic Studio* 1 (August 1899): 65.

———. Letter to the editor. *Keramic Studio* 3 (July 1901): 49.

———. "Losanti Ware." *Keramic Studio* 3 (December 1901): 178–79.

———. "Losanti Ware." *Craftsman* 3 (December 1902): 186–87.

———. "Miss McLaughlin Tells Her Own Story." *Bulletin of the American Ceramic Society* 17 (May 1938): 217–22.

———. "Treatment of Supplement Designs." *Art Amateur* 10 (February 1884): 69–70, extra supplement plates 325, 327.

Mendenhall, Lawrence. "Cincinnati's Contribution to American Ceramic Art." *Brush and Pencil* 17 (February 1906): 47–61.

Miller, L. W. "Industrial Art: The Exhibition of Art Industry at Philadelphia." *Art Amateur* 21 (November 1889): 134.

Monachesi, Mrs. [Nicola di Rienzi]. "Miss M. Louise McLaughlin and Her New 'Losanti' Ware." *Art Interchange* 48 (January 1902): 11.

"Necrology: Another Honorary Member Has Passed Away, Mary Louise McLaughlin." *Bulletin of the American Ceramic Society* 18 (February 1939): 66–67.

Nelson, M. J. "Art Nouveau in American Ceramics." *Art Quarterly* 26 (4) (1963): 441–59.

"Newspaper Accounts of Her Faience." *Bulletin of the American Ceramic Society* 17 (May 1938): 222–24.

Newton, Clara Chipman. "The Cincinnati Pottery Club." *Bulletin of the American Ceramic Society* 19 (September 1940): 345–51.

———. "The Porcelain League of Cincinnati." *Bulletin of the American Ceramic Society* 18 (November 1939): 445–46.

Perry, Elizabeth Williams (Mrs. Aaron F.). "Cincinnati Art Pottery." *Harper's Weekly* (May 29, 1880): 341–42.

———. "Decorative Pottery of Cincinnati." *Harper's New Monthly Magazine* 62 (May 1881): 834–45.

———. "The Work of Cincinnati Women in Decorated Pottery." *Art and Handicraft in the Woman's Building of the World's Columbian Exposition, Chicago 1893*, edited by Maud Howe Elliot. New York: Goupil & Co., 1893.

"Personalities." *Hampton-Columbian Magazine* (January 1912): 835–36.

"Porcelain." *Keramic Studio* 9 (December 1907): 178–80.

"Porcelain League of Cincinnati." *Bulletin of the American Ceramic Society* 19 (September 1940): 351–53.

"Pottery at the Arts and Crafts Exhibit, Craftsman Building, Syracuse." *Keramic Studio* 5 (June 1903): 36–38.

"Rookwood Pottery." *Round the World* (Cincinnati: Benzinger Bros., 1906): 71–89.

Sargent, Irene. "Some Potters and Their Products." *Craftsman* 4 (August 1903): 328–37.

Siegfried, Joan. "American Women in Art Pottery." *Nineteenth Century* 9 (Spring 1984): 12–18.

Sturgis, Russell. "The Field of Art: American Pottery." *Scribner's Monthly* 32 (November 1902): 637–40.

"Topics of the Time: Cincinnati." *Scribner's Monthly* 10 (August 1875): 510–11.

Trapp, Kenneth R. "Toward a Correct Taste: Women and the Rise of the Design Reform Movement in Cincinnati, 1874–1880." *Celebrate Cincinnati Art: In Honor of the 100th Anniversary of the Cincinnati Art Museum, 1881–1981,* edited by Kenneth R. Trapp. Cincinnati: Cincinnati Art Museum, 1982.

"Treatment of Supplement Designs." *Art Amateur* 10 (February 1884): 69–70, and supplement plates 325, 327.

Weidner, Ruth Irwin. "The Early Literature of China Decorating." *American Ceramics* 2 (Spring 1983): 28–33.

Whiting, Lilian. "Ceramic Progress in Cincinnati." *Art Amateur* 3 (June 1880): 32–33.

———. "The Cincinnati Exposition." *Art Amateur* 1 (November 1879): 119–20.

———. "The Cincinnati Pottery Club." *Art Amateur* 3 (June 1880): 10–11.

Wilkie, Harriet Cushman. "Some American Porcelains." *Modern Priscilla* 20 (February 1907): 1–2.

Primary Sources—Manuscript Collections

The Cincinnati Historical Society Library, Cincinnati

Elizabeth Haven Appleton, et al., correspondence, account books, bankbooks, a list of students, a tribute, etc., 1855–1891.

Clara Chipman Newton Papers, 1864–1938.

"Pottery." 1890. A very good edited version appears as "Overture of Cincinnati Ceramics." *Bulletin of the Cincinnati Historical Society* 25 (January 1967): 70–84.

Rookwood Collection.

Ross C. Purdy Collection.

The Woman's Art Club Papers, 1892–1972.

Records of the Women's Art Museum Association.

Records of the Women's Columbian Exposition Association of Cincinnati, 1893.

Vital Statistics File.

The Coille McLaughlin Hooven Collection, San Francisco.

Mary R. Schiff Library, Cincinnati Art Museum, Cincinnati

Cincinnati Artist File for Mary Louise McLaughlin. Includes a paper read by McLaughlin at the meeting of the Porcelain League, April 25, 1914. An edited version appears in the *Bulletin of the American Ceramic Society* 17 (May 1938): 217–25.

Cincinnati Art Museum Scrapbooks.

Jane Porter Hart Dodd Scrapbook.

Theodore Ashmead Langstroth Collection.

Mitchell Memorial Library, Mississippi State University. Rookwood Pottery Collection.

Smithsonian Institution, The Archives of American Art, Detroit. The Papers of Charles Fergus Binns.

University of Cincinnati Libraries, Archives and Rare Books Department. Catalogs and Circulars from the School of Design, 1871–1884.

Primary Sources—Newspapers and Directories

"Aged Ceramic Artist Dies: Louise McLaughlin Known to Patrons in Every Nation." *Cincinnati Enquirer*, January 17, 1939, p. 1, cols. 6–7+.

"The Ali Baba Vase." *Cincinnati Commercial*, February 6, 1880, p. 8, col. 4.

"American Pottery and Porcelain: New Forms and Colors from the Rookwood, Merrimac, Newcomb, and Losanti Kilns." *New York Times*, April 13, 1902, p. 9, cols. 4–6.

"Architects Who Planned Prominent Buildings of Early Cincinnati Recalled." *Cincinnati Enquirer Sunday Magazine*, December 2, 1923, 6–7+.

"Art and Artists: More about the Pottery Club Reception." *Cincinnati Commercial*, May 1, 1881, p. 2, col. 3.

"Art in Clay: Annual Reception of the Cincinnati Pottery Club." *Cincinnati Enquirer*, May 2, 1883, p. 4, col. 5.

"Art in Pottery: Pleasant Reception by the Cincinnati Pottery Club." *Cincinnati Enquirer*, May 6, 1880, p. 8, col. 5.

"Art Notes: Miss M. Louise M'Laughlin." *Cincinnati Commercial Tribune*, December 23, 1906, p. 10, cols. 4–5.

"An Artistic Affair: Annual Reception To-Day by the Pottery Club." Unidentified Cincinnati newspaper, May 16, 1884. Found in the Theodore Ashmead Langstroth Collection. Mary R. Schiff Library. Cincinnati Art Museum.

"At the Potter's Wheel." *Cincinnati Daily Gazette*, November 27, 1879, p. 6, col. 4.

"Beautiful Pottery: At the Arts and Crafts Exhibit." *Cincinnati Times-Star*, December 9, 1904, p. 5, cols. 2–3.

"A Brother's Promise." *Cincinnati Commercial Gazette*, October 13, 1893, p. 2, col. 6.

"Centennial Glory: The Rain Does Not Drown Out the Fires of Patriotism." *Cincinnati Daily Gazette*, May 22, 1875, p. 4, cols. 3–6.

"Centennial Tea Party: Its Continued Success as an Attraction and an Enterprise." *Cincinnati Commercial*, May 22, 1875, p. 1, col. 6; p. 2, col. 1.

"Ceramic Art: The Reception Yesterday of the Pottery Club—An Aesthetic Reunion." *Cincinnati Times-Star*, May 6, 1880, p. 8, col. 2.

"Ceramics: Annual Reception of the Pottery Club of Cincinnati." *Cincinnati Commercial*, May 13, 1882, p. 2, col. 5.

"Cincinnati Art: What Is Said in England of the Cincinnati Loan Collection, and What Is Said in Paris of Miss McLaughlin's Faience." *Cincinnati Daily Gazette*, October 5, 1878, p. 8, col. 3.

"Cincinnati Ceramics: Another Local Triumph of Miss M. Louise McLaughlin." *Cincinnati Daily Gazette*, February 7, 1880, p. 10, col. 2.

"Cincinnati Ceramics: How Miss McLaughlin's Discovery Has Revolutionized Faience." *Cincinnati Enquirer*, November 27, 1878, p. 8, col. 5.

"Cincinnati Contemporaries: The Gazette." *Cincinnati Times-Star*, May 13, 1882, p. 4, cols. 2–3.

Cincinnati Directories. Cincinnati: 1819, 1825, 1829, 1831, 1834, 1836–37, 1840, 1842–43, 1846, 1849–1939.

"Cincinnati Faience—An Exact Statement as to the Discovery." *Cincinnati Enquirer*, December 3, 1878, p. 8, col. 6.

"Cincinnati Faience at Buffalo." *Cincinnati Daily Gazette*, November 2, 1880, p. 8, col. 2.

"Cincinnati Faience: Miss Louise M'Laughlin's Discoveries." *Cincinnati Daily Gazette*, September 18, 1879, p. 8, col. 3.

"Cincinnati Faience: The Pottery Club Receives a Host of Its Friends." *Cincinnati Daily Gazette*, April 30, 1881, p. 10, cols. 1–2.

"The Cincinnati Pottery Club." *Cincinnati Daily Gazette*, January 17, 1880, p. 8, col. 2.

"Cincinnati Pottery Club: Annual Reception at the Literary Club Rooms To-Day." *Cincinnati Times-Star*, May 1, 1883, p. 3, col. 1.

"Cincinnati Pottery: Some Notable Products of Western Civilization—The Works of Two [sic] Ladies—Mrs. Nichols, Miss McLaughlin, and Mrs. Plimpton." *Cincinnati Enquirer*, October 14, 1879, p. 9, col. 2.

"Cincinnati Room: The Woman's Building of the White City." *Cincinnati Tribune*, August 10, 1893, p. 4, col. 4.

"Cincinnati's Fair Potters: The Tenth Annual Reception of 'The Club' at the Lincoln." *Cincinnati Times-Star*, March 27, 1890, p. 7, col. 6.

"Cincinnati's First Ceramic Artist." *Cincinnati Enquirer*, January 19, 1939, p. 6, cols. 2–4.

"Completing New Book." *Cincinnati Times-Star*, October 10, 1935, p. 15, cols. 7–8.

"Dainty Gems: Annual Exhibit of the Pottery Club." *Cincinnati Enquirer*, December 7, 1888, p. 5, col. 1.

Dall, Caroline H. "Miss McLaughlin's Work in Decorating Pottery." *Boston Advertiser*, April 4, 1879.

"Deaths: McLaughlin." *Cincinnati Commercial*, May 18, 1874, p. 5, col. 3.

"Deaths: McLaughlin." *Cincinnati Enquirer*, May 19, 1874, p. 5, col. 2.

"Decorative Art: Annual Reception of the Pottery Club." *Cincinnati Enquirer*, May 13, 1882, p. 4, col. 2.

"Decorative Art: Miss McLaughlin's Exhibit." *Cincinnati Commercial*, September 16, 1879, p. 3, col. 5.

"Decorative Art: The Pottery Club." *Cincinnati Commercial*, September 17, 1879, p. 7, cols. 2–3.

"Died: McLaughlin." *Cincinnati Daily Gazette*, May 18, 1874, p. 5, col. 3.

"Died: McLaughlin—Suddenly." *Cincinnati Commercial Gazette*, October 13, 1893, p. 5, col. 6.

"The Exposition: Rain Something of a Damper Yesterday." *Cincinnati Commercial*, September 13, 1879, p. 3, cols. 4–5.

"Fair Hands: That Make Pretty Things in Pottery." *Cincinnati Enquirer*, March 28, 1890, p. 4, col.5.

"The Fair Potters: Fine Display of Exquisite Chinaware This Year." *Cincinnati Times-Star*, December 6, 1888, p. 7, col. 6.

"Fair Potters at Dinner: Celebrating the Birthday of an Artists' Club." *Cincinnati Times-Star*, April 2, 1889, p. 7, col. 6.

"Famed Artist Never Left House or Climbed Stair in Nineteen Years." *Cincinnati Times-Star*, January 17, 1939, p. 9, cols. 4–6.

"George M'Laughlin: In a Fit of Despondency He Kills Himself." *Cincinnati Tribune*, October 12, 1893, p. 2, col. 4.

H., C. [Halsey, Calista]. "Miss McLaughlin's Triumph." *Cincinnati Times*, November 29, 1878, p. 2, col. 5.

"How a Clifton Girl Won the First Prize at the National China Painters' Competition." *Cincinnati Times-Star*, November 19, 1897, p. 10, col. 1.

"Impress Left by Queen City upon the Art Development of America." *Cincinnati Enquirer*, February 4, 1912, p. 17, cols. 4–5.

"An Interesting Piece of Pottery." *Baltimore American*, November 25, 1900.

"Letter from Eli Perkins: Cincinnati Bears Off the Palm!" *Cincinnati Enquirer*, October 20, 1878, p. 10, cols. 5–6.

"McLaughlin Art Given to Museum." *Cincinnati Post*, January 21, 1939, p. 1, col. 1.

"McLaughlin Exhibit." *Cincinnati Times-Star*, September 12, 1941, p. 29, col. 5.

"Miss M'Laughlin, China Painter, 91." *New York Times*, January 18, 1939, p. 19, col. 5.

"Miss McLaughlin's Art Discovery." *Cincinnati Commercial*, November 7, 1878, p. 4, cols. 5–6.

"Miss M'Laughlin's Faience: A Cincinnati Young Lady Suddenly Becomes Famous." *Cincinnati Enquirer*, November 29, 1878, p. 8, col. 3.

"Miss M. Louise McLaughlin, Ceramic Authority, Is Dead." *Cincinnati Post*, January 17, 1939, p. 9, cols. 3–4.

"The Museum Association: A Walk through the Department of Cincinnati Decorated Pottery." *Cincinnati Daily Gazette*, February 10, 1882, p. 3, cols. 3–4.

"Museum Willed Work by Prominent Artist." *Cincinnati Enquirer*, January 22, 1939, p. 24, col. 3.

"A Neglected Mine of Wealth." *Cincinnati Daily Gazette*, September 27, 1879, p. 6, col. 4.

"Neighbors' Objections to Kiln Fumes Hampered Efforts of Young Ceramicist." *Cincinnati Times-Star*, Eve. Edition, January 27, 1939, p. 9, cols. 1–4.

N., T. S. [Noble, Thomas S.]. "Ceramics: An Important Discovery by a Cincinnati Lady." *Cincinnati Daily Gazette*, March 21, 1878, p. 8, col. 1.

"Oldest of the Arts: Brilliant Reception by the Pottery Club." *Cincinnati Commercial*, April 30, 1881, p. 4, cols. 6–7.

Perry, Elizabeth Williams [Mrs. Aaron F.]. "The Museum Association." *Cincinnati Daily Gazette*, February 10, 1882, p. 3, cols. 3–4. Although there is no byline to this article, a notation in the Women's Art Museum Association Scrapbook (vol. 2, 81), Cincinnati Historical Society Library, tells us that it was written by Mrs. Perry.

Plimpton, Cordelia A. "The Exposition of 1878." *Cincinnati Commercial*, July 21, 1878, p. 1, col. 1.

"Pottery Artists: Gather about the Round-table in Celebration of the Tenth Pottery Club Anniversary." *Cincinnati Enquirer*, April 2, 1889, p. 4, col. 7.

"The Pottery Club." *Cincinnati Daily Gazette*, May 13, 1882, p. 5, col. 6.

"Pottery Club: The Annual Reception Unusually Brilliant." *Cincinnati Daily Gazette*, May 2, 1883, p. 3, col. 4.

"Pottery Club: Art Work in Many Beautiful Phases—A Year's Brilliant Progress." *Cincinnati Commercial Gazette*, December 22, 1887, p. 3, col. 5.

"Pottery Club: A Brilliant and Artistic Reception." *Cincinnati Enquirer*, April 30, 1881, p. 4, cols. 3–5.

"The Pottery Club: Christmas Exhibit at the Lincoln Club." *Cincinnati Commercial Gazette*, December 17, 1886, p. 2, col. 7.

"The Pottery Club: Ninth Annual Reception in Beautiful Lincoln Hall." *Cincinnati Commercial Gazette*, December 7, 1888, p. 5, cols. 1–2.

"Pottery Club: Seventh Annual Reception at the Lincoln Club." *Cincinnati Enquirer*, December 18, 1886, p. 4, col. 2.

"The Pottery Club: Specimens of Cincinnati Work for Exhibition in London." *Cincinnati Commercial Gazette*, March 18, 1883—Extra Sheet, p. 2, col. 2.

"The Pottery Club: A Very Beautiful Exhibit of Pottery and Decorative Arts." *Cincinnati Commercial Gazette*, May 30, 1885—Extra Sheets, p. 1, col. 7.

"Pottery Club Reception." *Cincinnati Daily Gazette*, May 13, 1882, p. 4, col. 5.

"Pottery Club Reception." *Cincinnati Commercial Gazette*, December 18, 1886, p. 7, col. 7.

"Pottery Club Reception: The Beautiful and Unique from Fair Hands." *Cincinnati Times-Star*, December 17, 1886, p. 5, col. 3.

"Pottery Club Reception: A Brilliant Reception Given by the Pottery Club, Attended by the Elite of Cincinnati." *Cincinnati Commercial*, May 6, 1880, p. 3, cols. 3–4.

"The Pottery Club Reception: A Delightfully Artistic Affair at the Ortiz." *Cincinnati Enquirer*, May 17, 1884, p. 4, col. 4.

"The Pottery Club Reception: A Fashionable Crush at the Lincoln." *Cincinnati Times-Star*, December 21, 1887, p. 7, col. 5.

"Pottery Club Reception: Ladies' Day at the Handsome Lincoln Club-house." *Cincinnati Commercial Gazette*, March 28, 1890, p. 8, cols. 1–2.

"Pottery Club Reception: Splendid Exhibit at the Ortiz." *Cincinnati Commercial Gazette*, May 17, 1884—Extra Sheets, p. 1, col.2.

"The Pottery Club's Reception." *Cincinnati Enquirer*, May 30, 1885, p. 4, col. 6.

"Pretty Artists: Gather about the Round-Table in Celebration of the Tenth Pottery Club Anniversary." *Cincinnati Enquirer*, April 2, 1889, p. 4, col. 7.

"The Reception of the Pottery Club." *Cincinnati Daily Gazette*, May 13, 1882, p. 6, col. 1.

"Sad Suicide of George McLaughlin." *Cincinnati Commercial Gazette*, October 12, 1893, p. 8, col. 1.

Thompson, Glenn. "Fame as Ceramic Artist Lingers." *Cincinnati Enquirer*, September 29, 1937, p. 12, cols. 1–3.

"Turning Back the Clock." *Cincinnati Times-Star*, December 28, 1944, p. 22, cols. 3–4.

"Under Favorable Auspices: The New Painting Class Begins Its Work." *Cincinnati Times-Star*, October 22, 1890, p. 8, col. 5.

"War among the Potters, T. J. Wheatley Secures a Patent on American Limoges." *Cincinnati Daily Gazette*, October 7, 1880, p. 8, cols. 4–5.

"Woman Potter to Show Work in N. Y." *Cincinnati Post*, March 27, 1907, p. 3, col. 4.

"The Woman's Building: Cincinnati the Only City in the World Honored with a Special Room." *Cincinnati Enquirer Supplement*, April 30, 1893, p.17, col. 8.

"Women's Art Museum Plans." *Cincinnati Enquirer*, October 20, 1879, p. 10, col. 3.

Primary Sources—Records

McLaughlin, M. [Mary] Louise. "The Losanti Record Book, 1898–1902." Mary R. Schiff Library. Cincinnati Art Museum.

———. Last Will and Testament, Estate 138459, Will Book #233, 531–34. Probate Court, Hamilton County Court House, Cincinnati, Ohio, 1939.

Primary Sources—Theses and Unpublished Manuscripts

Brinker, Lea J. "Women's Role in the Development of Art as an Institution in Nineteenth-Century Cincinnati." Master's thesis, University of Cincinnati, 1970.

Brunsman, Sue. "The European Origins of Early Cincinnati Art Pottery, 1870–1900." Master's thesis, University of Cincinnati, 1973.

Chewning, Cecelia Scearce. "Benn Pitman, Craftsman and Crusader: The Americanization of the Decorative Arts." Master's thesis, University of Cincinnati, 1988.

Dunn, Kimberly A. "The Losanti Ware of Mary Louise McLaughlin." Master's thesis, University of Cincinnati, 1983.

Kriebl, Karen J. "The Woman's Life That Is Art: Mary Louise McLaughlin and the Cincinnati Arts and Crafts Movement, 1876–1939." Master's thesis, Miami University, 1991.

Langstroth, Theodore. "The Cincinnati Pottery Club and Mary Louise McLaughlin." Manuscript. Cincinnati Public Library.

Marks, Patricia. "Susan S. Frackelton: Inventive Artist in Milwaukee Past." Manuscript. Milwaukee Public Museum Internship, Department of History, June 12, 1995.

McLaughlin, Mary Louise. "The History of Porcelain Making. The Losanti Ware." Manuscript. Cincinnati Historical Society Library.

Vitz, Robert C. "Cincinnati Art and Artists: 1870–1920." Master's thesis, Miami University, 1967.

Secondary Sources—Books

Austerlitz, E. H. *Cincinnati from 1800 to 1875*. Cincinnati: Block & Company, 1875.

Biographical Encyclopedia of Ohio of the Nineteenth Century. Cincinnati: Galaxy Publishing Company, 1876.

Blair, Karen J. *The Clubwoman as Feminist: True Womanhood Redefined, 1868–1914*. New York: Holmes & Meier Publishers, 1980.

Boehle, Rose Angela. *Maria Longworth*. Dayton: Landfall Press, Inc., 1990.

Bonar, L. J. *A Sketch and Some Sketches on Fire Insurance*. Mansfield, Ohio: n.p., 1920.

Callen, Anthea. *Angel in the Studio: Women of the Arts and Crafts Movement, 1870–1914*. London: Astragal Books, 1979.

Cameron, Elizabeth. *Encyclopedia of Pottery & Porcelain, 1900–1960*. New York: Facts on File Publications, 1986.

Denker, Ellen Paul. "The Grammar of Nature: Arts & Crafts China Painting." In *The Substance of Style: New Perspectives on the American Arts and Crafts Movement*. Winterthur, Del.: Henry Francis duPont Winterthur Museum, 1996.

Encyclopedia of World Art. Vol. 3. Philadelphia: McGraw-Hill Book Company, Inc., 1960.

Greve, Charles Theodore. *Centennial History of Cincinnati and Representative Citizens*. Chicago: Biographical Publishing Company, 1904.

King, Moses, ed. *King's Pocket-Book of Cincinnati*. Cambridge, Mass.: n.p., 1880.

Lewis, Dottie L., ed. *Women in Cincinnati: Century of Achievement, 1870–1970*. Cincinnati: The Research and Resources Institute of the Center for Women's Studies at the University of Cincinnati, 1983. Originally published in *Queen City Heritage: The Bulletin of the Cincinnati Historical Society* 41 (Winter 1983).

Lewis, Lloyd, and Henry Justin Smith. *Oscar Wilde Discovers America [1882]*. New York: Harcourt, Brace and Company, 1936.

McLaughlin, George. *The Board of Review of the City of Cincinnati Report of George McLaughlin, Special Examiner, in Regard to the Affairs of the City Waterworks*. Cincinnati: The Commercial Gazette Job Print, 1892.

Naylor, Gillian. *The Arts and Crafts Movement: A Study of Its Sources, Ideals and Influence on Design Theory*. Cambridge: Massachusetts Institute of Technology, 1971.

———. *The Encyclopedia of Arts and Crafts: The International Movement, 1850–1920*. Charlotte Plimmer, ed., Wendy Kaplan, consulting ed. New York: E. P. Dutton, 1989.

Vitz, Robert C. *The Queen and the Arts: Cultural Life in Nineteenth-Century Cincinnati*. Kent, Ohio: Kent State University Press, 1989.

Weimann, Jeanne Madeline. *The Fair Women*. Chicago: Academy Chicago, 1981.

Weiss, Peg, ed. *Adelaide Alsop Robineau: Glory in Porcelain.* Syracuse: Syracuse University Press, 1981.

Wilde, Oscar. *Decorative Art in America: A Lecture.* Edited with an introduction by R. B. Glaenzer. New York: Brentano's, 1906.

Secondary Sources—Exhibition Catalogs

Bumpus, Bernard. *Théodore Deck: Céramiste.* Great Britain: H. Blairman & Sons Ltd. and Haslam & Whiteway Ltd., 2000.

D'Albis, Jean and Laurens. *Céramique impressionniste: L'Atelier Haviland de Paris-Auteuil, 1873–1882.* Paris: 1974.

Denker, Ellen Paul. *After the Chinese Taste: China's Influence in America, 1730–1930.* Salem, Mass.: Peabody Museum, 1985.

Secondary Sources—Journals / Magazines

Barber, Edwin AtLee. "The Exhibition of Paintings on China." *Magazine of Art* 1 (1878): 176–79.

———. "The Pioneer of China Painting in America." *Ceramic Monthly* 2 (September 1895): 5–20.

Binns, Charles F. "Barbotine." *Crockery and Glass Journal* 15 (May 18, 1882): 27.

Brandimarte, Cynthia A. "Somebody's Aunt and Nobody's Mother: The American China Painter and Her Work, 1870–1920." *Winterthur Portfolio* 23 (Winter 1988): 203–44.

———. "Darling Dabblers: American China Painters and Their Work, 1870–1920." *American Ceramic Circle Journal* 6 (1988): 6–27.

Callen, Anthea. "Sexual Division of Labor in the Arts and Crafts Movement." *Women's Art Journal* 5 (Fall 1984–Winter 1985): 1–6.

"Ceramics at Philadelphia." *American Architect and Building News* 1 (July 29, 1876): 244–45; (August 5, 1876): 252–53; (August 12, 1876): 260–61; (August 19, 1876): 267–69; (August 26, 1876): 274–75; (September 23, 1876): 308–10; (September 30, 1876): 316–17; (October 7, 1876): 324–25; (October 21, 1876): 342–43.

"The Chicago World's Fair." *Bulletin of the American Ceramic Society* 18 (November 1939): 444.

"Cincinnati Ceramics." *Art Amateur* 2 (February 1880): 55.

"The Cincinnati Pottery Club." *American Art Review* 1 (November 1879): 87.

"Cincinnati Reports." *Crockery and Glass Journal* 15 (June 15, 1882): 12.

"Cincinnati Reports." *Crockery and Glass Journal* 18 (September 27, 1883): 44.

"David Haviland." *Art Amateur* 2 (February 1880): 55.

Durand, J. "Woman's Position in Art." *Crayon* 8 (February 1861): 25–28.

Edgerton, Giles. "Is There a Sex Distinction in Art? The Attitude of the Critic toward Women's Exhibits." *Craftsman* 14 (1908): 238–51.

Fink, Lois, ed. "Introduction: From Amateur to Professional: American Women and Careers in the Arts." *Women's Studies* 14 (1988): 301–3.

Godman, Barbara. "Breaking the Mould: Why Women's Involvement in Ceramic Practice Had Ceased from 1850–1920." *Ceramic Review* 93 (1985): 38–39.

Harris, Frank. "The French Potters' Wages." *Crockery and Glass Journal* 10 (October 30, 1879): 5.

"Haviland Faience." *Art Amateur* 8 (December 1882): 1.

Humphreys, Mary Gay. "Volkmar Faience." *Art Amateur* 8 (January 1883): 42–43.

Jervis, P. W. "Women Potters of America." *Pottery, Glass & Brass Salesman* 16 (December 13, 1917): 93.

"Louisiana Purchase Exposition Ceramics (continued)." *Keramic Studio* 7 (May 1905): 7–8.

Monachesi, Mrs. [Nicola di Rienzi]. "Painting under the Glaze." *Art Interchange* 38 (June 1897): 144.

———. "Painting under the Glaze, Second Paper." *Art Interchange* 39 (September 1897): 63.

———. "Painting under the Glaze, Third Paper." *Art Interchange* 39 (October 1897): 83.

Nochlin, Linda. "Why Have There Been No Great Women Artists?" Reprinted in *Art and Sexual Politics*, edited by Thomas B. Hess and Elizabeth C. Baker. New York: Macmillan Publishing Co., Inc., 1973.

Paine, Judith. "The Women's Pavilion of 1876." *Feminist Art Journal* 4 (Winter 1975–76): 5–12.

Pentland, Heather. "Sarah Worthington King Peter and the Ladies' Academy of Fine Arts." *Cincinnati Historical Society Bulletin* 39 (Spring 1981): 7–16.

Pitman, Benn. "Practical Woodcarving and Designing, IX." *Art Amateur* 20 (December 1888): 18.

"Porcelain-Painting." *Harper's New Monthly Magazine* 61 (November 1880): 903–7.

"The Potteries: Cincinnati." *Crockery and Glass Journal* 16 (July 27, 1882): 28.

"The Potteries: Cincinnati." *Crockery and Glass Journal* 16 (August 3, 1882): 12.

Purnell, Thomas. "Woman and Art." *Art Journal* 7 (1861): 107–8.

Rinder, Frank. "Woman Artists." *Art Journal* 60 (March 1908): 65–72.

Robineau, S. "The Robineau Porcelains." *Keramic Studio* 13 (August 1911): 80–84.

Smith, Kenneth E. "Laura Ann Fry: Originator of Atomizing Process for Application of Underglaze Color." *Bulletin of the American Ceramic Society* 17 (September 1938): 368–72.

Strong, Susan R. "The Searching Flame." *American Ceramics* 1 (Summer 1982): 44–49.

Trapp, Kenneth R. "Rookwood and the Japanese Mania in Cincinnati." *Cincinnati Historical Society Bulletin* 39 (Spring 1981): 51–75.

Vitz, Robert C. "Seventy Years of Cincinnati Art: 1790–1860." *Cincinnati Historical Society Bulletin* 25 (January 1967): 50–60.

Vors, Frederick. "Haviland Faience." *Art Amateur* 1 (June 1879): 14–15.

Whiting, Lilian. "Cincinnati Ceramics." *Art Amateur* 2 (February 1880): 55.

Wright, M. B. "Haviland Faience." *Art Amateur* 6 (December 1881): 14–15.

"Art Pottery." *Cincinnati Daily Gazette*, October 7, 1880, p. 8, cols. 2–3.

"Bricks without Straw." *Cincinnati Daily Gazette*, October 16, 1880, p. 10, col. 3.

"Centennial Contributions." *Cincinnati Enquirer*, October 9, 1874, p. 8, col. 2.

"The Centennial Fair." *Cincinnati Enquirer*, May 20, 1875, p. 8, col. 1.

"Centennial Glory: Bewildering Beauty in Exposition Hall." *Cincinnati Daily Gazette*, May 21, 1875, p. 4, cols. 5–6; p. 5, col. 1.

"The Centennial Tea Party: Children's Day." *Cincinnati Commercial*, May 23, 1875, p. 1, cols. 3–5.

"The Centennial Tea Party: It Closes in the Full Tide of Success." *Cincinnati Daily Gazette*, May 24, 1875, p. 8, cols. 3–4.

"The Centennial Tea Party: Patriotic Work of the Ladies of Cincinnati." *Cincinnati Commercial*, May 21, 1875, p. 1, col. 6; p. 2, cols. 1–2.

"Deaths: Mary A. McLaughlin." *Cincinnati Enquirer*, July 13, 1881, p. 5, col. 6.

"The Decorative Arts." *Cincinnati Star*, May 5, 1880, p. 4, cols. 1–2.

"Died: Mary A. McLaughlin." *Cincinnati Daily Gazette*, July 12, 1881, p. 7, col. 5.

"Died: Mary A. McLaughlin." *Cincinnati Daily Gazette*, July 13, 1881, p. 5, col. 4.

"Excellent for Study." *Cincinnati Commercial Gazette*, October 10, 1890, p. 8, col. 2.

"The Female Centennial." *Cincinnati Enquirer*, November 24, 1874, p. 8, col. 2.

"Ladies Centennial Tea-Party." *Cincinnati Commercial*, May 20, 1875, p. 8, col. 1.

"The Martha Washington Party." *Cincinnati Enquirer*, February 23, 1875, p. 4, col. 4.

McLaughlin, George. "The Ceramic Arts: American Progress in the Past Seventeen Years." *Cincinnati Tribune*, August 9, 1893, p. 4, cols. 4–5.

"Mrs. Nichols' Pottery." *Cincinnati Daily Gazette*, September 13, 1880, p. 6, col. 3.

"Mrs. Nichols' Pottery." *Cincinnati Daily Gazette*, March 10, 1881, p. 5, col. 5.

"A New Art School." *Cincinnati Commercial Gazette*, May 18, 1990, p. 1, col. 4.

"New York Letter: Bennett's Faience." *Cincinnati Enquirer*, October 11, 1878, p. 2, col. 4.

"The Paris Exhibition." *Cincinnati Enquirer*, February 21, 1878, p. 8, col. 5.

"The Paris Exposition." *Cincinnati Enquirer*, February 16, 1878, p. 4, col. 7.

"Paris Exposition." *Cincinnati Enquirer*, February 20, 1878, p. 4, col. 5.

"1776–1876: The Grand Opening of the Festival Tonight." *Cincinnati Daily Gazette*, May 20, 875, p. 4, col. 4.

"The Tea-fight." *Cincinnati Enquirer*, May 22, 1875, p. 4, cols. 5–6.

"Women as Potters." *Cincinnati Commercial Gazette*, March 20, 1883, p. 8, col. 3.

"Women's Art Museum Association." *Cincinnati Daily Gazette*, June 18, 1878, p. 8, col. 3.

"The Women's Work: Centennial Tea at Exposition Hall." *Cincinnati Enquirer*, May 21, 1875, p. 8, cols. 1–3.

Index

Page numbers in italics refer to illustrations.

molds, designed and carved by McLaughlin, 135–36, 148
Monachesi, Nicola di Renzi, 150–51
Moorish Revival style, Plum Street Temple, 5
Morris, William, 18
Murdock, Mrs. James R. *See* Carlisle, Florence
Music Hall, WAMA reception in, 89

National Ceramic Association, 122–23
National China Painter's Competition, 136–37
nature, as artistic inspiration, 46–47, 96, 108
New York Sun, 172
New York Times, 156
Newcomb College, 169
Newcomb Pottery, 119
Newton, Clara Chipman, *21*, 31, 50, 59, 93, *117*, *120*, *164*, 168
 Ali Baba vase, naming of, 76
 Associated Artists of Cincinnati, secretary of, 110
 Centennial Tea Party, omission as contributor to, 35
 china-painted teacups, 29–30, 37–38
 Cincinnati Pottery Club, membership in, 66–67, 100–101, 104, 107
 Columbian Exposition, Cincinnati Room, work on, 124–25
 friendships, McLaughlin and Nichols, 70, 130–31
 pieces exhibited, 85
 Pottery Club reception, 87, 114–15
 student of Pitman, 11, 19–22, 24–25, 29
Nichols, George Ward, 16–17, 72, 78, 87, 102–3, 116
Nichols, Maria Longworth, 16–17, *18*, 59, 101
 Centennial Tea Party, involvement in, 27
 sales made at, 35
 Cincinnati Art Museum, pieces in, 23
 Dallas Pottery, work at, 68, 71–72
 McLaughlin and
 correspondence with, 128–29
 rivalry between, 35, 69–70, 73, 103–4, 123
 Miss Appleton's, attendance at, 11
 Pottery Club reception, attendance at, 87
 Rookwood Pottery Company, founding of, 91–93
 underglaze technique, use of, 94
 widowhood and second marriage of, 116
 Wilde, Oscar, meeting with, 105–6
Nimitz, Herman and Ruth, 60
Noble, Thomas S., 13, 55, 103

North Hall, Exposition Hall, 32–33
Nourse, Elizabeth, 19–20, 85, 100
Noyes, General Edward, 34
Noyes, Mrs. Edward, 57

obituaries, M. Louise McLaughlin, 172
oil painting on canvas, 119
 McLaughlin's interest in, 40, 163
 See also portraiture
one-fire method, 149
Osgood Art School of New York, 110
overglaze
 inferiority of underglaze decoration, 41
 kiln at Dallas Pottery, 74
 orange effect, 112

P. L. Coultry & Co., 51–52
painting. *See* china painting; portraiture
Painting in Oil, 110, 163
Pallisy, Bernard, 40
Palmer, Mrs. Potter, 124, 134
Pan-American Exposition, Buffalo, 149
Paris Exposition of 1900, 143
parrot, Teddy, 168, *169*
patents
 inlay technique, 134
 underglaze slip technique
 Rookwood Pottery, 123–24
 Wheatley, T. J., 91
Peachey, H. W., 68, *115*
Peck, Herbert, 70, 107, 127
Peintures émaillées, 58
Pendleton and Fifth Street Market Railroad Company, 3
Perkins, Eli, 63
Perry, Aaron F., 87, 103
Perry, Elizabeth Williams, 35
 acknowledgment of McLaughlin by, 62–63
 Bennett, John, request to, 59–60
 Centennial Tea Party, organizer of, 27, 29, 37
 Harper's Weekly, quotation in, 79
 Loan Exhibition, 56
 McLaughlin and, 175
 correspondence with, 129–30
 refusal to teach, 59, 95
 withdrawal of support, 126–27
 Pottery Club reception, attendance at, 87
 WAMA, president of, 50, 89, 111
 Women's Columbian Exposition Association of Cincinnati, president of, 124
 women's employment, advocacy for, 44